Dedicated to Catherine Bailey

DAVID BAILEY
BY
PALOMA
BAILEY

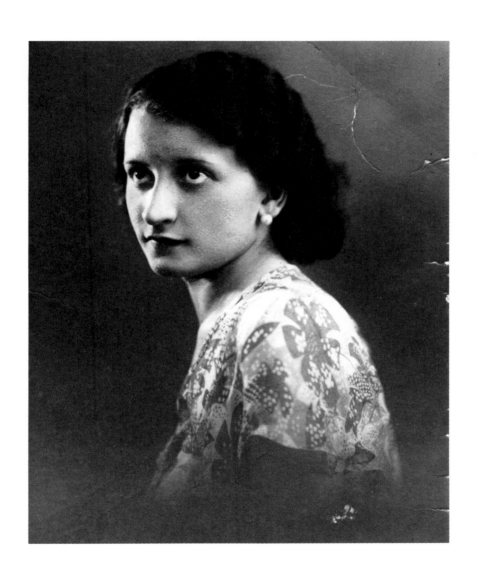

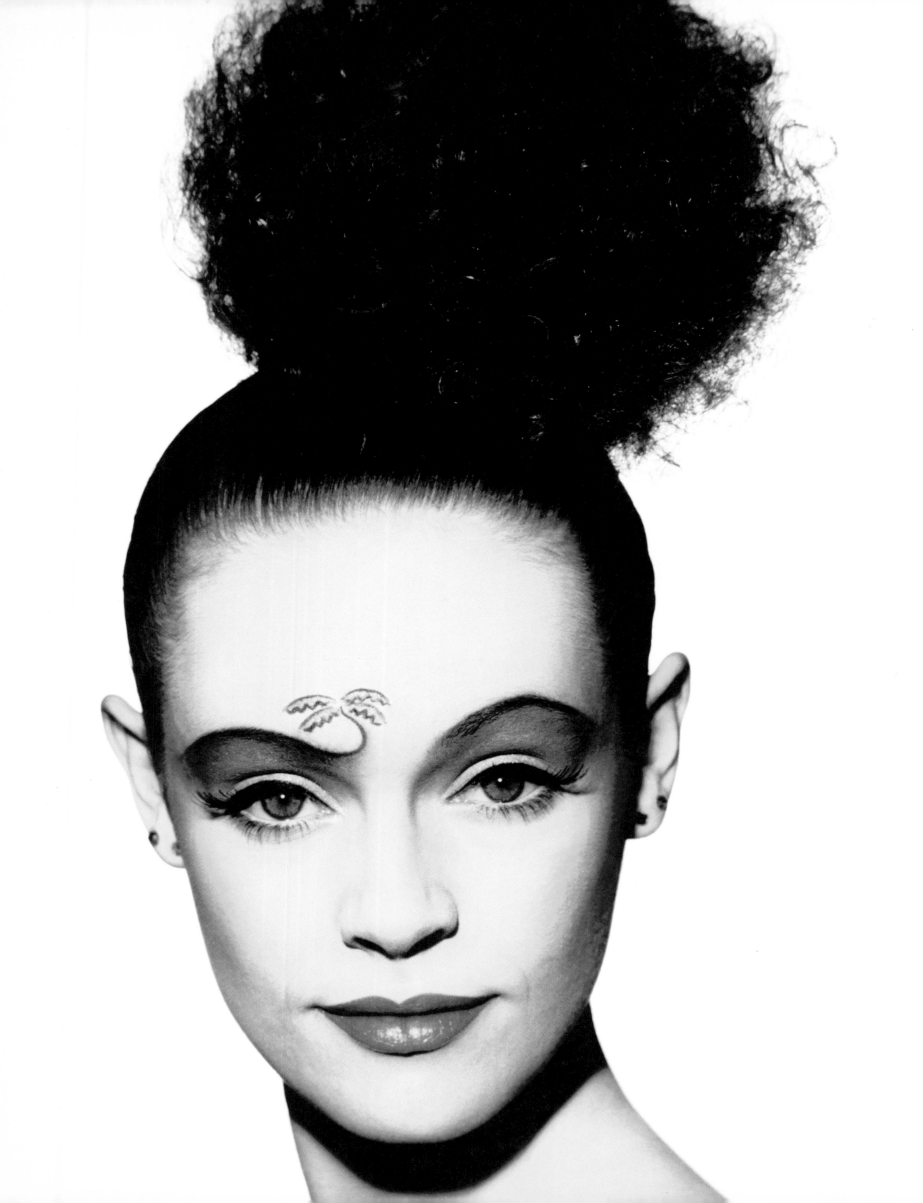

Robin Muir

# DavidBailey

## Chasing Rainbows

WITH OVER 150 COLOUR ILLUSTRATIONS

 Thames & Hudson

**Design by Gerard Saint @ Big Active**

First published in the United Kingdom in 2001
by Thames & Hudson Ltd, 181A High Holborn,
London WC1V 7QX

British Library Cataloguing-in-Publication Data
A catalogue record for this book is available
from the British Library

ISBN 0-500-54241-4

Printed and bound in Germany by
Steidl Verlag und Druck

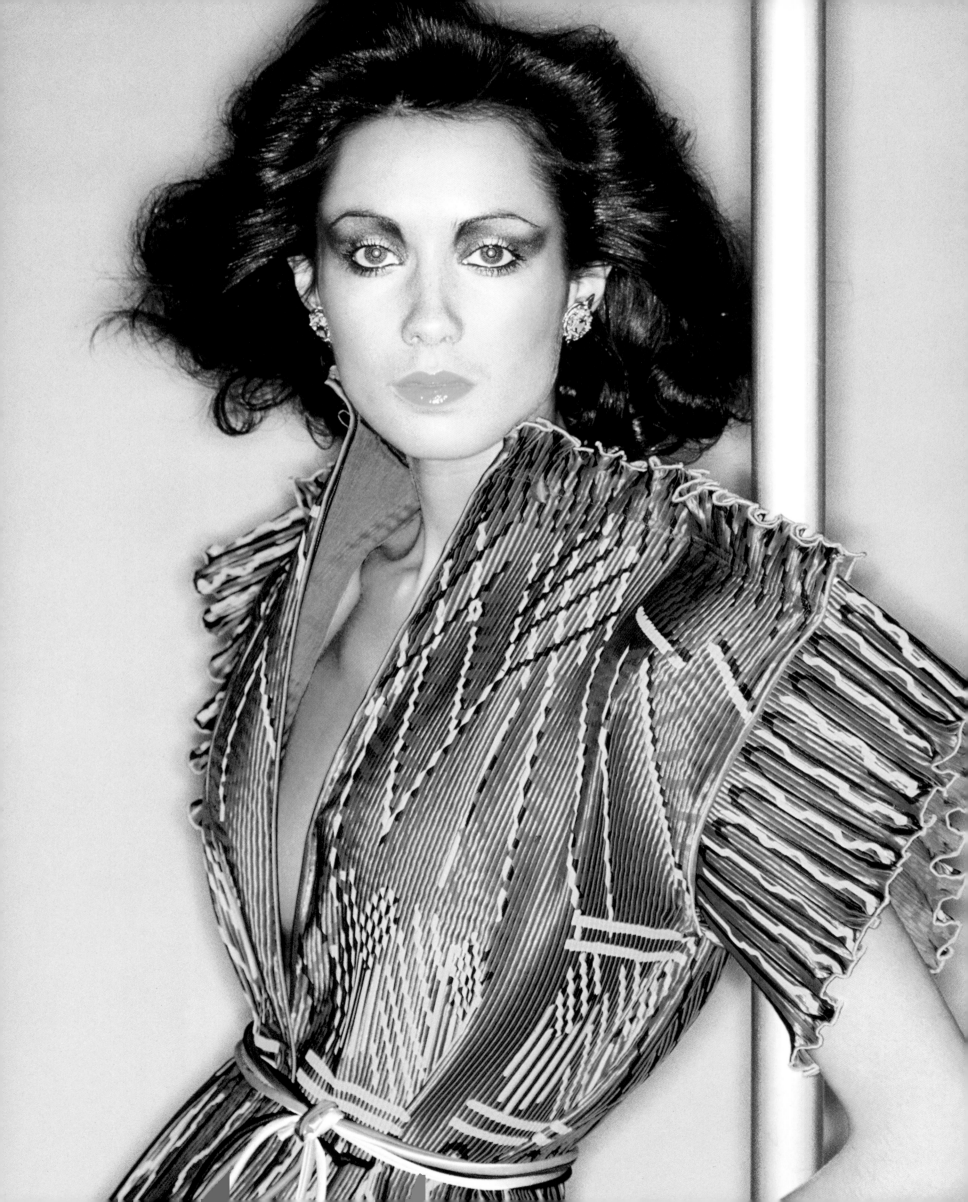

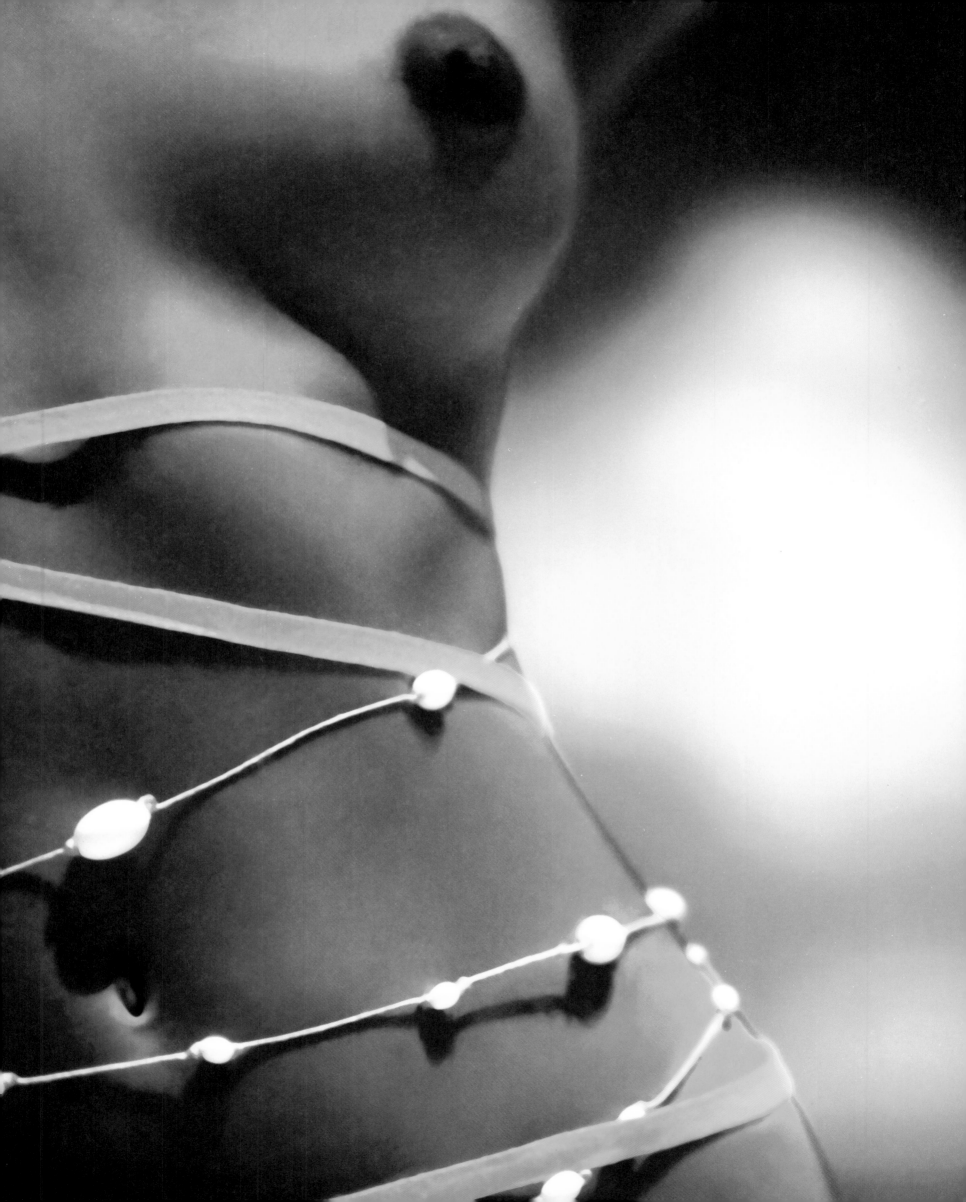

# Contents

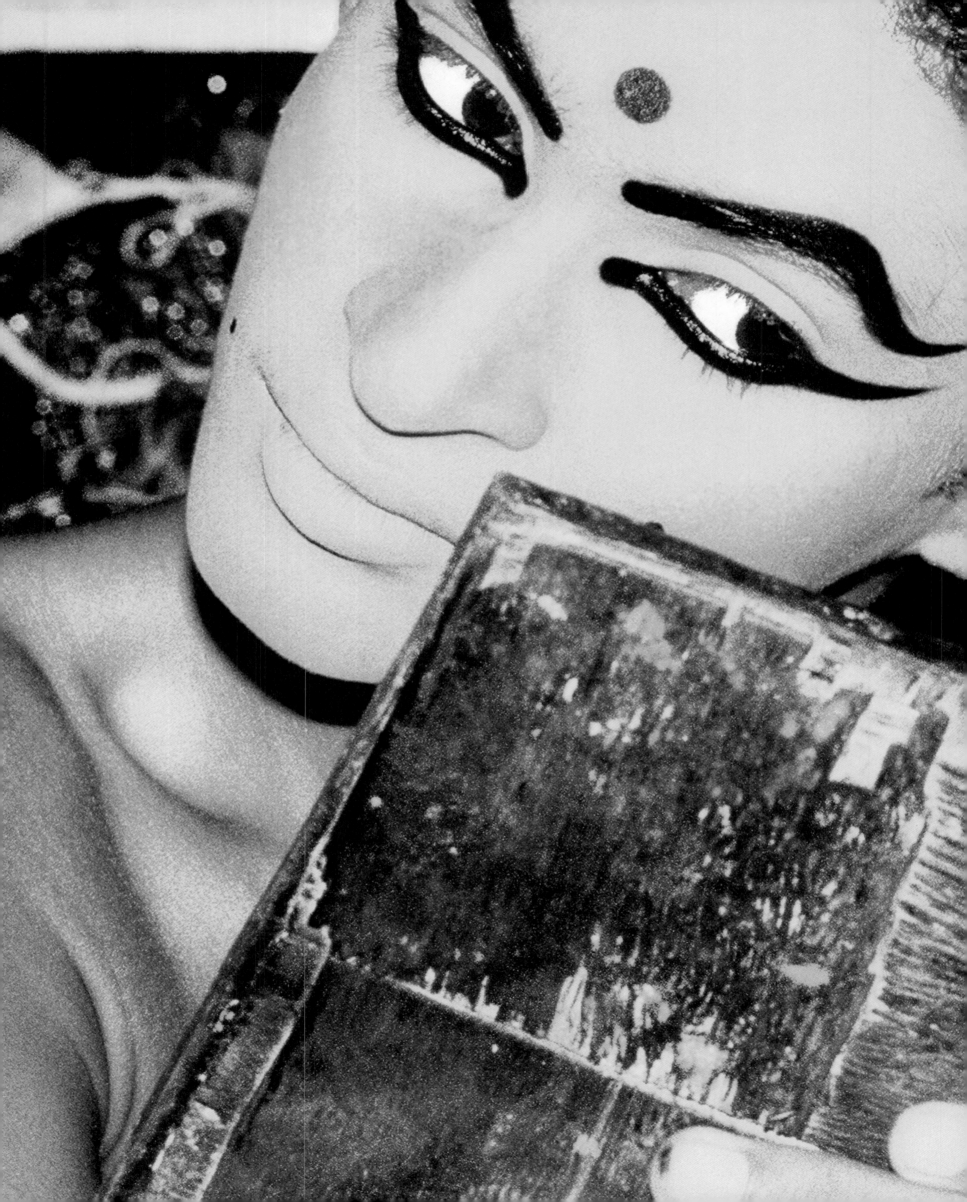

avid Bailey is part of the mythology of the 1960s, and any serious scrutiny of his career must first of all disengage him from that mythology. In the context of the photographs in this book – mostly magazine commissions from the mid-sixties to the present – the first fallacy is that Bailey's motivation, as the fifties drew to a close, was an assault on the upmarket glossy magazine. Though he achieved much in that field, and with surprising speed for a novice, this supposition ignores the fact that, on the whole, fashion photographers tend to be made, not born. Though shaped by their times, they are more frequently nurtured by magazines to be, at the very least, promoters of a corporate self-image. And British *Vogue*, the publication with which Bailey is most associated, was no exception.

True, as his career with the magazine progressed, Bailey's photographs begin to represent both a reaction against the perceived 'slickness' of the fashion world and his own determination to bring a more casual sensibility to the mainstream. This did not mean, it should be stressed, that he intended to divest himself in the process of any traces of 'glamour'. The photographs on these pages are the evidence. However, he was not the iconoclast or even the careerist fashion photographer of the popular imagination – at least, not when he started out. Within two years, however, he had succeeded in tweaking the magazine's self-perception into furthering his own artistic agenda.

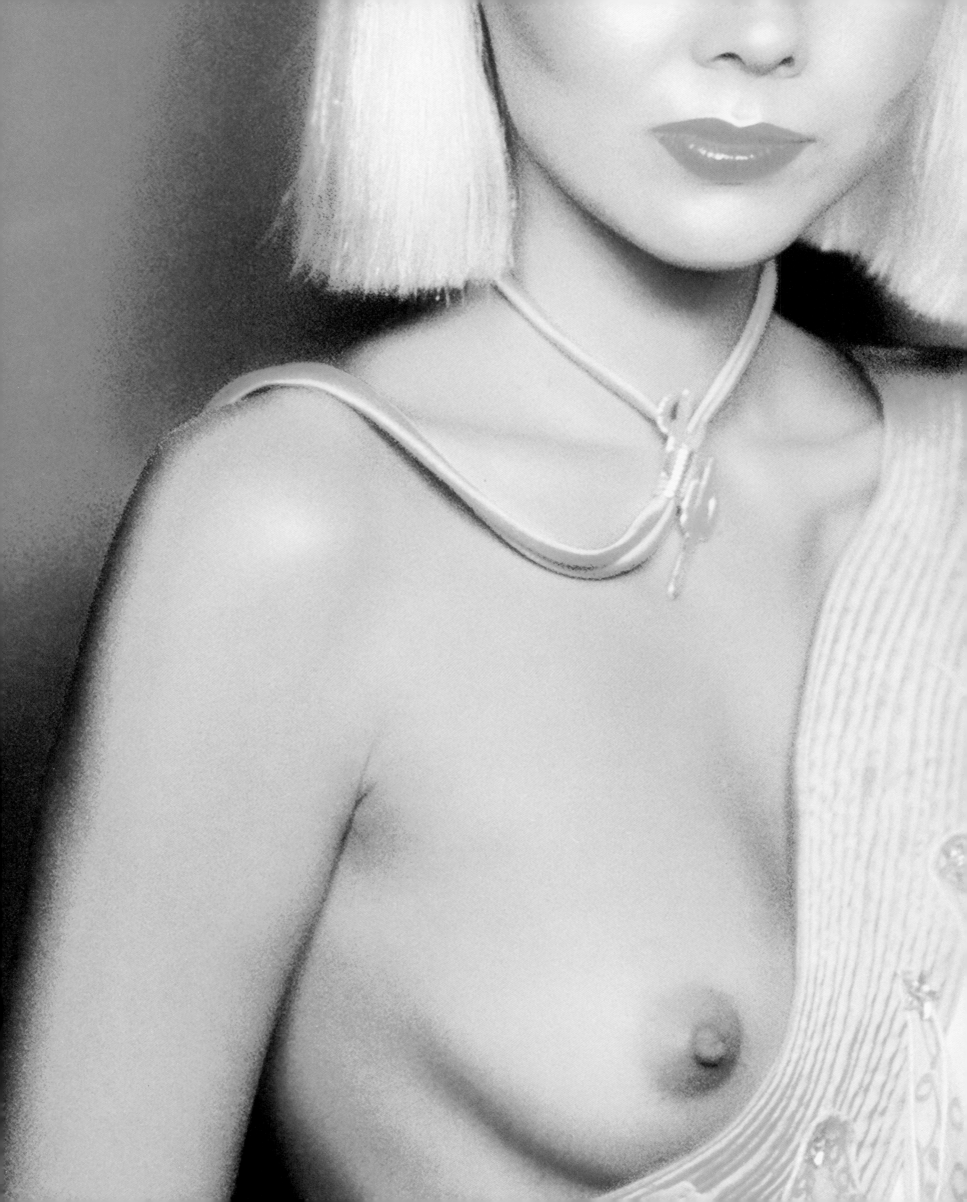

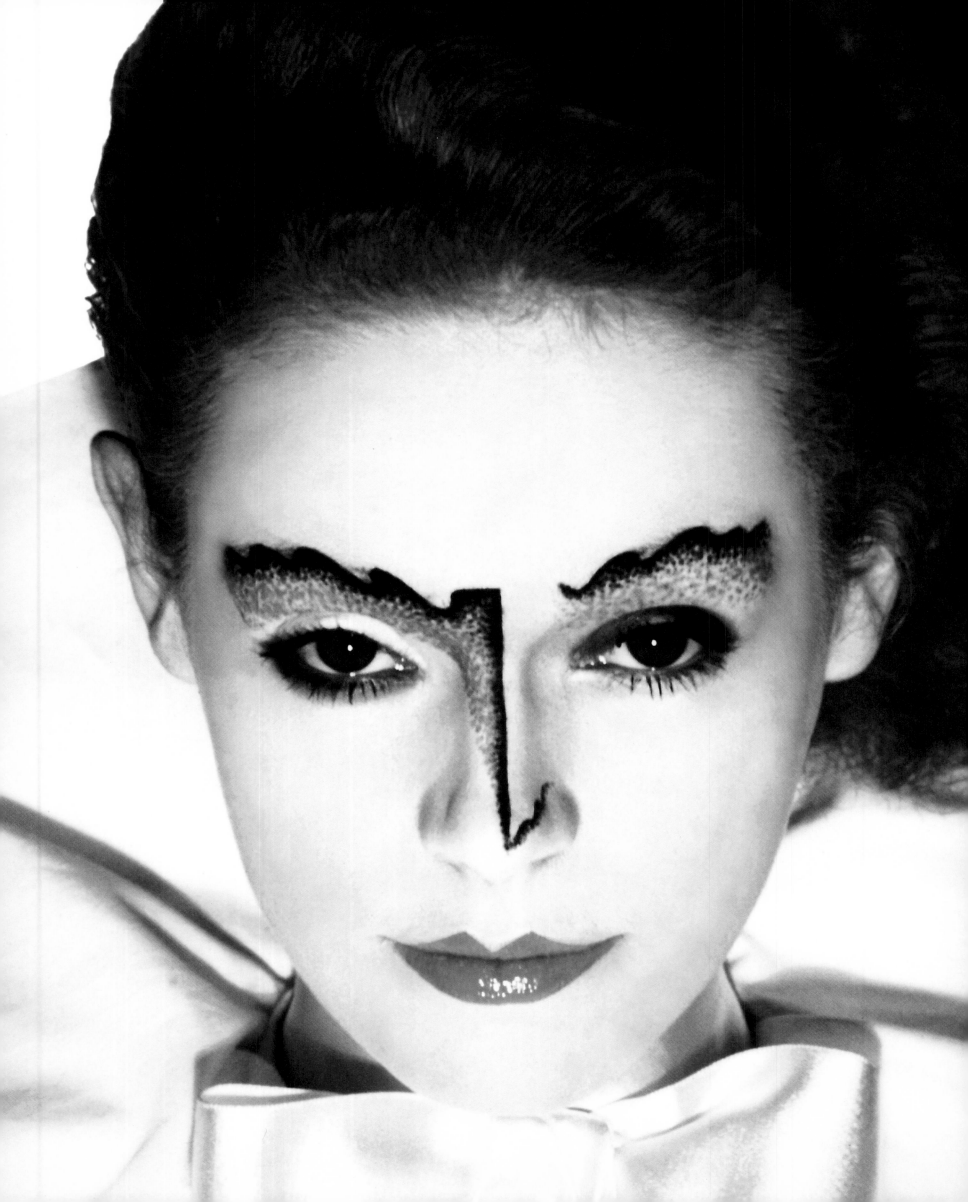

For example, for a fashion story with a horse-racing meet as a backdrop, Bailey combined a handheld *vérité* style with a formal documentation of the clothing provided. The results pleased both the magazine and the photographer.

Within the parameters set by *Vogue* (middle-market fashion and the setting and model of its choice), Bailey's artistic integrity remains intact. Whatever the magazine presented as a guideline he would find the means to flout, subtly or blatantly, giving rise, however his reaction manifested itself, to the most sustained fashion and beauty *oeuvre* of the sixties and seventies and beyond.

Besides an interest in girls and fashion photography, by the time he began with *Vogue*, Bailey was already an accomplished portraitist and a documentary photographer of promise with a diversity of self-motivated projects behind him. After complimenting Bailey for his 'picturesque gear and an eye for beautiful young girls', Cecil Beaton, whose photographs dominated the pages of the magazine in the decade before Bailey's birth, admonished his younger colleague, saying that it would be sad if a craftsman like Bailey, so adept at one particular form of self-expression, were to branch out into 'too many distracting diversions'. The advice was promptly ignored. In any case, the distracting diversions had been operational since Bailey's days as an apprentice in the studio of John French at the tail-end of the 1950s.

Through his fashion photographs Bailey has always told us something about beauty, certainly much more than the clothes he was commissioned to depict. And he has continued to subvert and rework the genre of both beauty and fashion photography to suit his idiosyncratic vision. His points of reference are wide: the films of the *nouvelle vague* and of Eisenstein, of the spy film genre and the cold eye of the surveillance camera, reworkings of Picasso, of Schnabel, Schwitters. There is much that has Surrealism as a starting point or the photography of Man Ray. There are homages to the photographers Hans Bellmer and E. J. Bellocq, as well as to Manuel Alvarez Bravo, in particular the latter's bandaged torso *La Buena Fama Dormiendo* (1938).

When French gave Bailey his very first job, it was obvious that the younger man knew nothing about incandescent strobe or how to load a 10 x 8 film pack. Bailey asked French years later why he had been taken on: 'Well you know, David,' he replied, 'I liked the way you dressed' (*David Bailey: Black and White Memories,* 1983, p. 26). It's a throwaway remark that says so much about a synchronicity of style and of presence that has shaped Bailey's development for the last forty years. He is the photographer as hero, in fact the photographer as anti-hero, the man who transcended British insularity to take New York by storm, to count Andy Warhol as a friend and to bring a little of Warhol's pop art aesthetic back to London.

Of Cecil Beaton, sitting for Paul Tanqueray, Stuart Morgan wrote that 'As he sat there under the hot lights, his mind a blank, he became Fashion. Or Photography. Or maybe both at once' (*Cecil Beaton*, 1986, p. 119). It is perhaps Bailey's good luck or his curse that he, like his hero Beaton, is for us emblematic of both. He is synonymous with British photography – not simply fashion and beauty photography – and as the years recede and photography's pervasive influence stamps its mark on the culture of the last century and the current, he becomes part of our cultural landscape too, whether he agrees with it or not. The *enfant terrible*, who asked the managing director of *Vogue* to move his Humber so he could park his Rolls, is respectable.

The writer Fay Weldon once asked Catherine Bailey, 'What is a good photograph?' 'One', she replied, 'that contains the whole moment which surrounds it.' 'And a good photographer?' 'A photograph includes the photographer as part of the moment' (*The Lady Is a Tramp*, 1995). Her husband's moments have been many and he continues to be a part of our photographic vista. The extent to which he has managed to impose his views on magazine photography for so long remains an extraordinary achievement.

For his simplicity and his unbridled passion for his art, for all that has gone before and for all kinds of other reasons, a lot of which have nothing to do with photography, but a lot to do with art, and for never knowing when to stop chasing rainbows, Bailey is a hero to his own generation and beyond. And especially to those who couldn't begin to load an Olympus, let alone point and shoot it, and say something both cajoling and provocative and get away with it. Far less make a perfect distillation of female beauty out of it for nearly half a century.

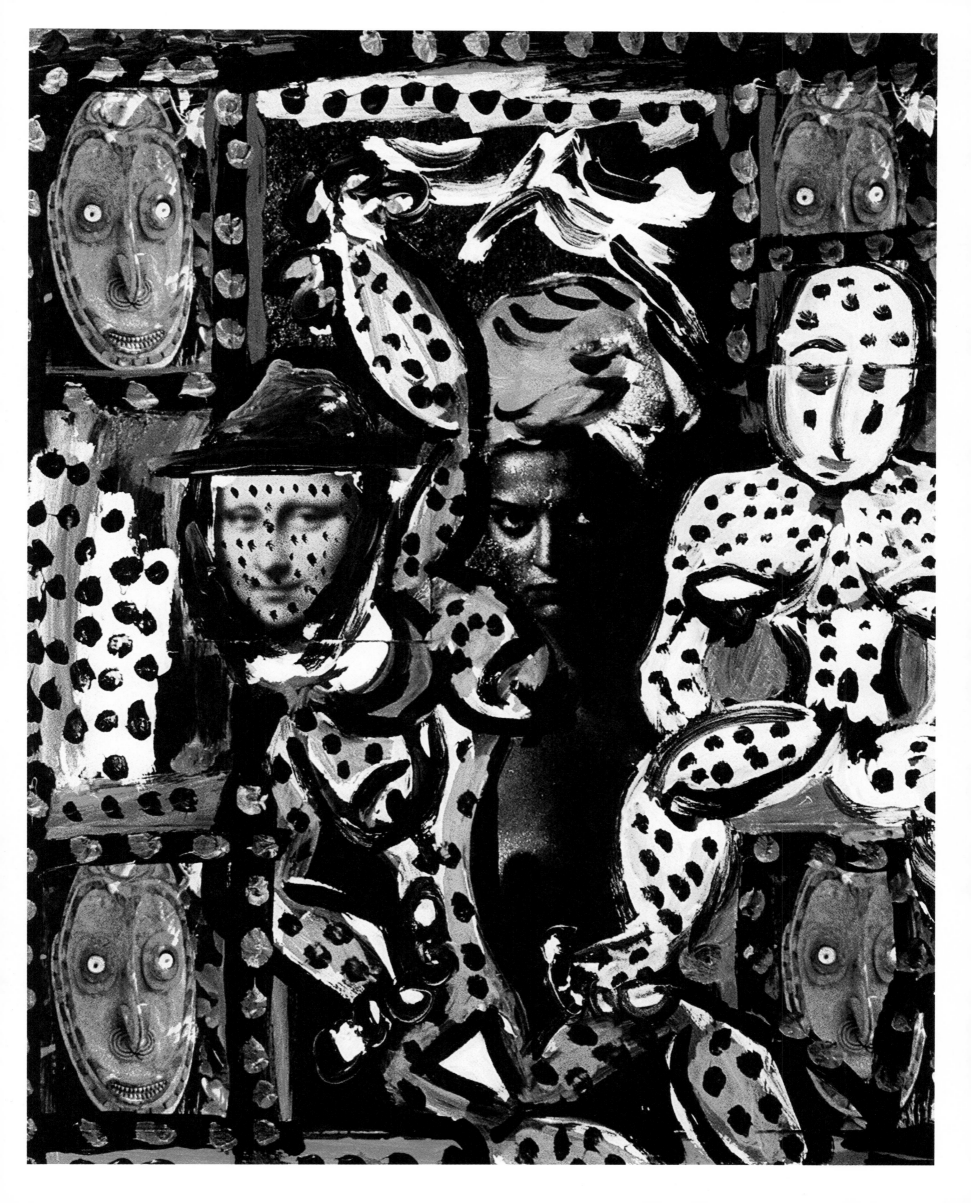

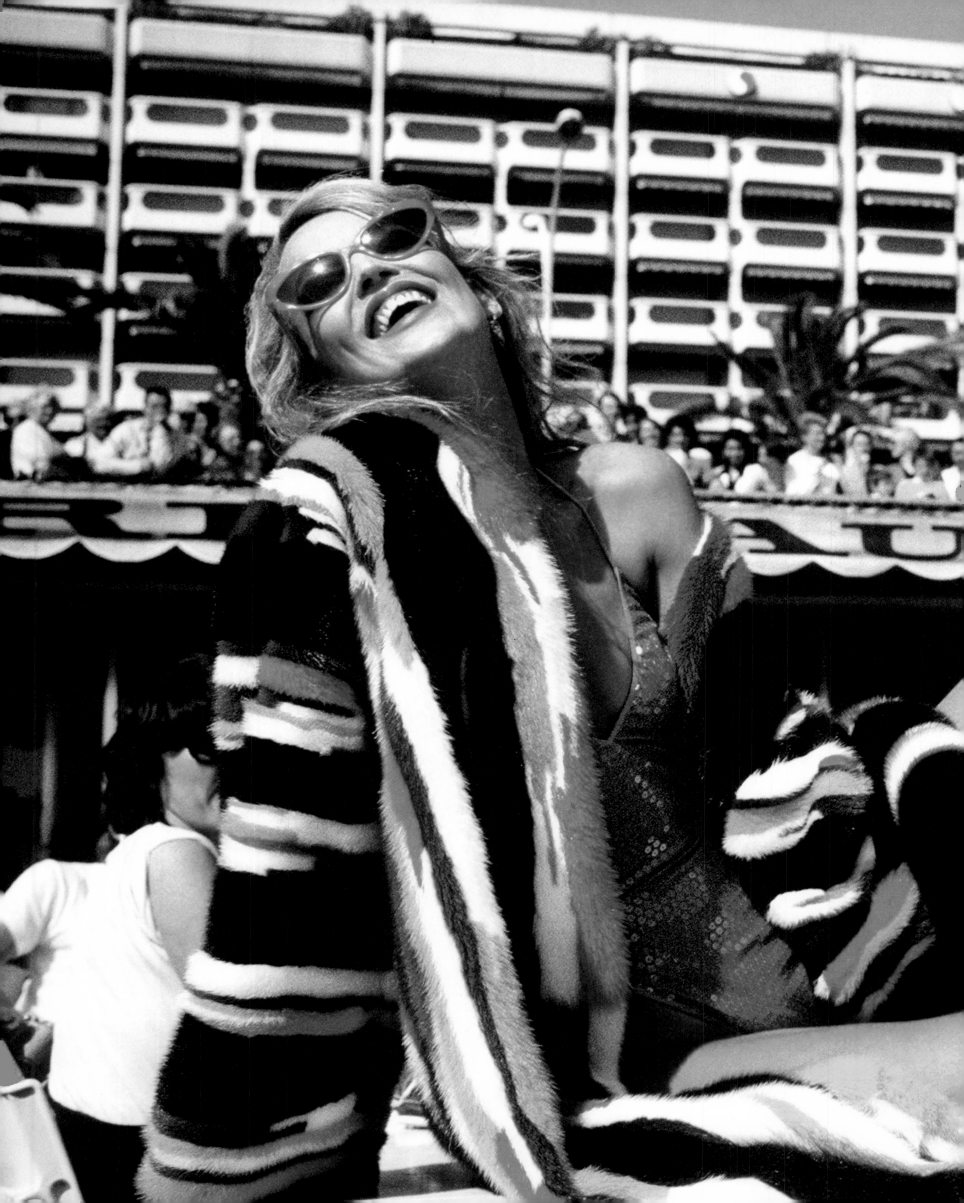

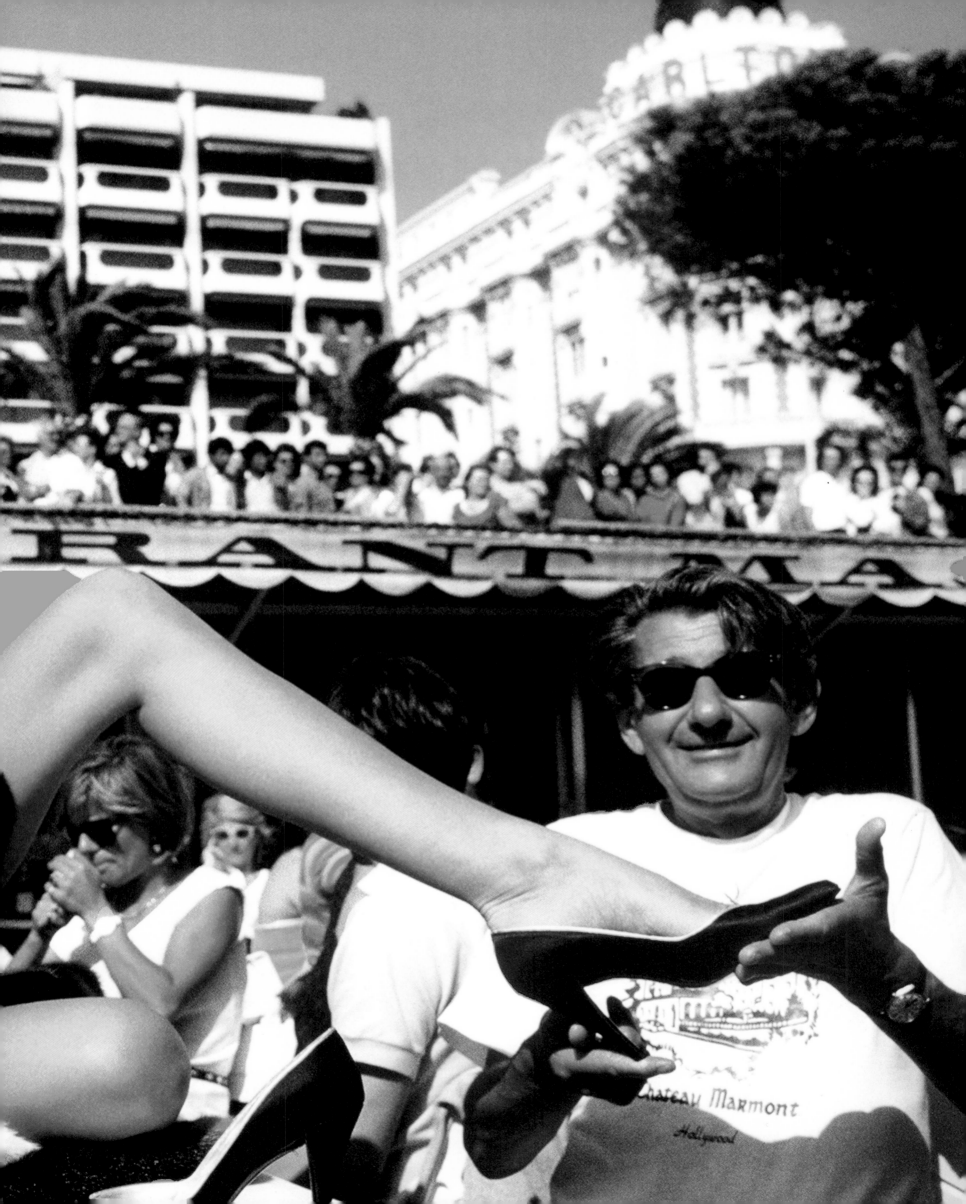

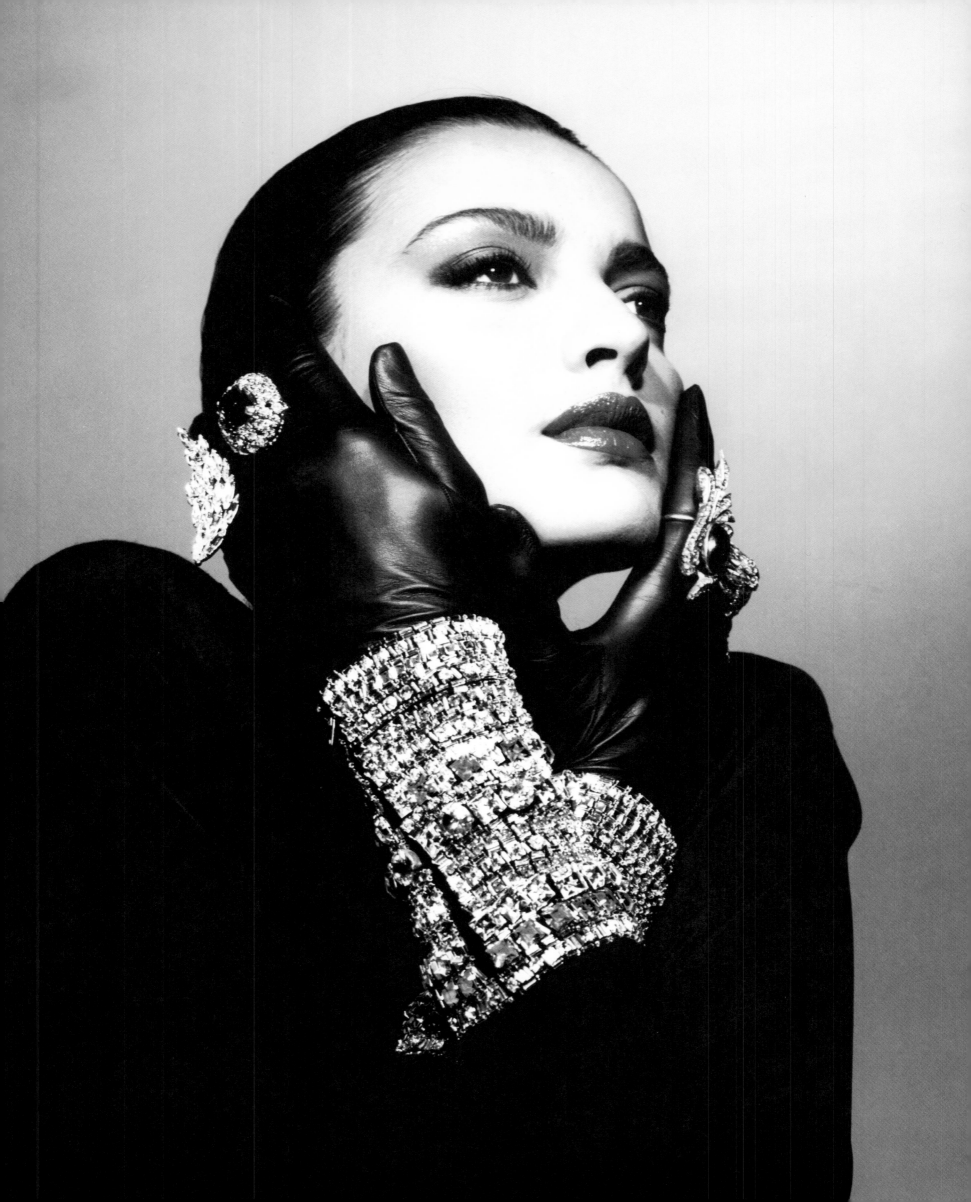

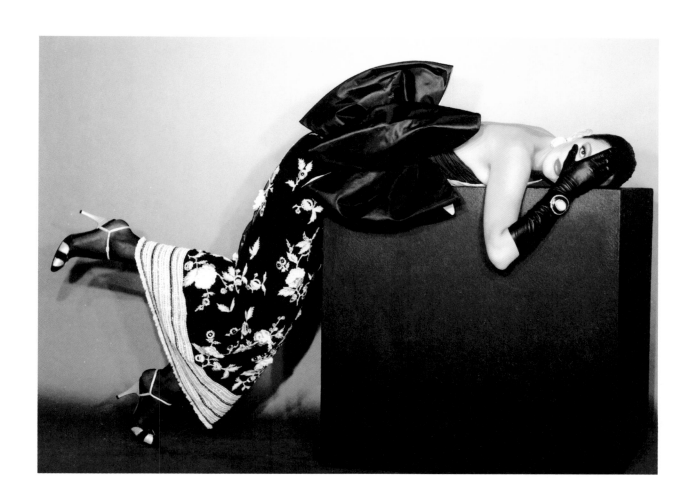

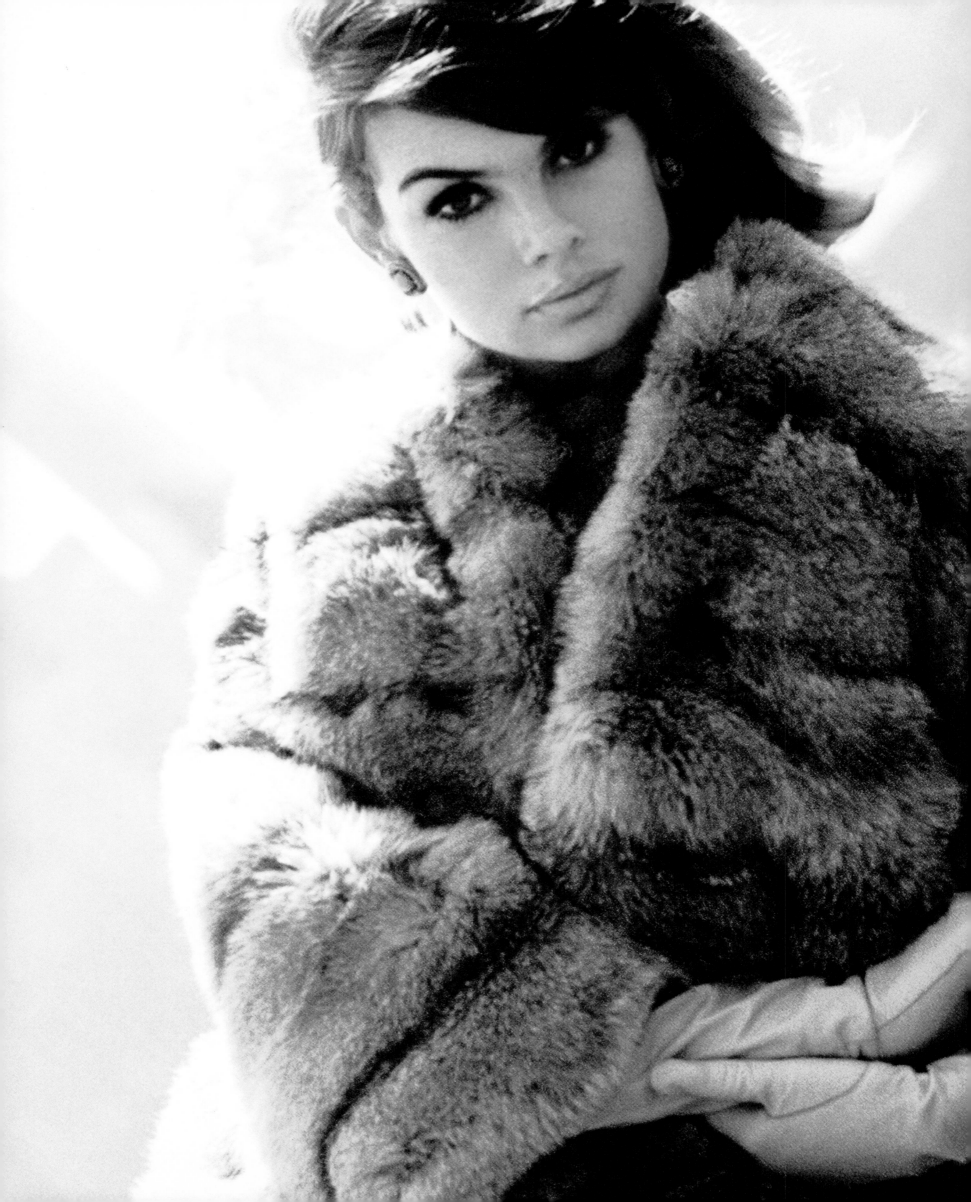

lamour has played a key role in the development of David Bailey's private and commercial work. The term 'glamour photography', however, might give rise, at least in the context of a magazine *oeuvre*, to misapprehension. Though not all of the pictures in this book were commissioned by magazines or advertising clients, most of them are, for want of a better term, and in the universal magazine parlance, 'beauty photographs'. This is perhaps a more apposite description, though it can be, on occasion, and with Bailey's particular slant, a peculiar kind of beauty.

To define beauty photography is difficult, so intertwined is it with the iconography of fashion depiction. According to Bailey a fashion picture itself 'only becomes one when captions and prices are put under it. Before this happens it is a portrait of someone wearing a dress' (*Shots of Style*, 1985, p. 9). A beauty photograph differs from a fashion photograph simply in that it is a picture which concentrates on the woman herself, regardless of what she might or might not be wearing. In the history of magazine photography, the beauty photographer appears rarely to have been a distinct and separate species – he is, in the end, merely a fashion photographer asked to take beauty shots.

As his books *Beady Minces* (1974), *Trouble and Strife* (1980), *Nudes 1981–1984* (1984), *The Lady Is a Tramp* (1995) and others reveal, Bailey has frequently taken such photographs for no reason other than the simple pleasure of it and to please no one but himself.

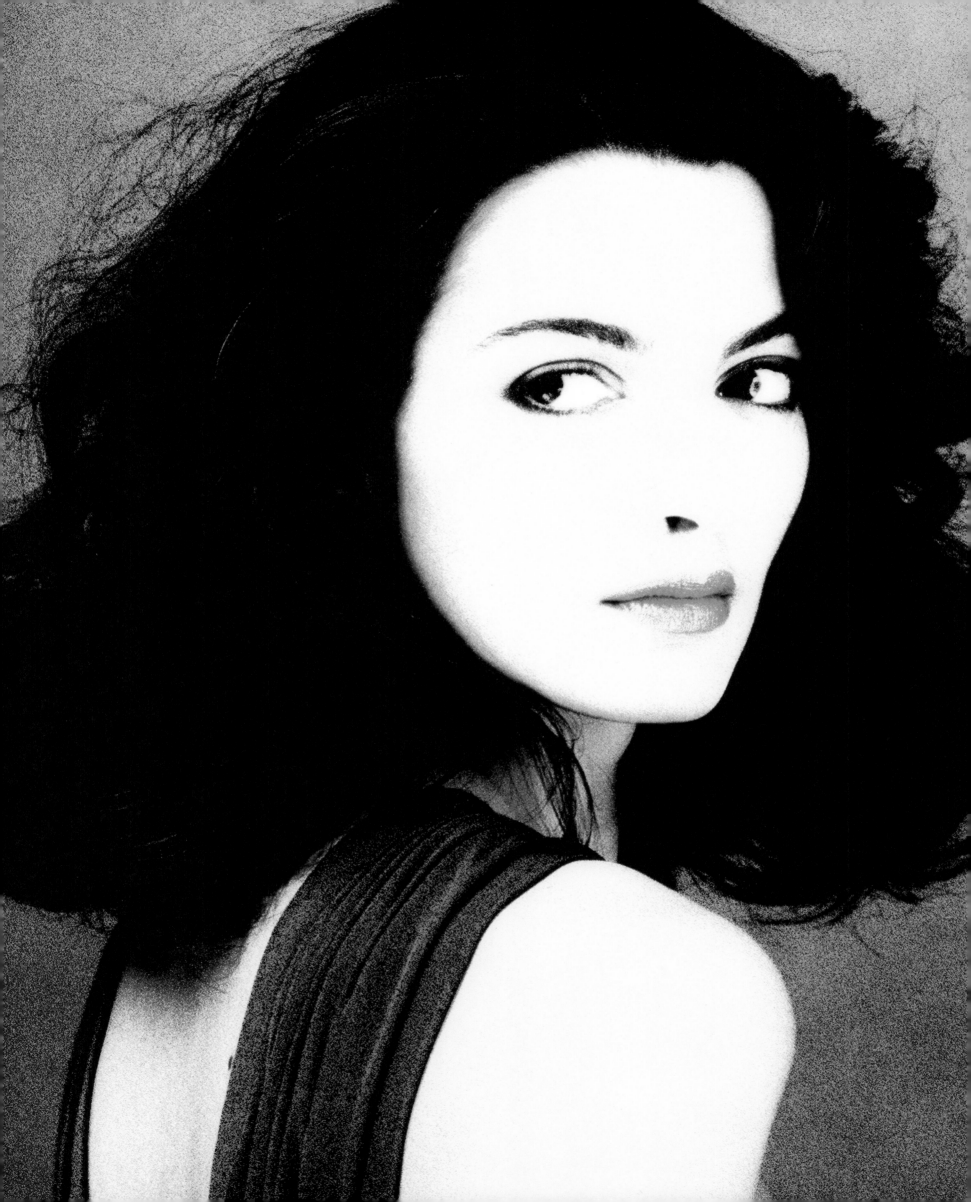

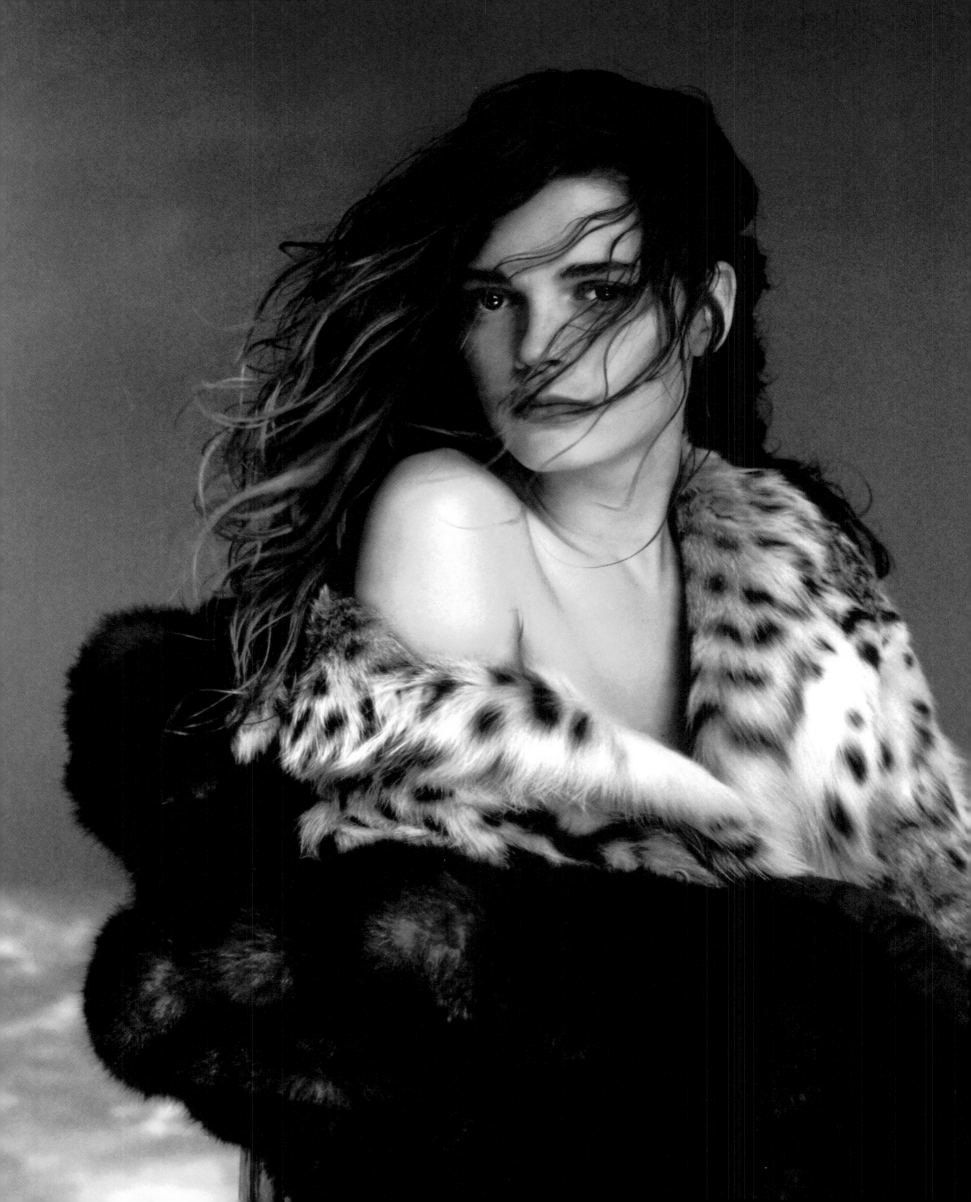

Even when commissioned, a good deal of Bailey's beauty and fashion work was never published. This is perhaps a consequence of the editing process of magazines – how editors and art directors choose the photograph to be published. Frequently their selection, made from several variants, has little to do with the best image and more with the best depiction of the clothes or beauty product or hairstyle. One photograph may, again in magazine shorthand, 'work' with another or dovetail best with whatever text is to accompany it. This is not to say, of course, that these rejected outtakes – the 'overs' – are any less crucial. They are often superior to the published versions and without the disadvantage of enlargement, reduction, reversal, cropping or the overlaying of text, headlines and caption detail that can despoil the purity of the photographer's original vision.

The *Vogue* to which Bailey first found himself contracted as a photographer and where he prepared the groundwork for much of this work was defined in January 1962 by the satirist Jonathan Miller – rather ungraciously, perhaps, since his adverse description appeared in the magazine itself. Alluding to *Vogue*'s famously teasing ambivalence, forever promising something it felt it ought not to, but stopping short of delivering it, Miller observed: 'The very name of the magazine, rare and glottal, stamps the publication as the brochure of stylish hedonism. The obsidian stare of the cover girls suggests an elegant corruption: a whiff of

Beardsley, of voluptuous evil. With all these exciting trappings, the content comes almost as a let down. One is confronted instead by gentility...' Despite the efforts of its younger staff members, a sheepish modesty trickles through its pages. The ladies of *Vogue*, as portrayed contemporaneously by Henry Clarke, Claude Virgin and Eugene Vernier, do nothing more effortful than to sit and stare, hand on chin. Only occasionally, as captured perhaps by William Klein, do they break into anything quicker than a fast trot towards Claridge's. And it is against this backdrop of aspirational posturing, from Ascot to teagowns, from gloved hands to greyhounds, that Bailey's first fashion and beauty photographs should be viewed. 'They – from Mars or wherever they are', he famously remarked in *Vogue* in November 1965, 'said I wouldn't be a fashion photographer because I didn't have my head in a cloud of pink chiffon. They forgot about one thing. I loved to look at all women.' His refusal (and inability) to conform to the stereotype of the time – epitomized by the *Vogue* contributor who asked his models to pose as if to 'catch a butterfly' – made for a striking iconography. Played out by Shrimpton in the early years, by Marie Helvin and Jerry Hall and Penelope Tree, and later by Kim Harris and Catherine Bailey, his tableaux – probably meticulously choreographed – betray a spontaneity and lightness of touch. This has always characterized Bailey's approach to fashion, then and now.

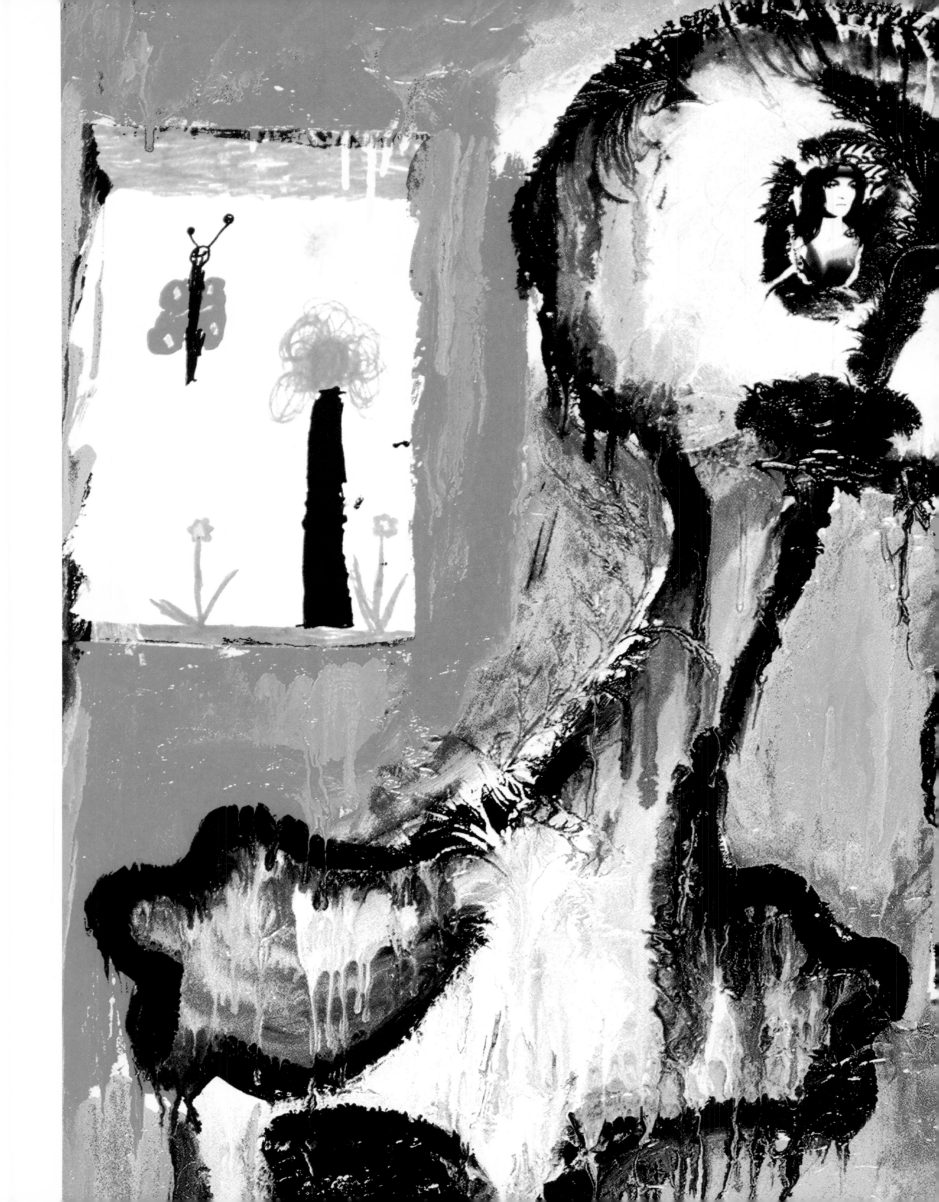

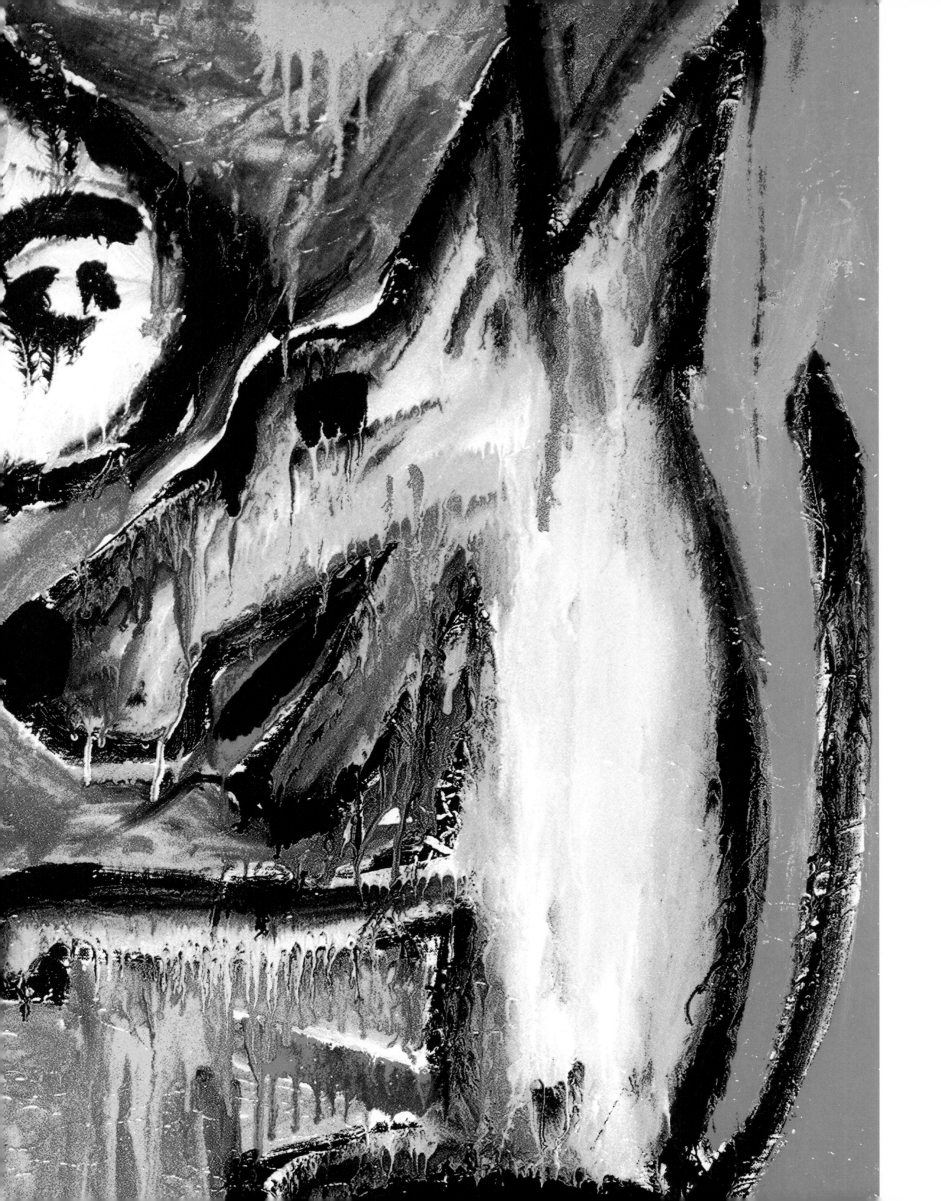

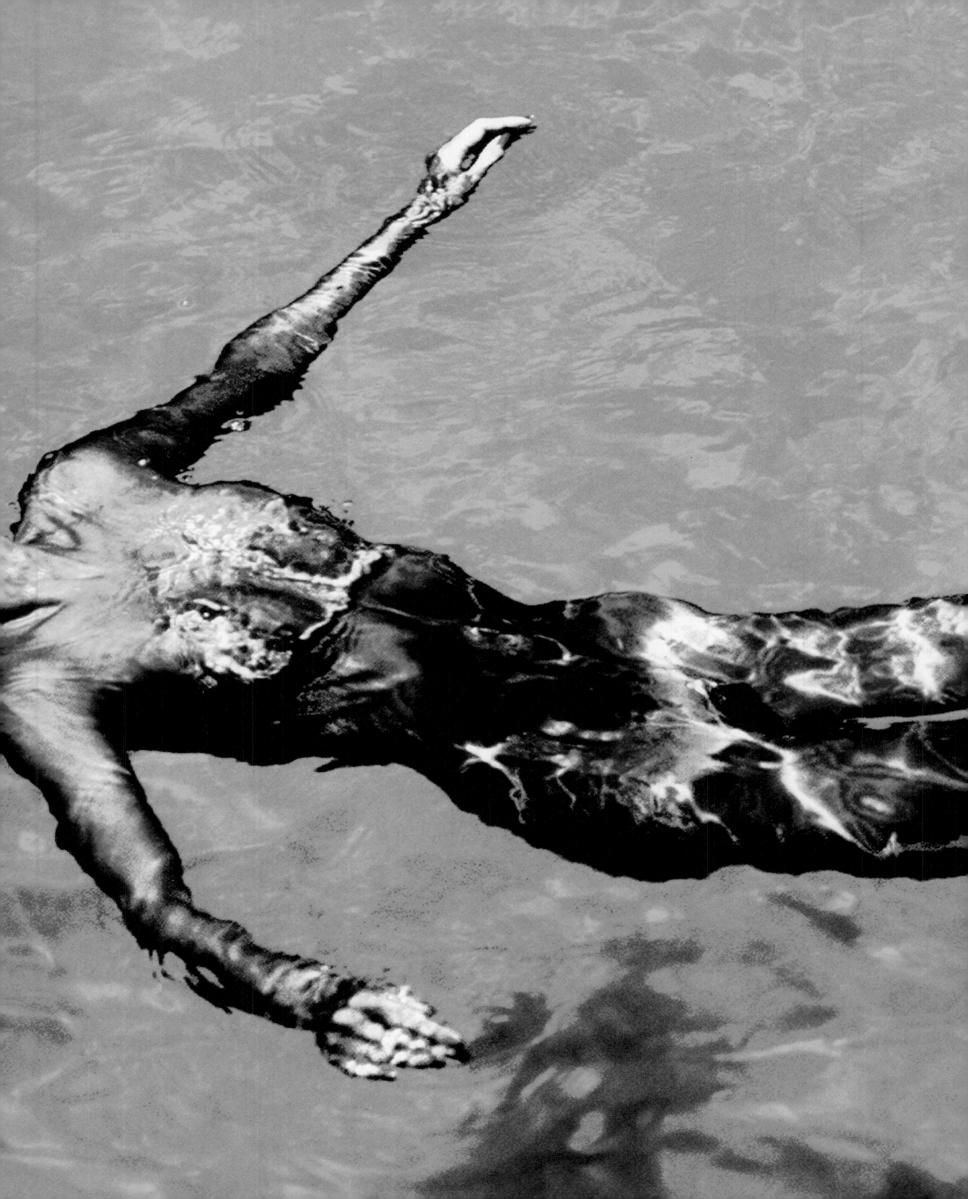

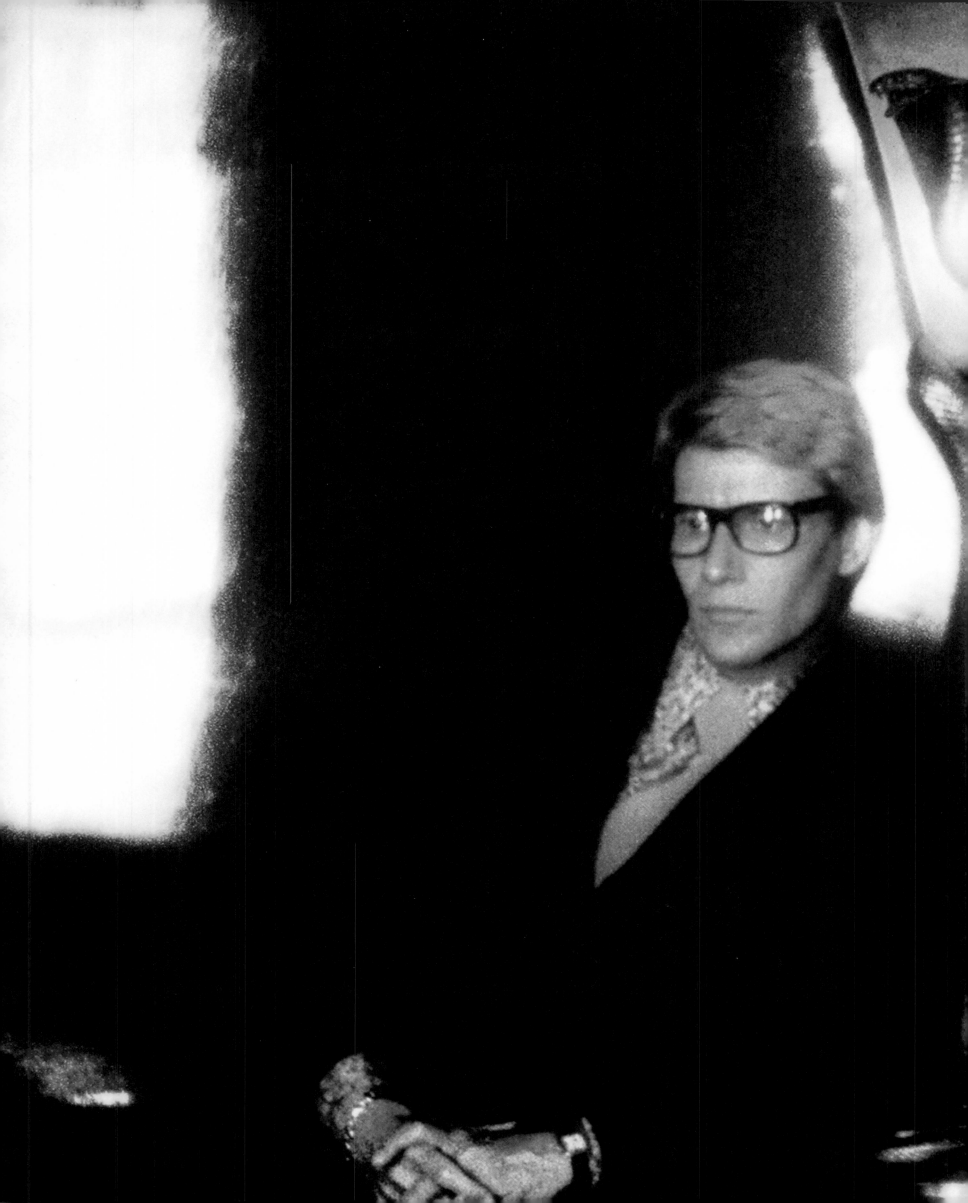

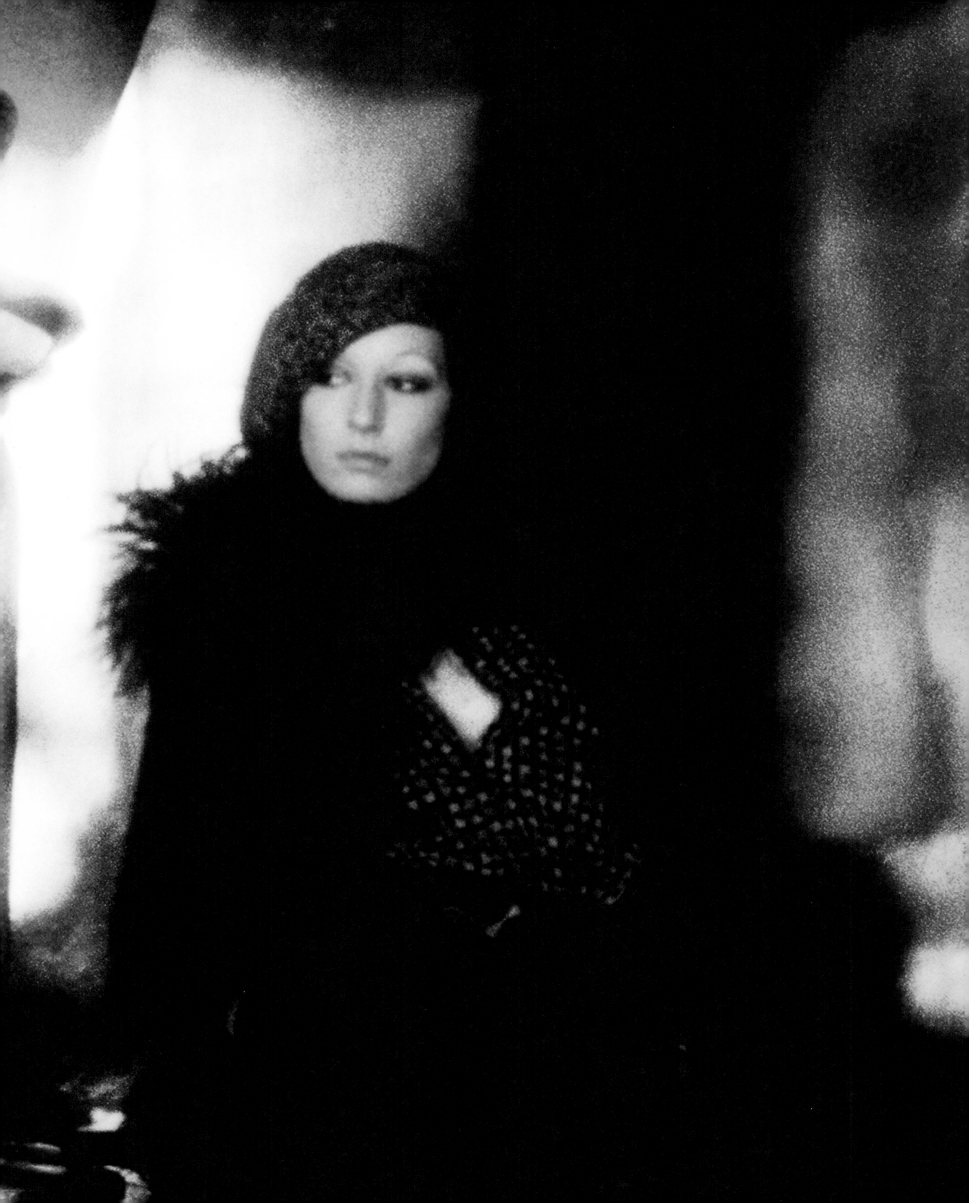

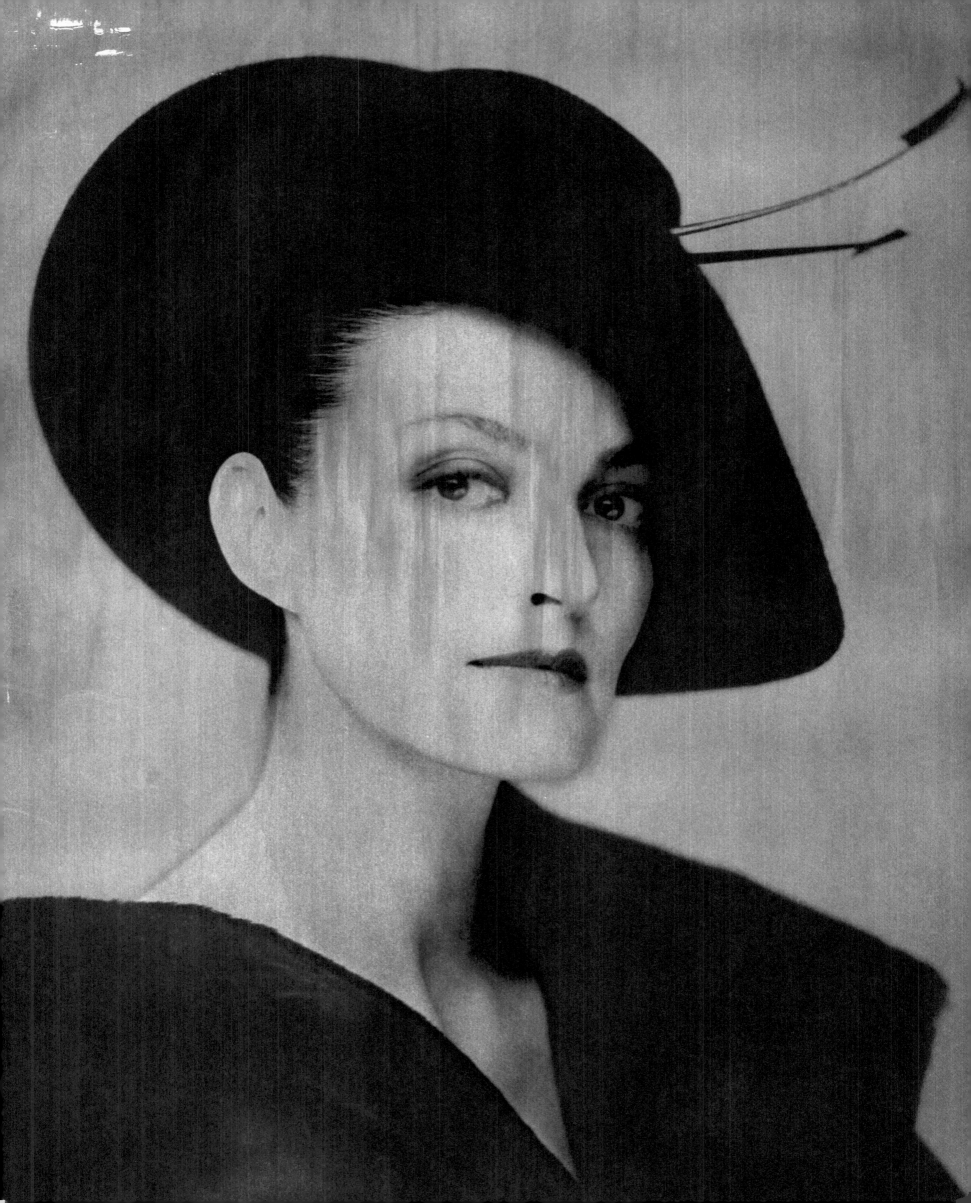

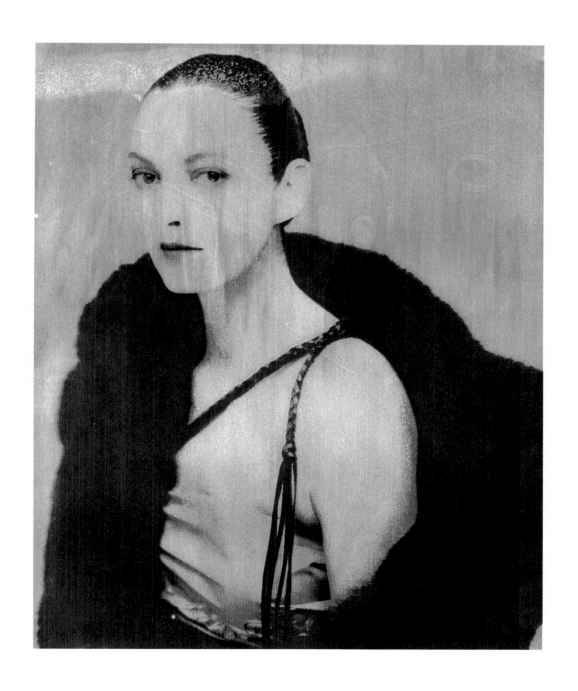

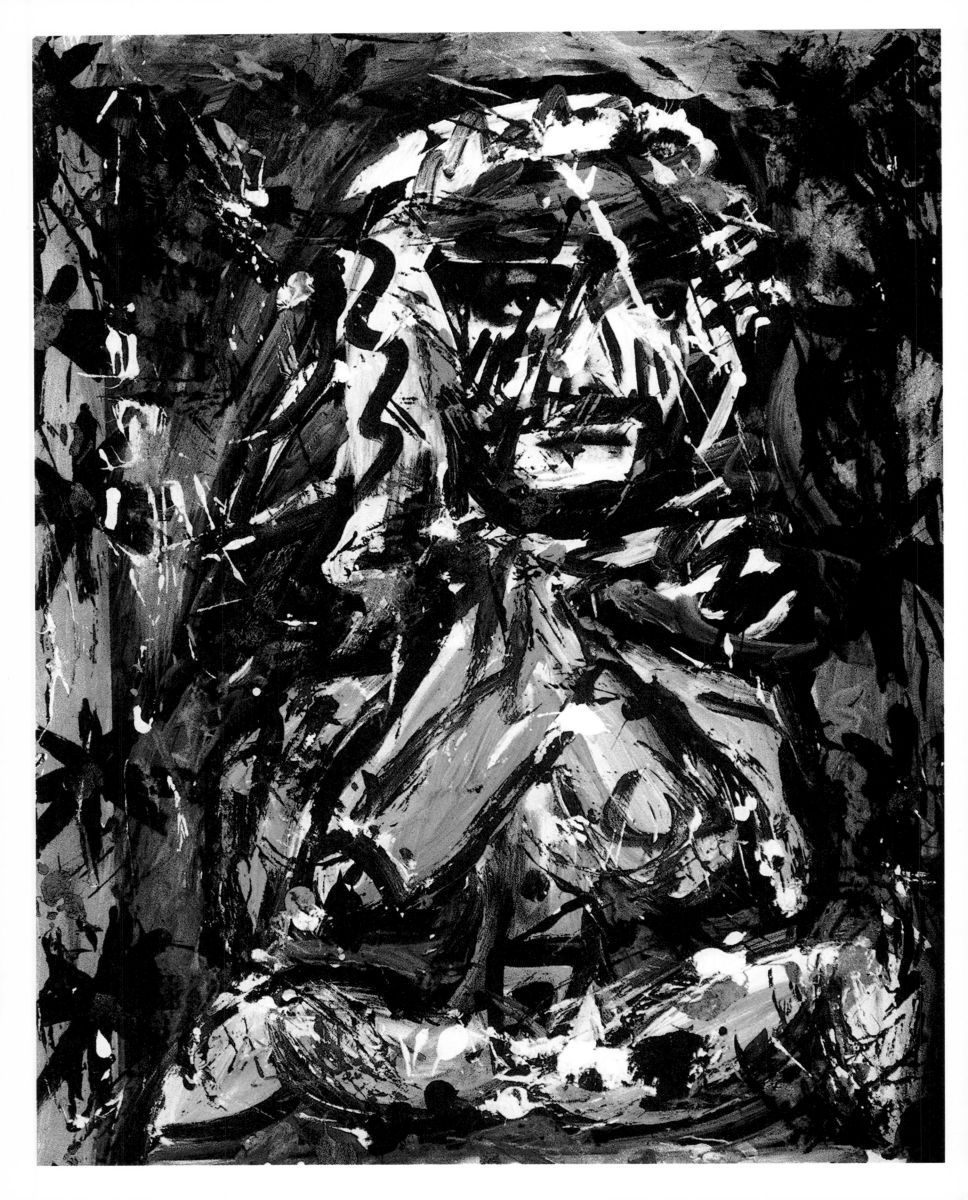

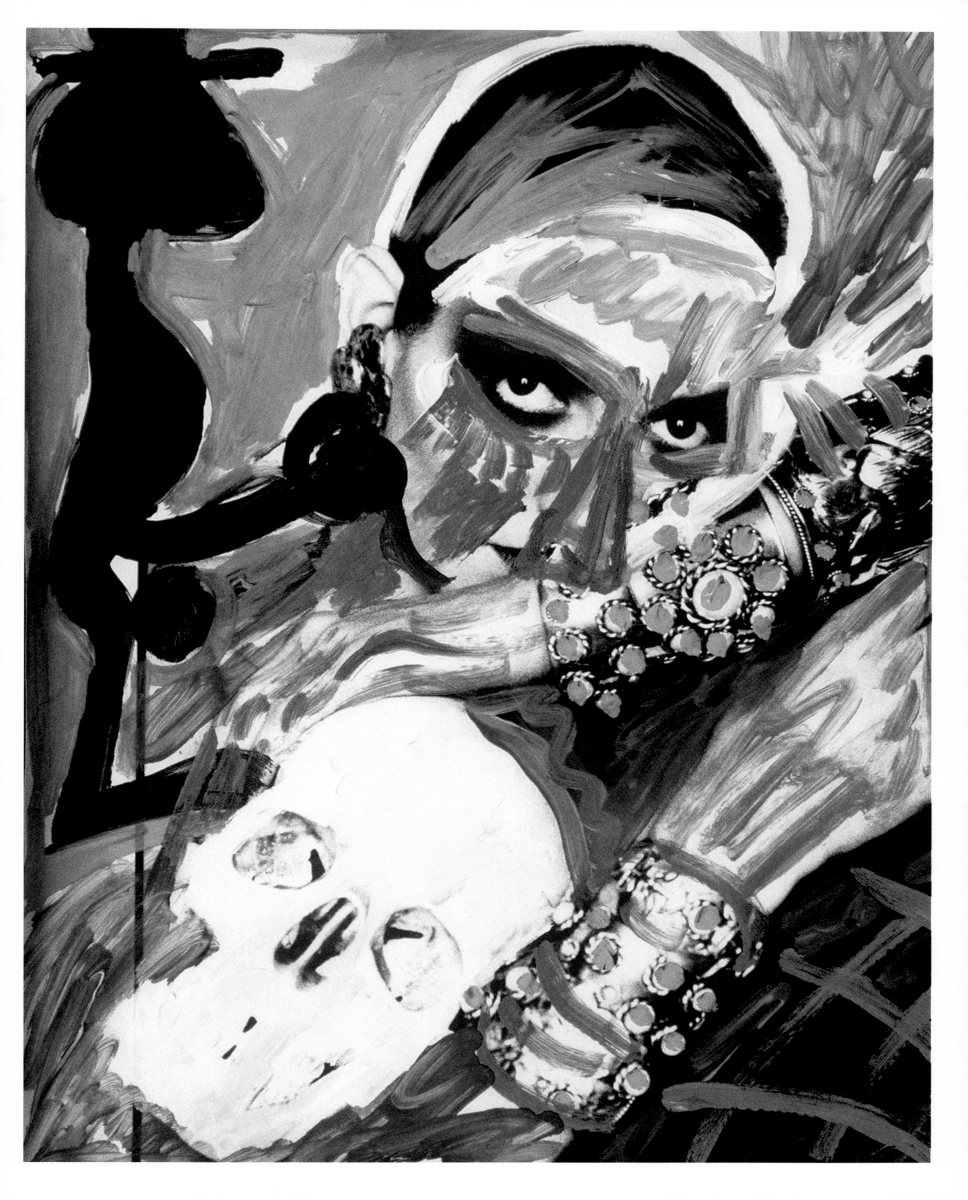

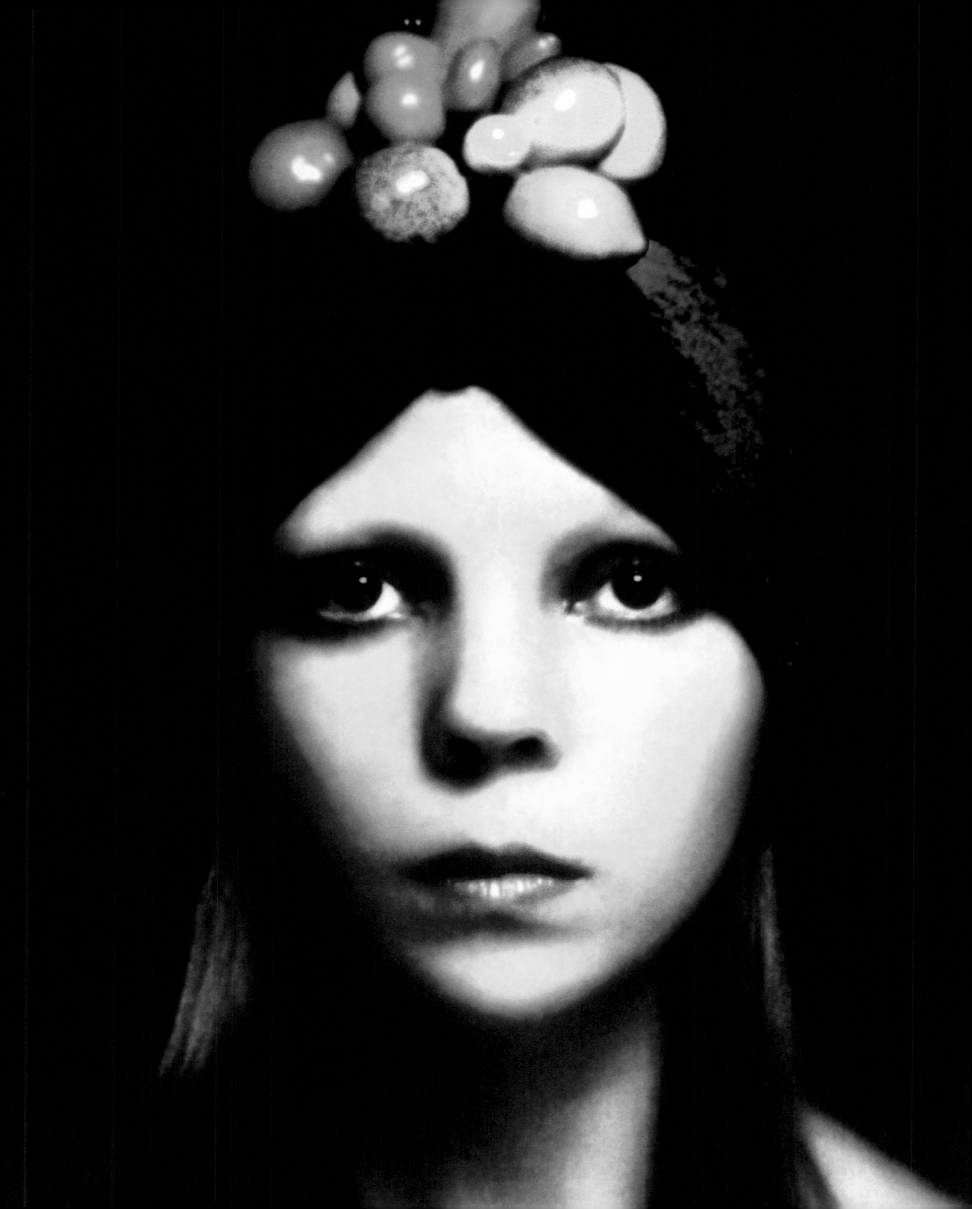

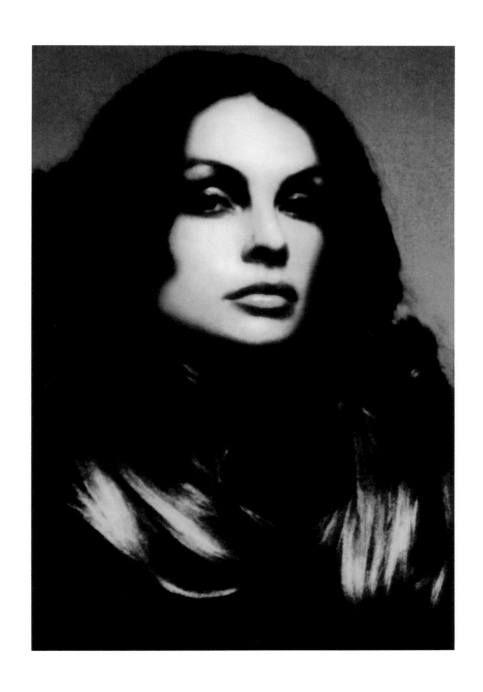

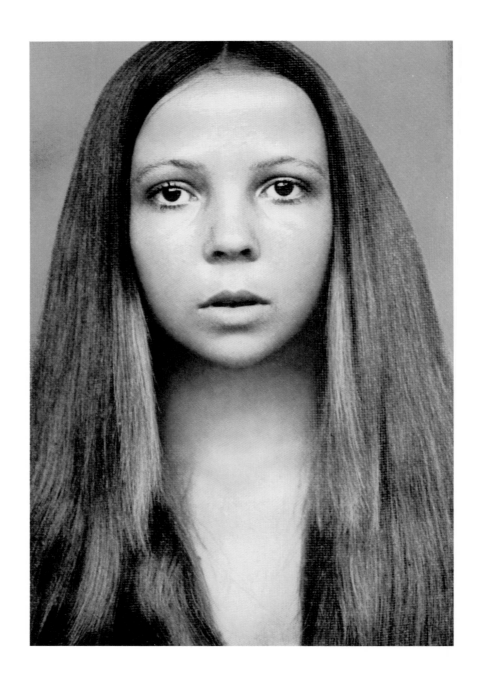

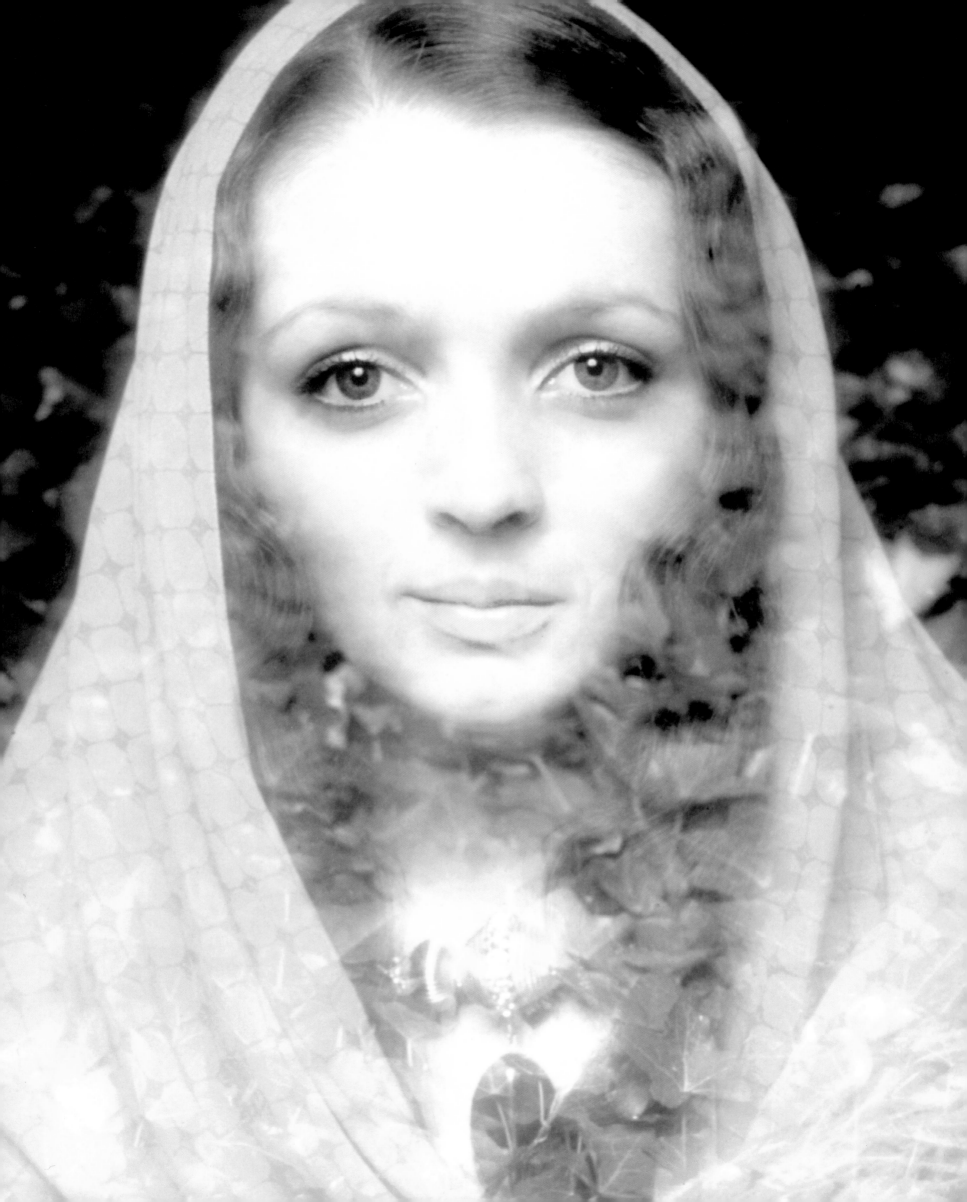

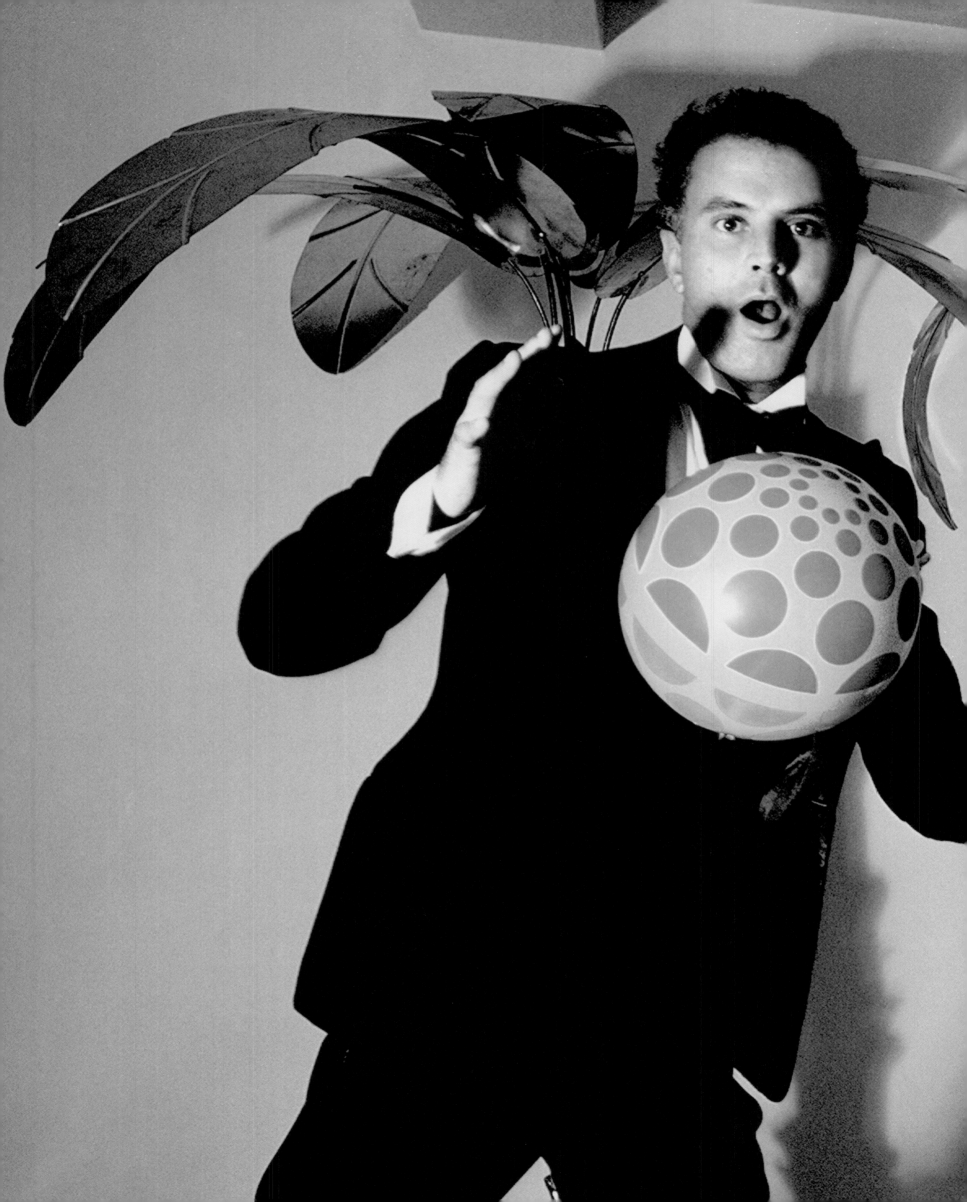

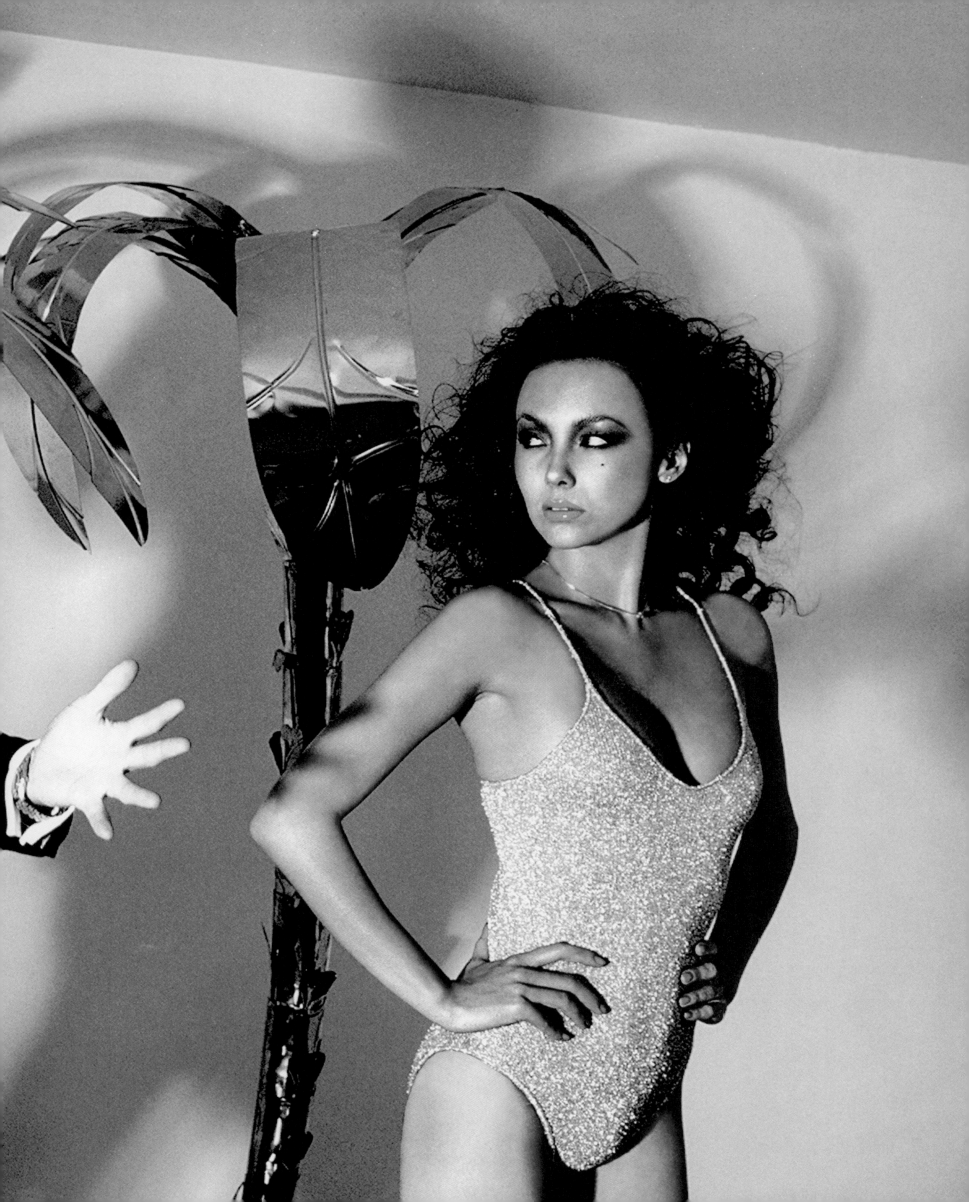

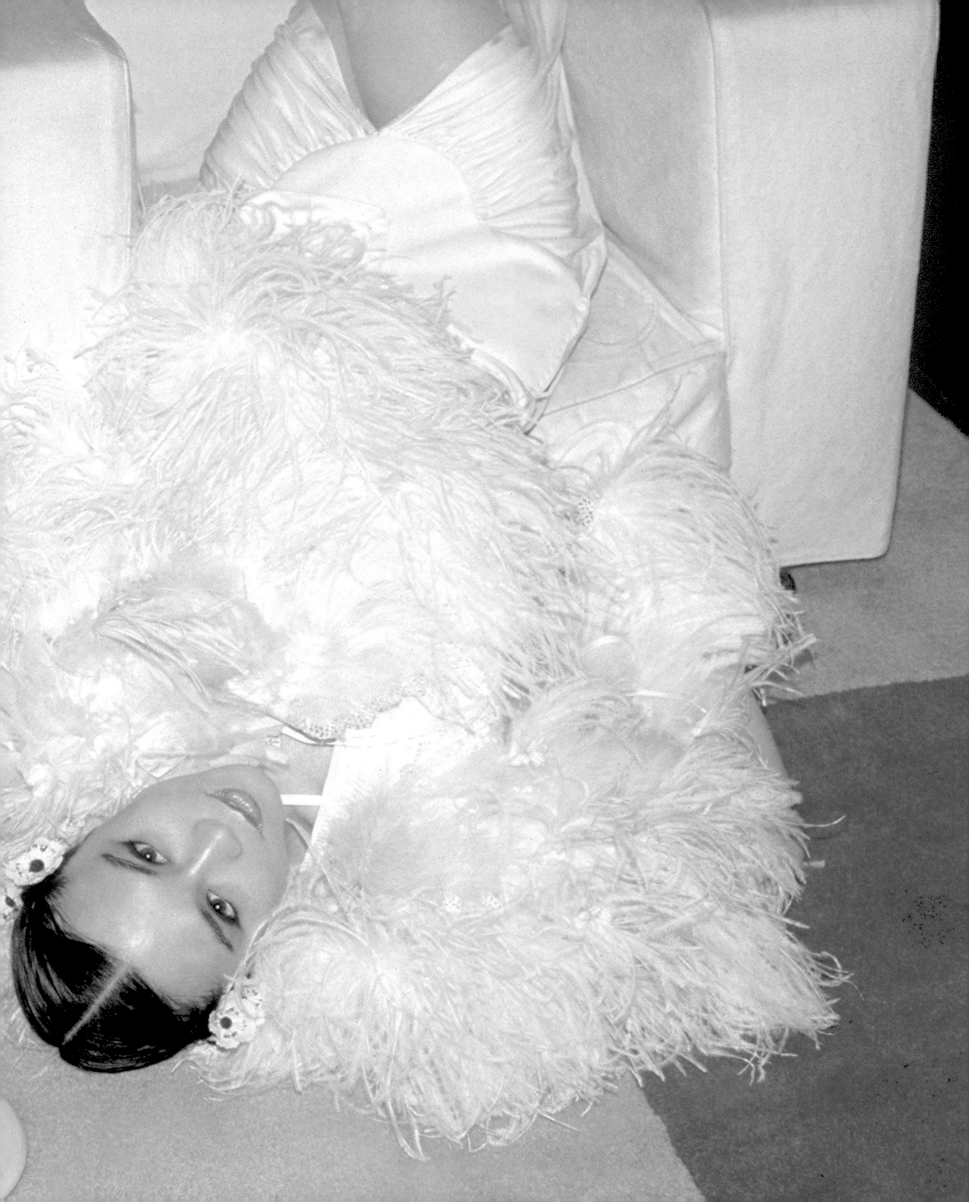

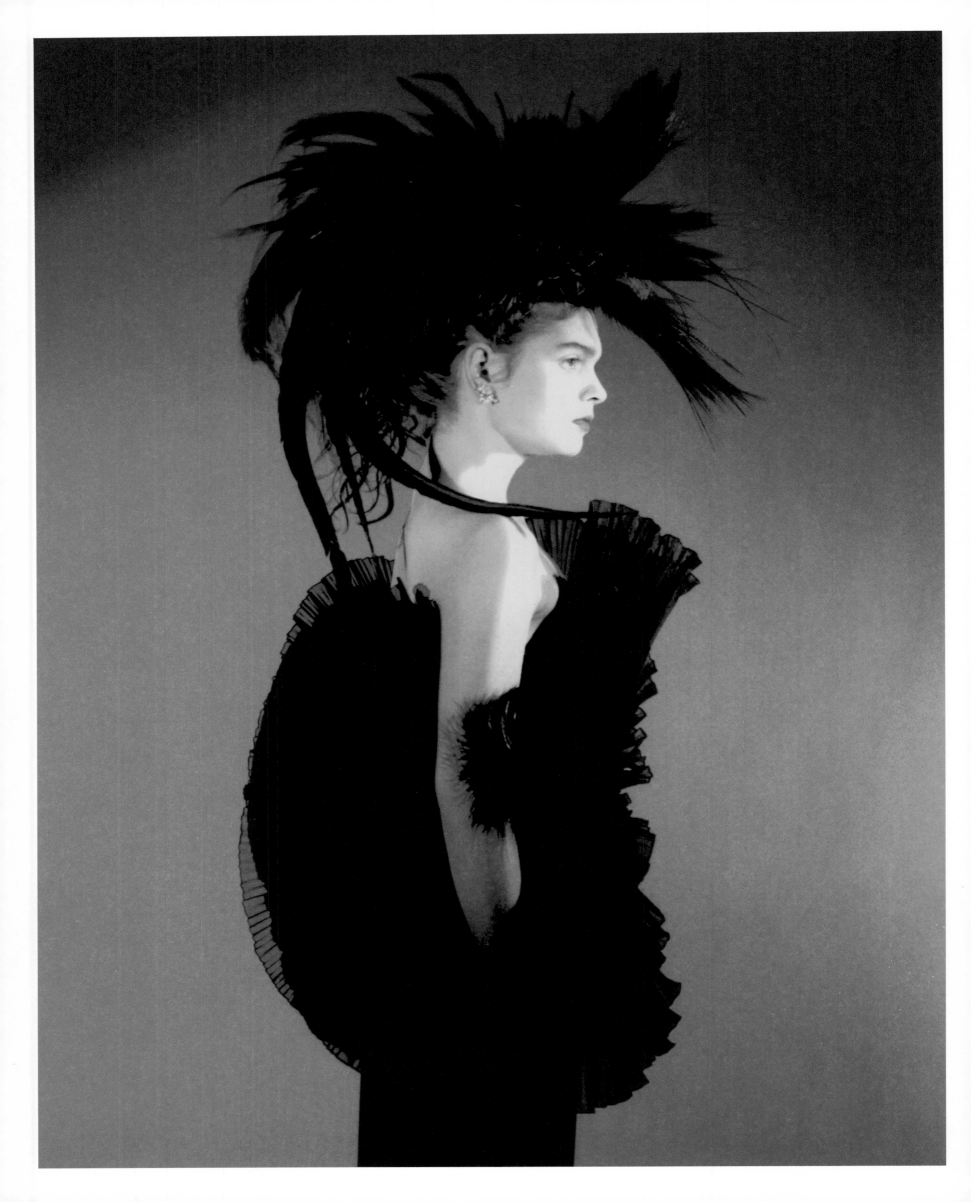

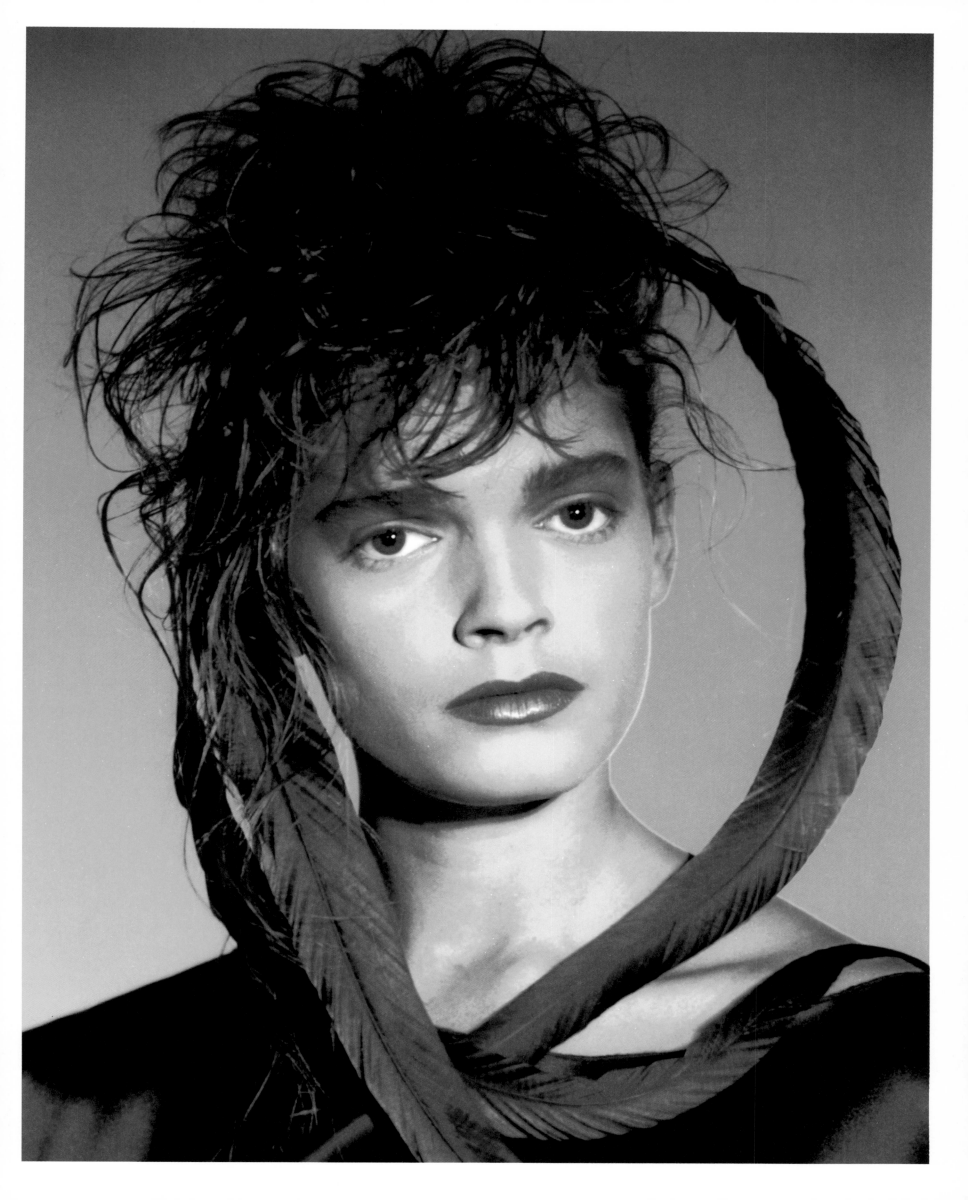

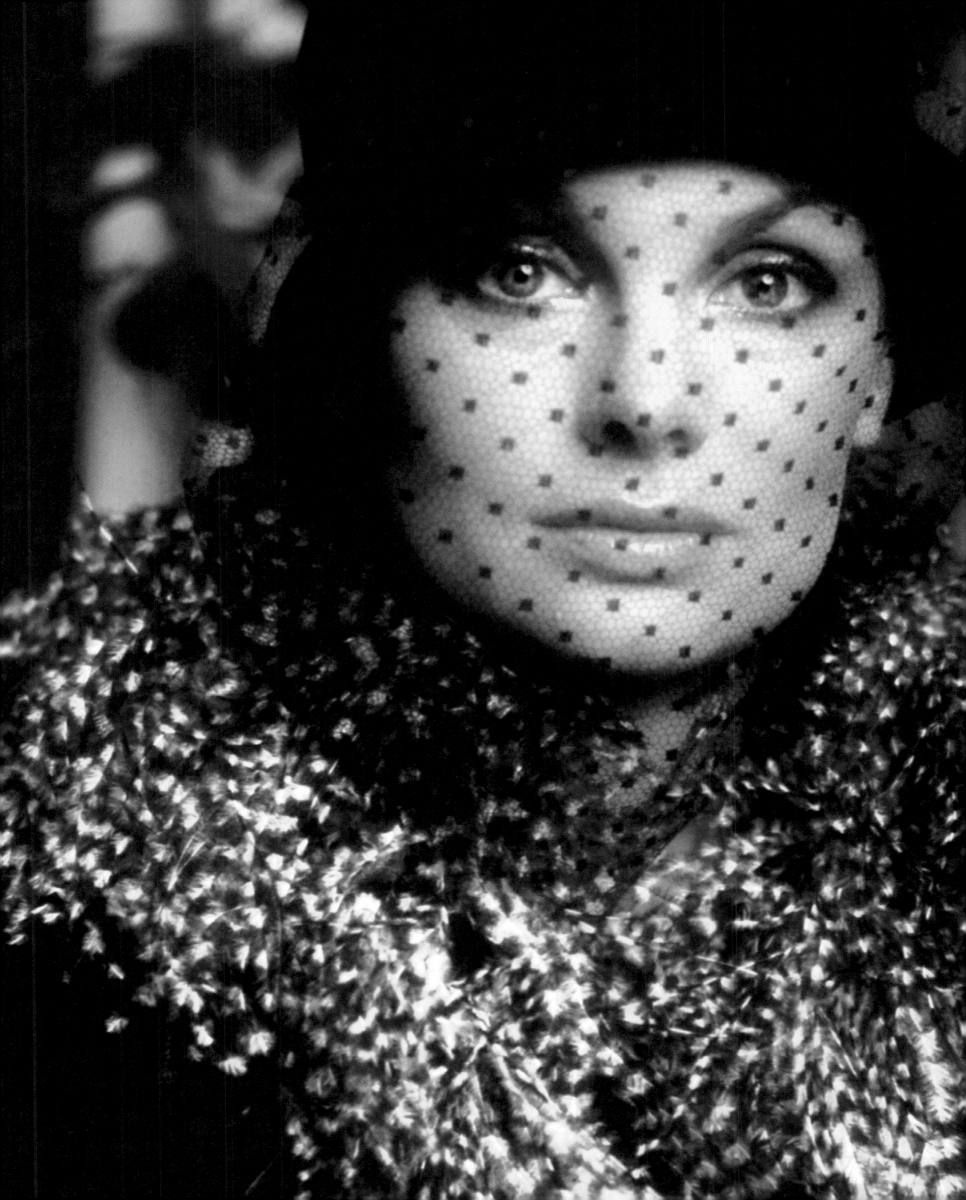

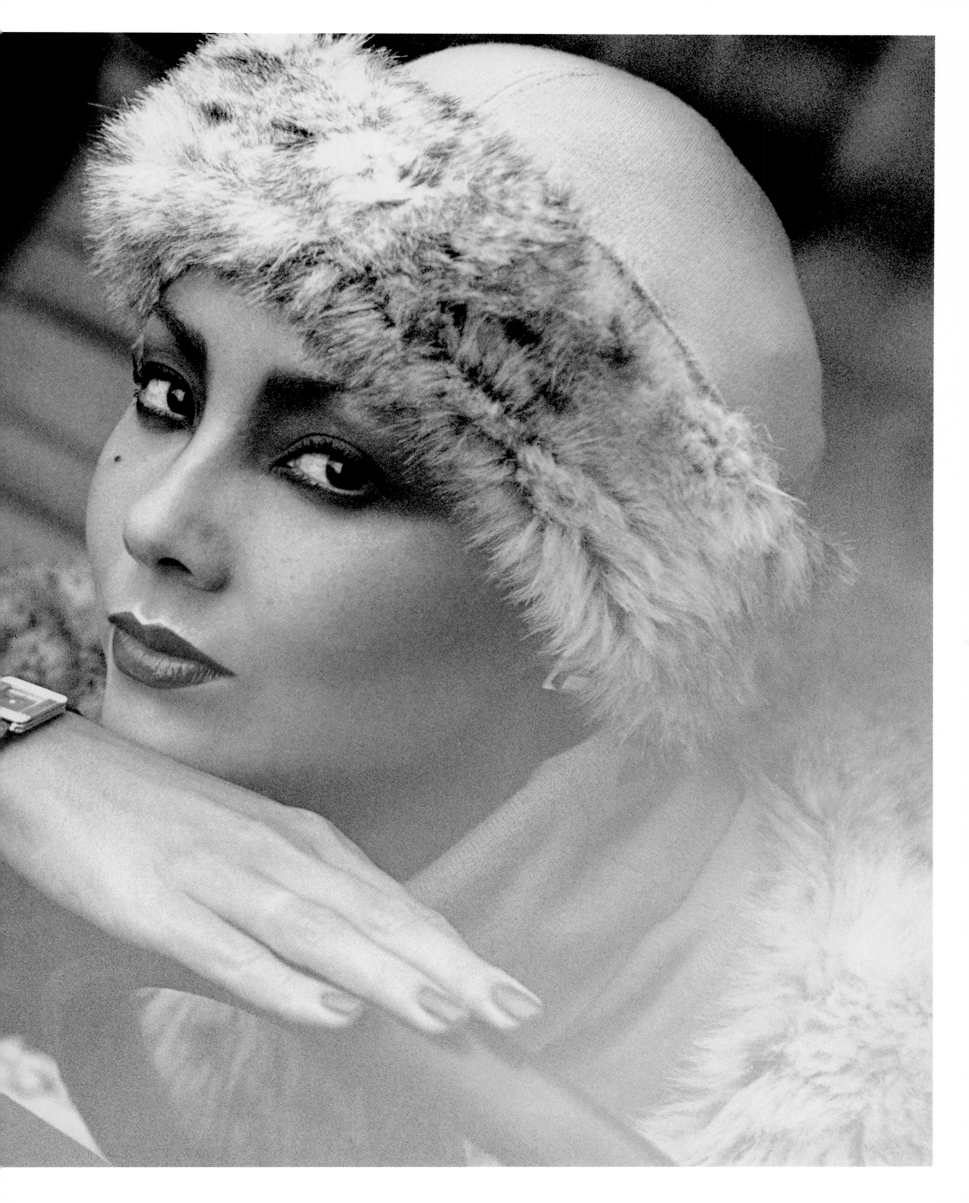

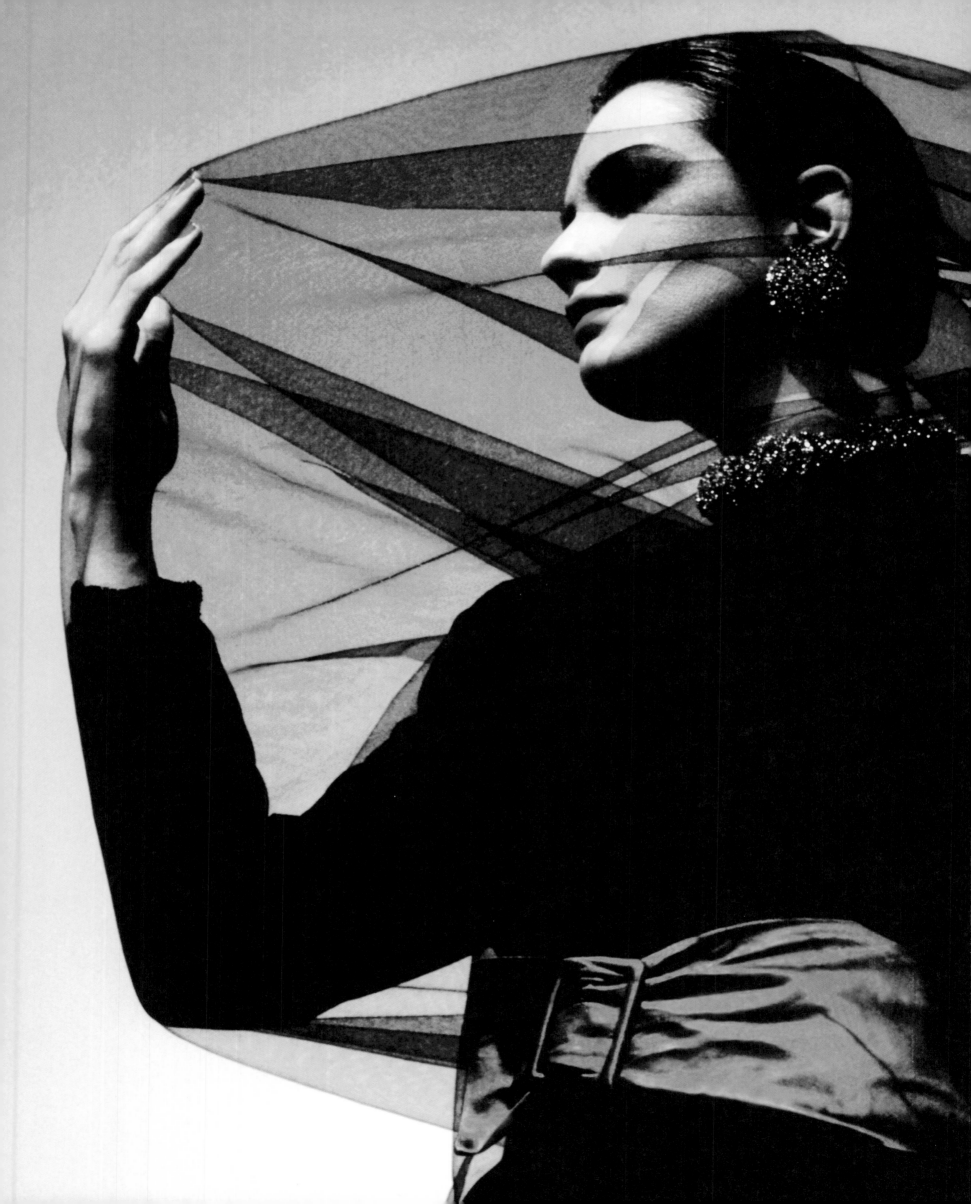

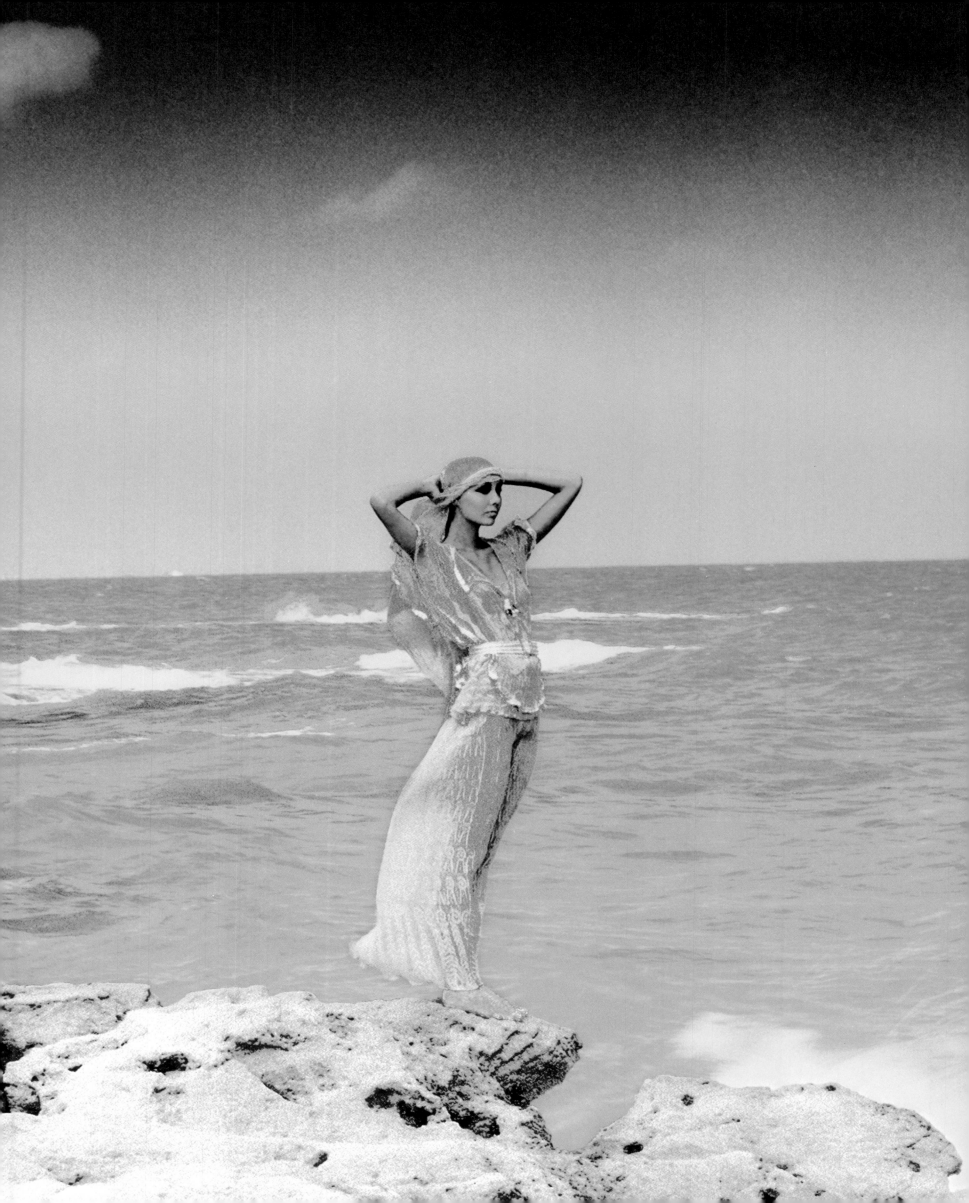

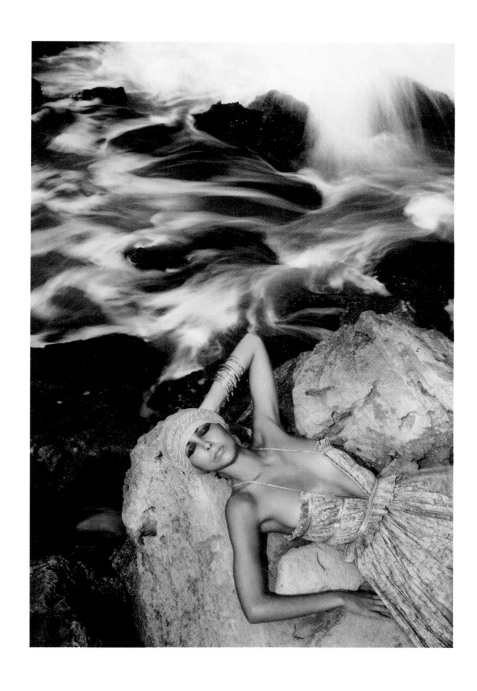

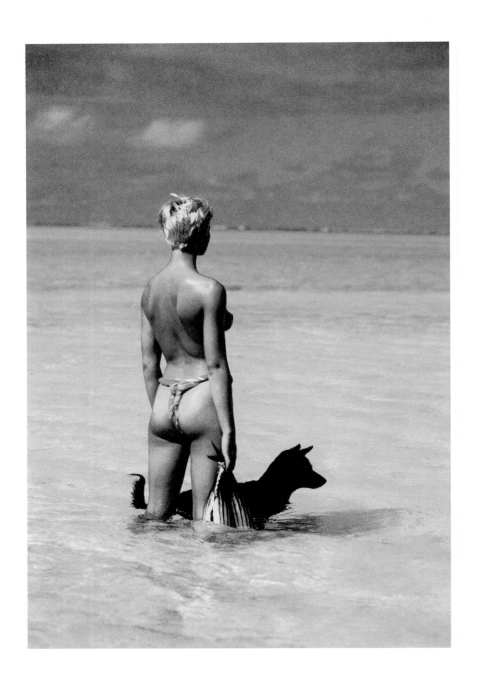

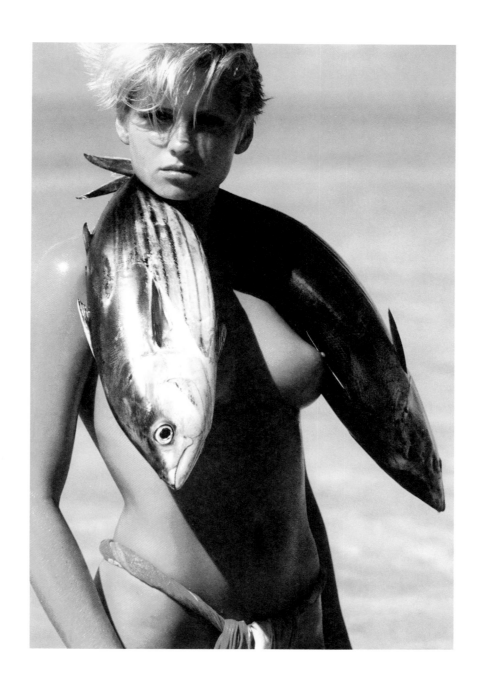

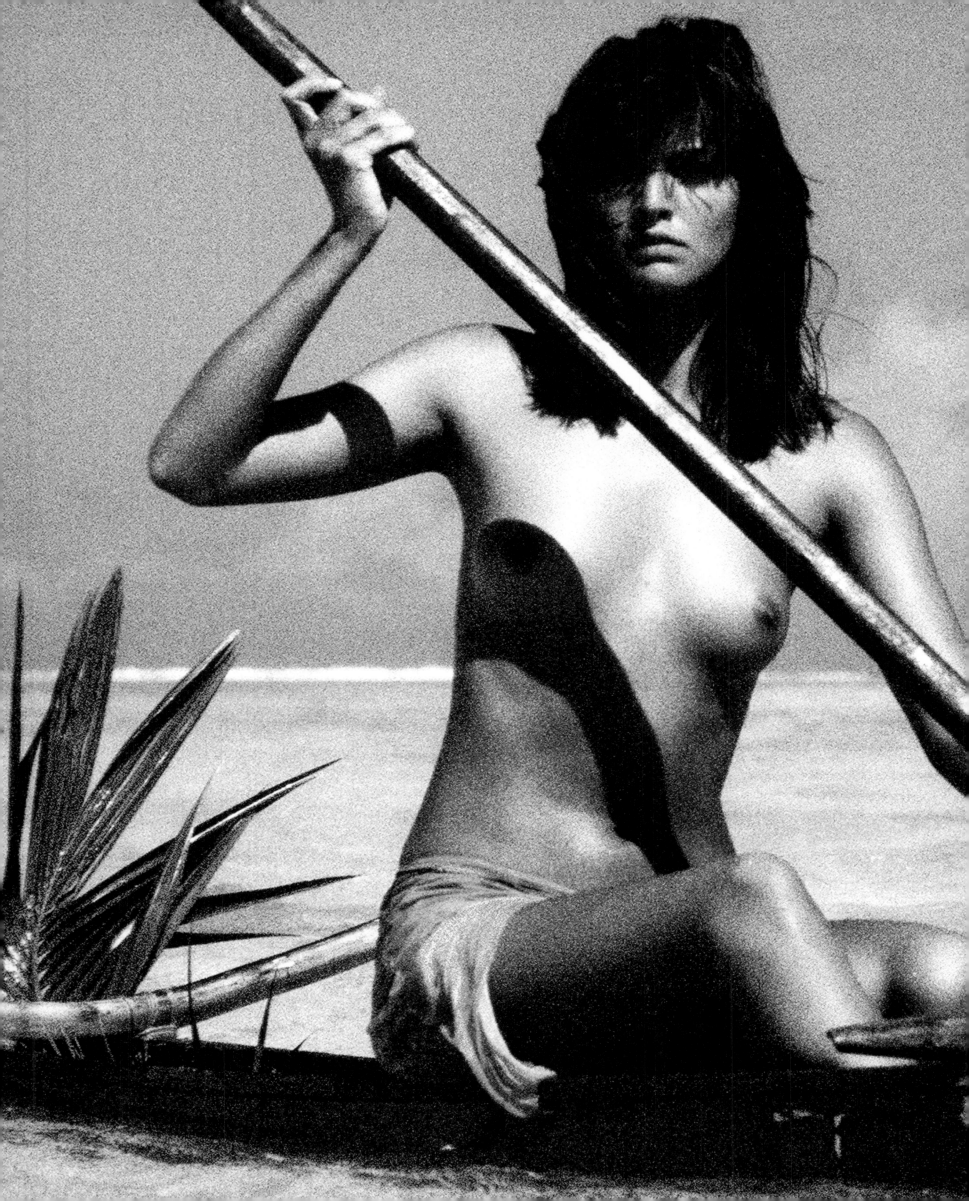

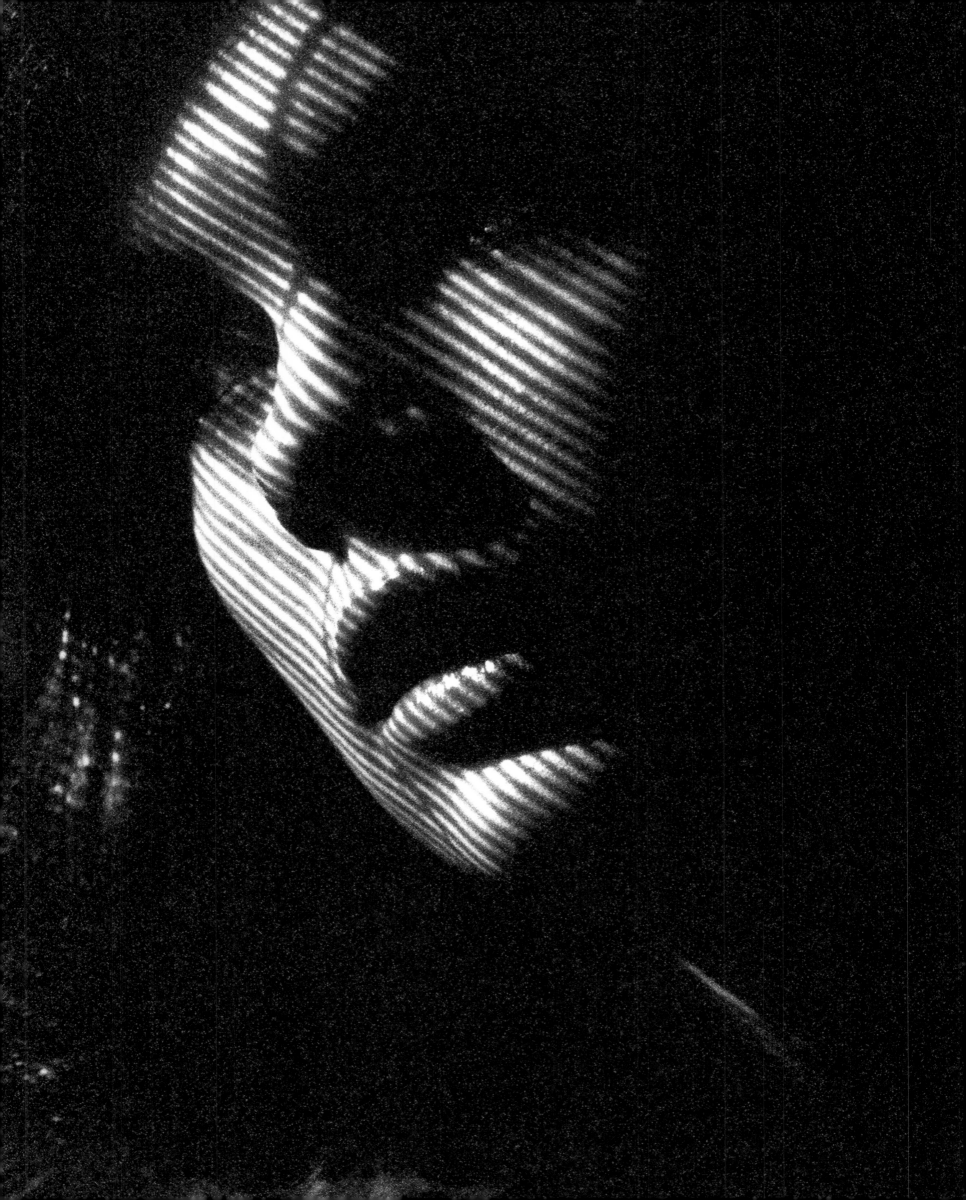

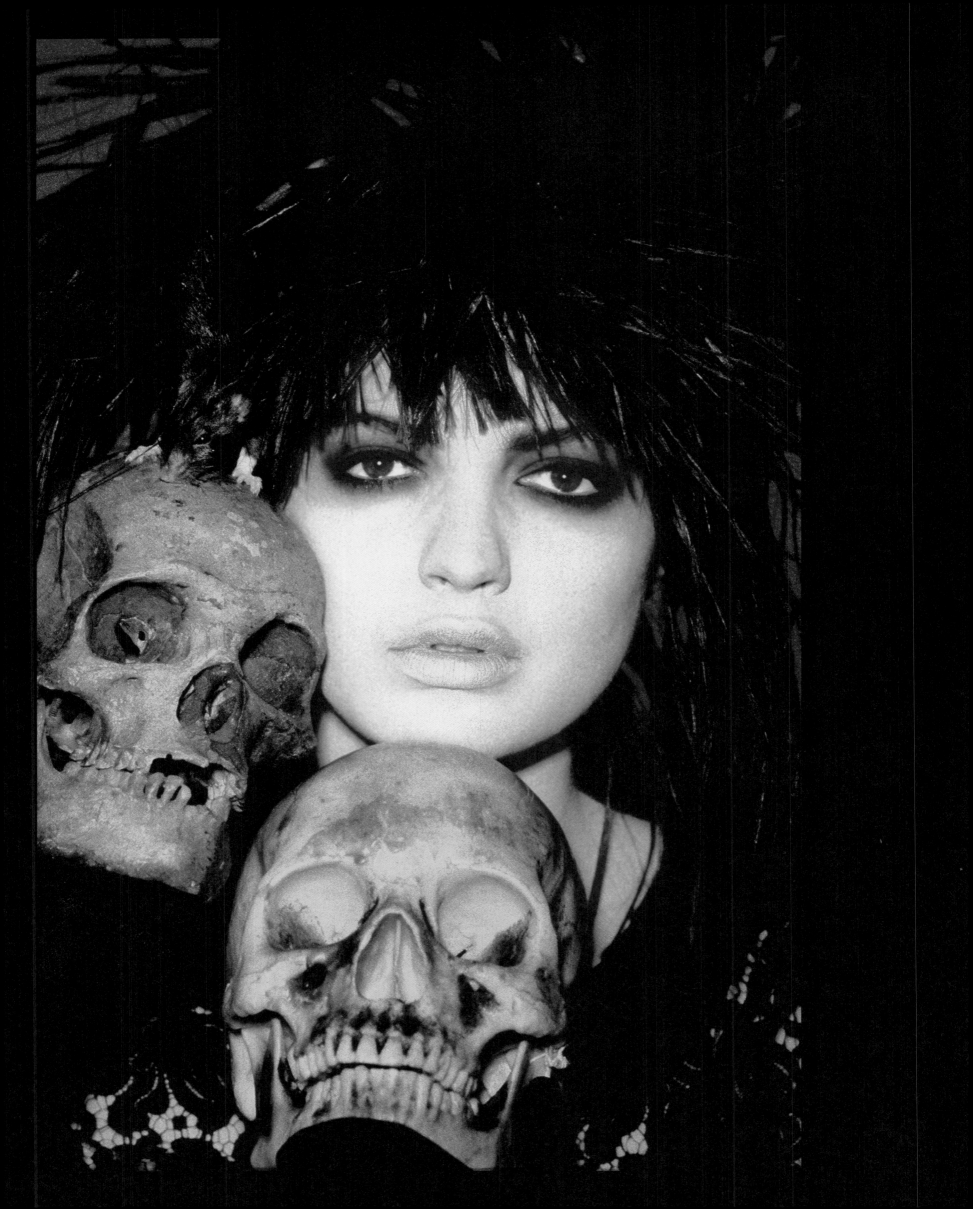

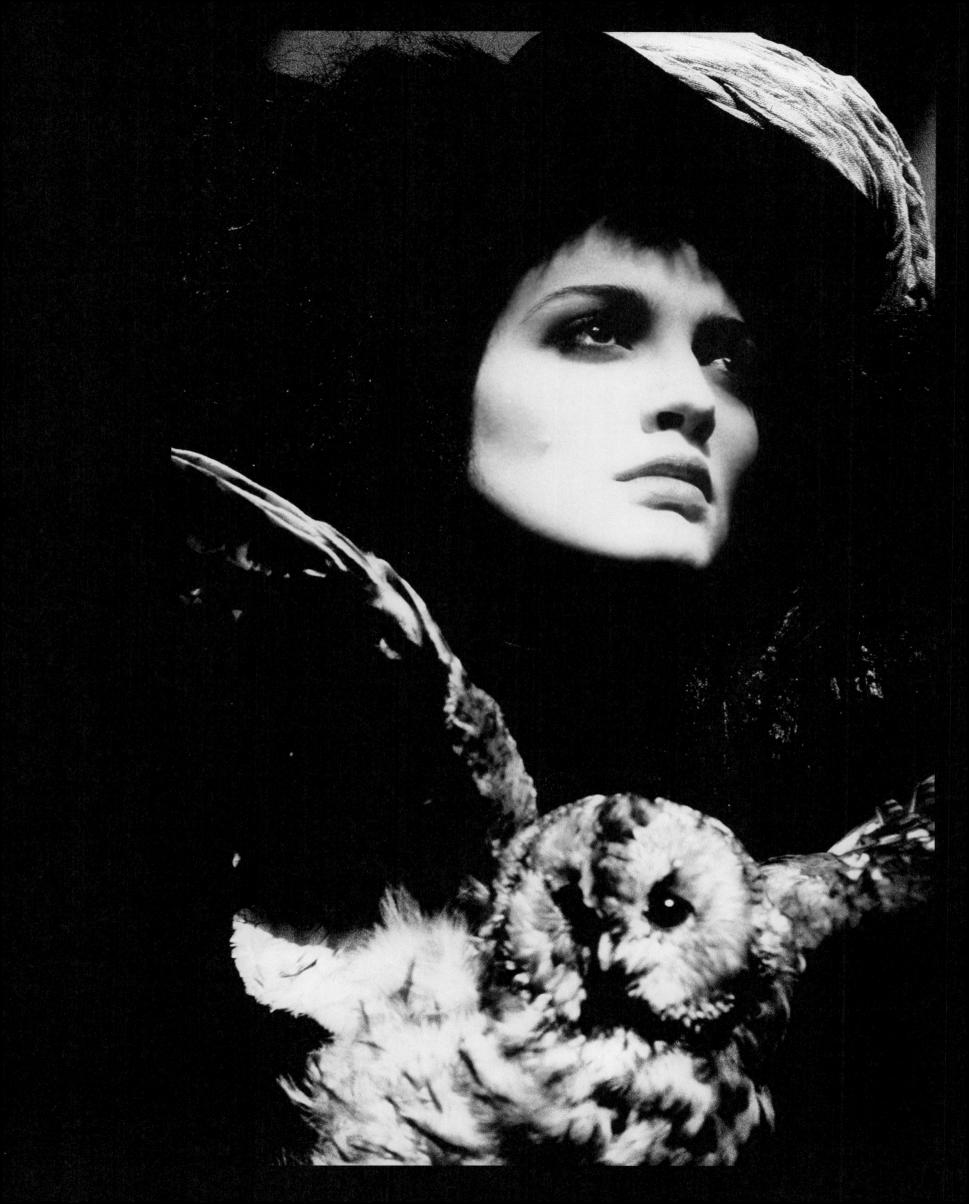

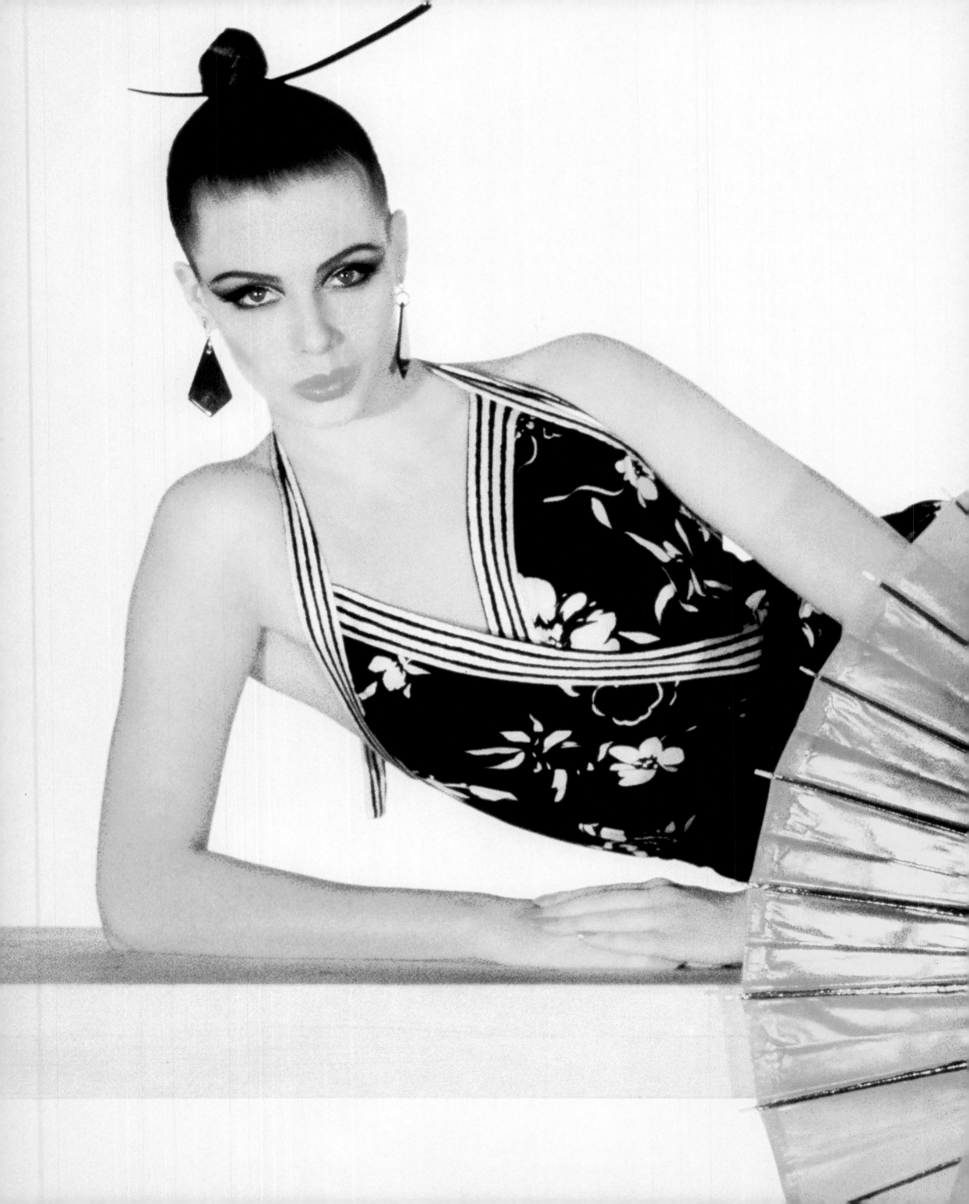

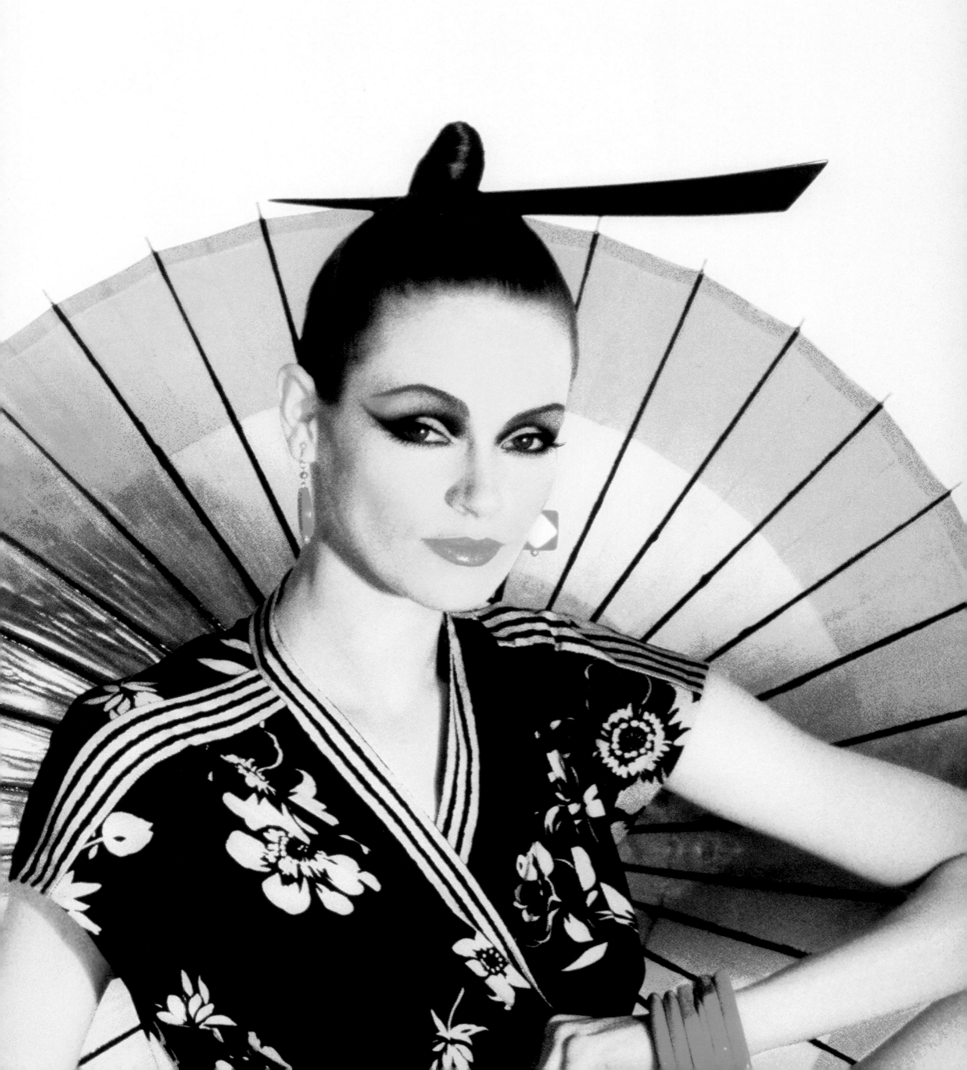

iction, in David Bailey's world, is not the opposite of truth. For a decade and a half Bailey battled for an authenticity of his own, and, in a sense, for true authorship of his pictures – he removed the artifice from them, toned down the styling if he didn't jettison it altogether, scraped back layers of make-up, played von Sternberg to his models and earned a reputation for being 'difficult' (not the 'perfectionist' he might be if London were Paris). 'I pioneered badness,' he told the writer Georgina Howell in an interview in the *Sunday Times* Magazine in 1989, 'I did diabolical things. Awful. Terrible. I had this compulsion to push forward all the time... I was trying to create a mood and see the whole image. And I had to cope with these women with no visual sense getting hysterical about some "amusing" little seam...'

Things have always tended to work out as Bailey has wanted them to, though not without considerable effort on his part. 'To be in his company', wrote Patrick Kinmonth in *Vogue* in October 1982, 'is to see things his way.' Girls, no matter how posh or indifferent they start out, alchemically turn into, as *Vogue* put it, 'The Most Bailey Girls in the World', about whom it must be said he was never slow with an opinion. For example: of his former wife Catherine Deneuve and her sister Françoise Dorléac, he remarked, 'Between them they made the perfect woman.' Of Jean Shrimpton he told *Vogue* in November 1965: 'A rose is not always

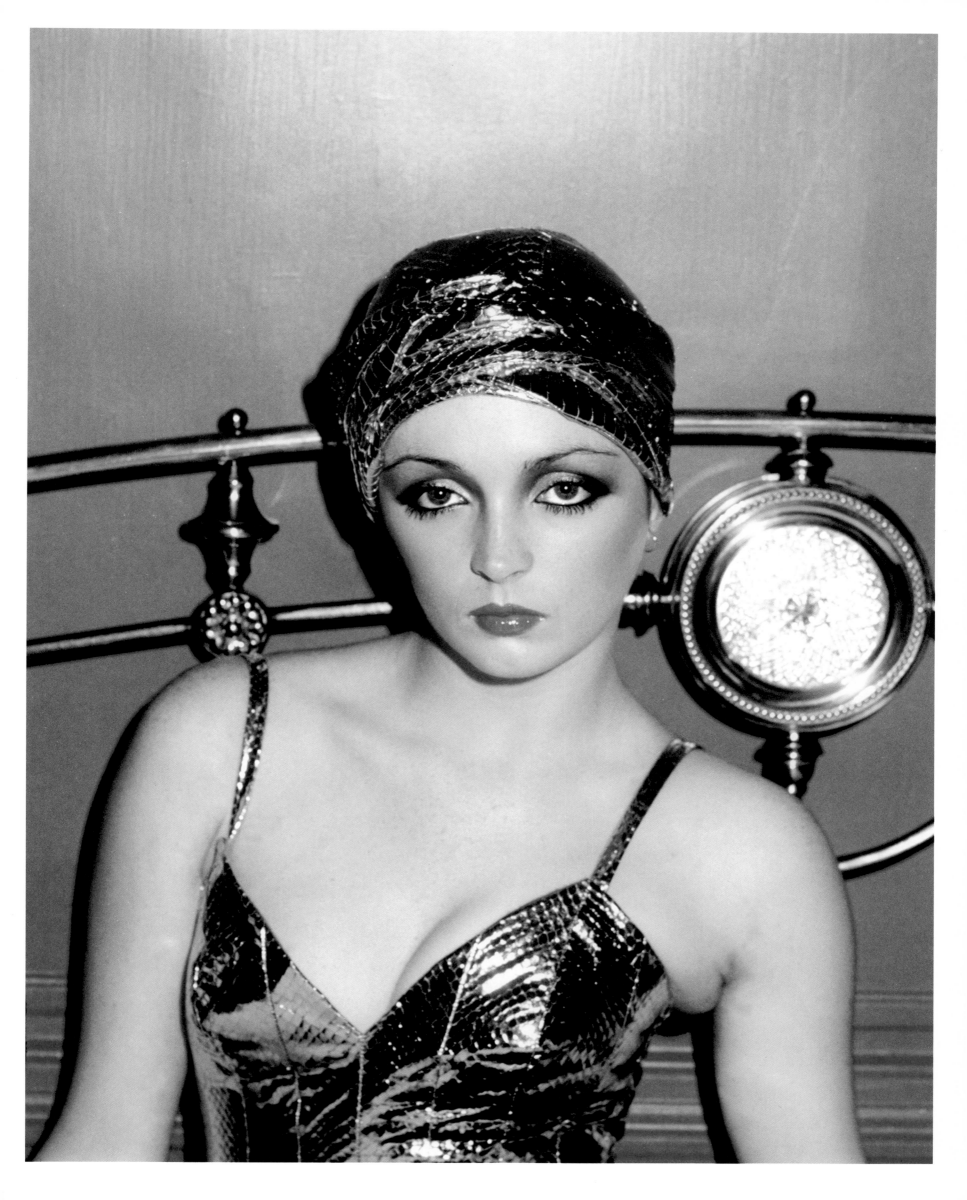

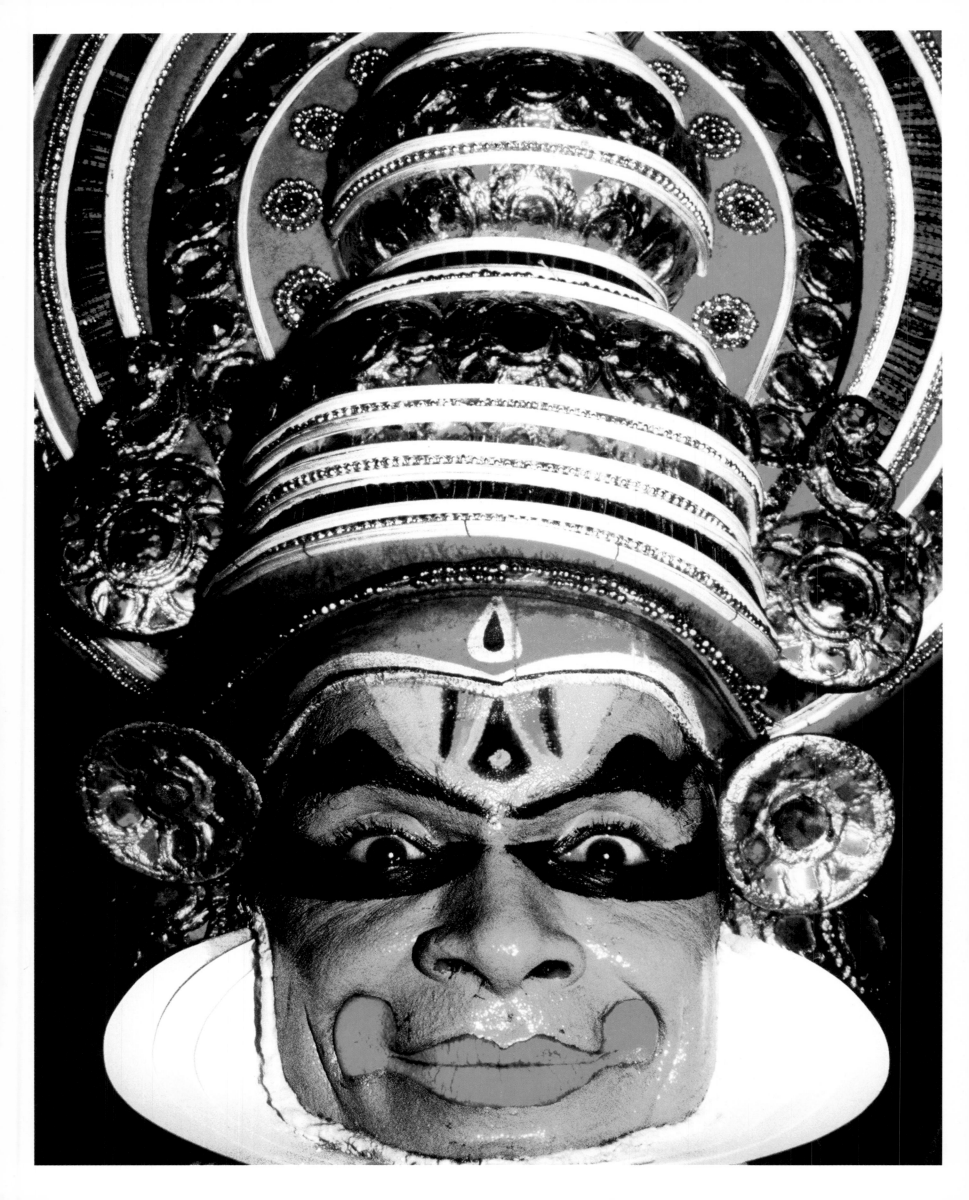

a rose, sometimes it is a Shrimpton. Growing into space, leaving sight of earth. Floating like a little white mouse wondering how she got there, wondering what all the fuss was about...' and so it went on. As fashion photography for Bailey became less to do with clothes, so too did beauty photography become less about make-up, more about disguise and make-believe, and relatively little if anything at all, about 'inner beauty'. Instead, it became Bailey's own vision of female beauty, a subject which, as every schoolboy knows, is close to his heart. And in turn, as his book *Goodbye Baby & Amen* (1969) showed, his beauty and fashion photography could occasionally become part of his iconic portraiture too.

Predictably, Bailey's *oeuvre* becomes most interesting of all when what he did for magazines became an extension of what he was doing for himself. When he was allowed to be the *auteur* he always intended to be, the boundaries blurred: 'I sometimes hate what I'm doing to the girls,' he told the critic Alexander Walker (*Evening Standard*, 22 March 1965), 'It turns them from human beings into objects. They come to believe they are actually like I photograph them and it gives me a terrific feeling of power.' This fetishizing of femininity and sexuality and the readiness of his subjects to present themselves in whatever erotic scenario he dreamt up has been emblematic of Bailey's glamour and beauty photographs, not quite for the consumption of the readers of *Vogue* perhaps but as part of the

self-motivated activity he has always pursued. In the process, quite what Bailey might have discovered about his own psyche has probably proved elusive, hence perhaps his title to this book.

Maybe in an effort to challenge himself further, and to find his own answers, he has also attempted to move away from the illustrative towards a more 'narrative' approach, whereby a sequencing of pictures might form, say, the *mise-en-scène* of an eroto-surrealist filmmaker. Many commentators on photography have long argued that what constitutes a great or memorable photographic image is that which has been objectively recorded, rather than that which has been invented. Until relatively recently, photographers who might manipulate the reality their lenses saw have tended to be sidelined. In regard to his beauty photographs, from the end of the 1960s, Bailey has often constructed – as the narrative photographer Les Krims has put it – 'anti-Decisive Moments'. In many of the photographs Bailey presents here there is evidence of a directorial stance. 'Photography is credible,' he told the art historian Martin Harrison (*The Naked Eye*, 1987, p. 121), 'We believe it is telling the truth, even when we should know better. This is why I find photographs which depict what is obviously unreal so fascinating. We are no longer conditioned to expect painting to deal with reality, but photographs that enter the forbidden territory have a kind of subversive edge...'

It is tempting especially in the light of the explicit filmic narrative of so many of his colour photographs – and his subsequent career as a commercials director and filmmaker – to return as many critics have to Bailey's love for film, the Hollywood fantasies of his youth – 'I wanted to be Fred Astaire', he confessed to *Vogue* in a November 1965 interview, 'but I couldn't.' His embracing of a fluid and informal manner of visual presentation was drawn from, among other sources, the films of Ingmar Bergman and the loose narrative structures of the filmmakers of the *nouvelle vague*.

Italian *Vogue* in particular gave him the freedom to experiment with, for example, different coloured lighting gels or with double exposure and solarization. As his own private obsessions began to seep through into published work, he turned his pictures into painterly tableaux or created disturbing fictive worlds where bandage-wrapped women might sit in perturbed isolation. This is not to say that they foreclose completely on artifice, glamour and make-believe. Many of his later photographs for the magazine share many of the preoccupations of the 1980s: surface glamour, materialism, the exoticism of location. Perhaps too in the creative hothouses of Paris and Milan, something of the stigma attached in Britain to 'commercial' photography began to dissipate and Bailey could work more freely, unimpeded by what he saw as the snobbery and inhibitions of the world of the British fashion magazine.

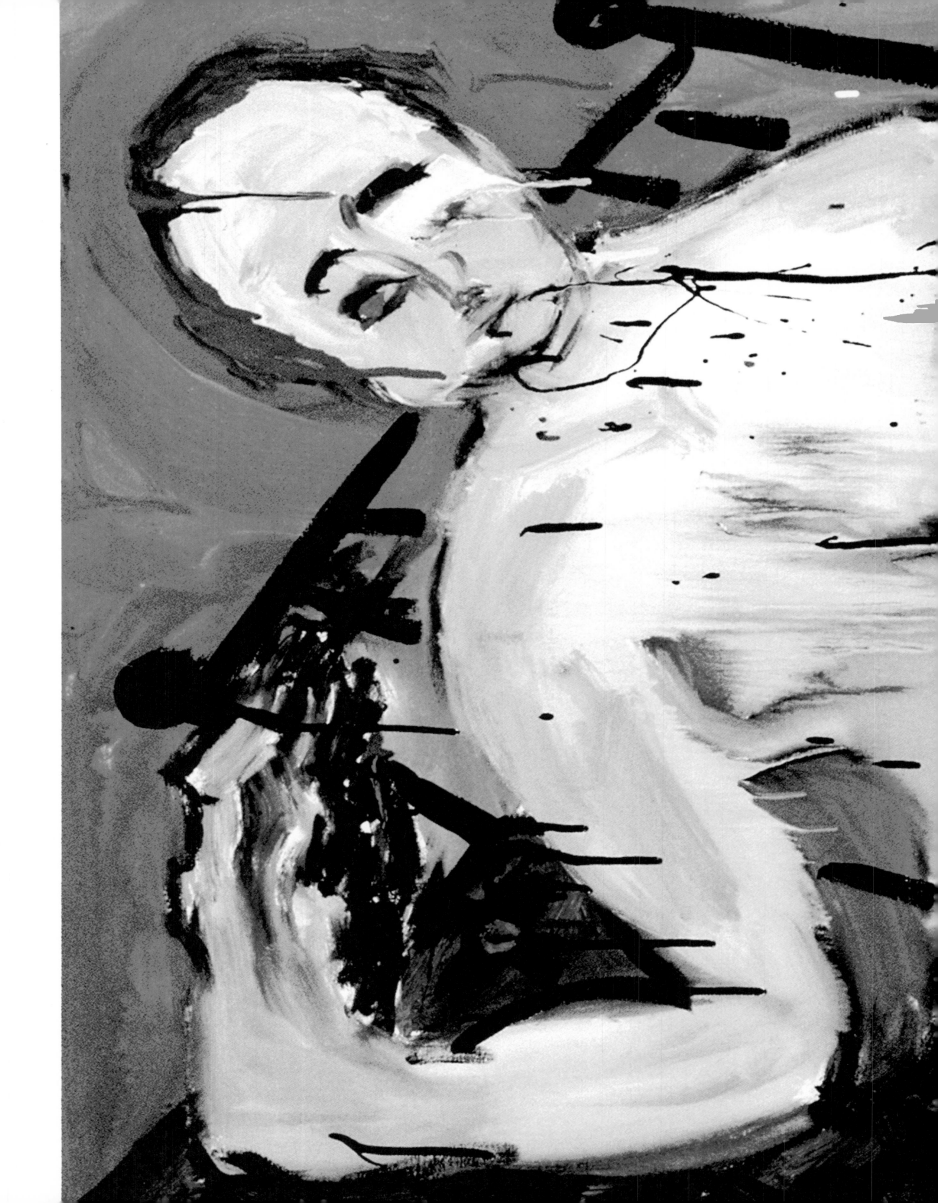

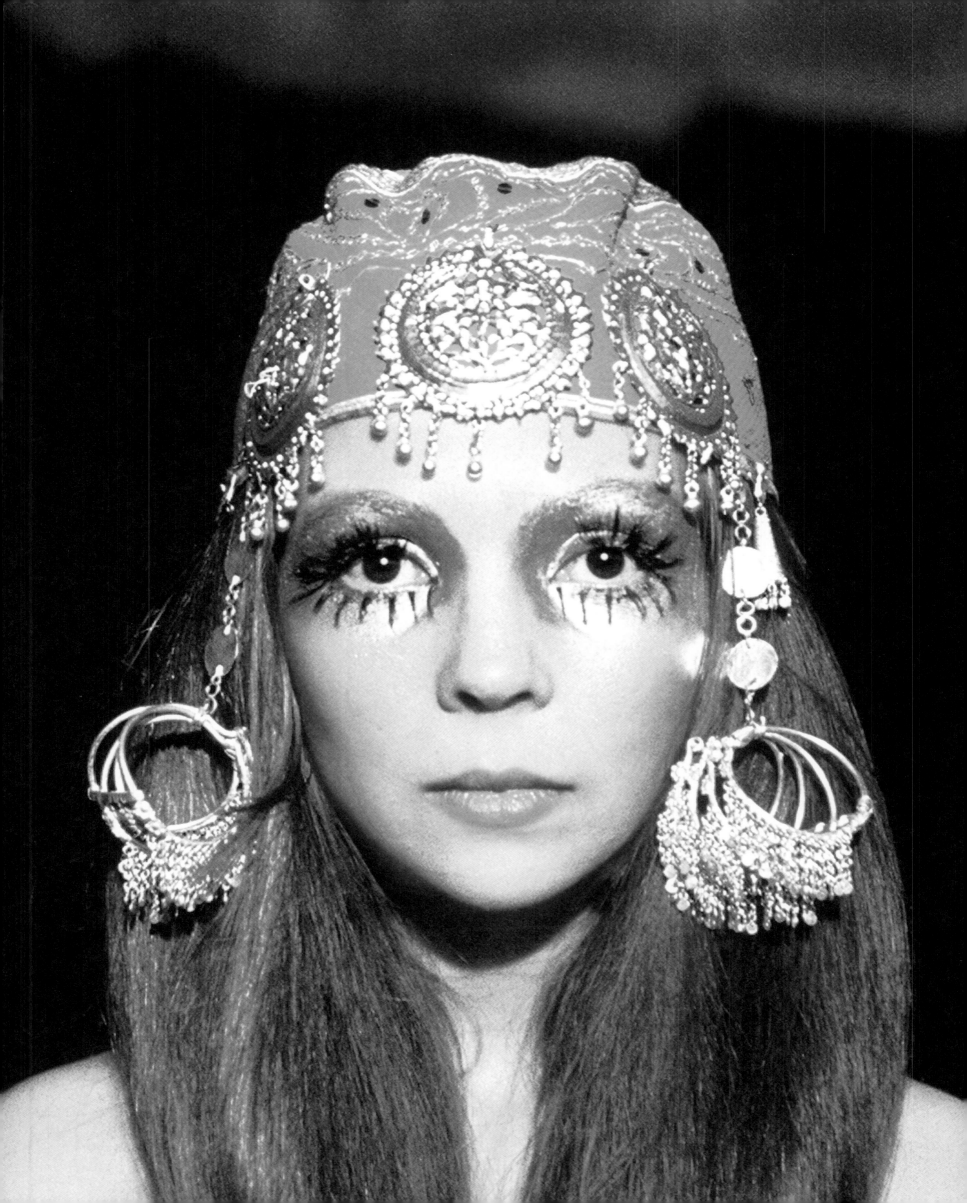

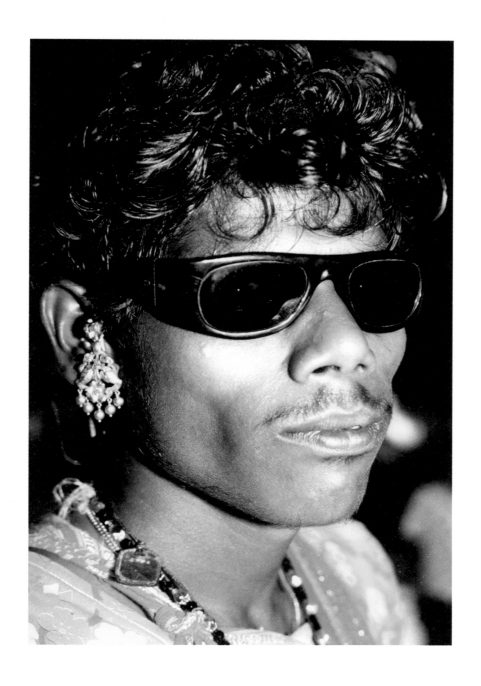

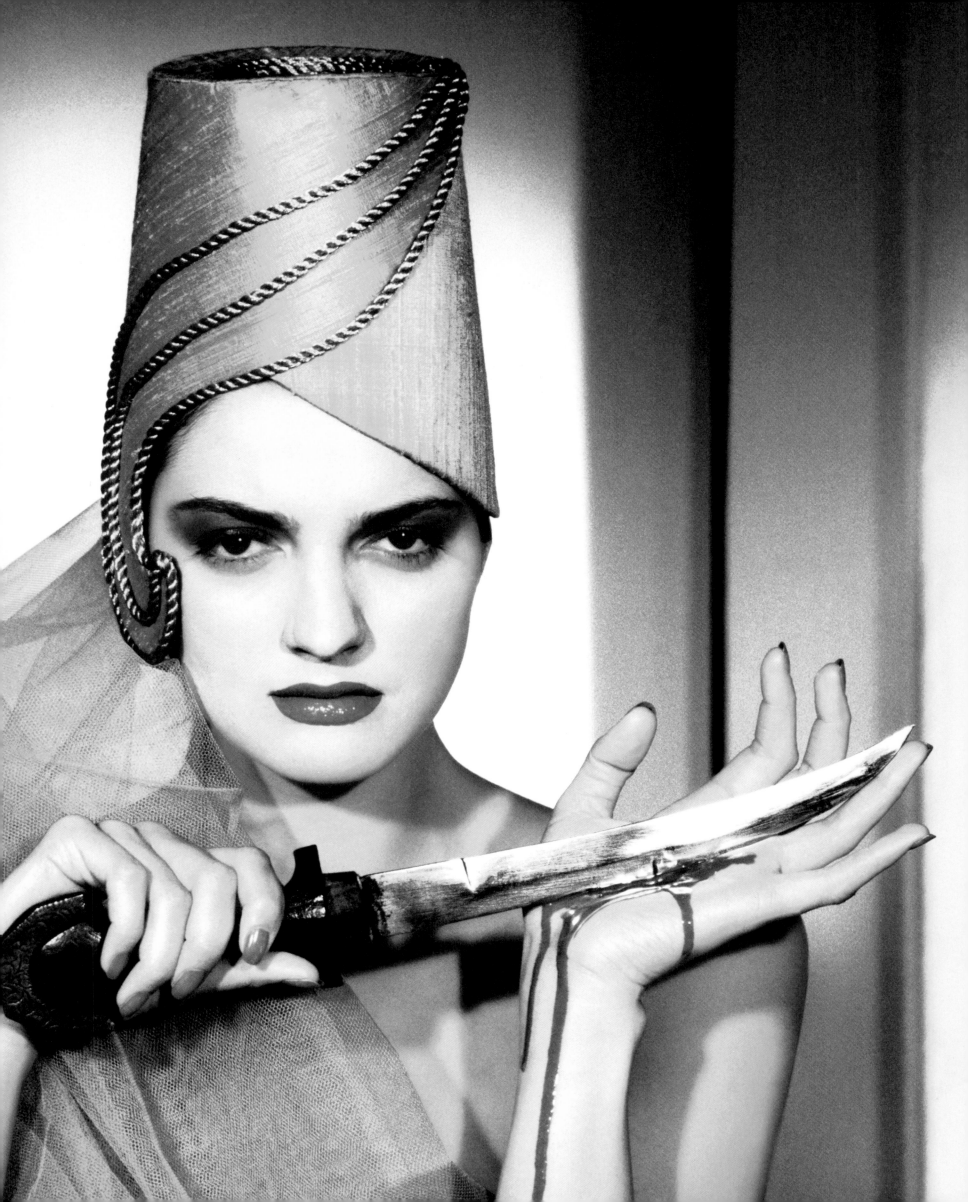

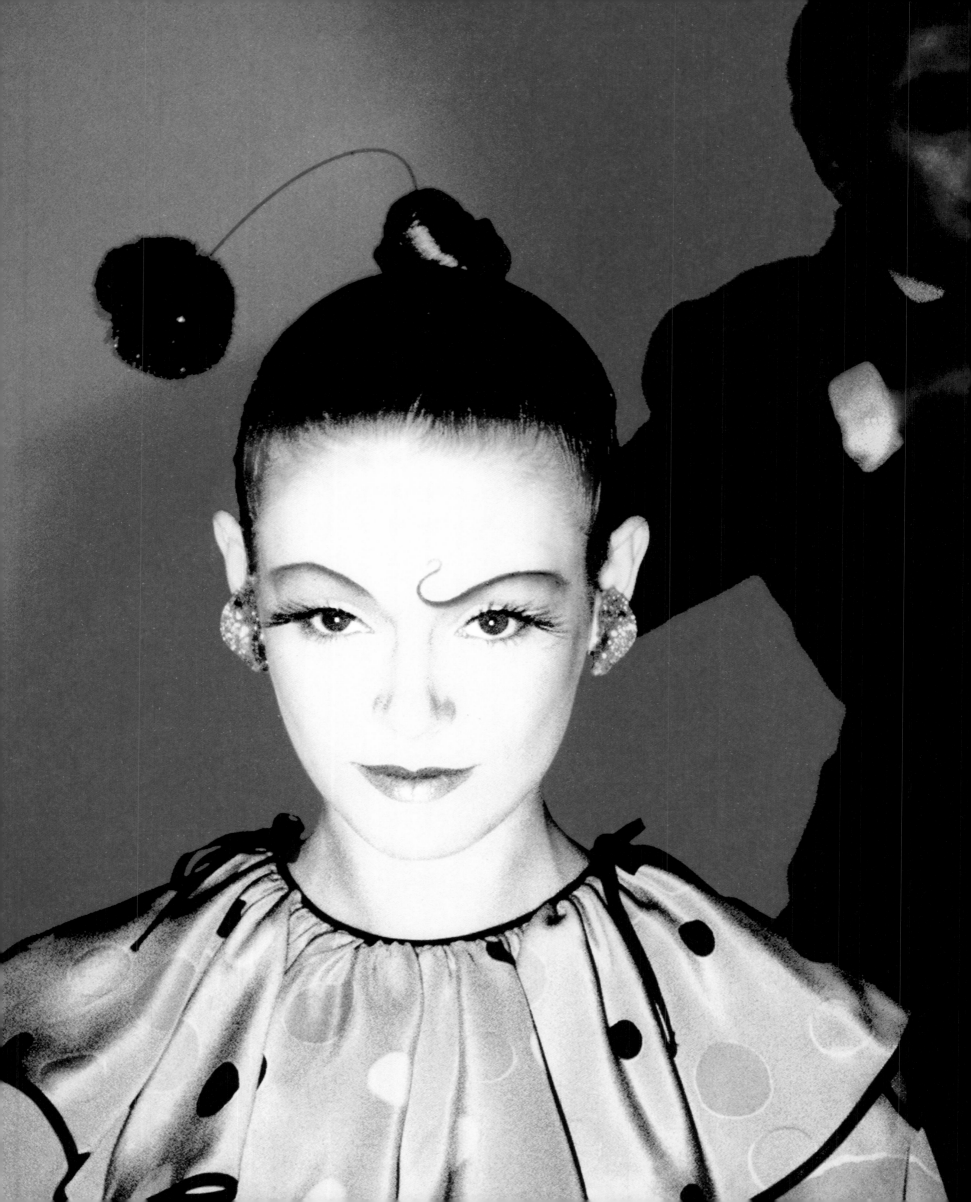

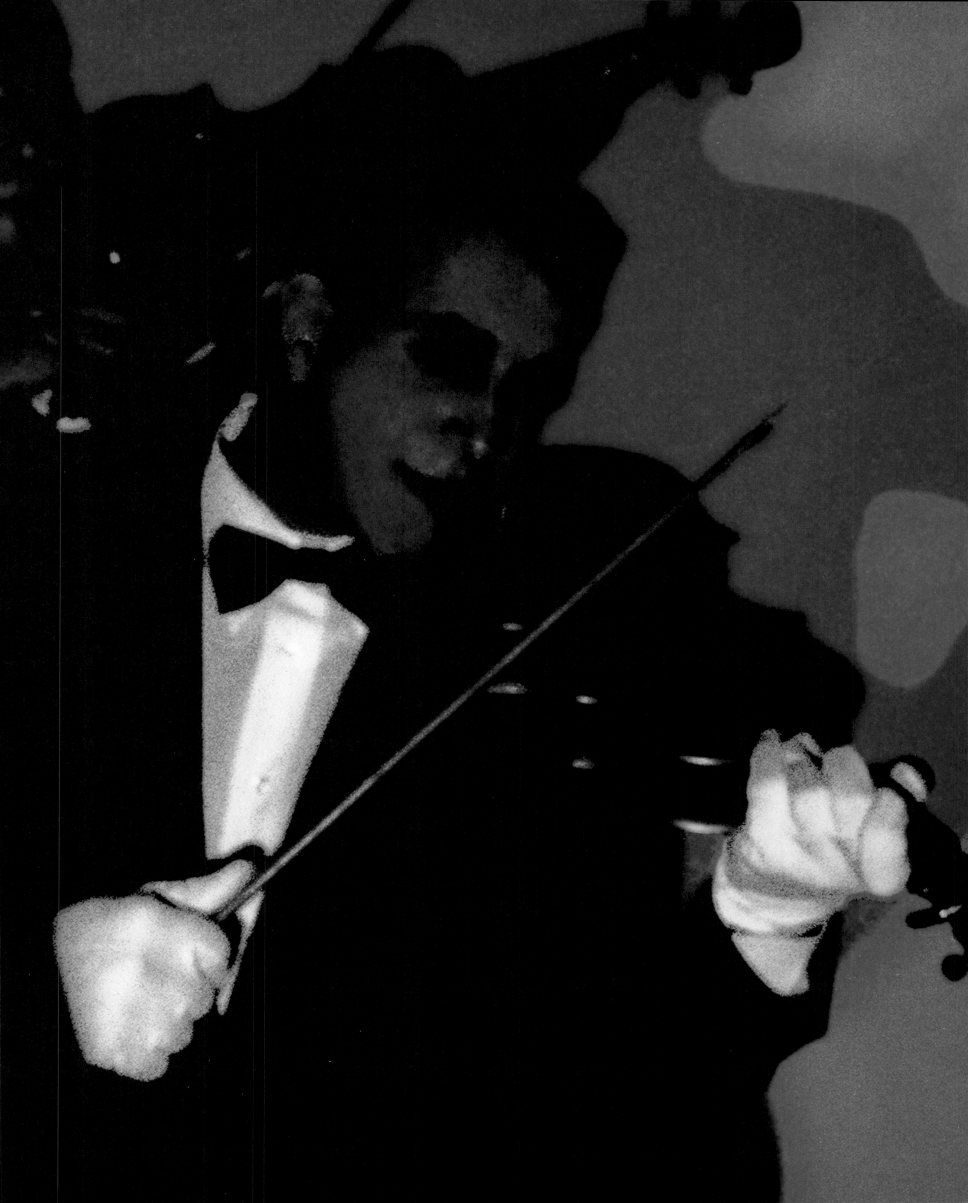

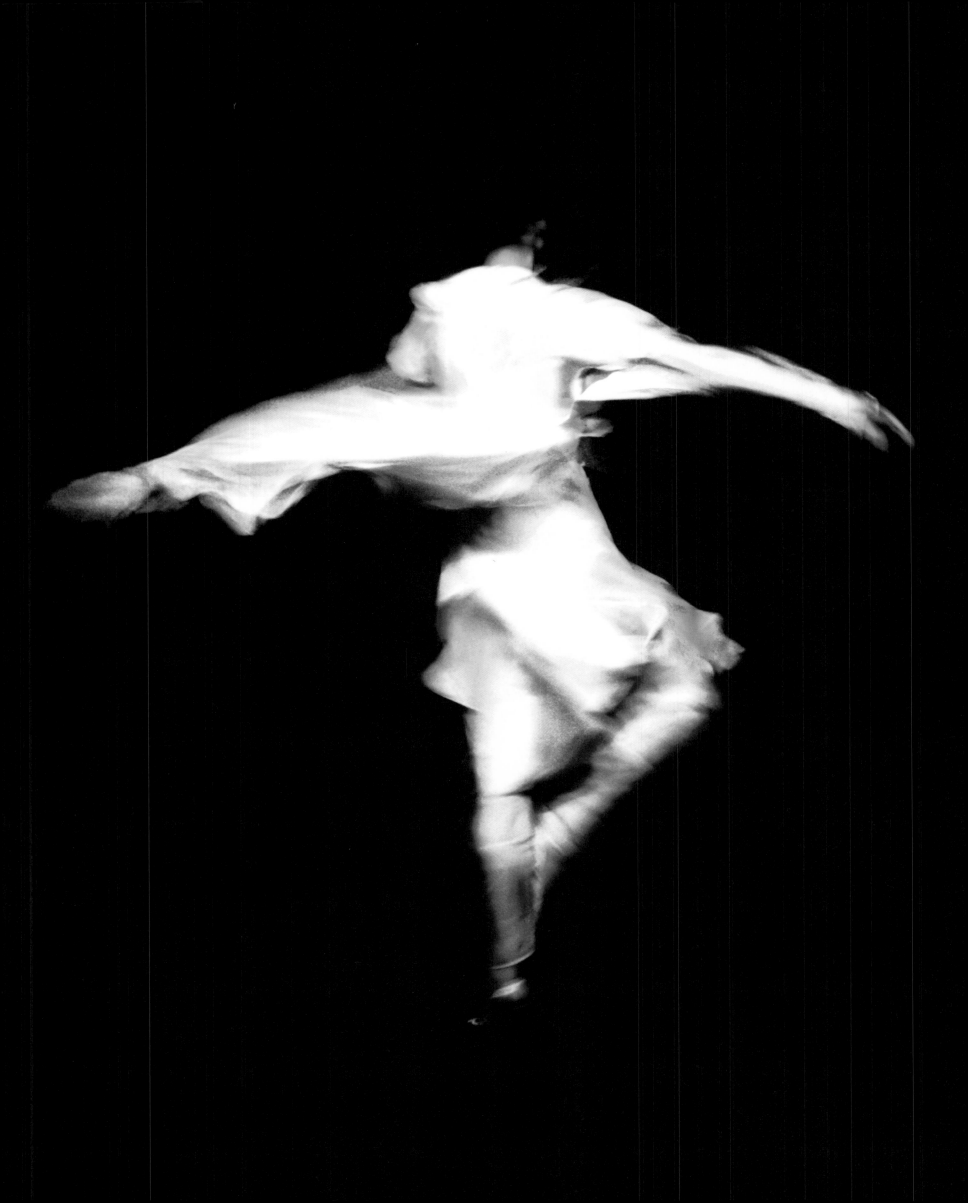

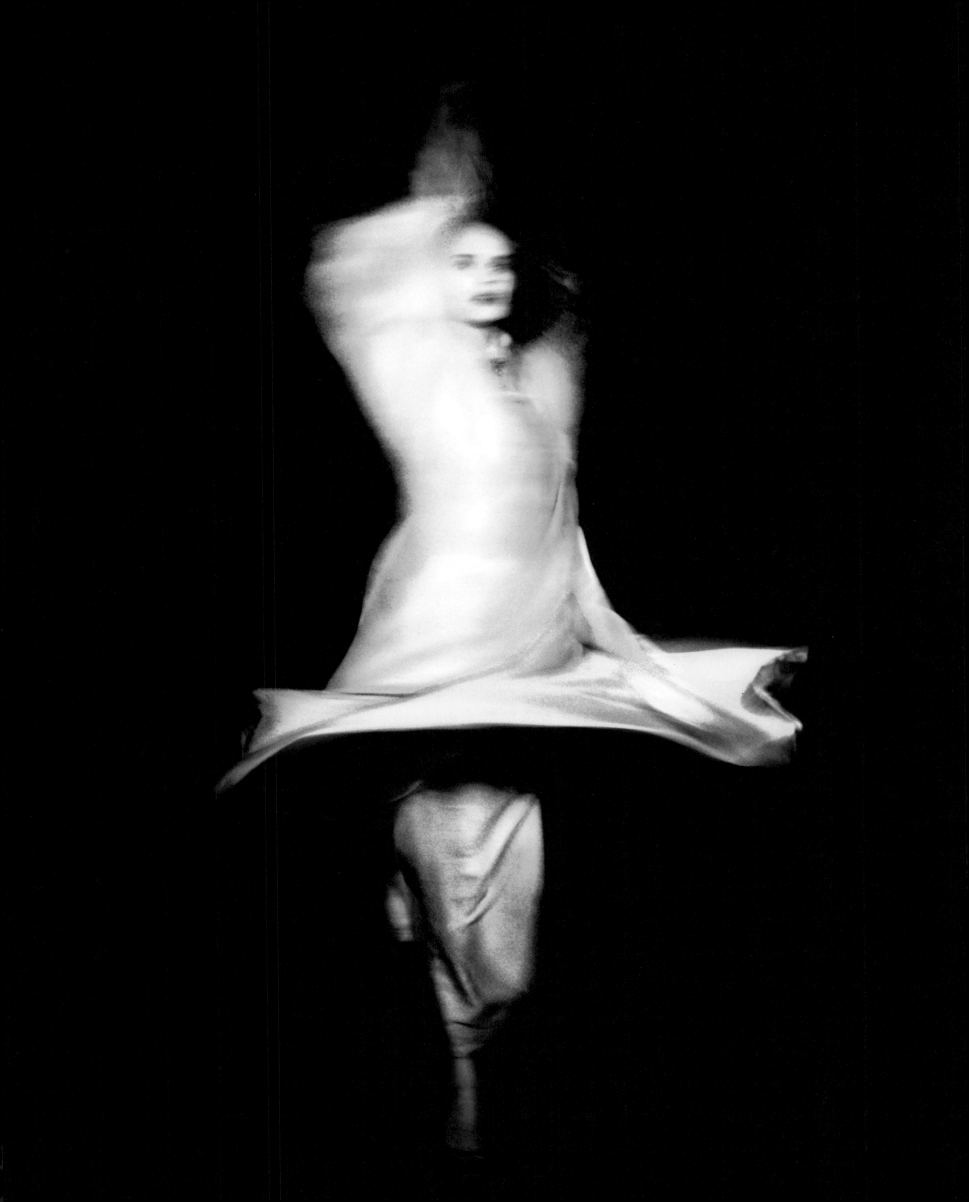

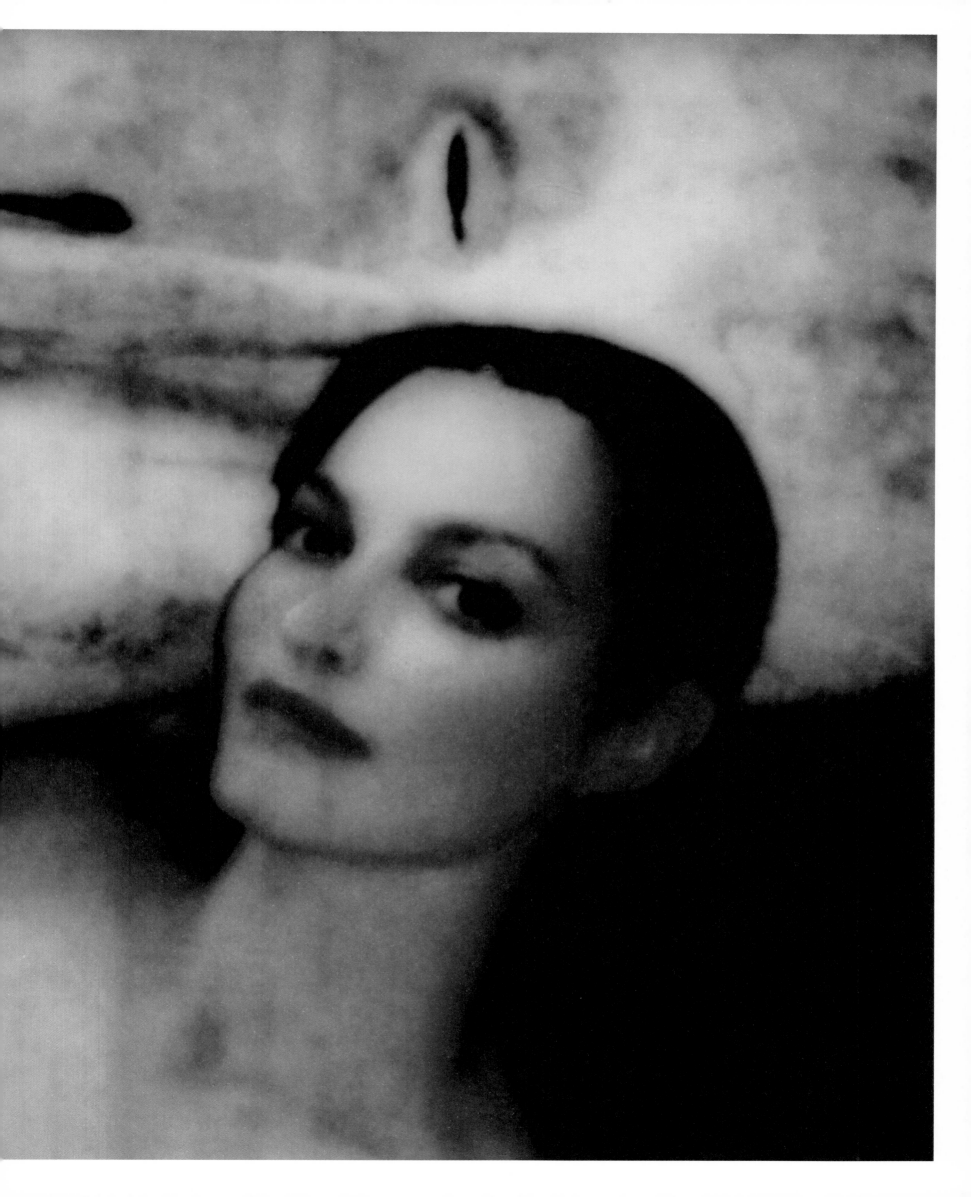

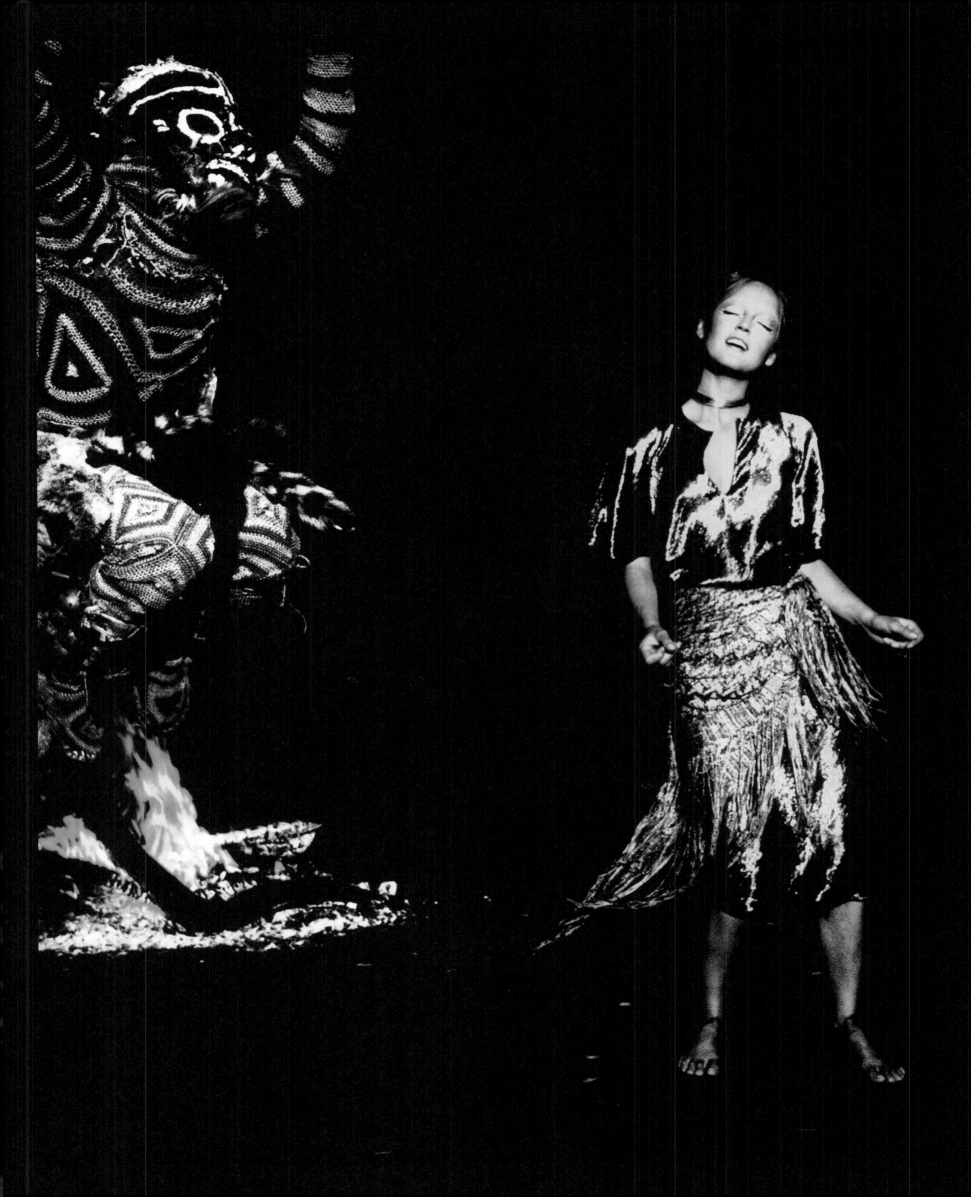

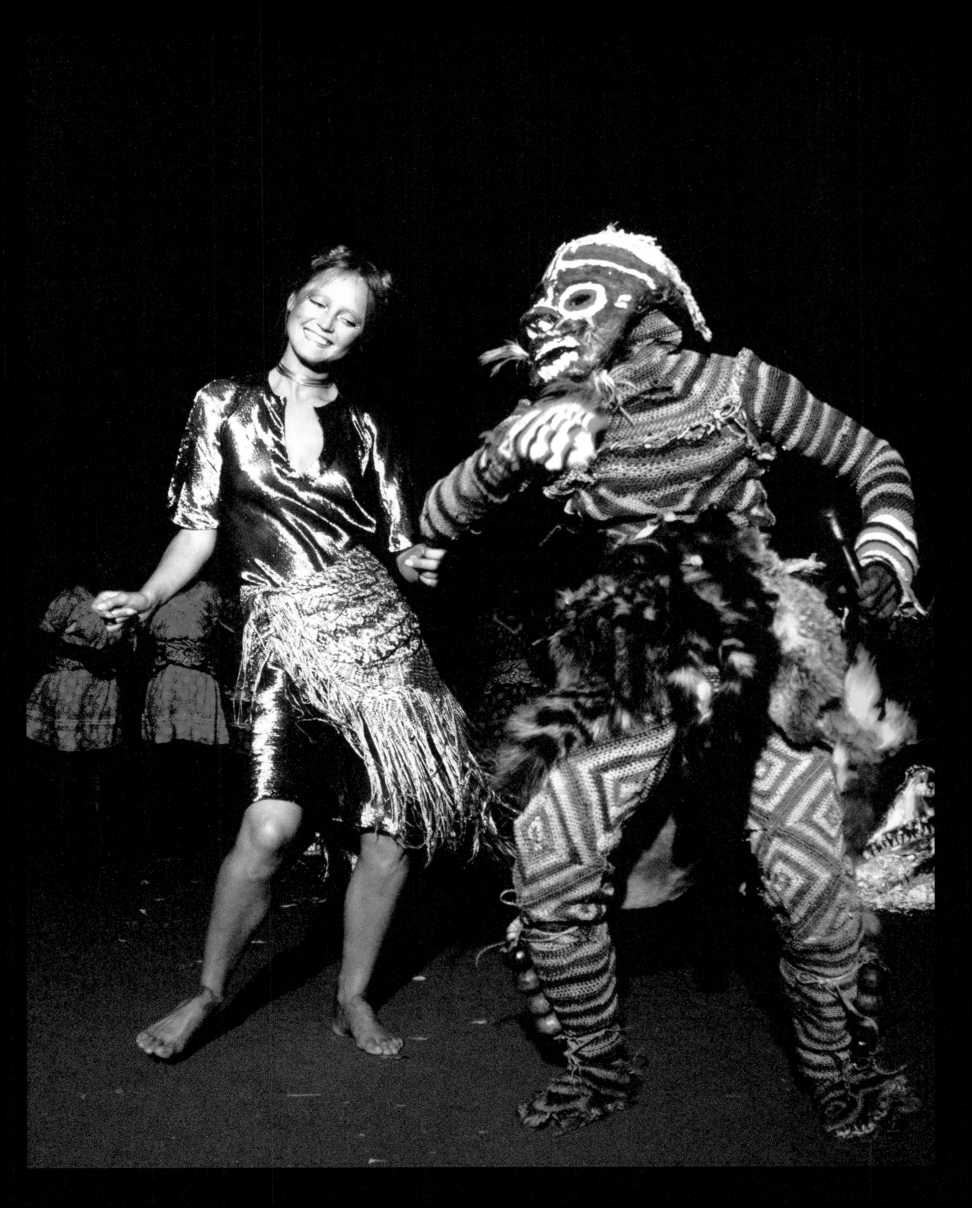

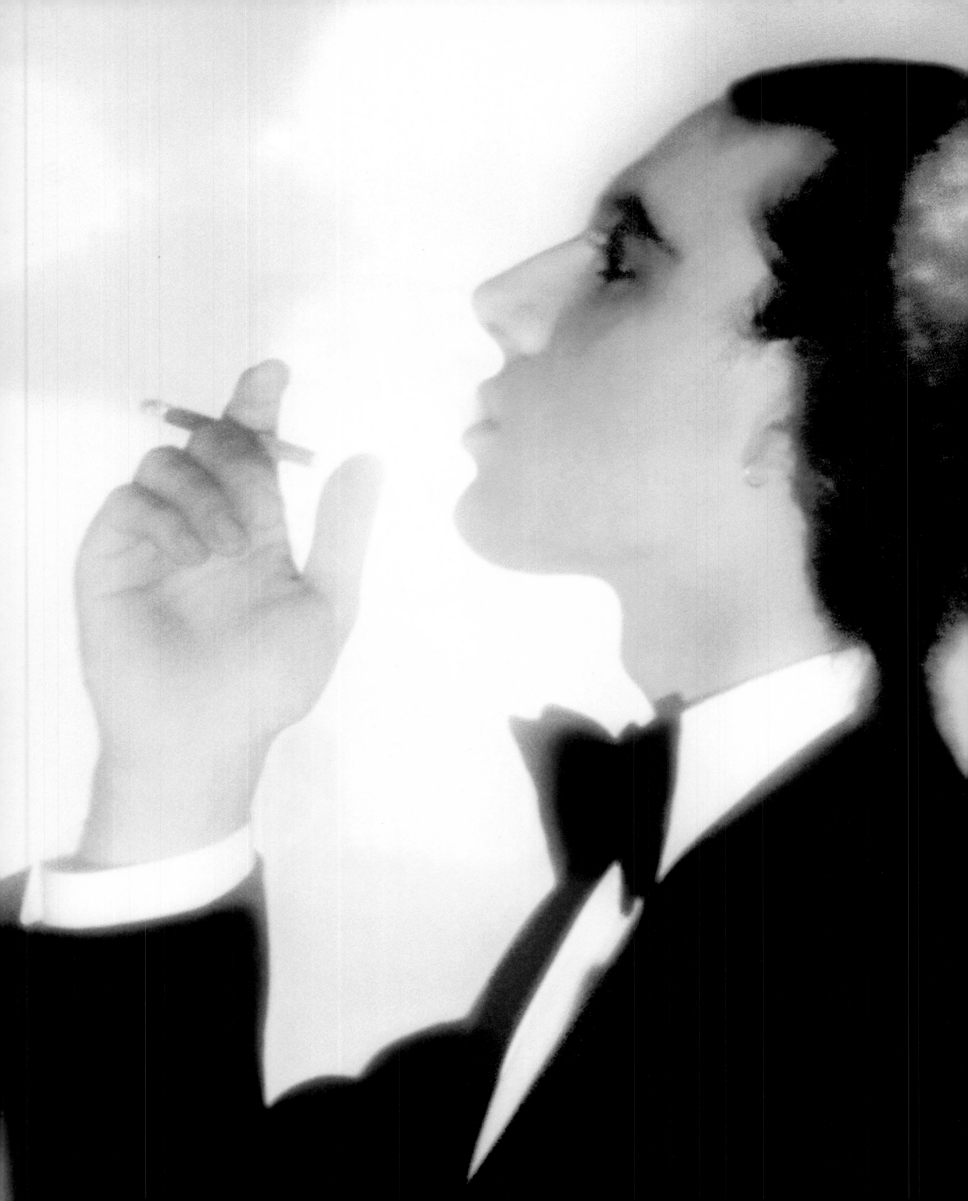

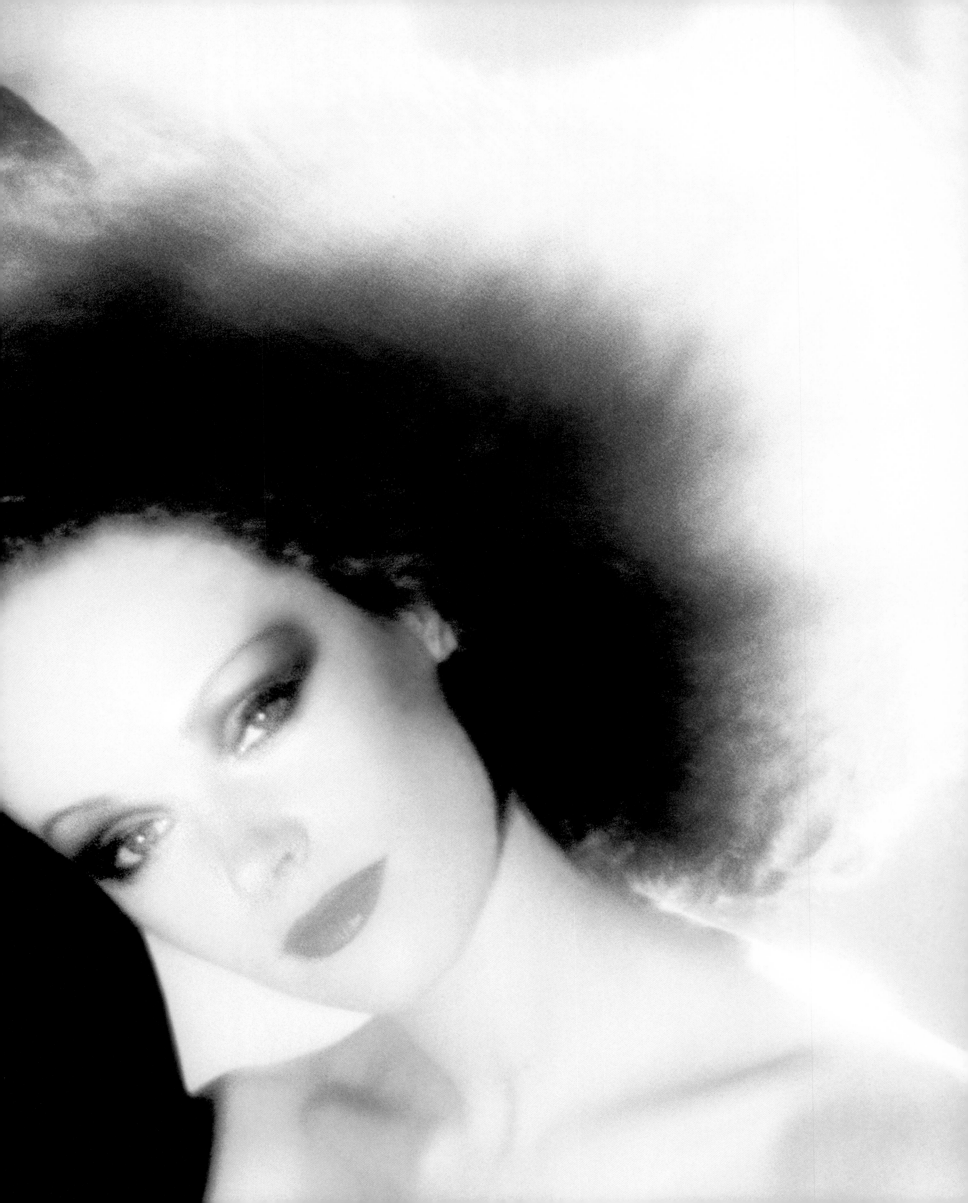

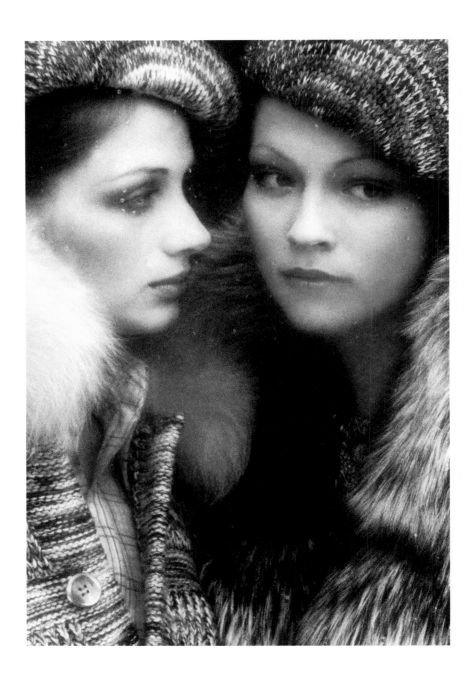

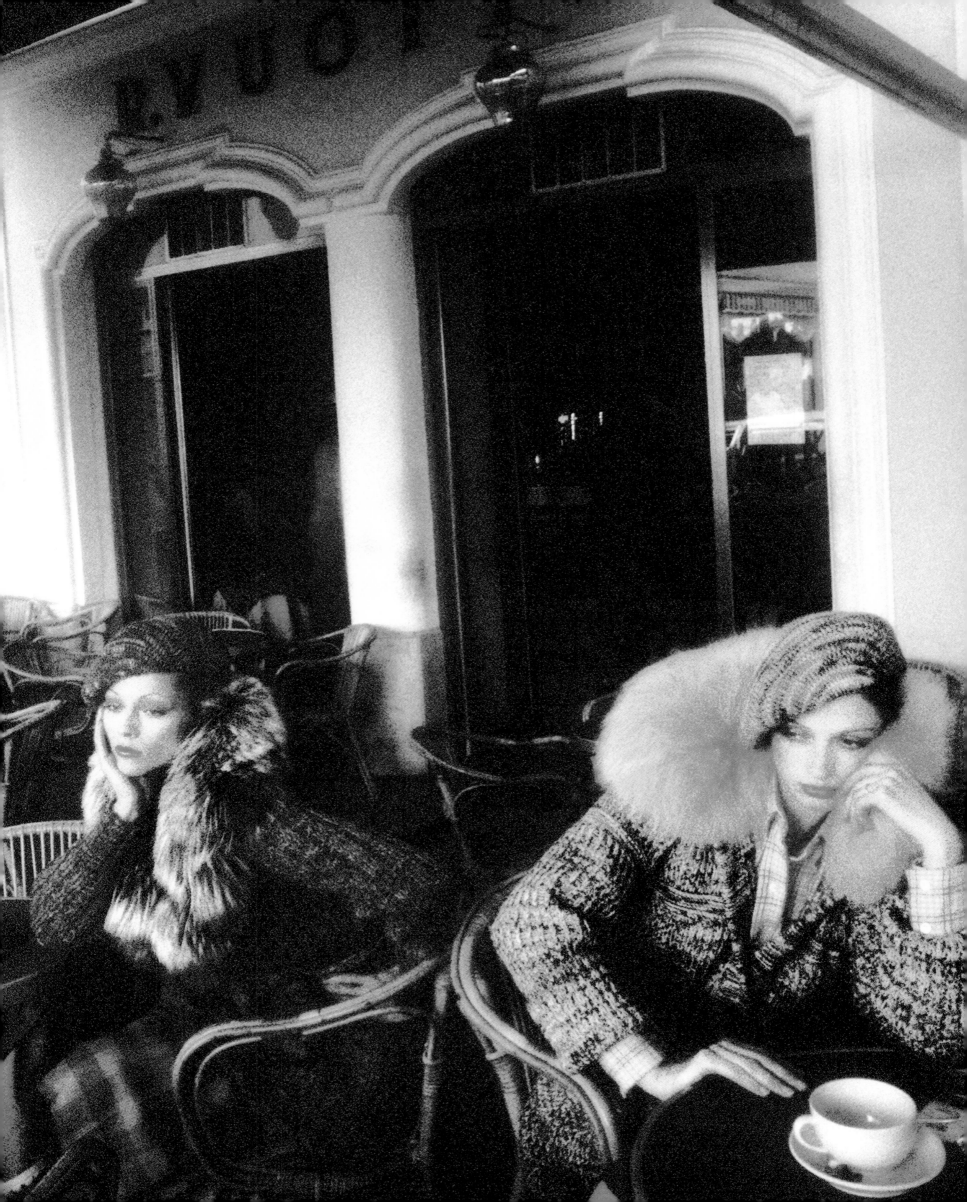

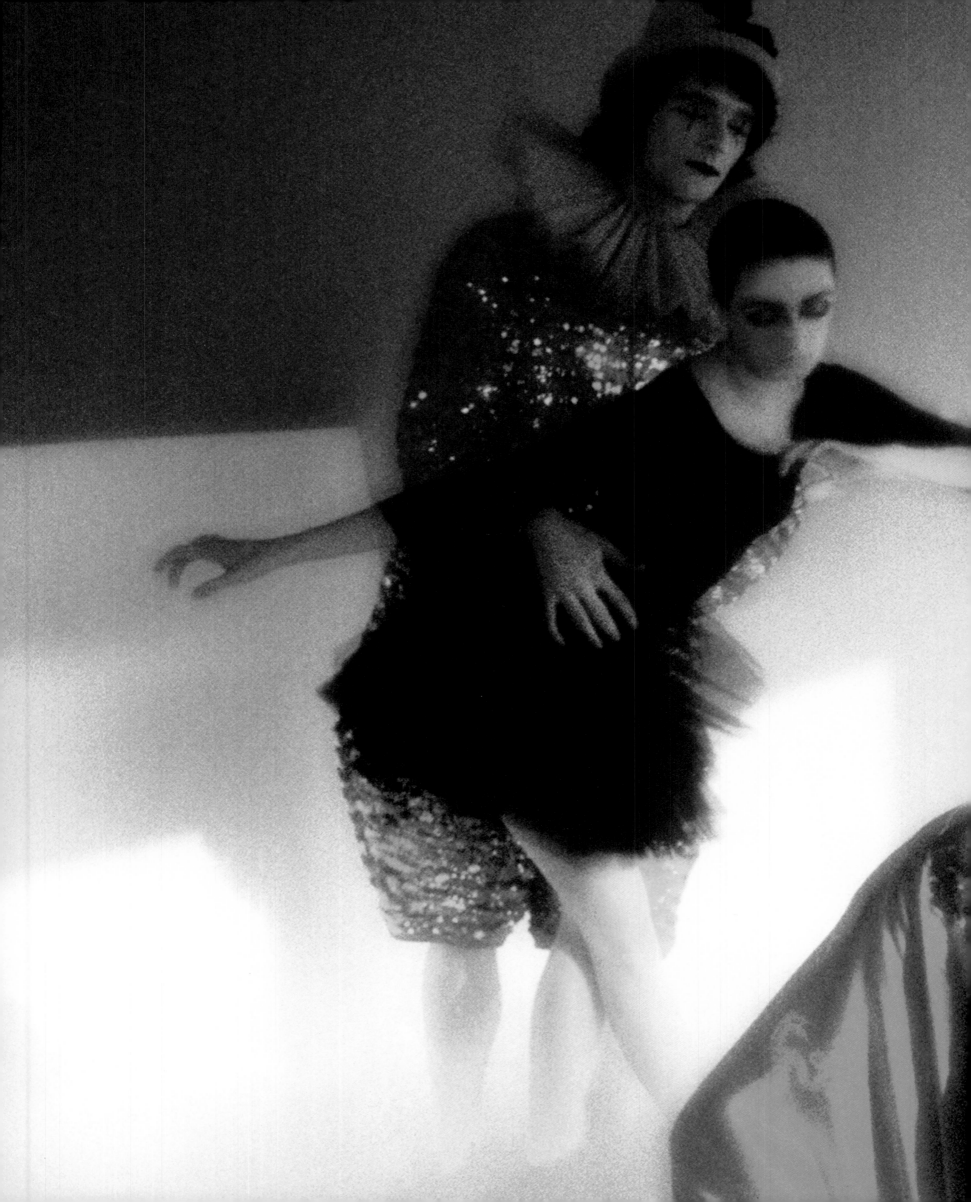

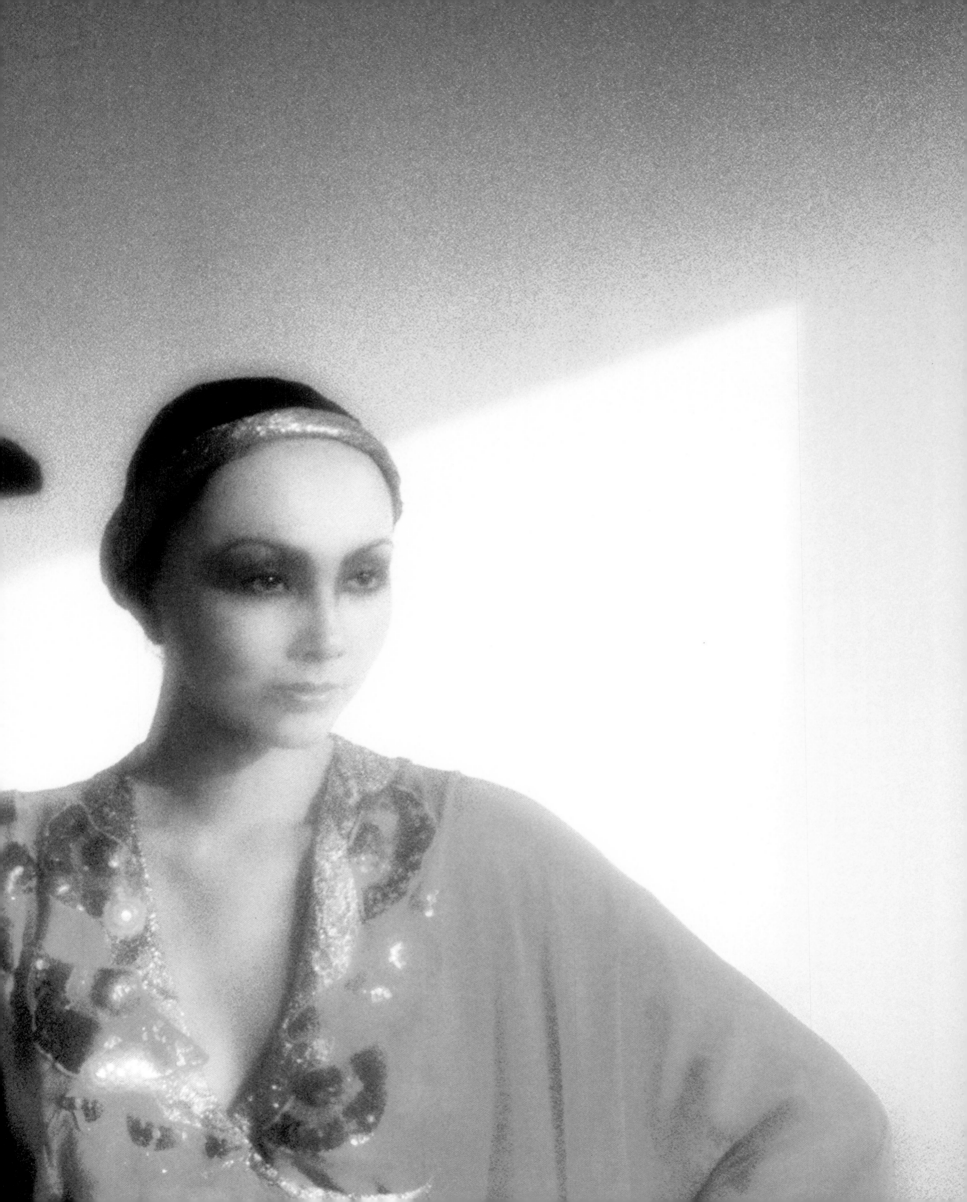

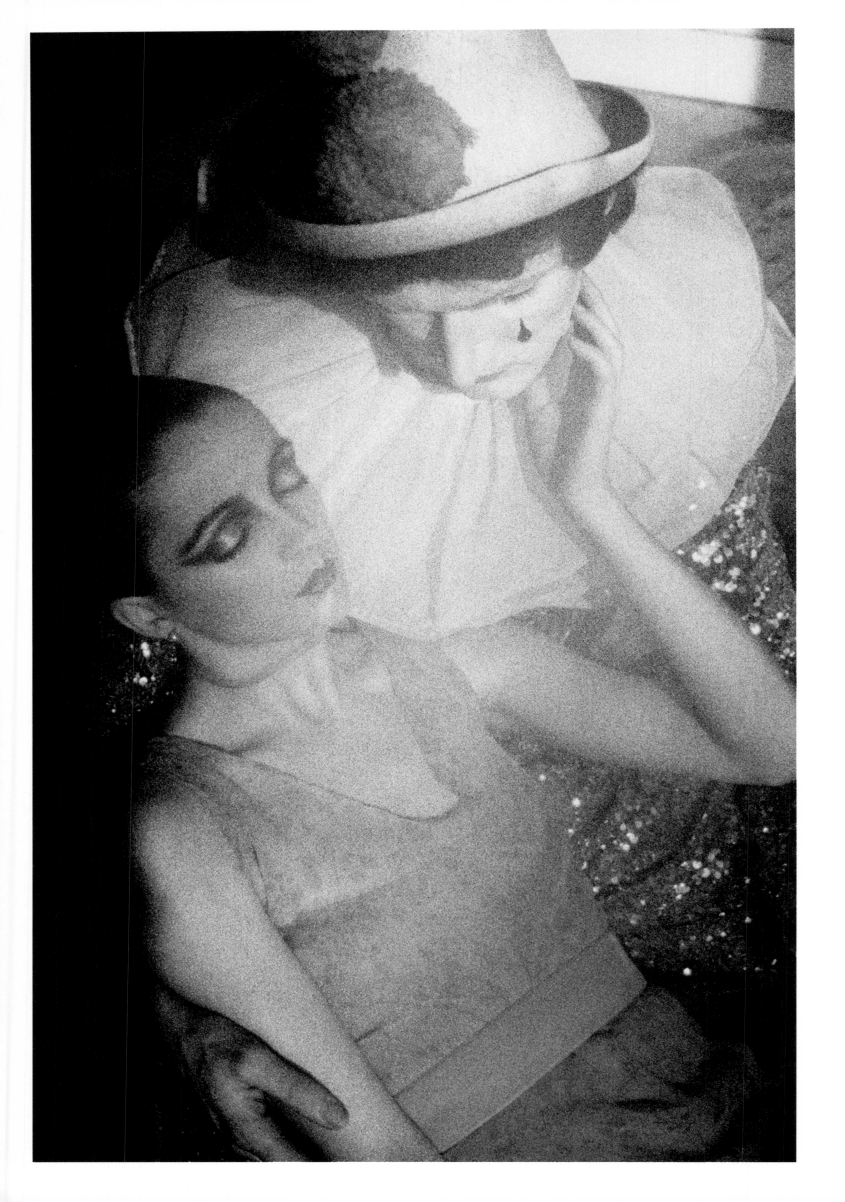

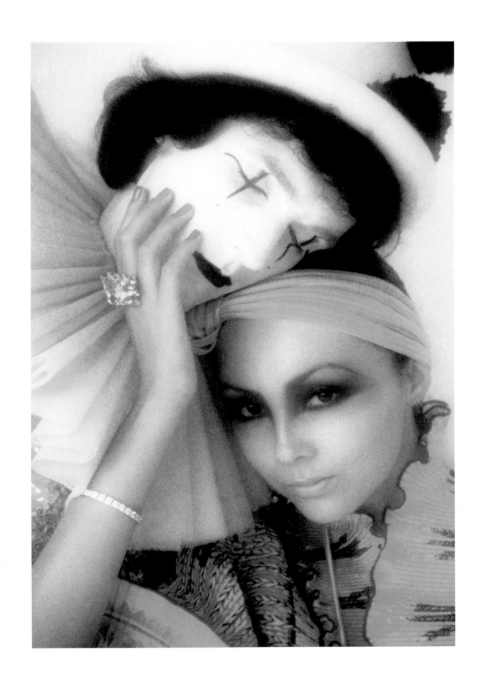

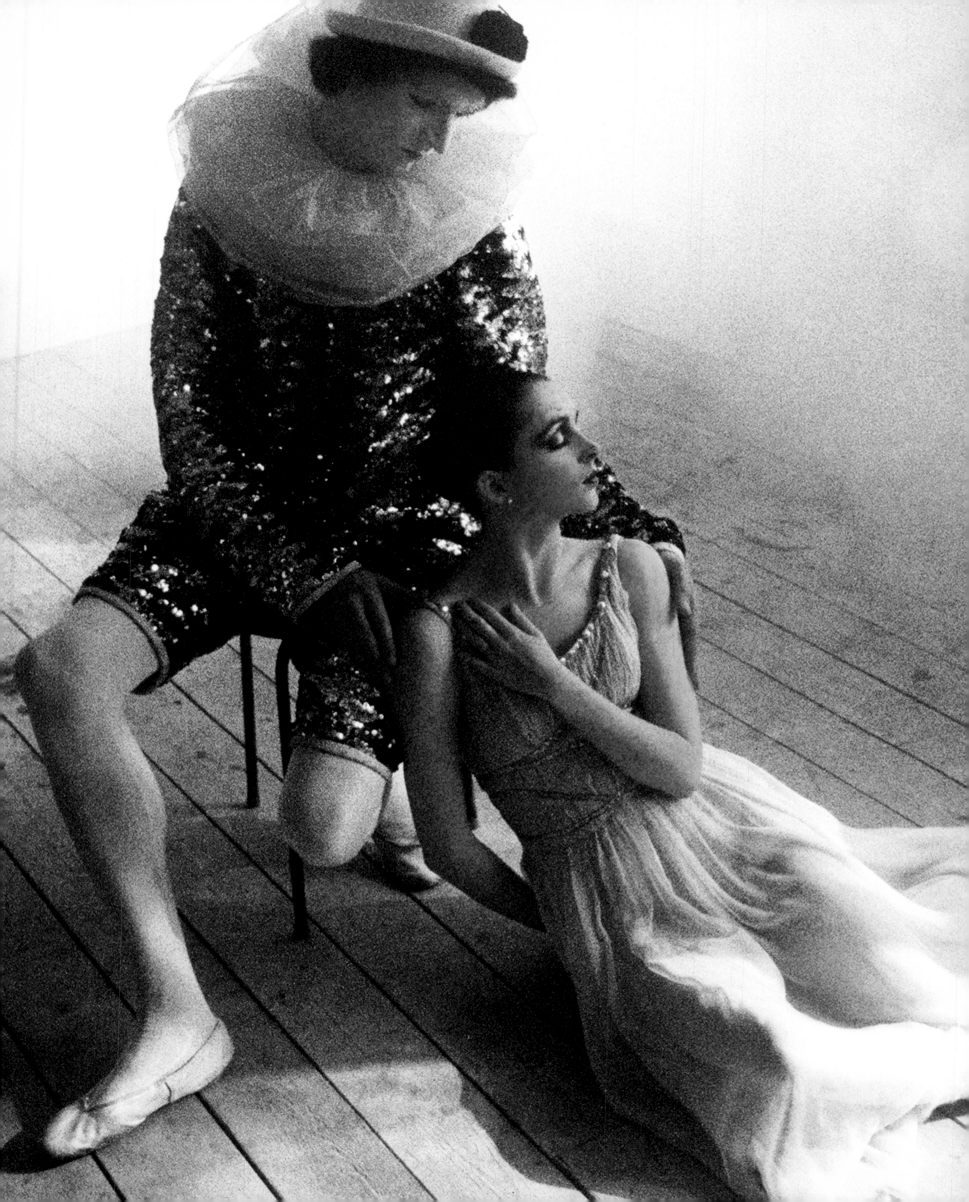

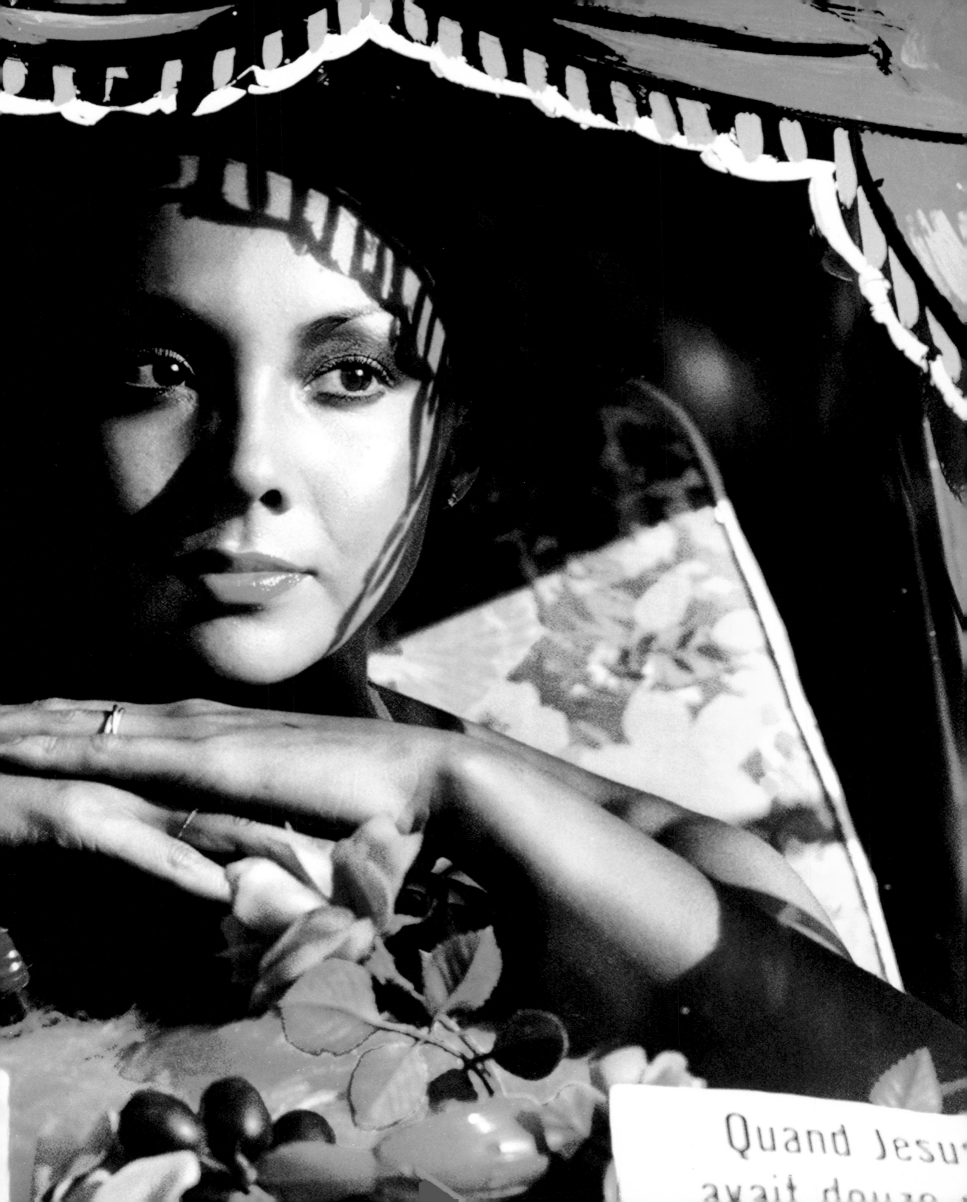

Quand Jesu
avait dou

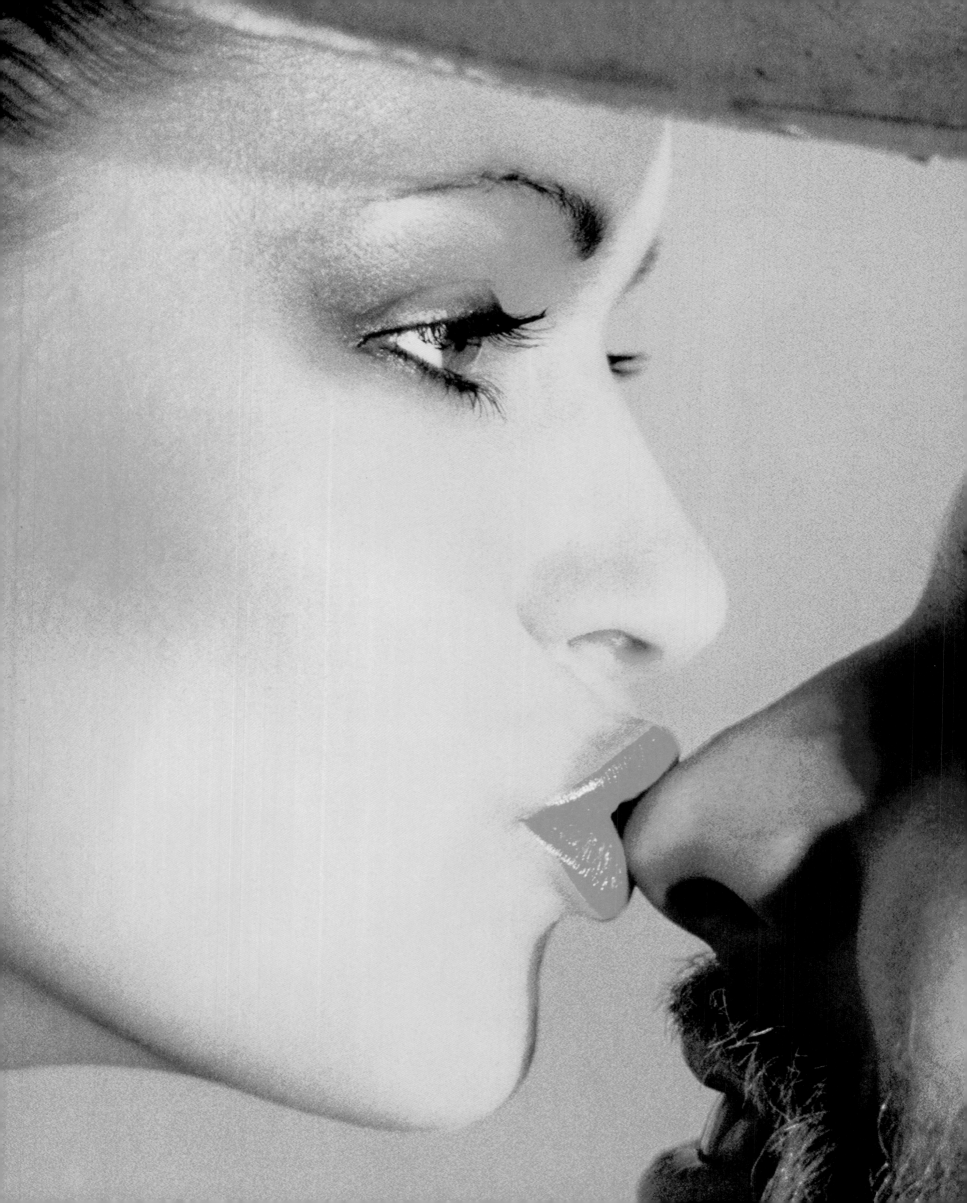

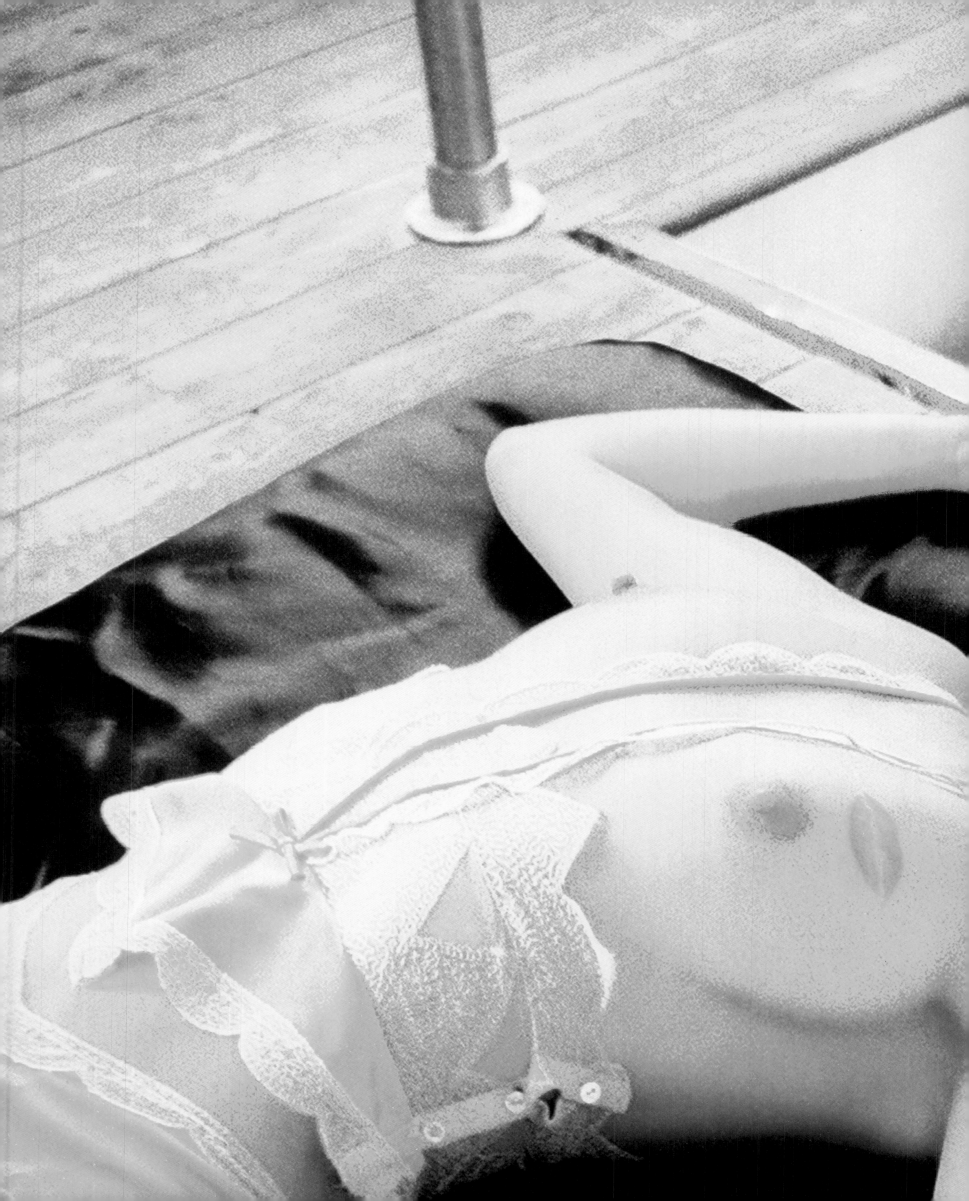

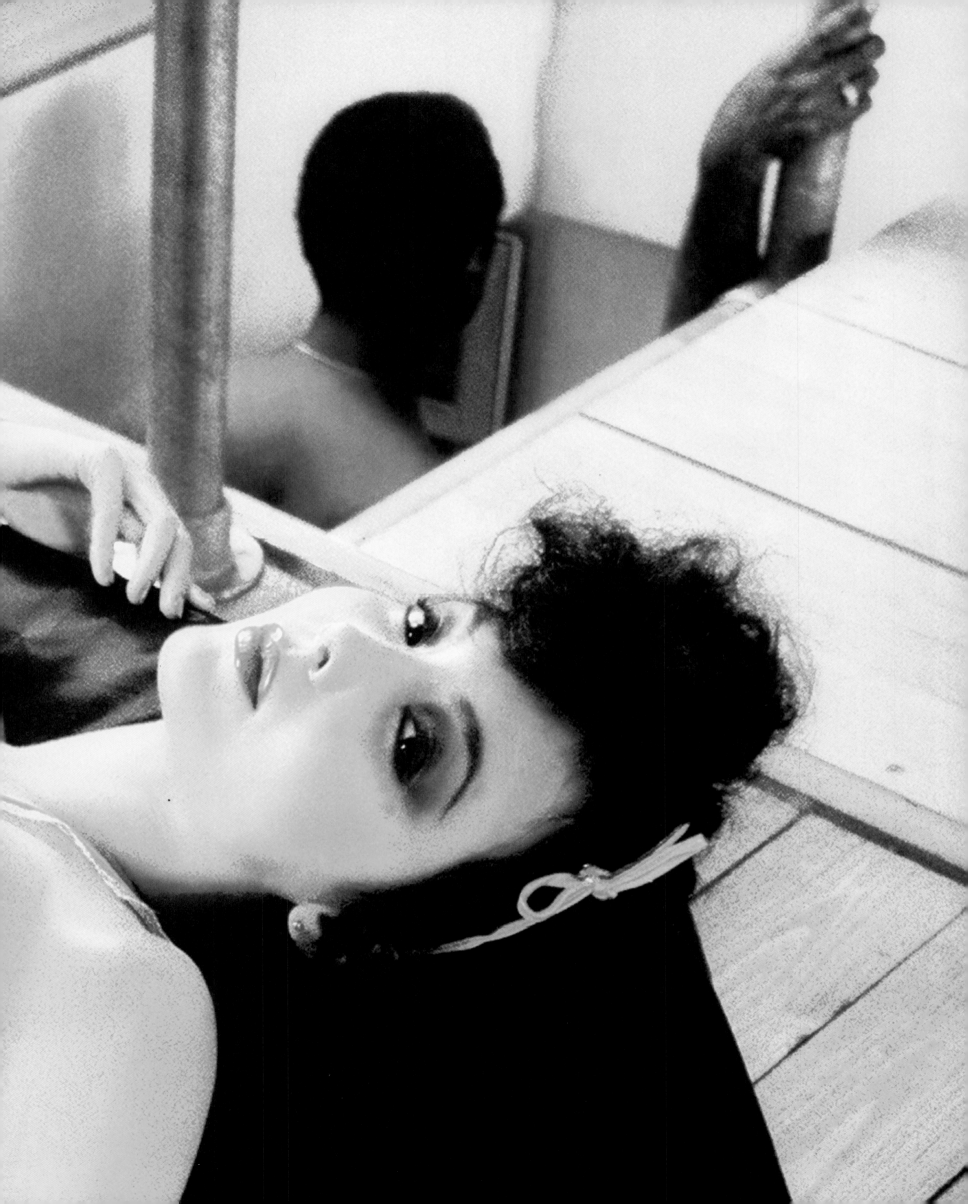

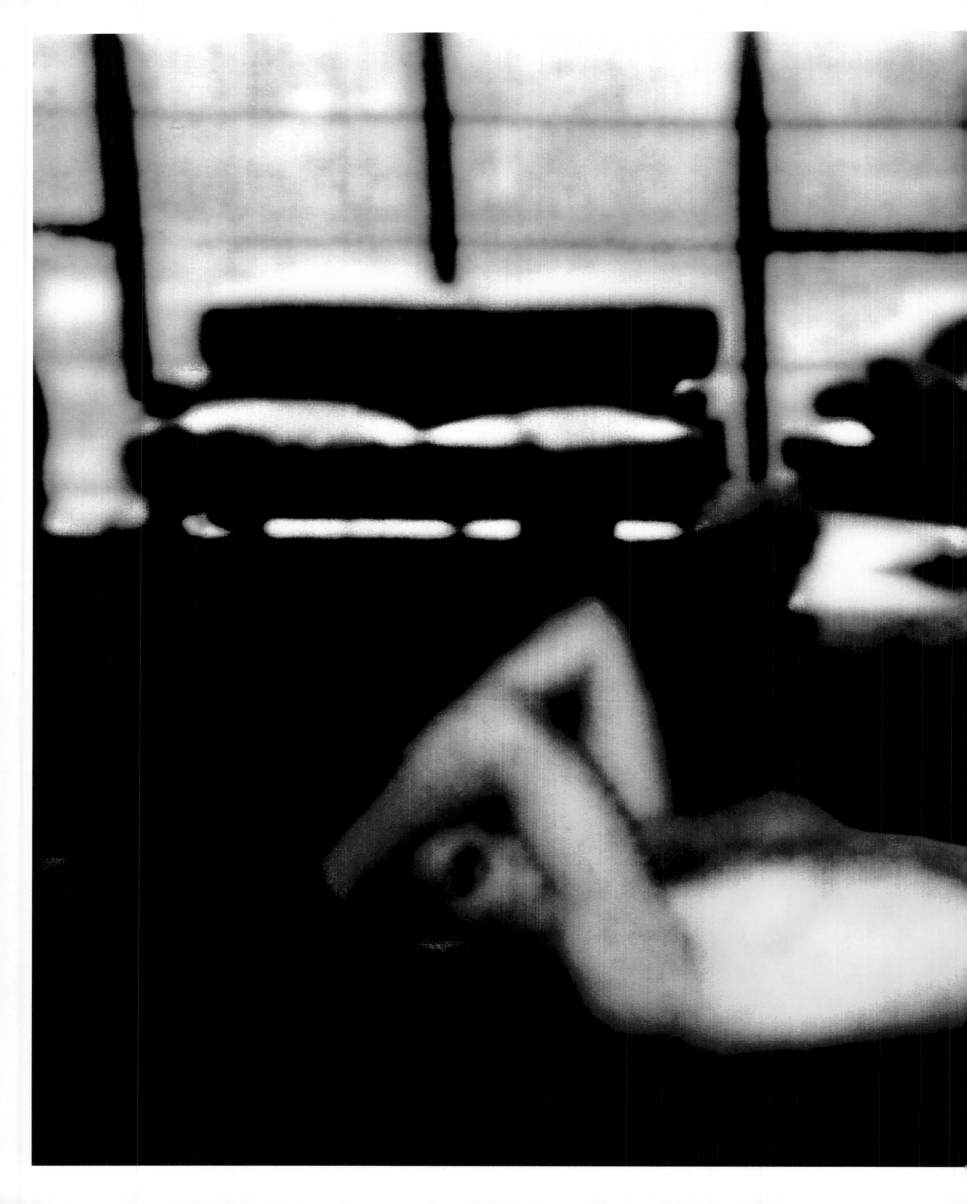

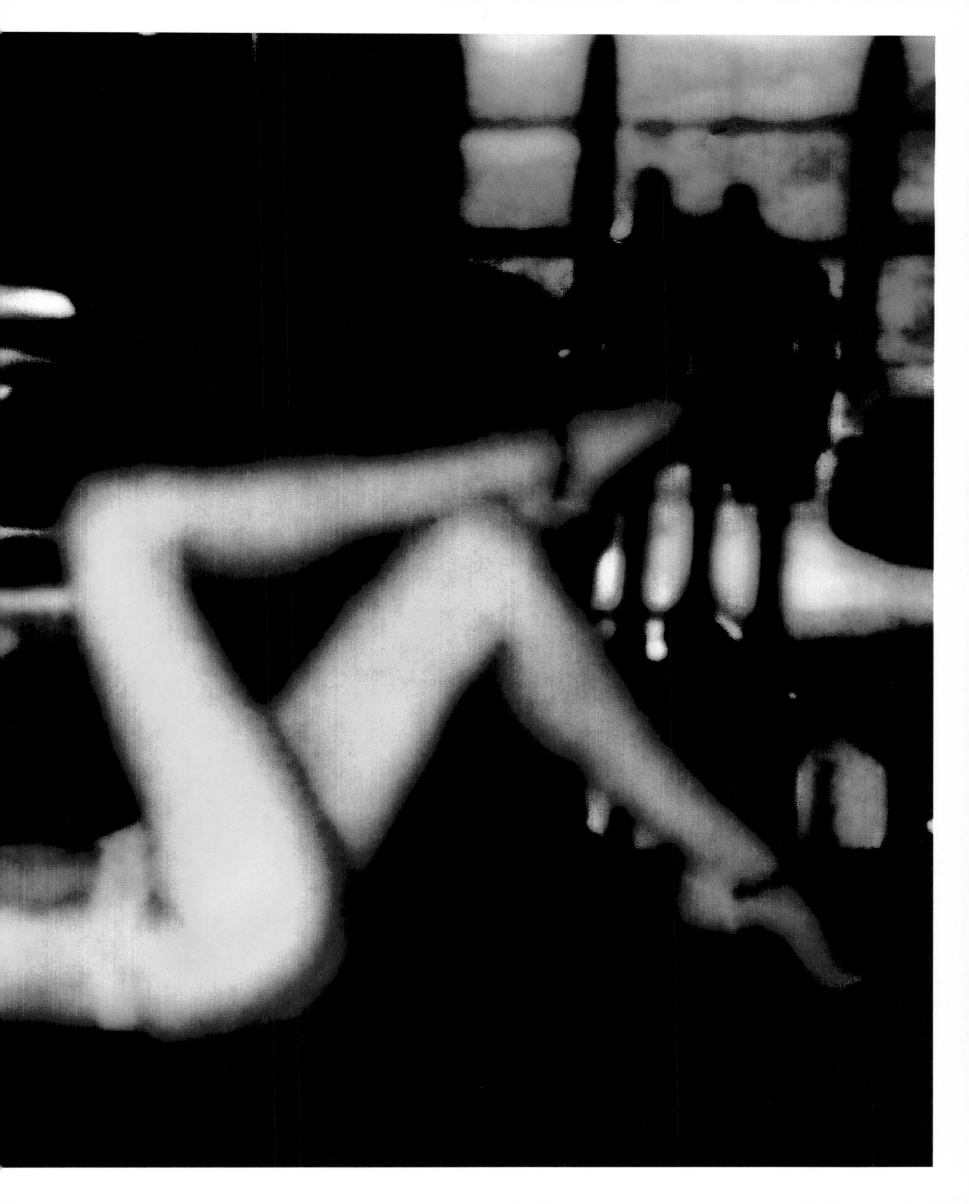

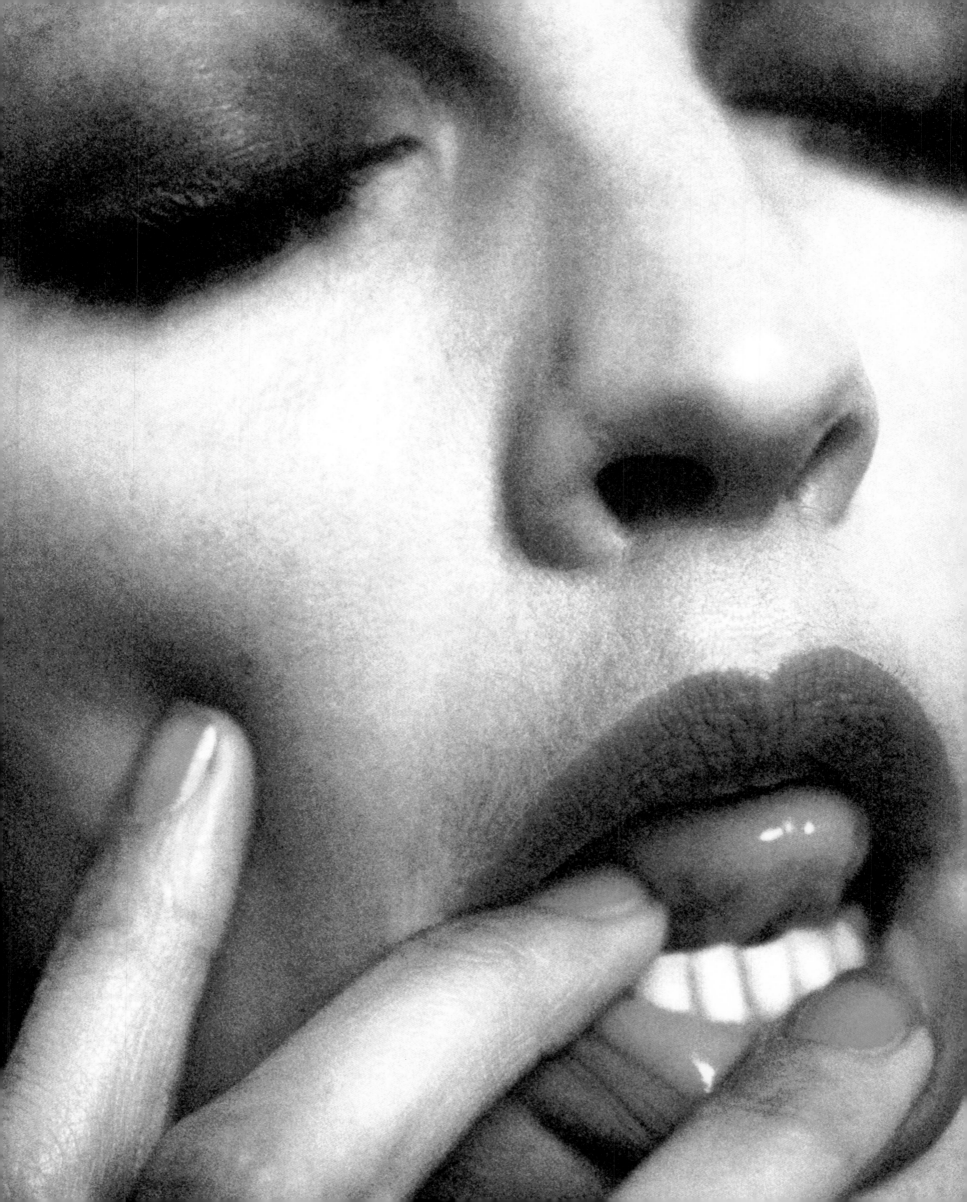

eduction, with its overtones of sexual conquest, is part of the relationship between Bailey and his models. Editors have found much in the Bailey *oeuvre* to disconcert them over the years. As George Melly observed in his preface to the 1992 Bailey book, *If We Shadows*: 'It is also certain...that his erotic photographs emanate a disturbing poetry. Art, after all, is not "correct" and Bailey is undoubtedly an artist.'

Even the more enlightened European fashion magazines, which have given him much creative freedom in terms of subject matter and page design have occasionally baulked at publishing a complete narrative sequence as envisaged by Bailey at his most megalomaniacal. The March 1976 issue of Italian *Vogue* proves an honourable exception, publishing a fashion shoot with Marie Helvin over an astonishing twenty-two pages and including more of the same shoot in the April issue.

As he began to abandon expressing fashion pictures in terms of the documentary tradition, Bailey found he was suited to the world of the fashion magazine both temperamentally and artistically – though not always it to him. Moreover, when he started out, the implicit sexuality of his images was at odds with contemporary magazine photography. 'The place was run like a point-to-point,' he recalled of *Vogue* in the *Sunday Times* Magazine, March 1989, 'Don't forget being a cockney was no help in the beginning – only after '65. I remember one of those women patting me on the head

and saying "Oh, doesn't he speak cute?"' 'I'll
give you *cute*, dear,' he vowed. His confrontational
depiction of his models, as evinced by their
stance and eye contact with the photographer,
suggested much more of an intimacy than was
customarily observed by his predecessors and
contemporaries. His gaze back was not
ambiguous: it was unblinkingly sexual.

In his beauty work, particularly, Bailey has
always attempted to push for the acceptance
of more psychologically complex pictures invested
with eroticism and sexual allure. Frequently there
is a discernible move away from preoccupations
with purely formal visual qualities in favour of a
freer, more spontaneous and provocative vision.
Bailey's experience, like that of his colleague
Helmut Newton, was that *Vogue* has always
acted as a kind of unofficial censor, what Bailey
referred to as 'a sort of Hayes Office' (*The Naked
Eye*, 1987, p. 128). But with the collusion of the
European *Vogue*s, Bailey has attempted to bring
some of his more personal obsessions to
wider currency.

The freedom afforded by working for non-
British magazines resulted in many of the
pictures here. For Bailey this is authenticity,
unstifled by an 'underground of small-time
gentry' – Jonathan Miller's description of *Vogue*'s
1962 readership – and unfettered by the legacy
of the mid-sixties, of *Blow-Up*, of marrying
Catherine Deneuve, it was said, on a whim, of
Reggie Kray's wedding, of *Box of Pin-ups* and
*Goodbye Baby*...

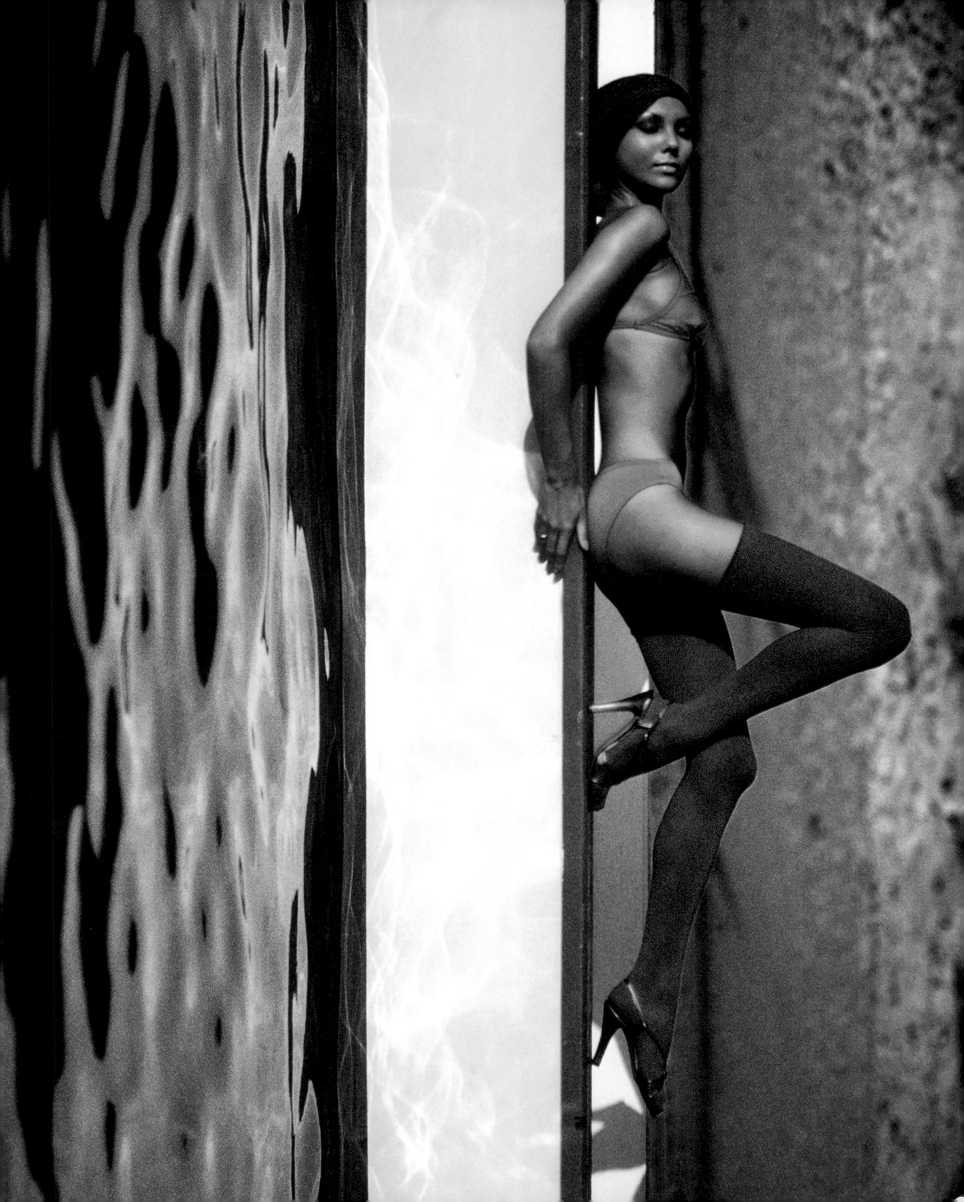

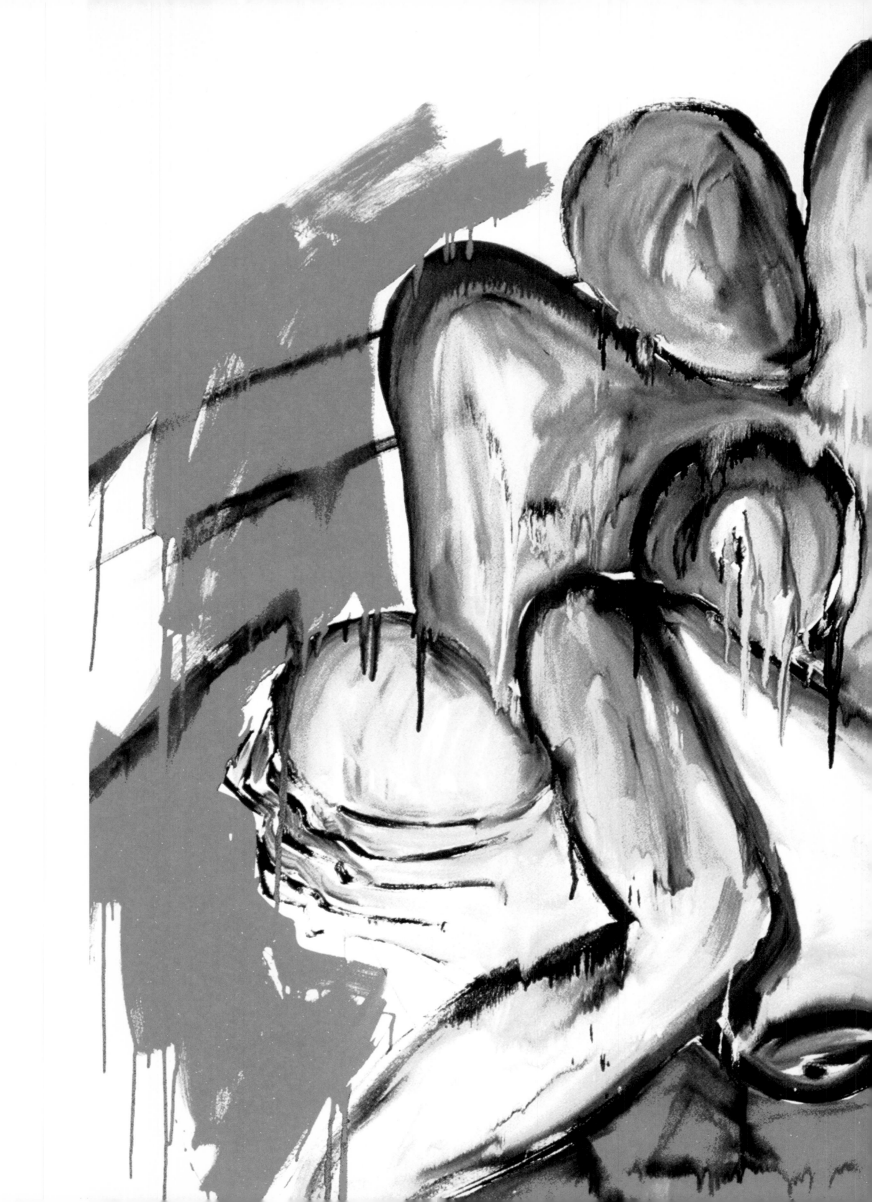

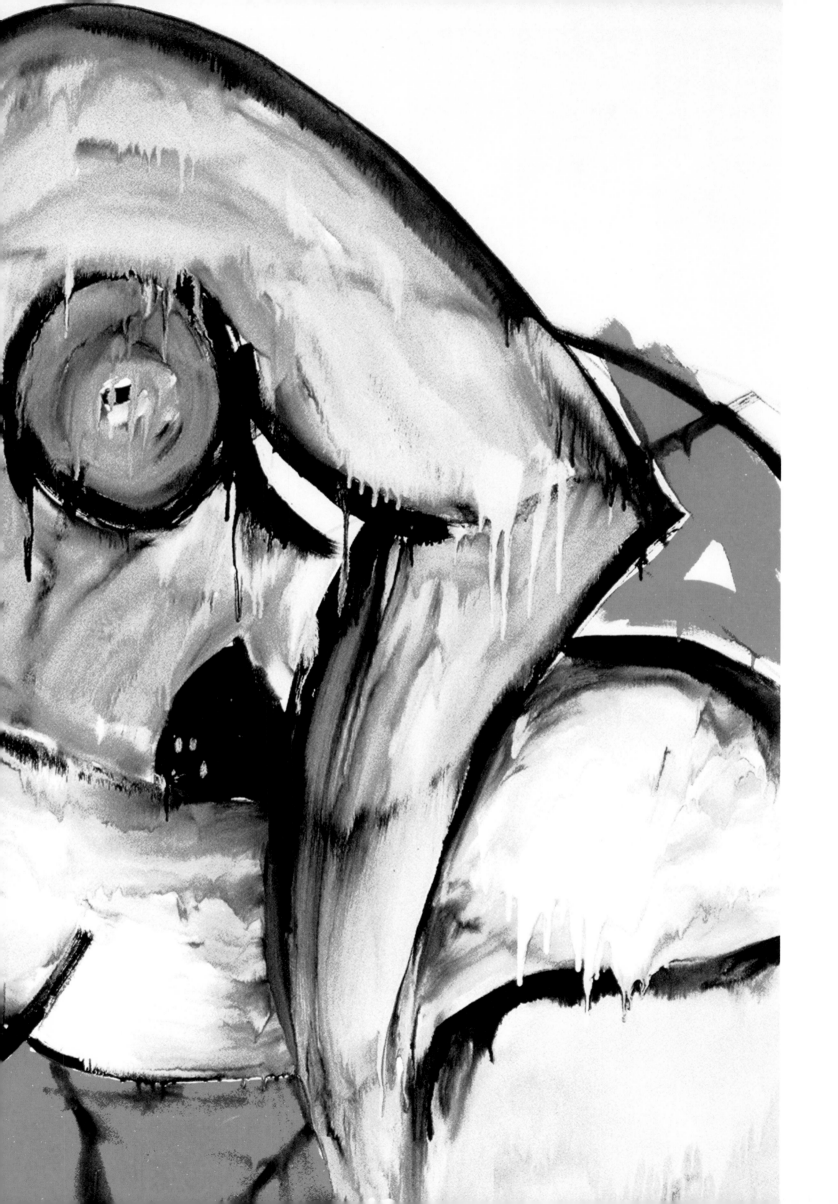

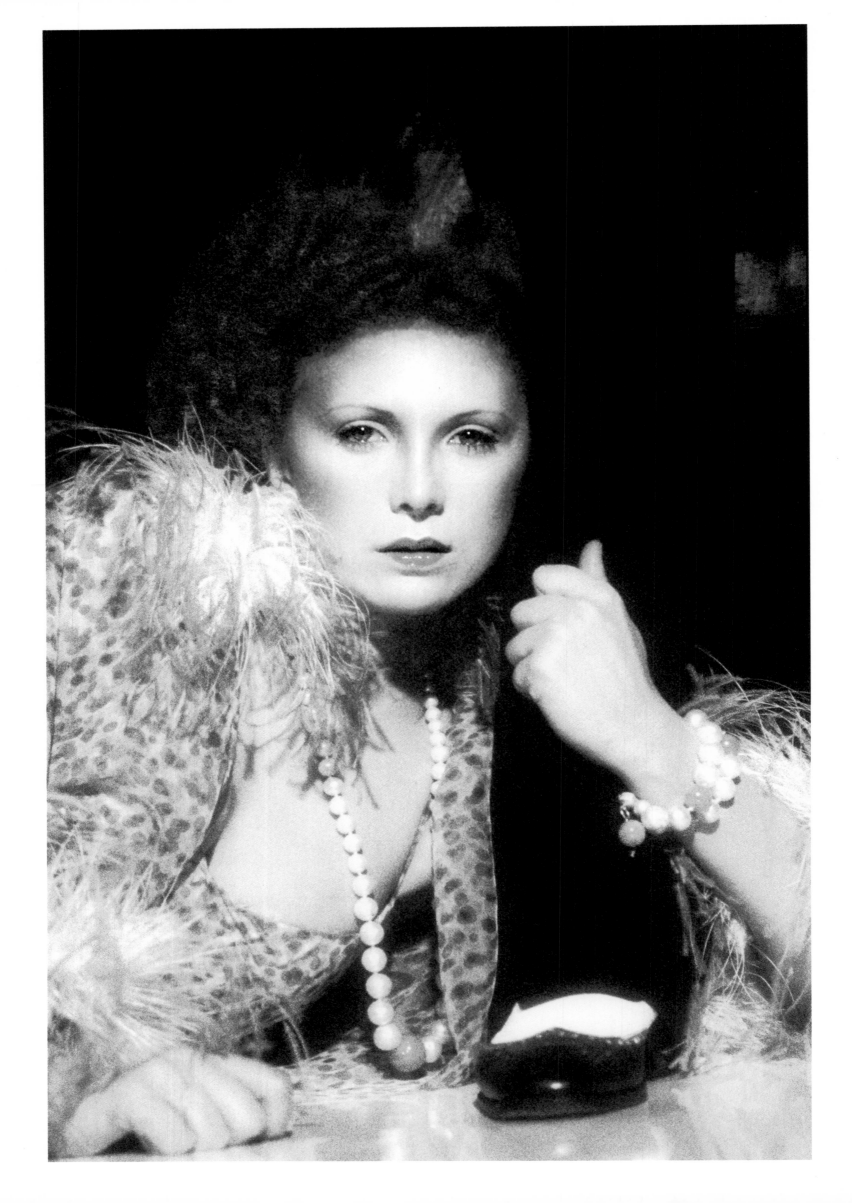

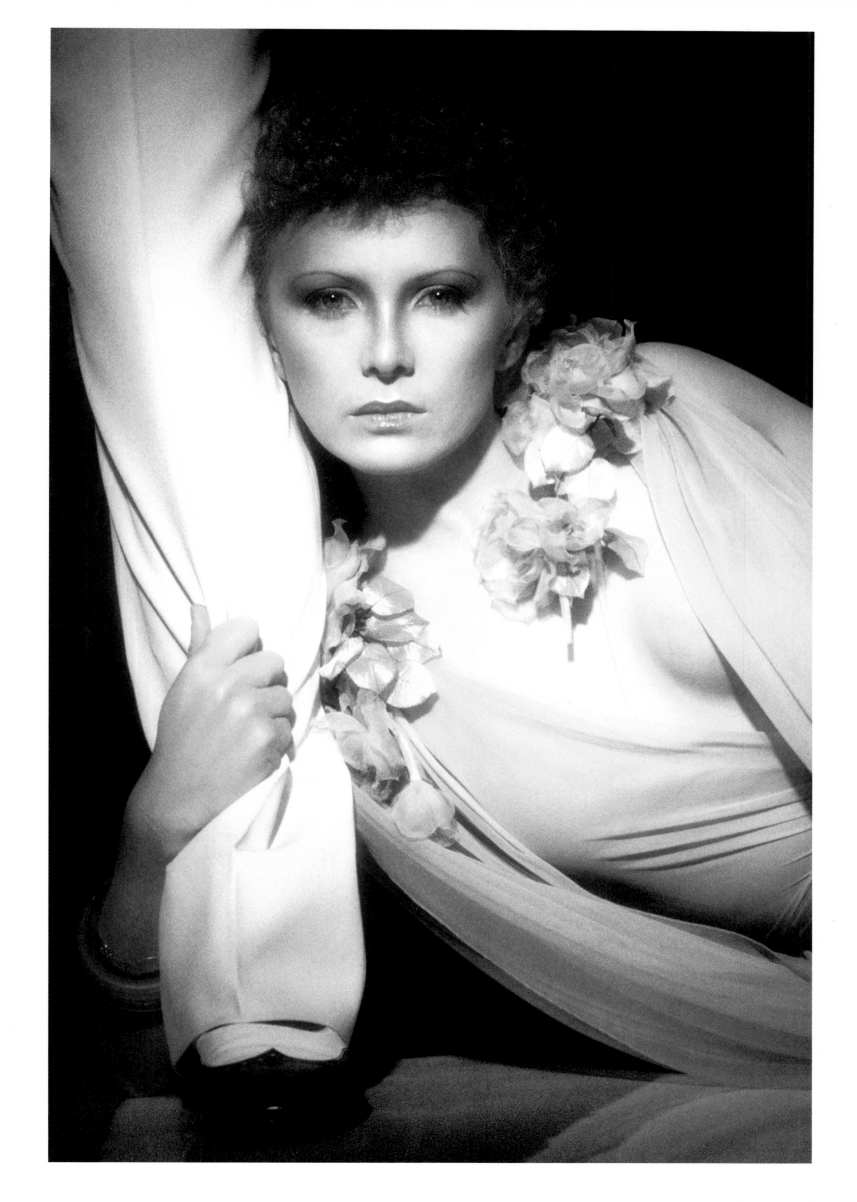

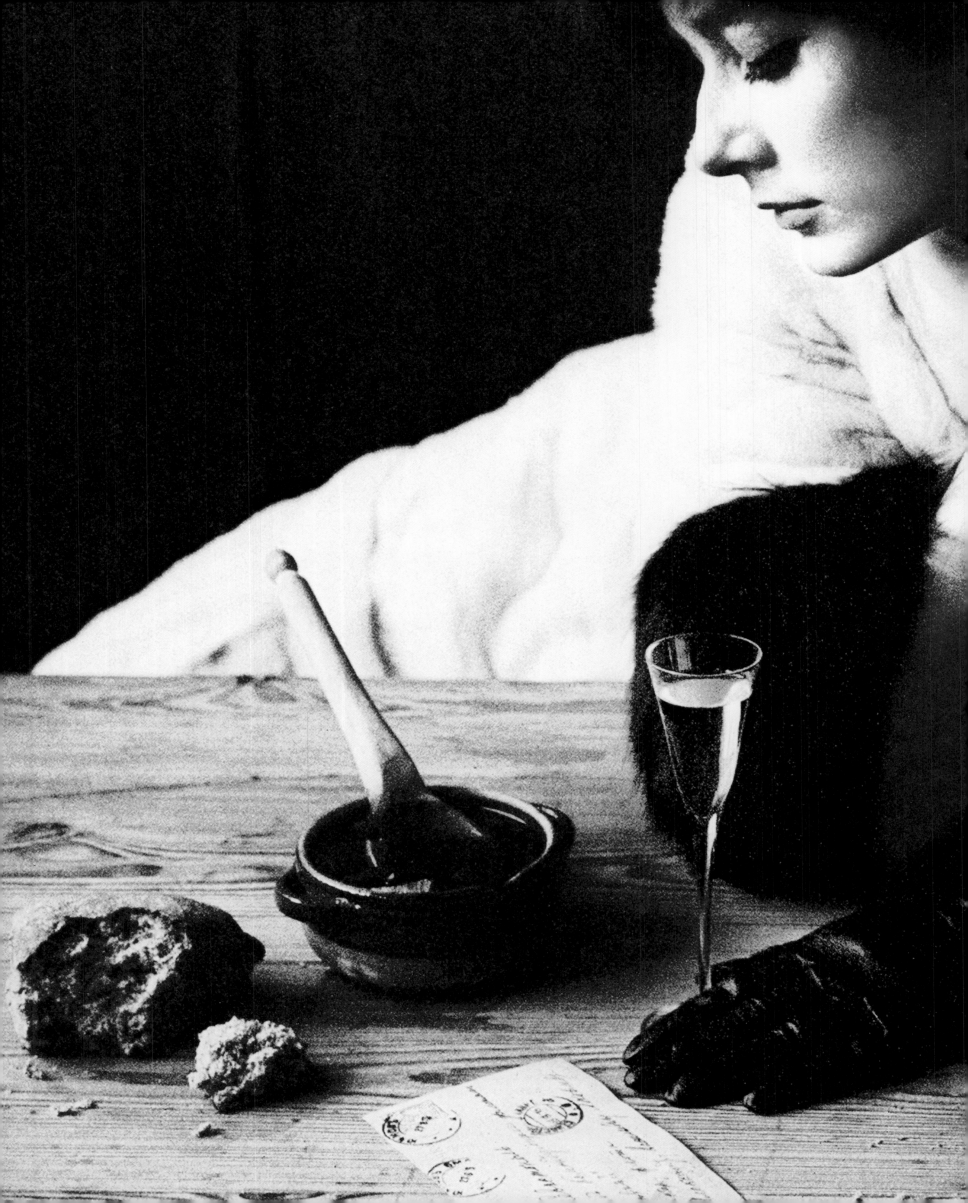

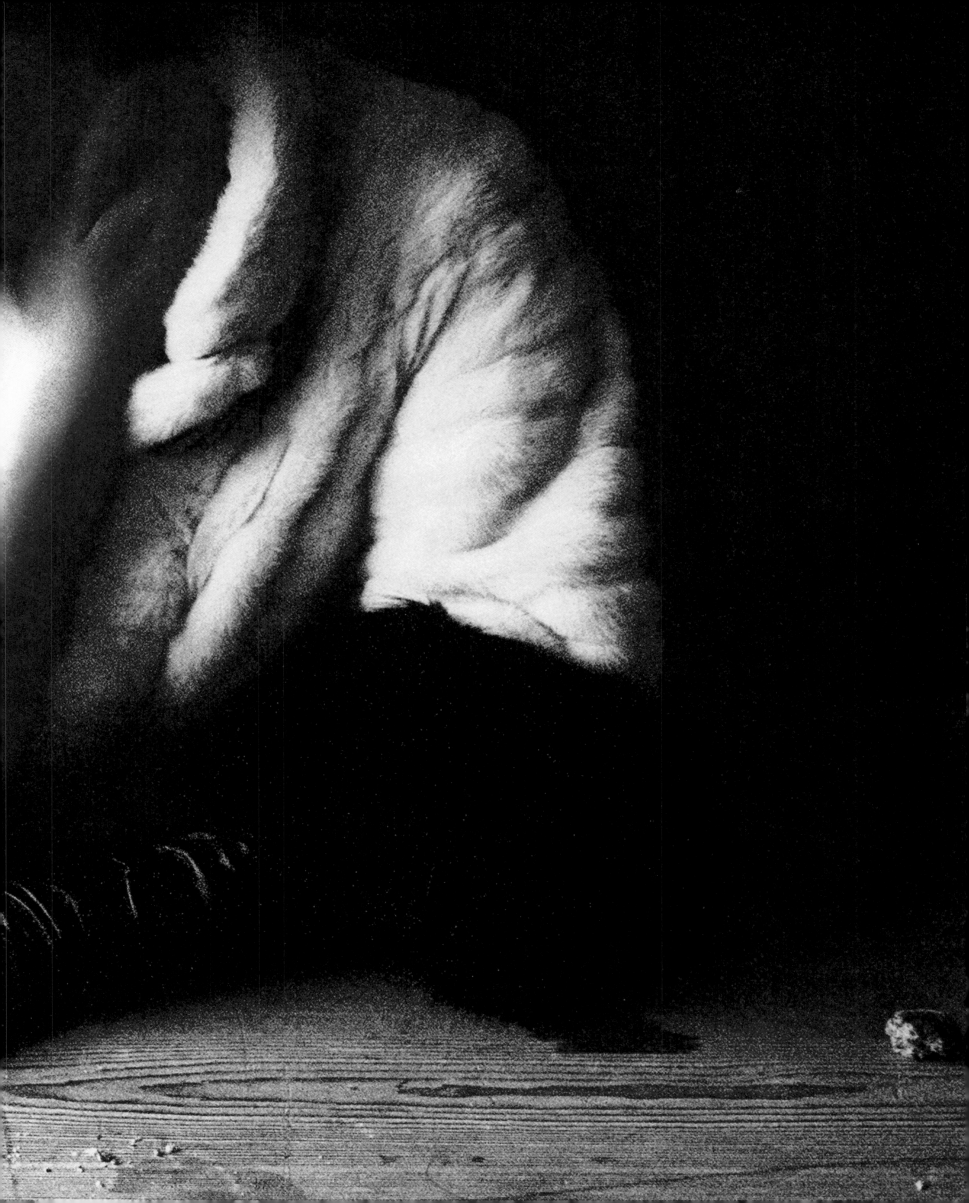

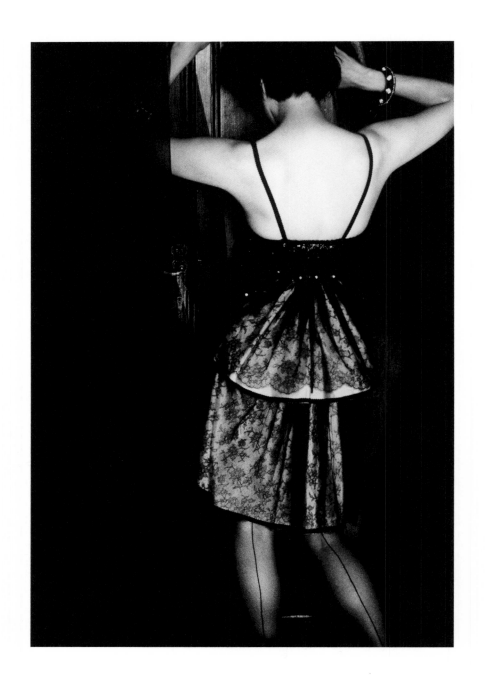

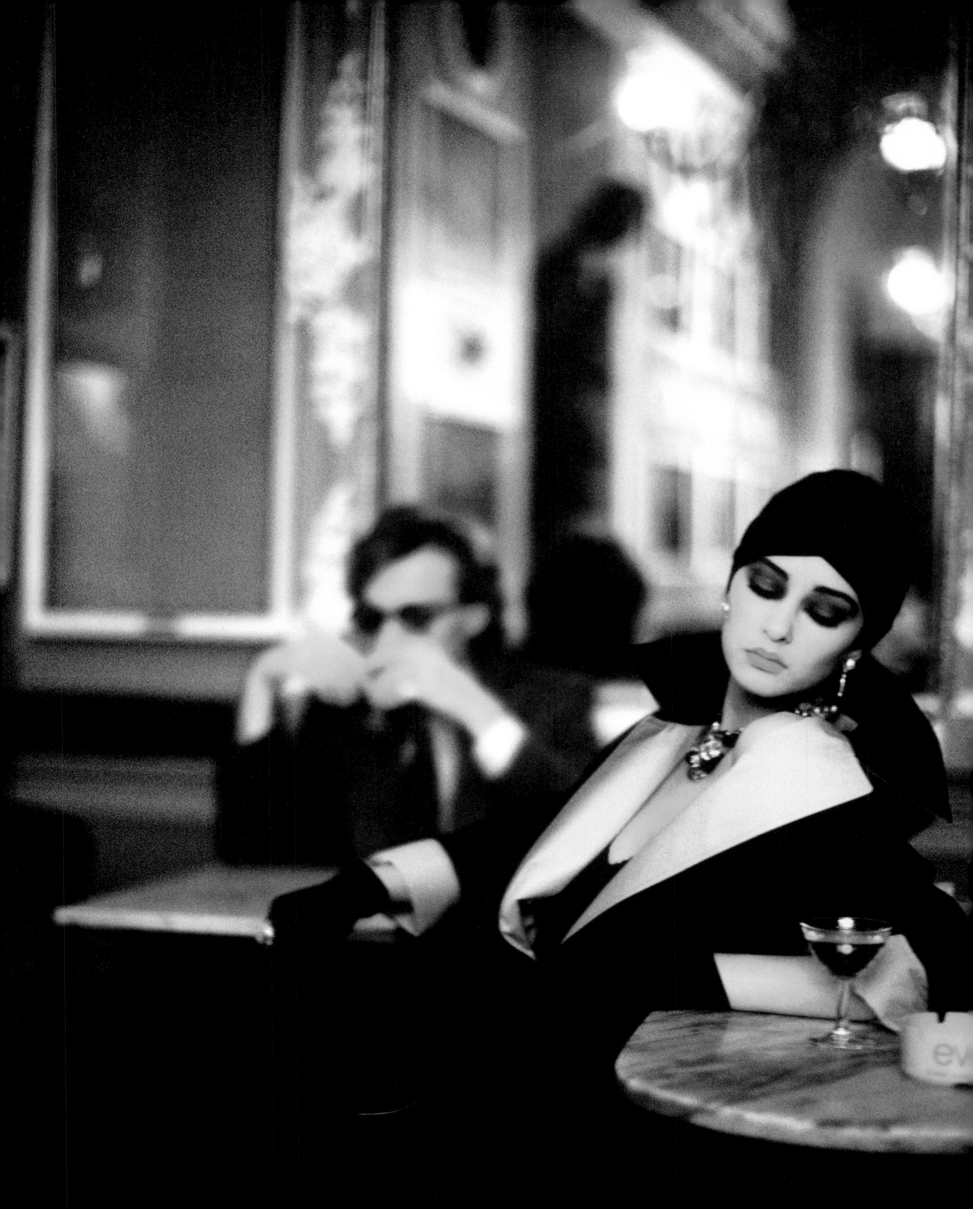

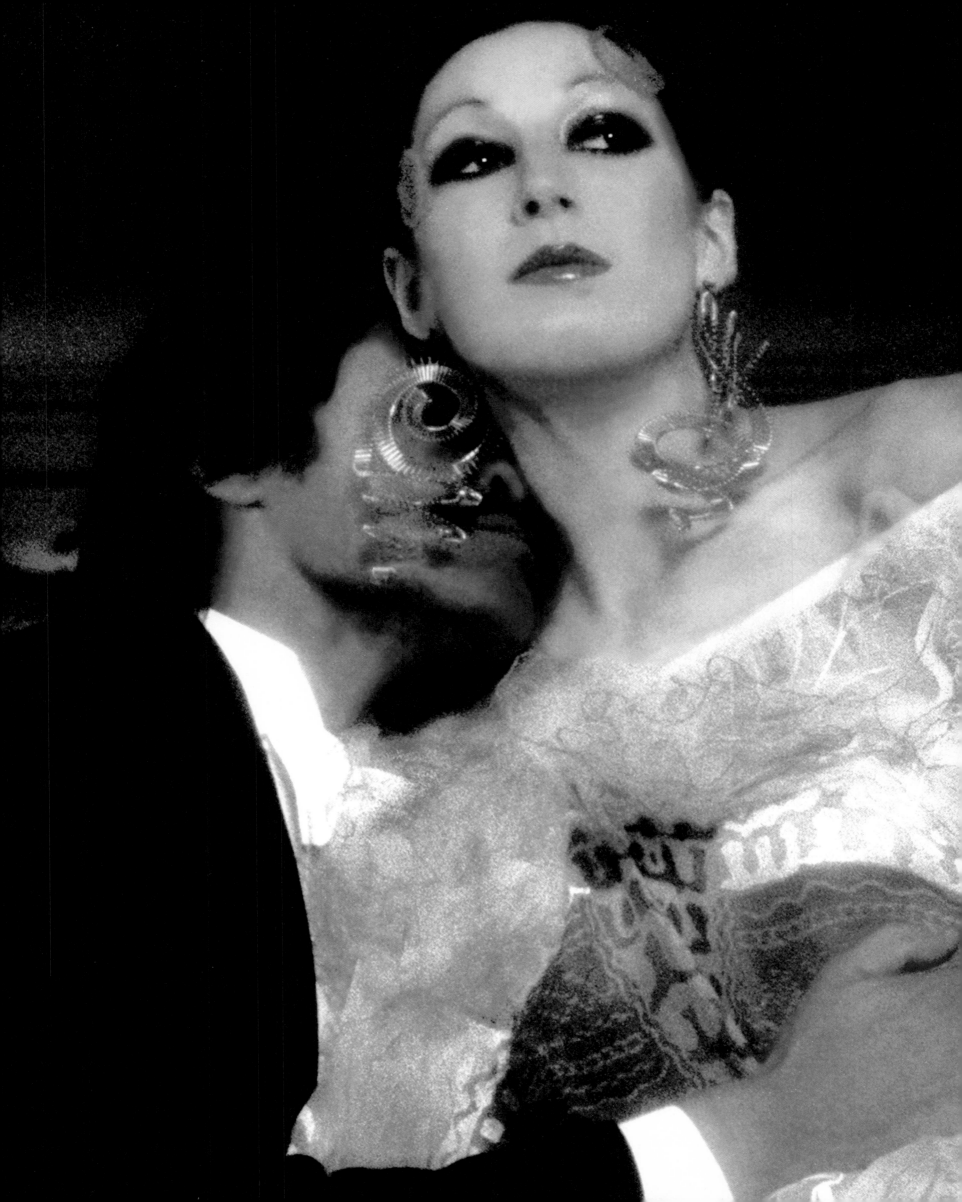

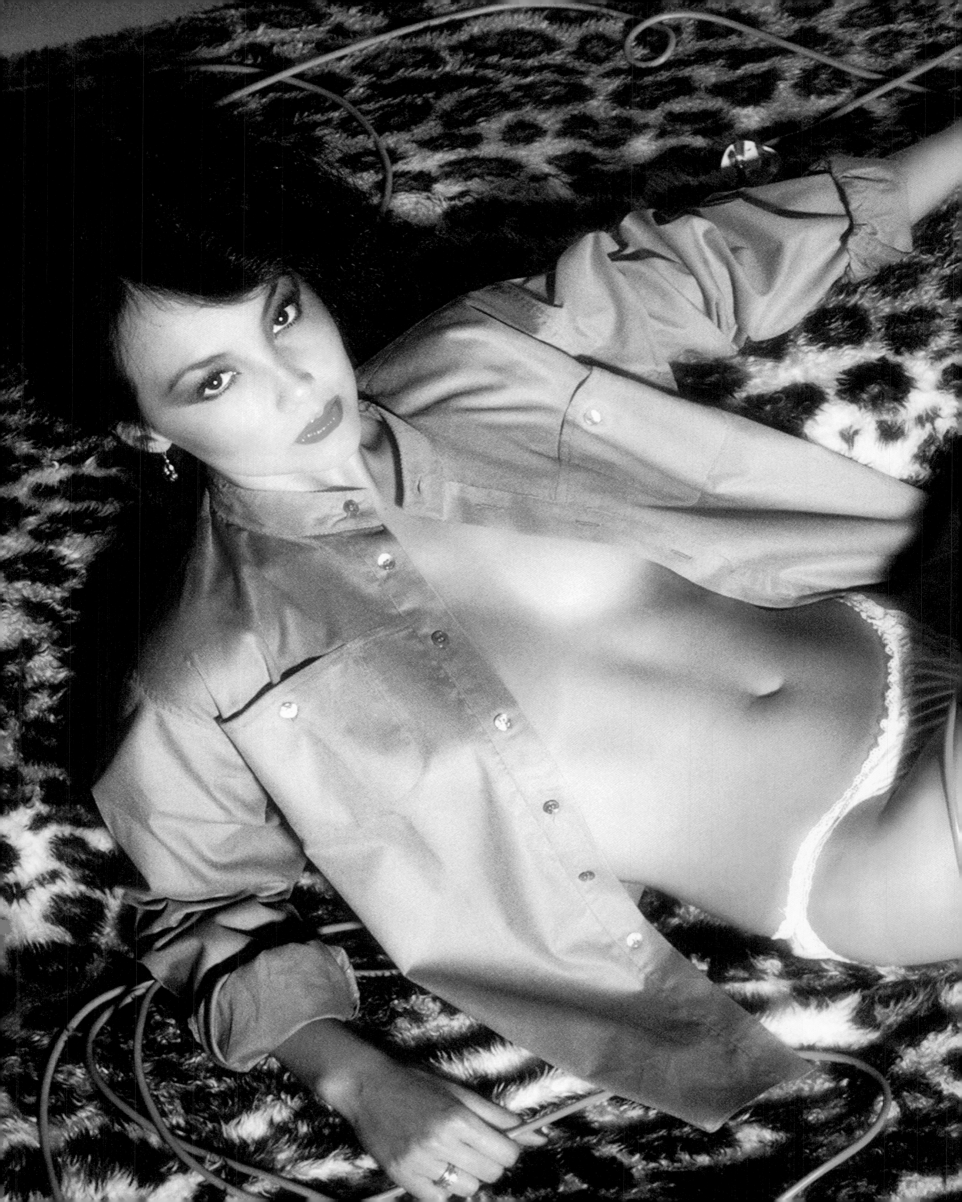

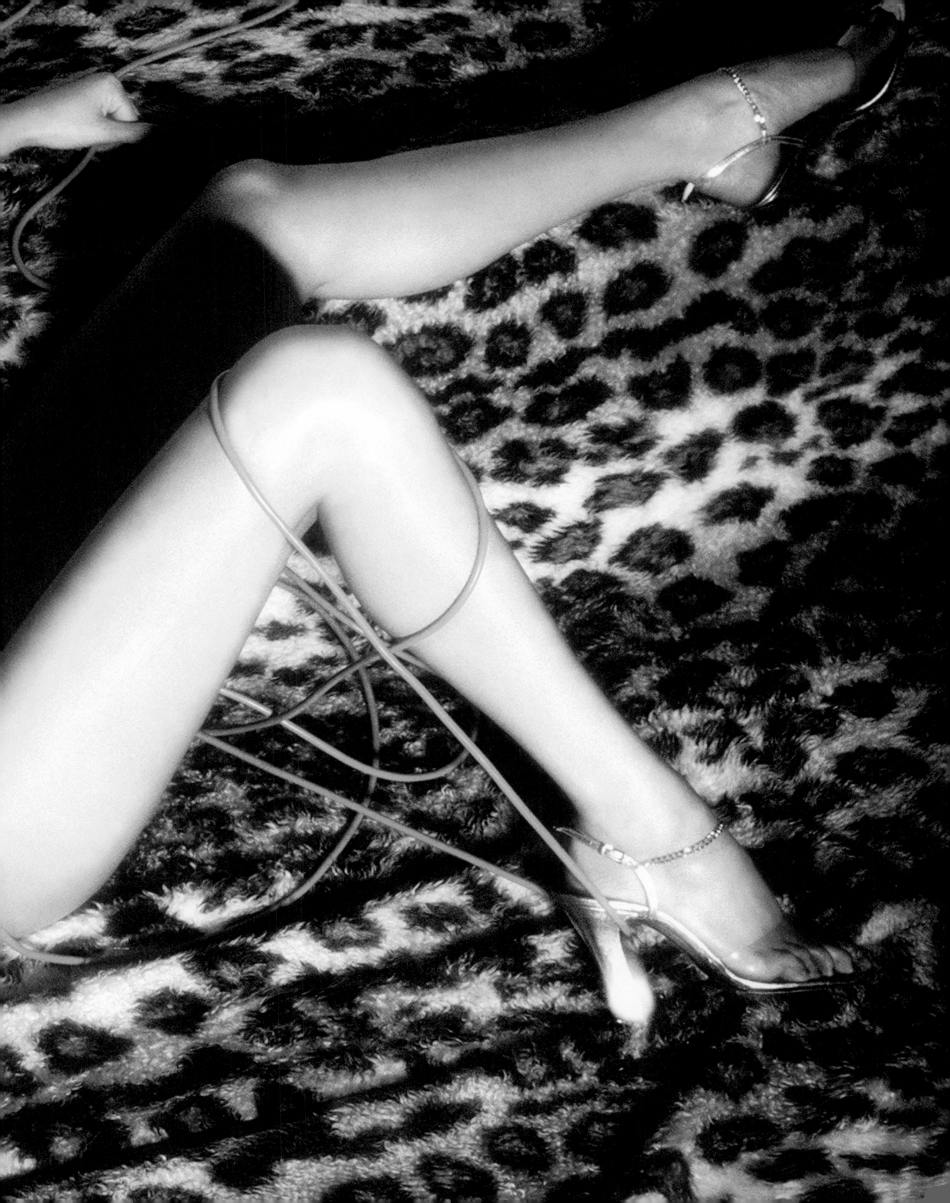

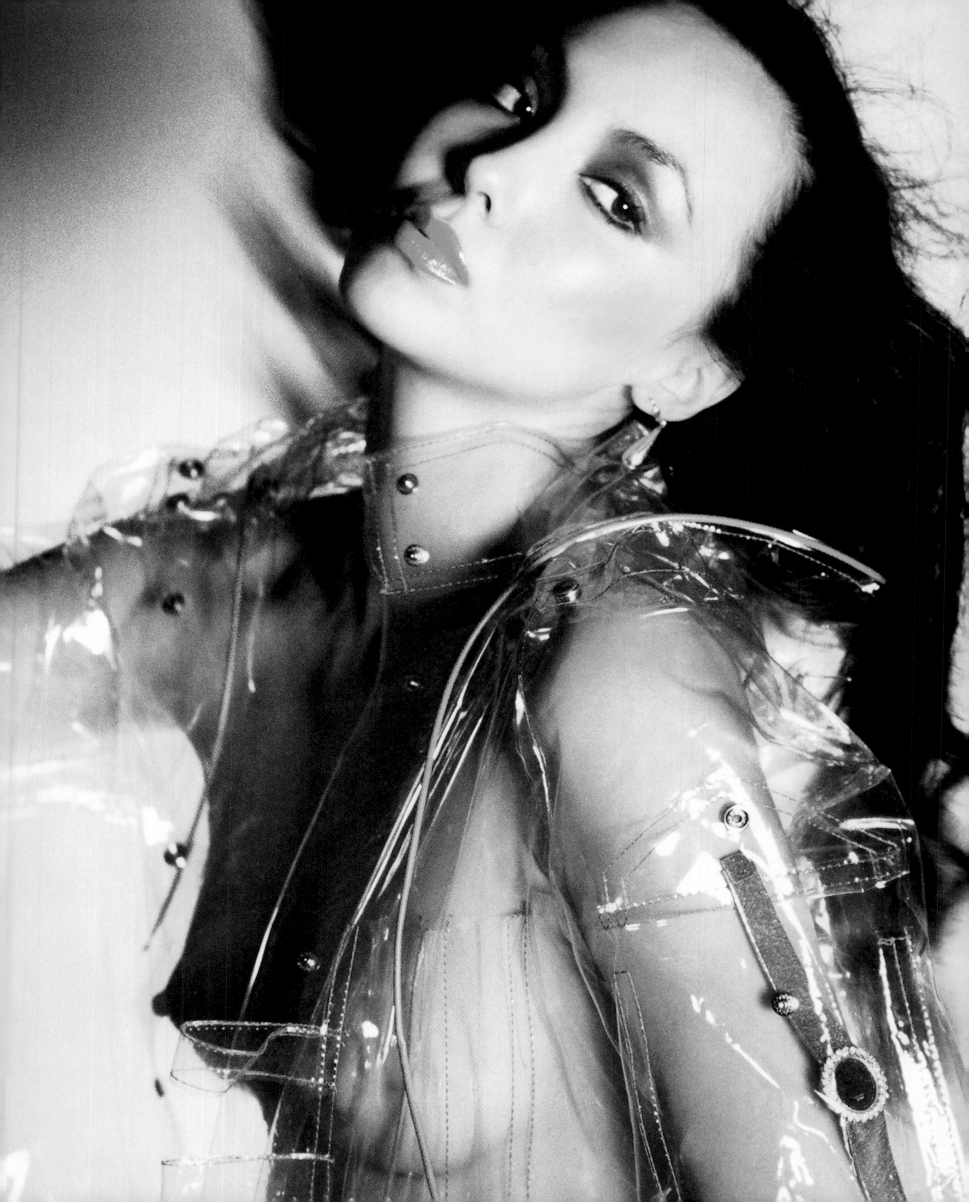

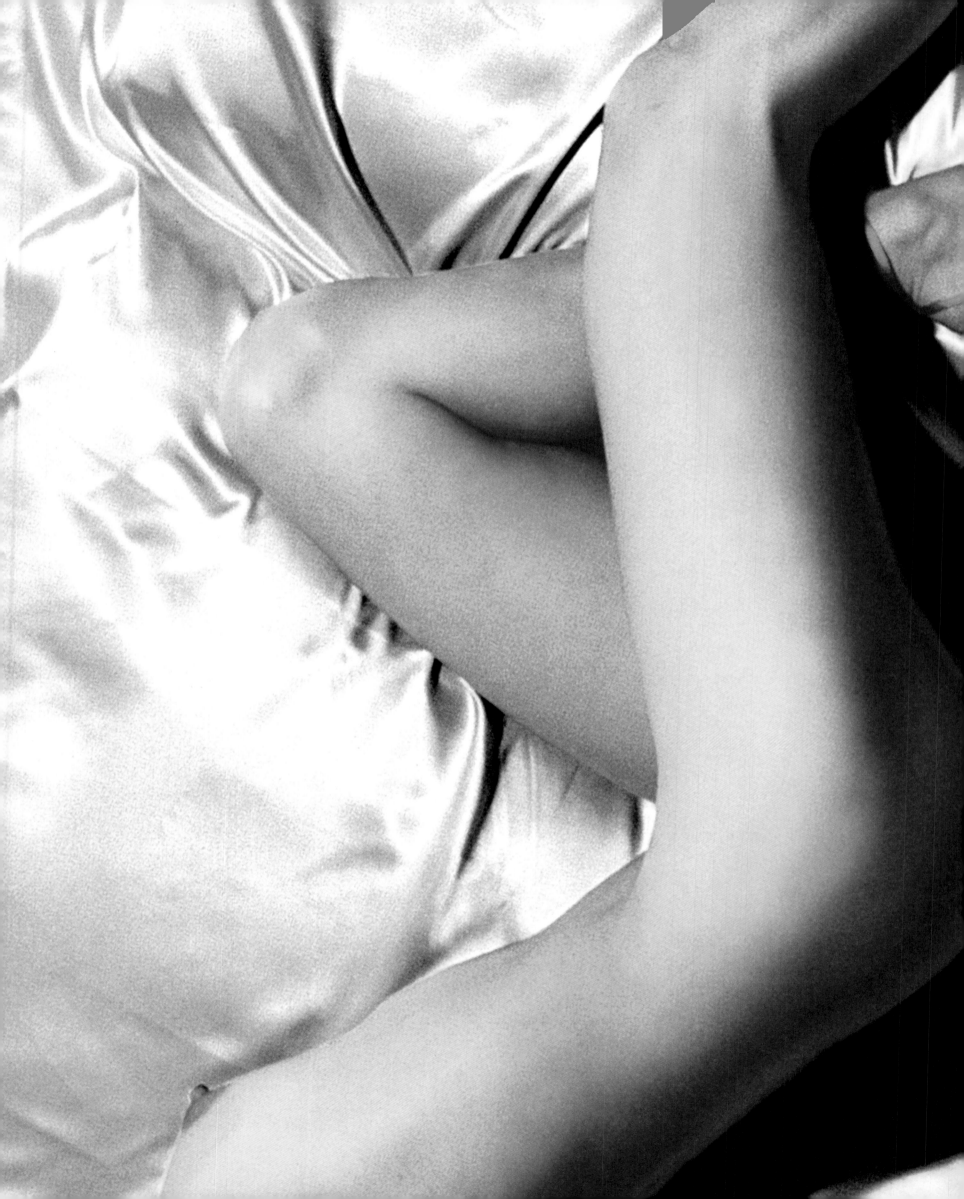

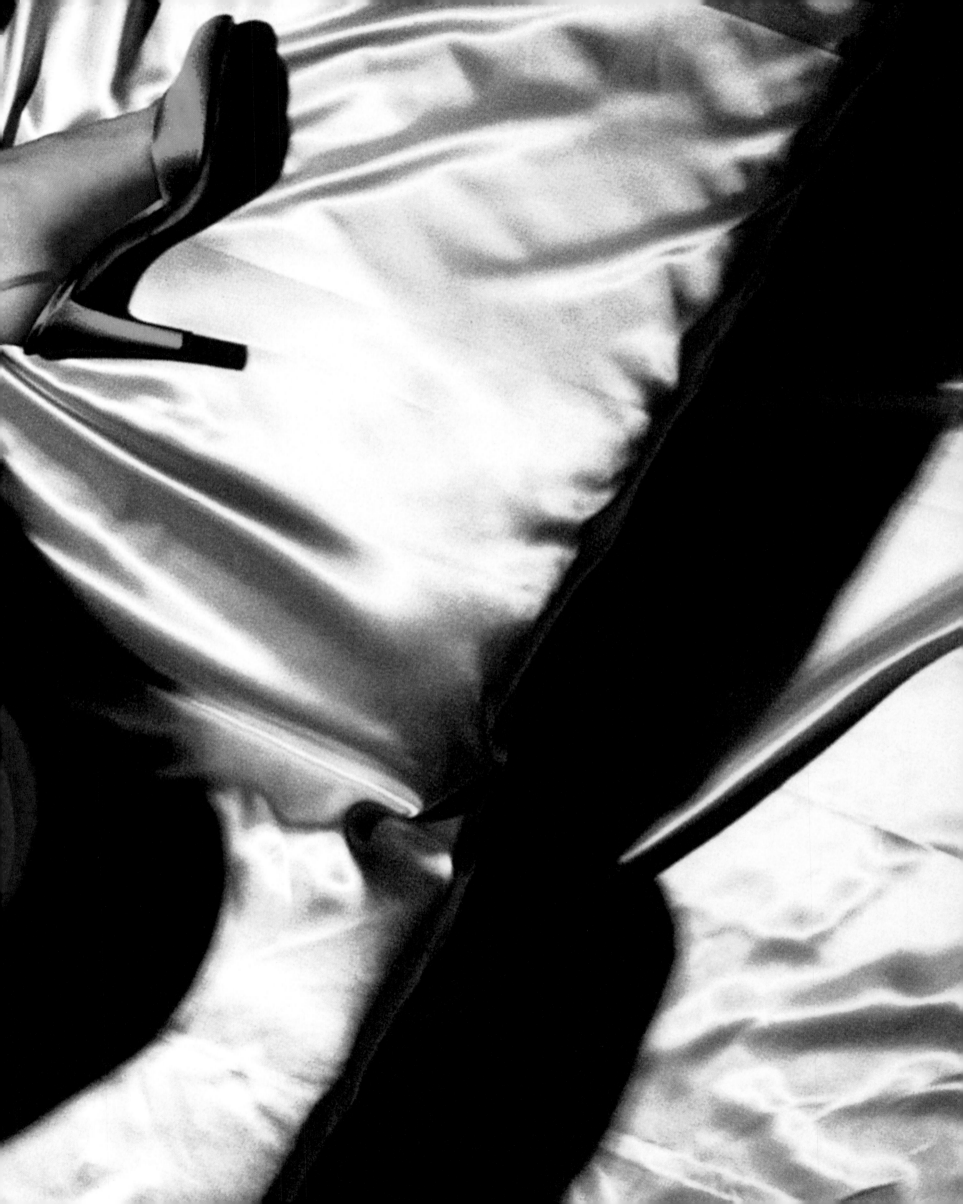

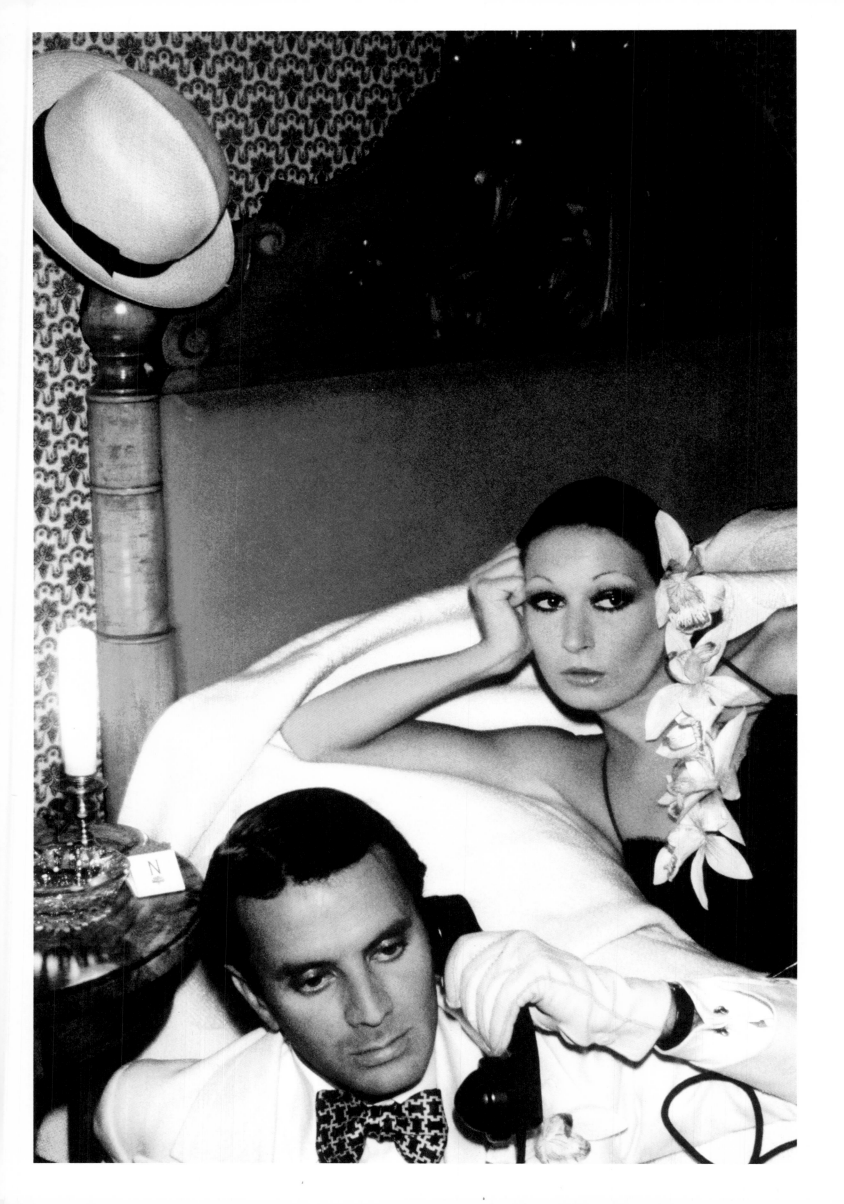

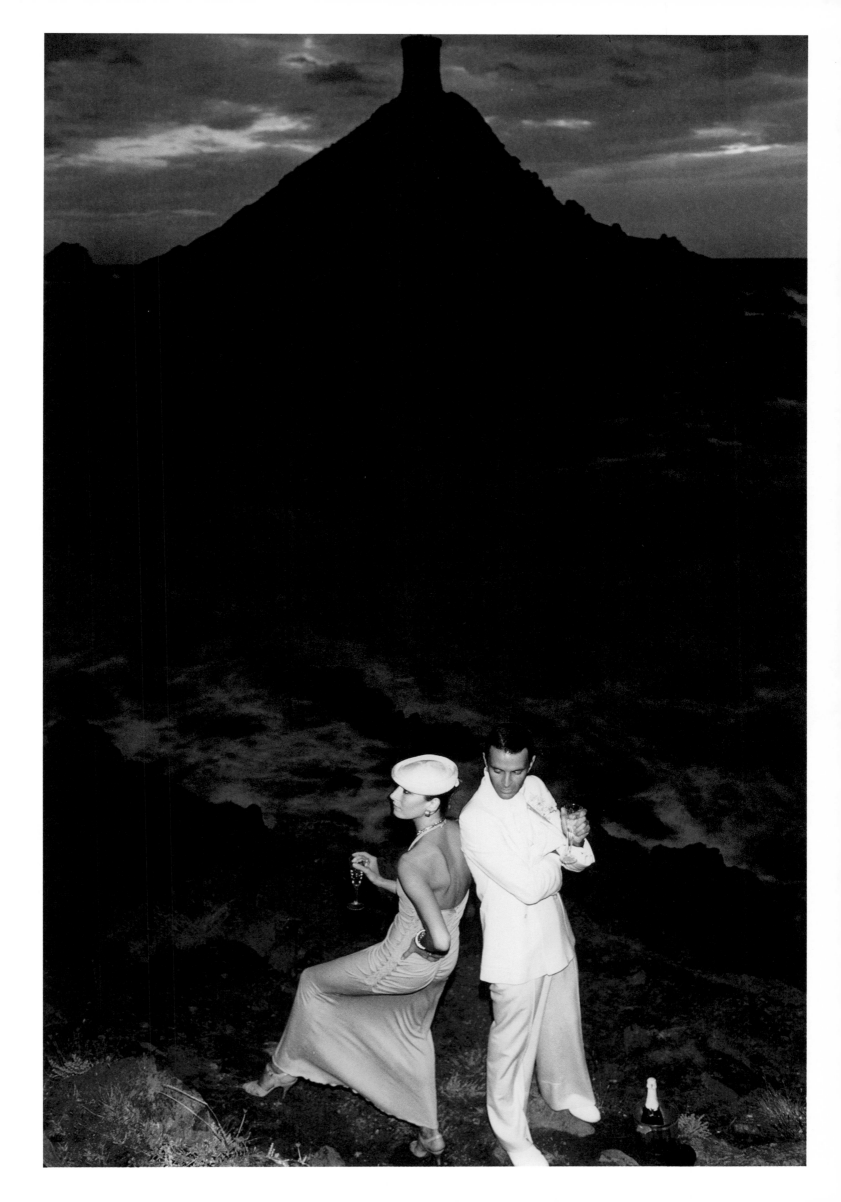

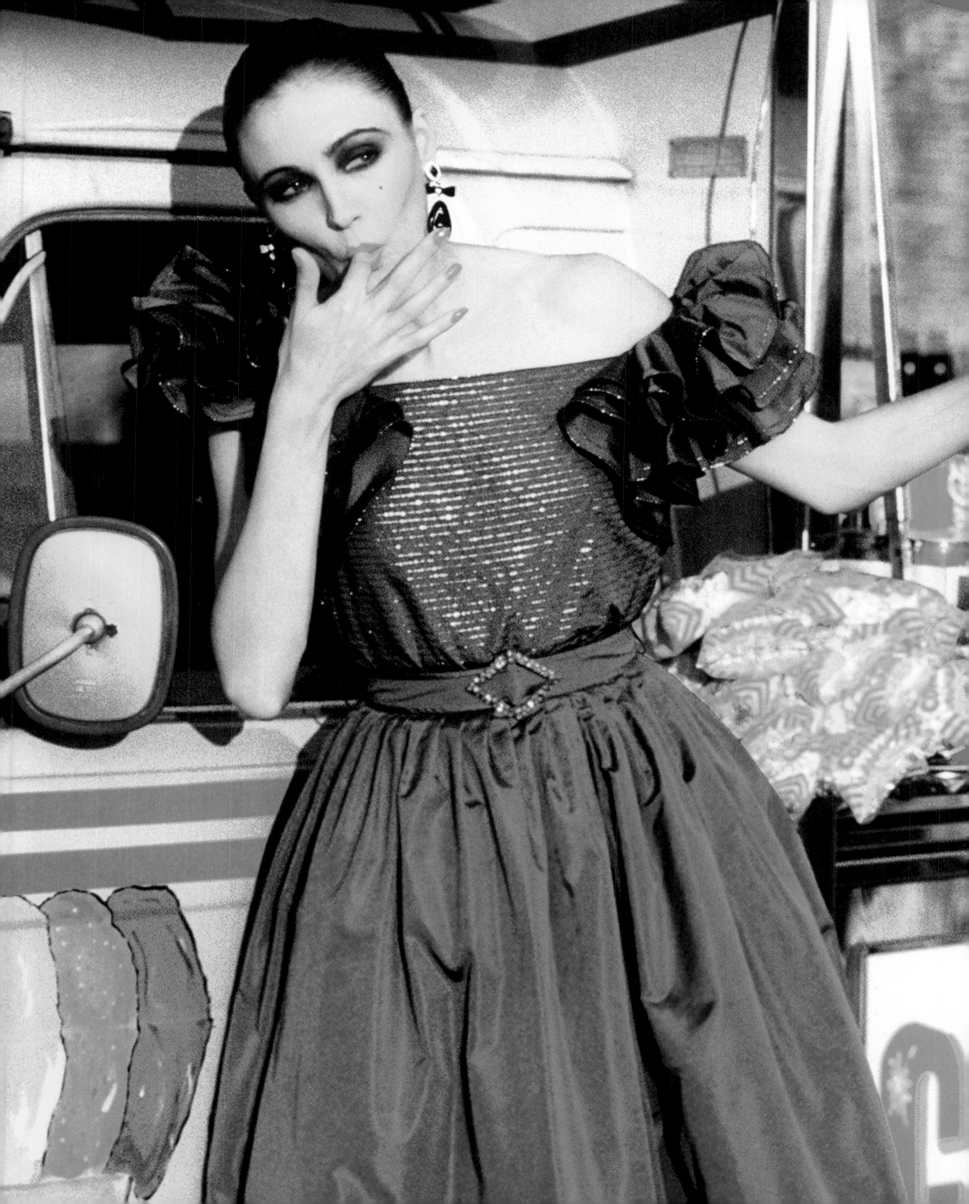

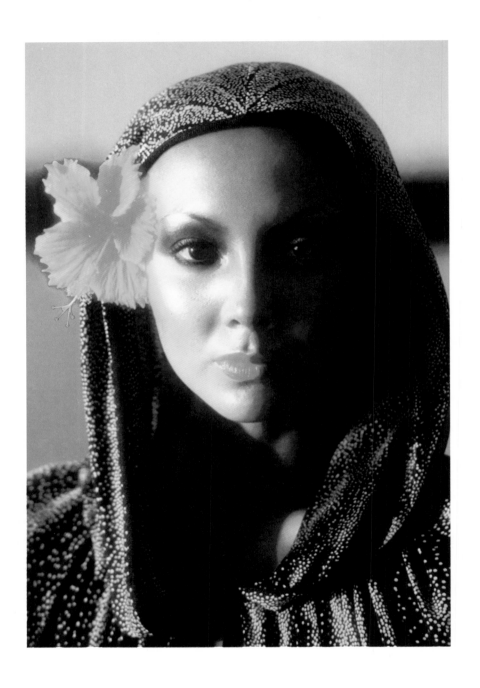

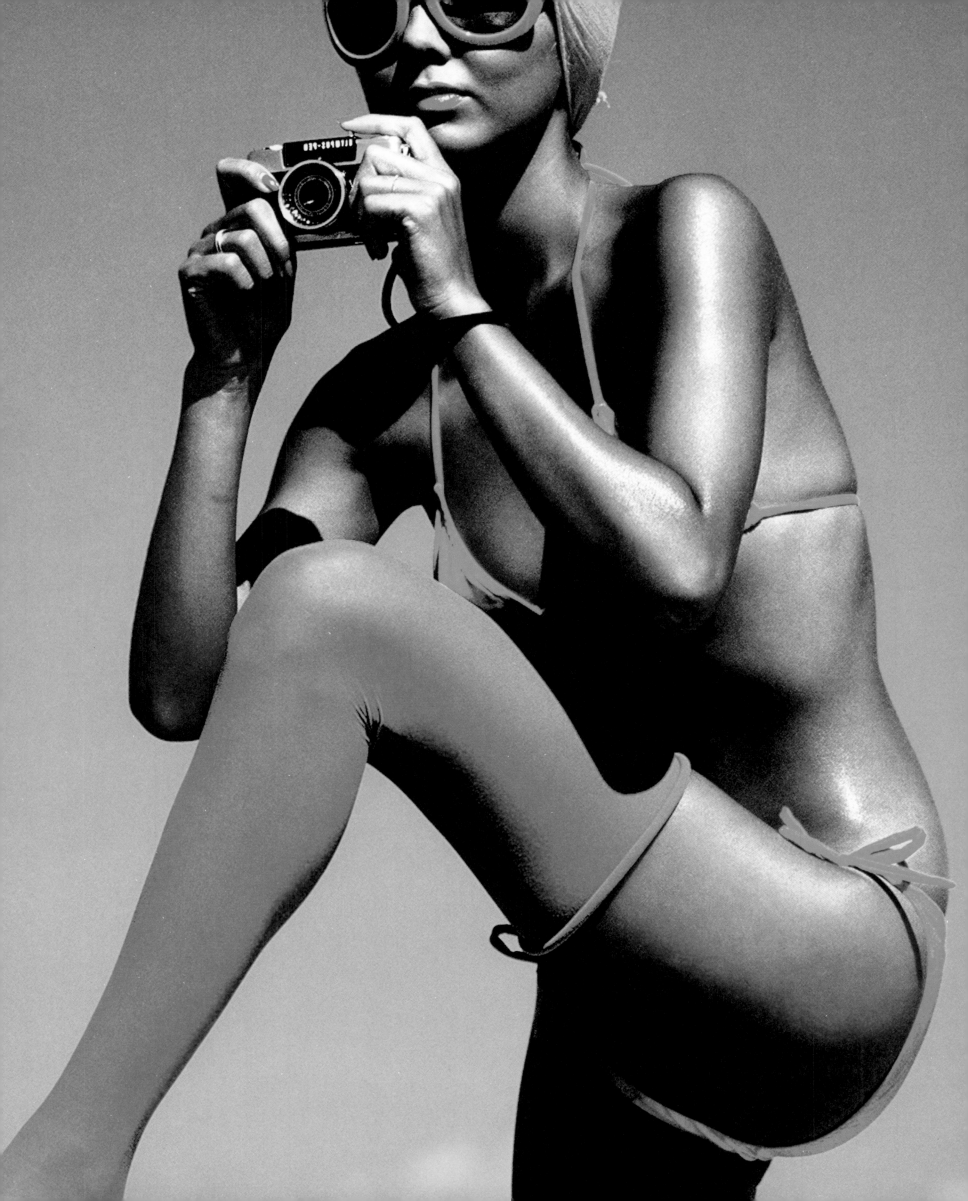

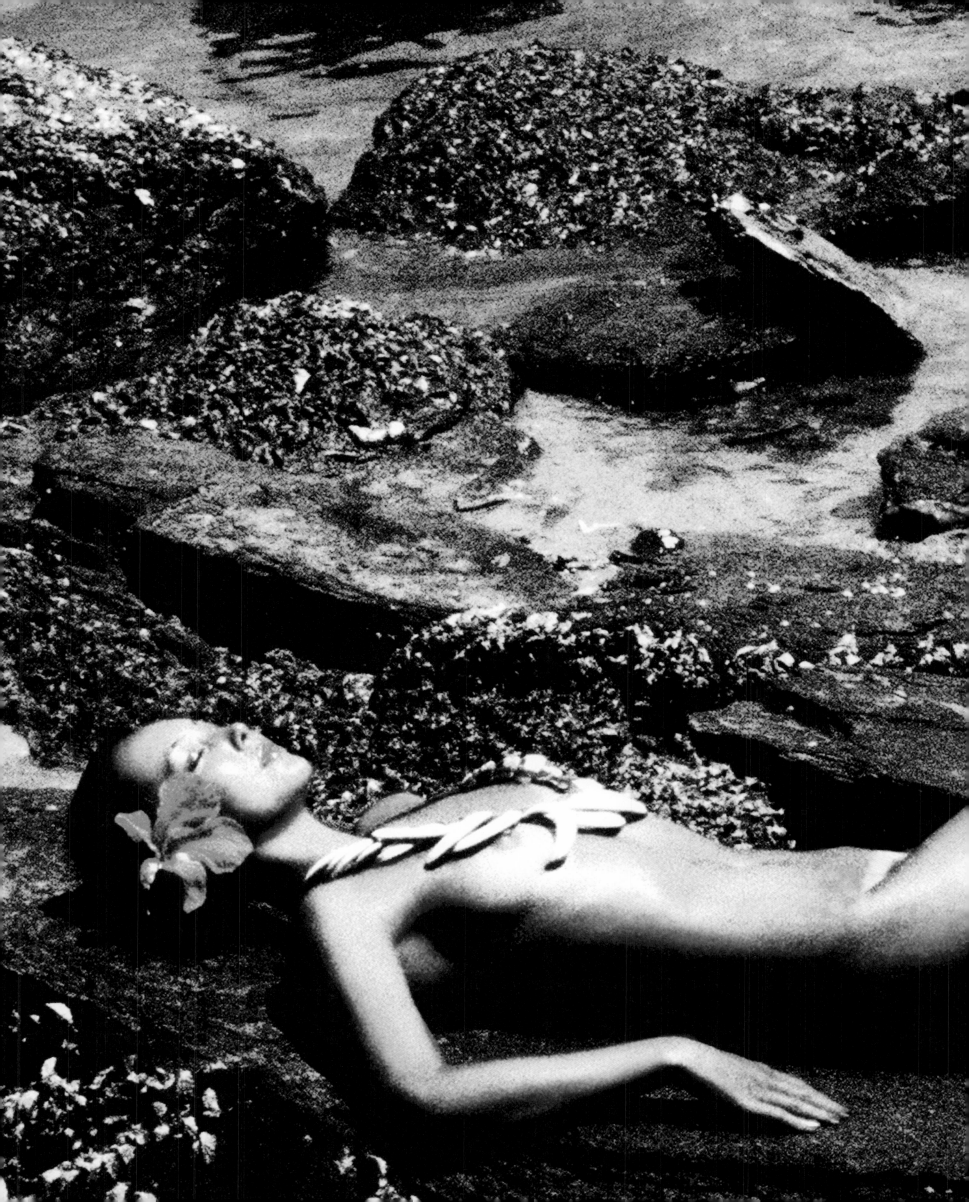

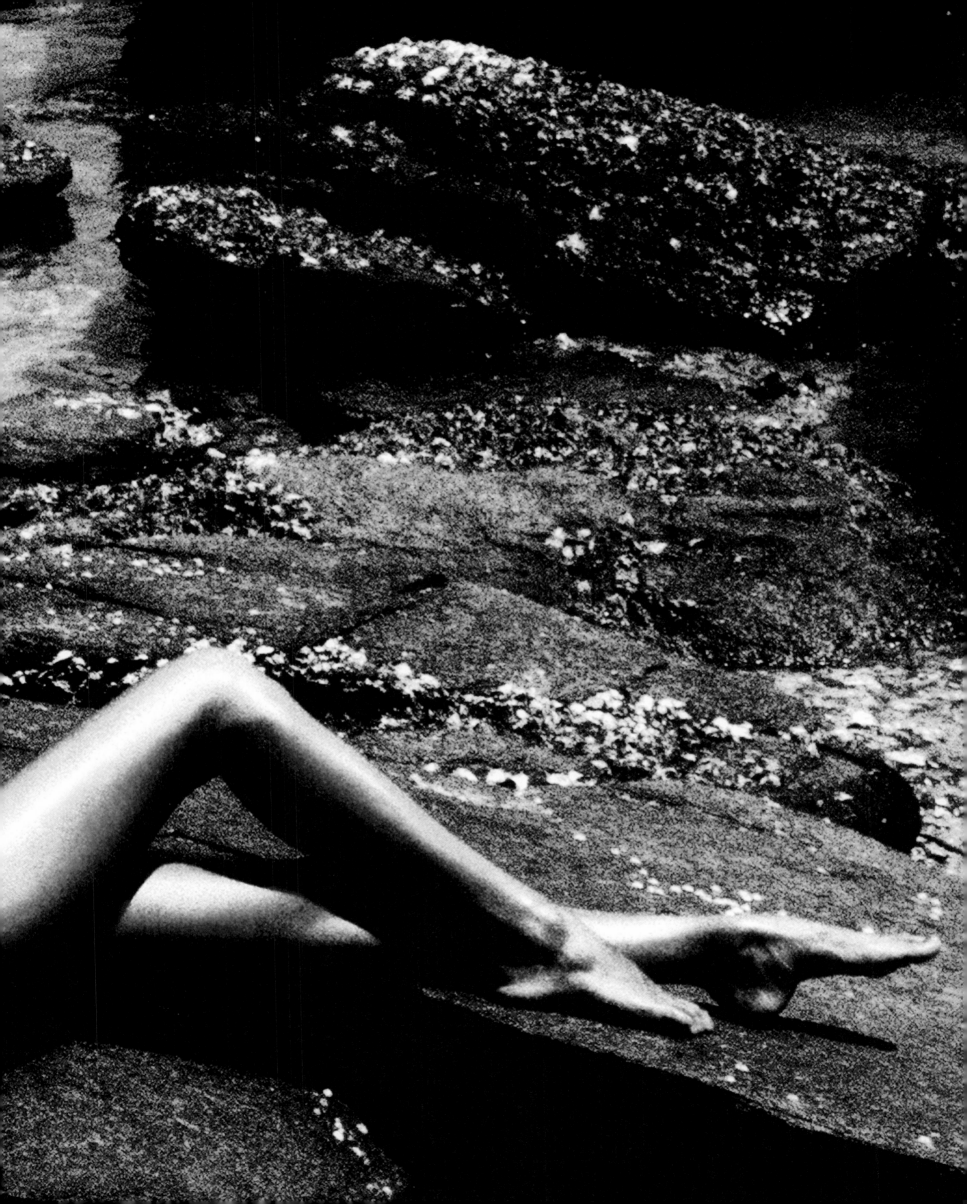

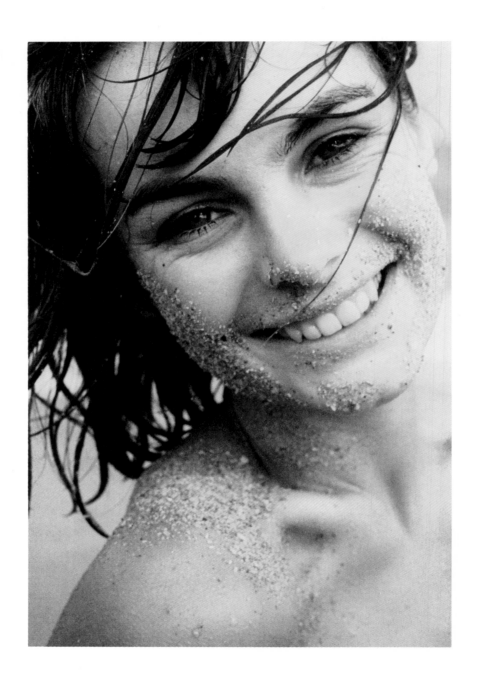

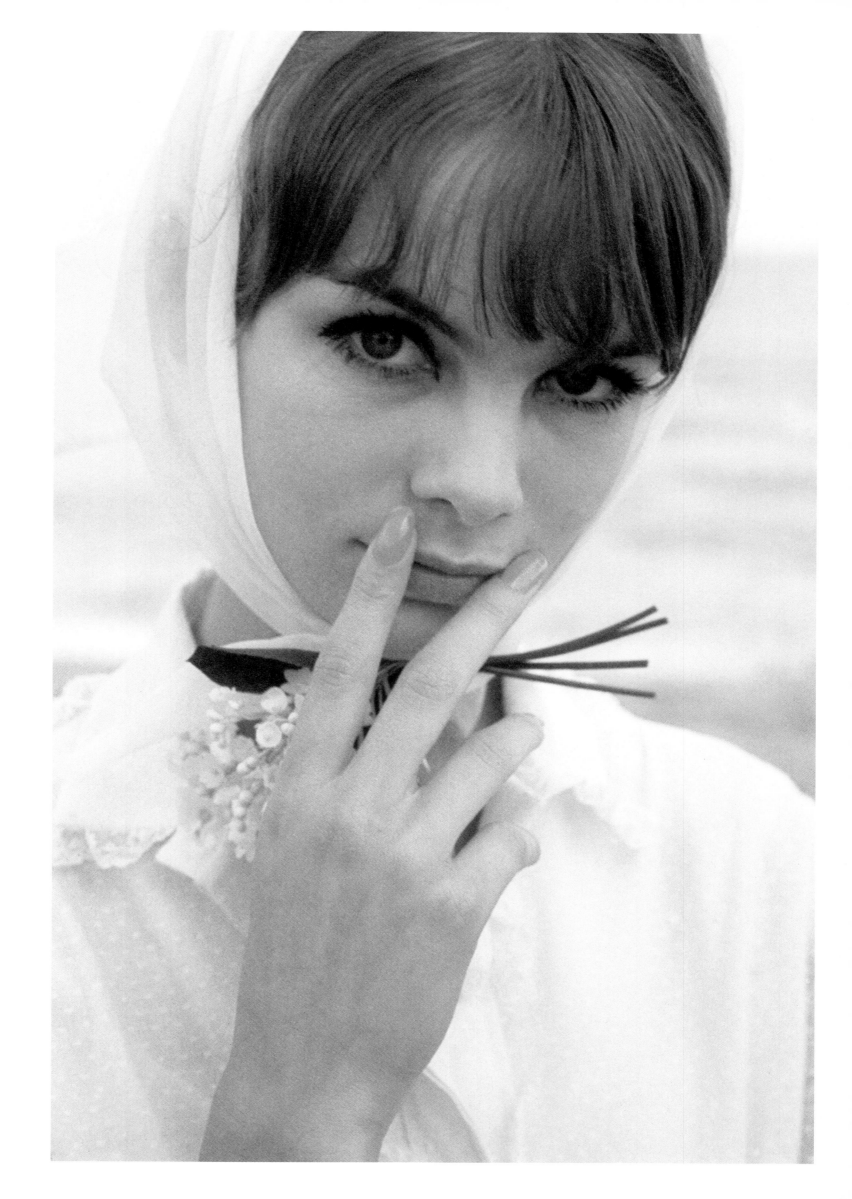

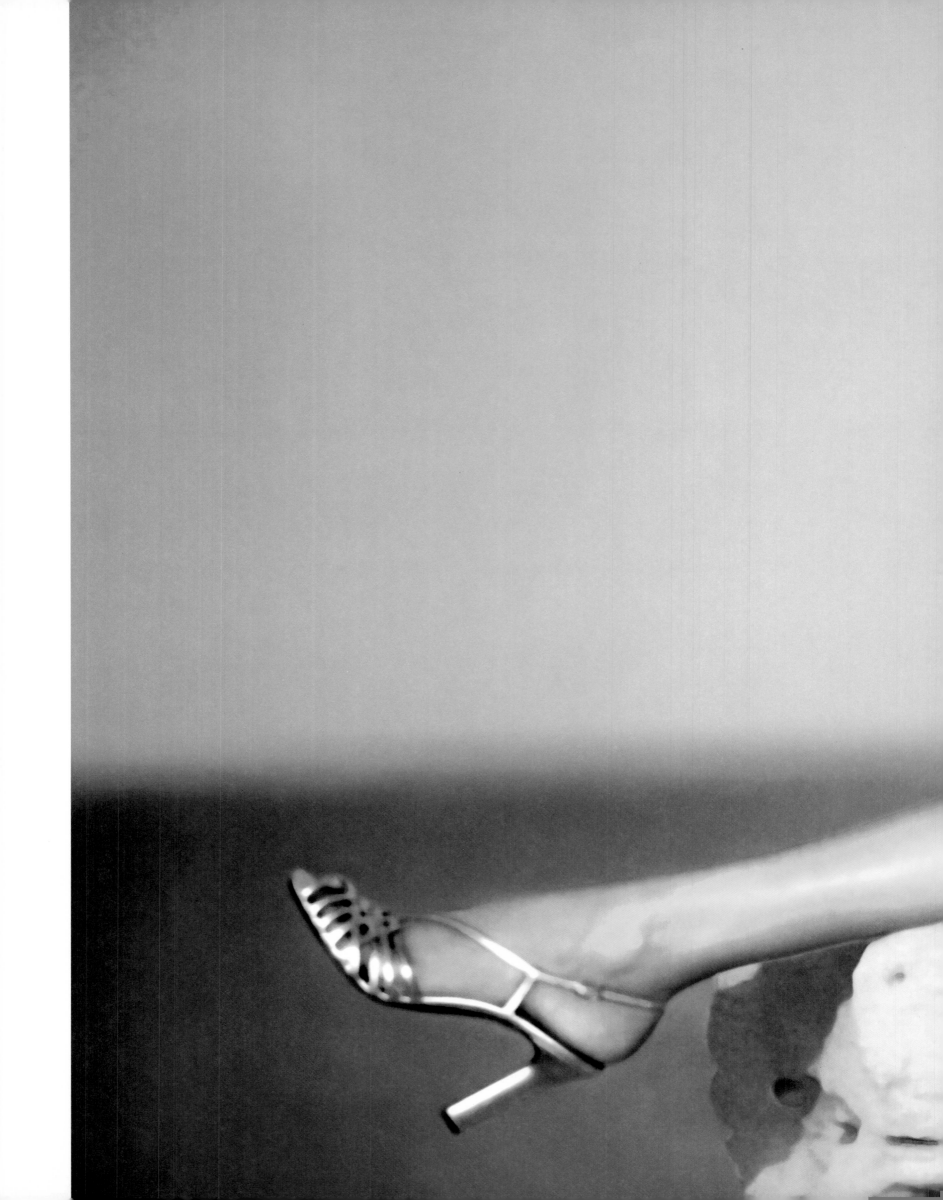

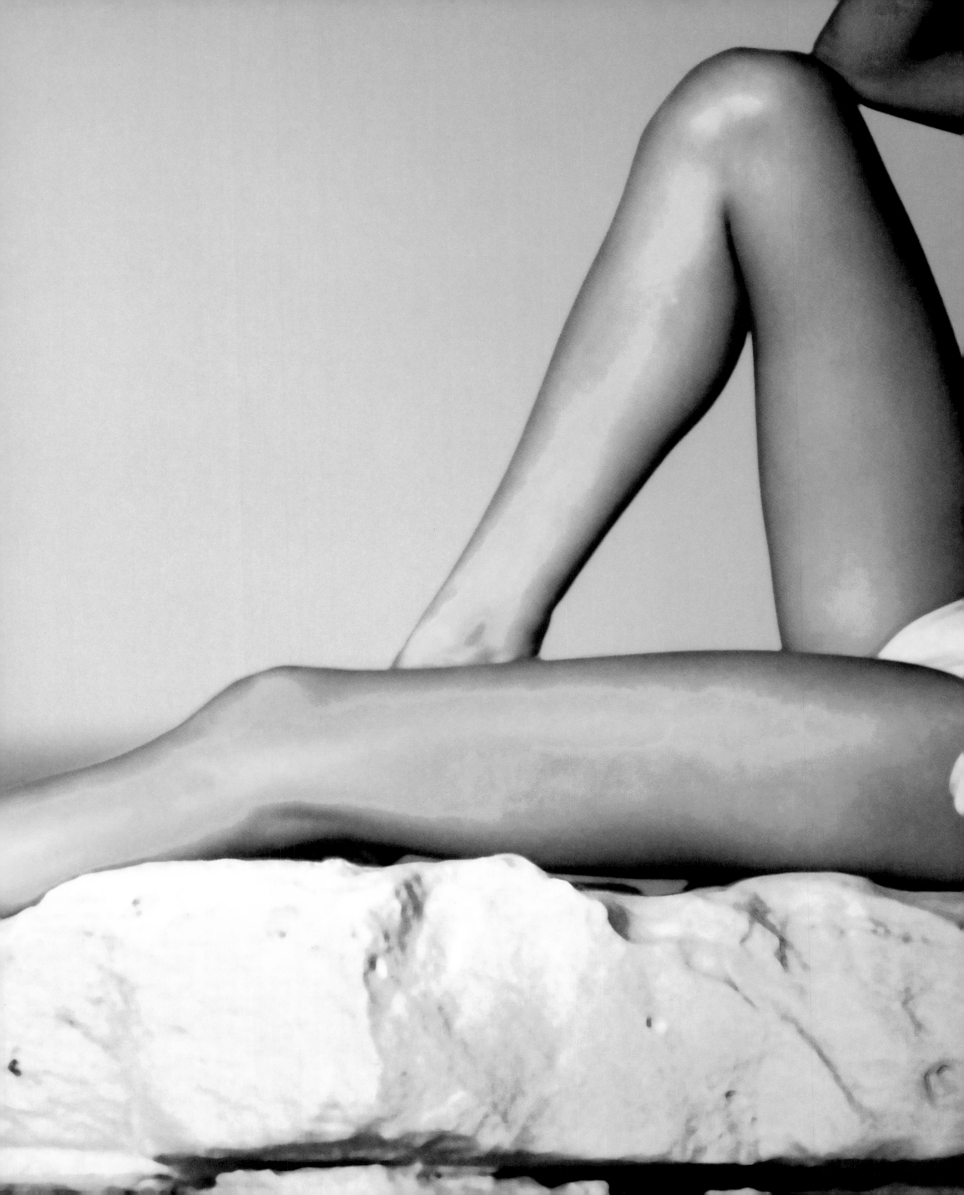

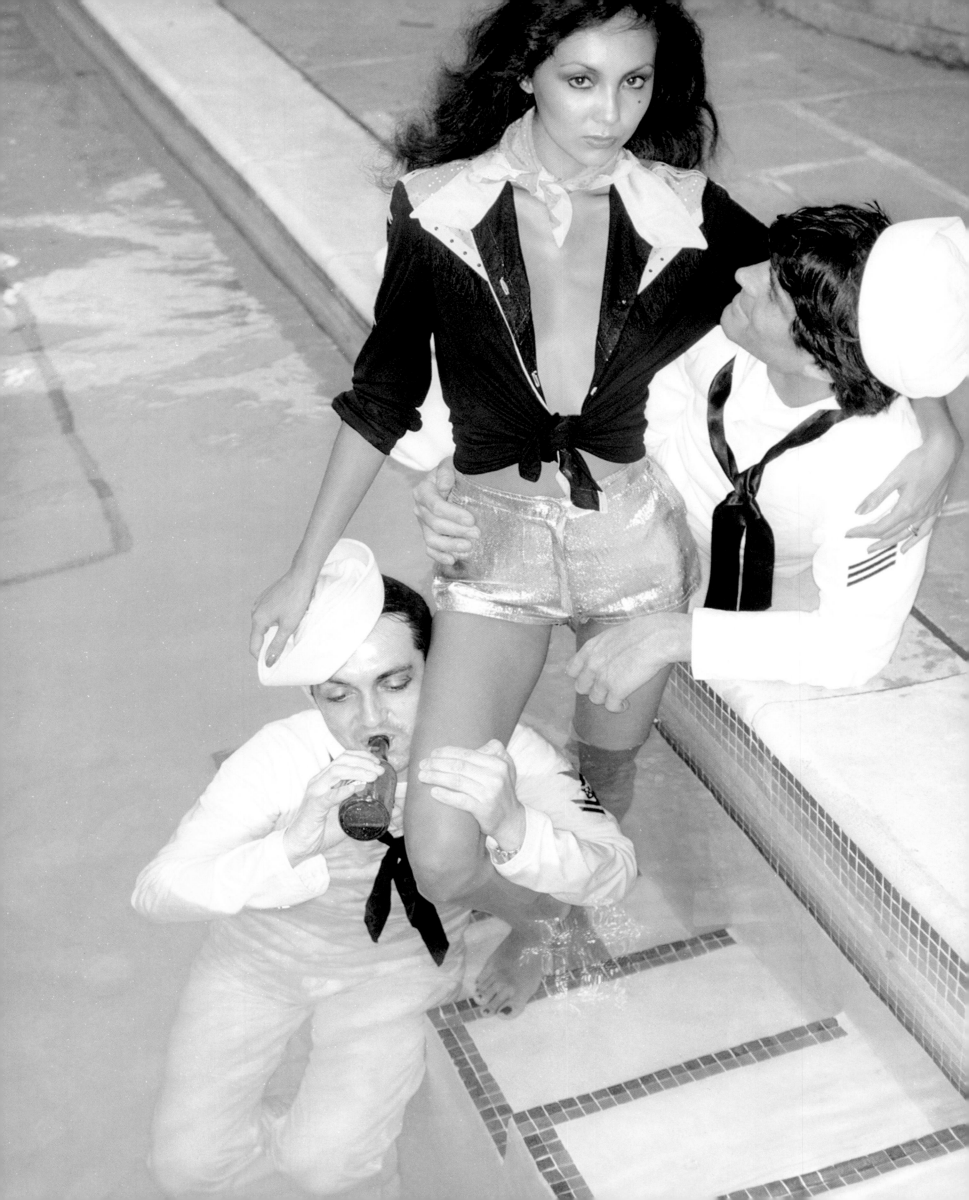

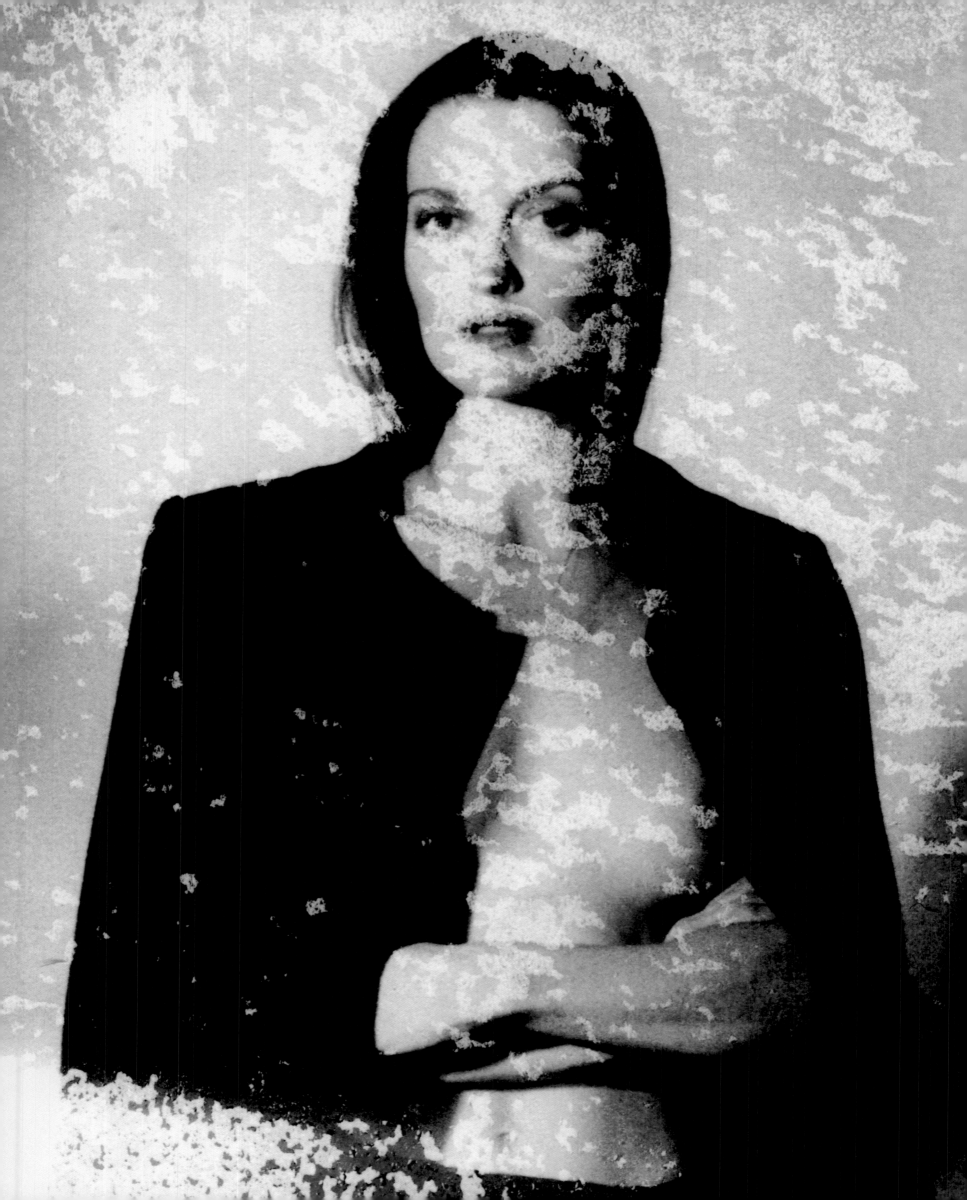

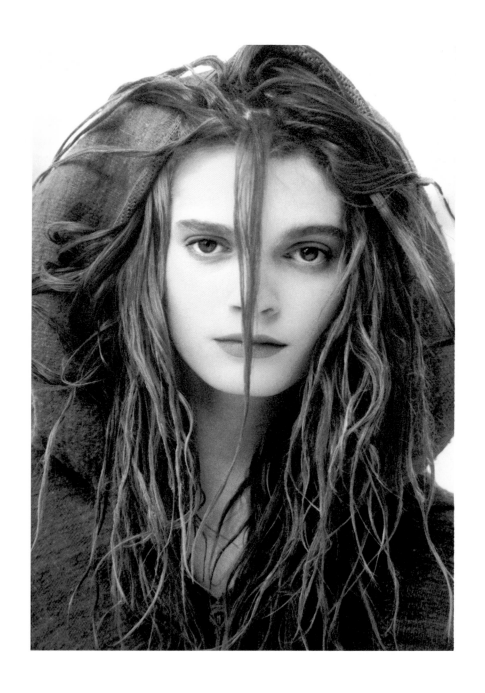

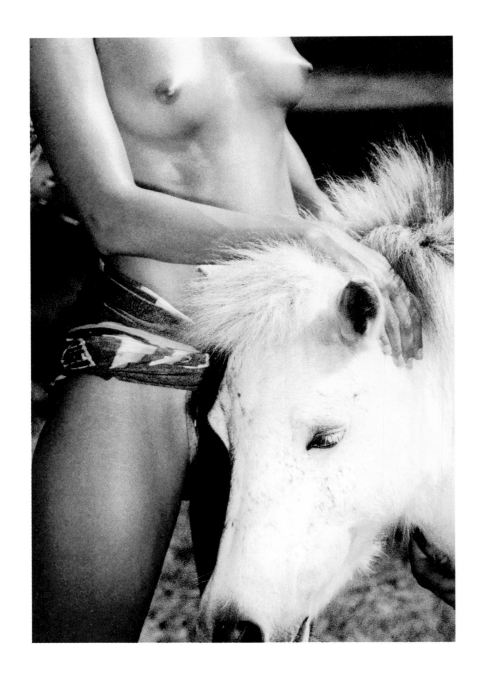

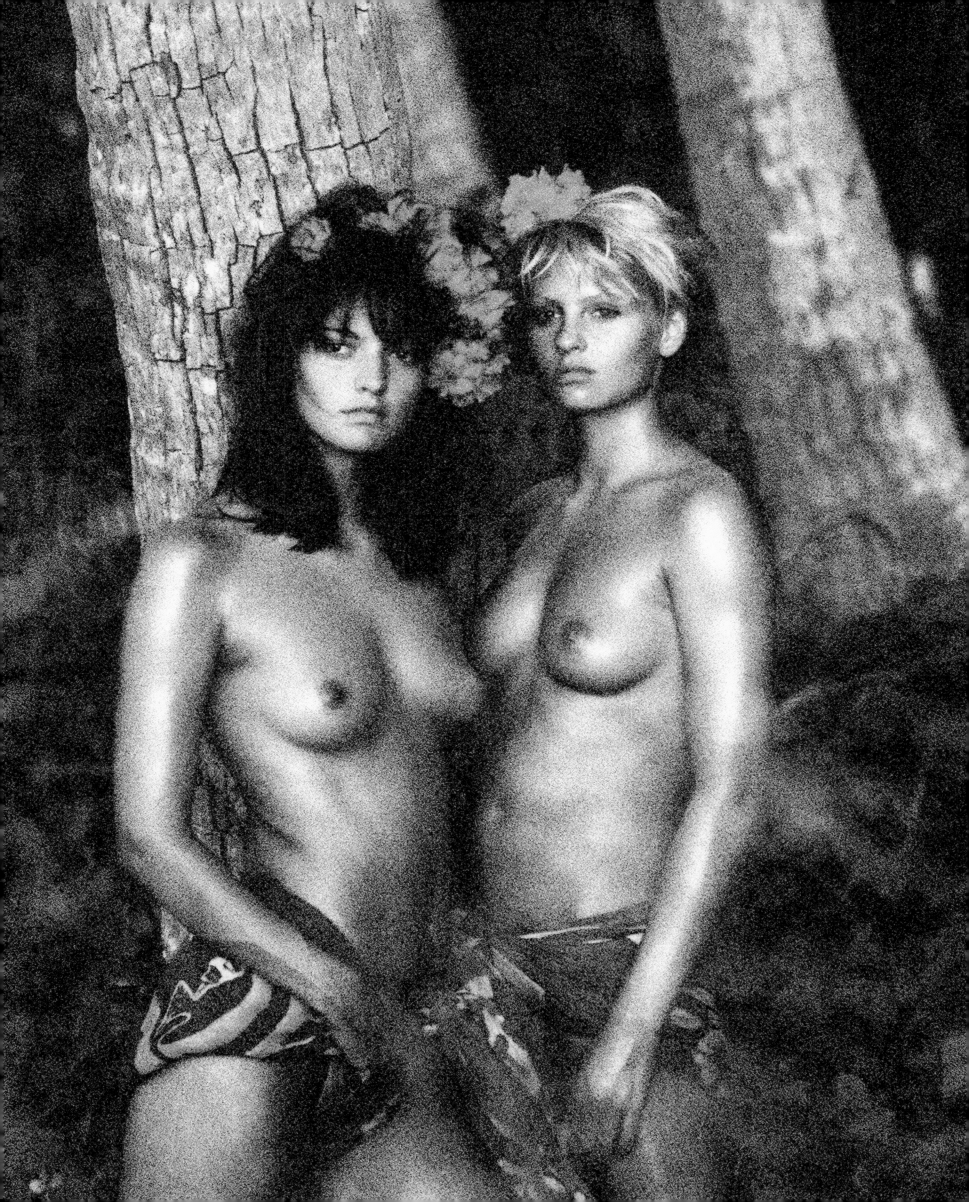

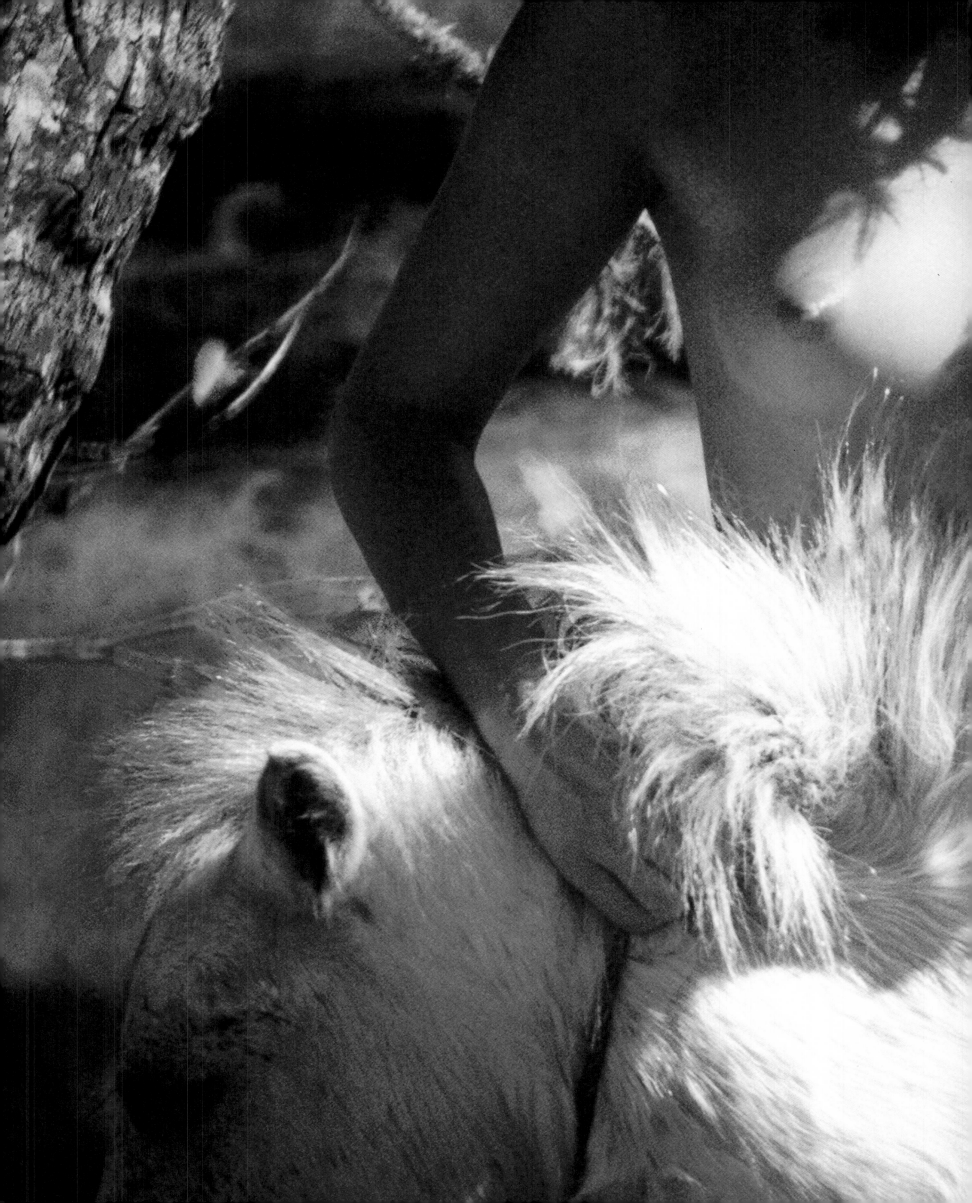

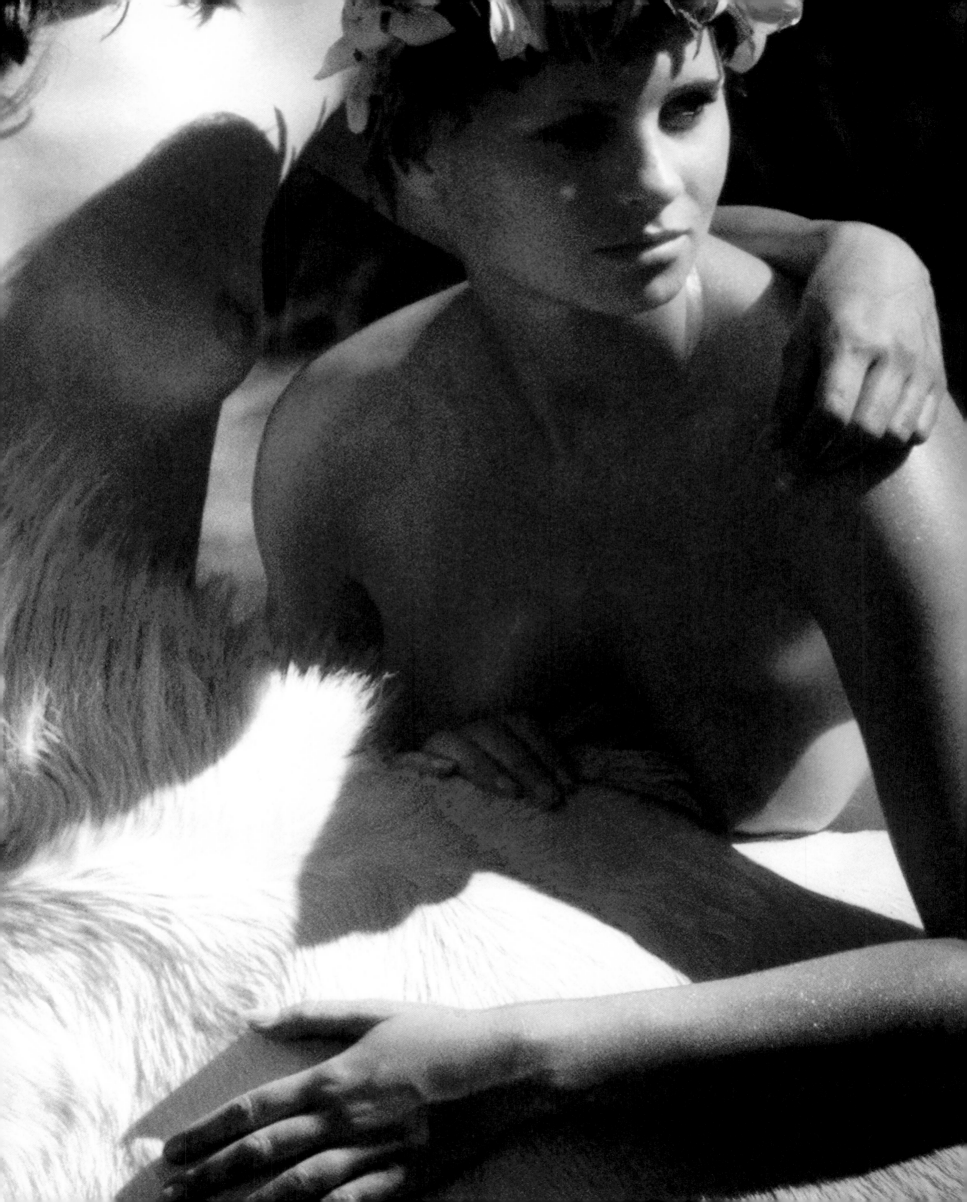

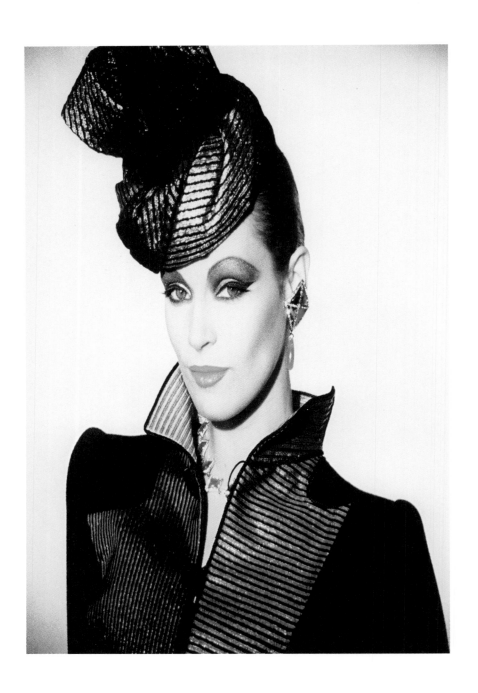

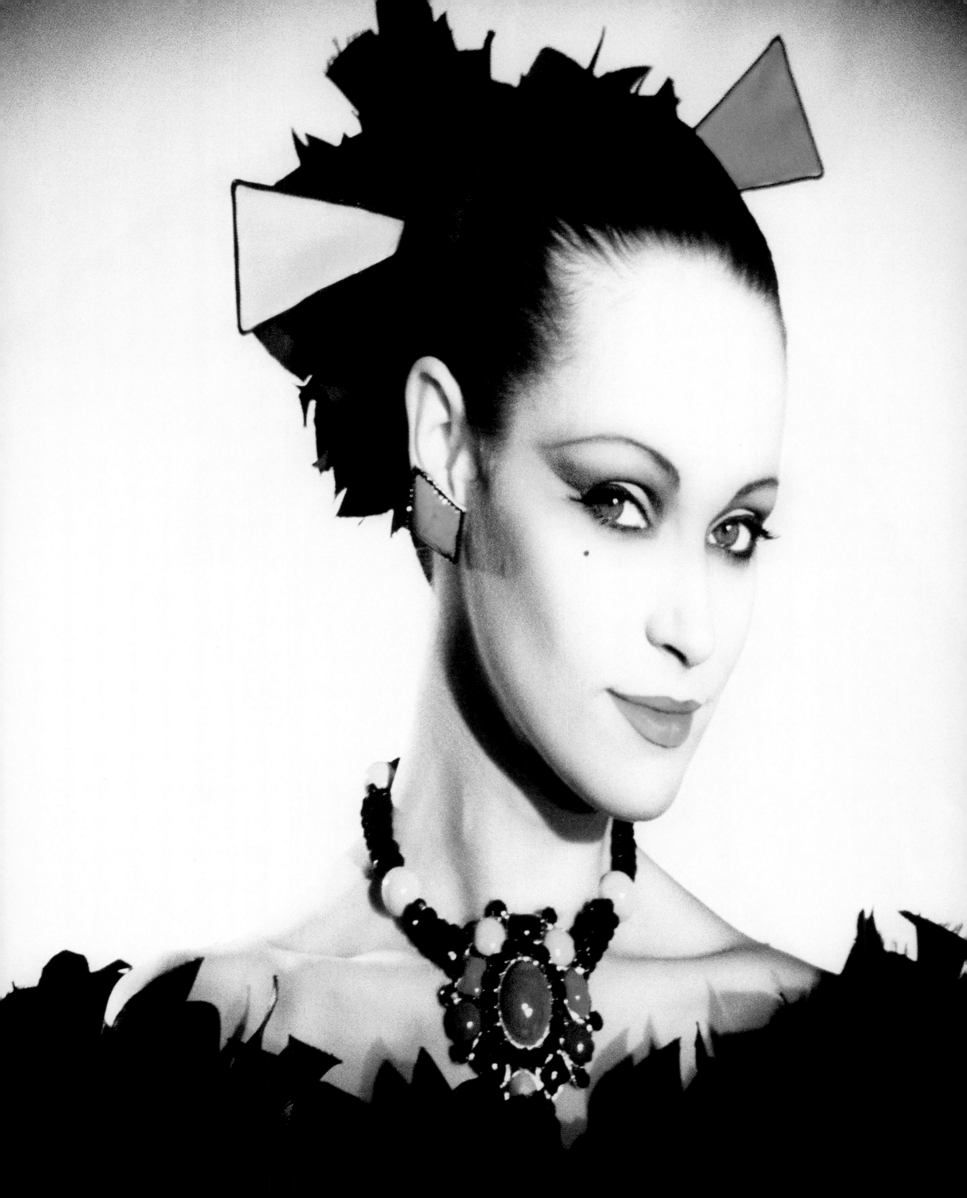

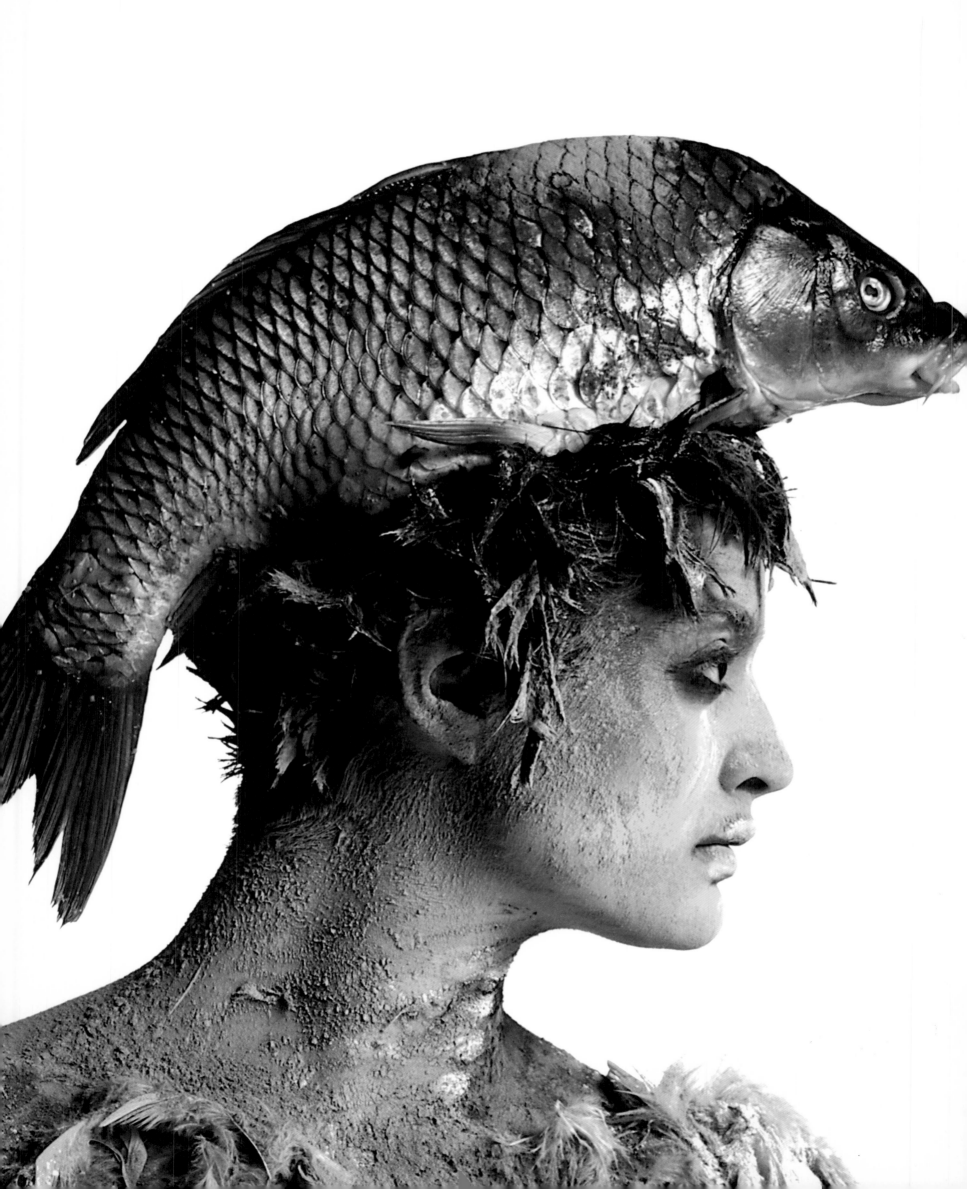

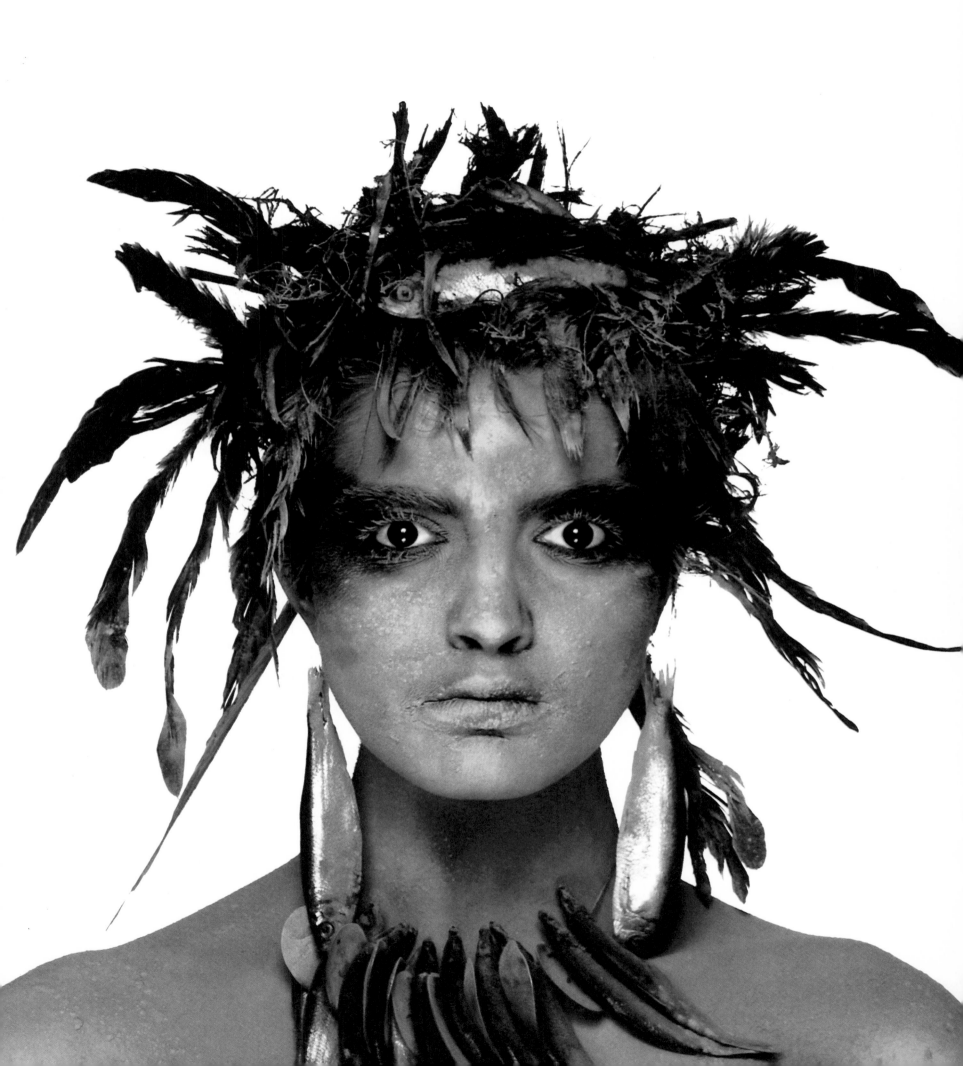

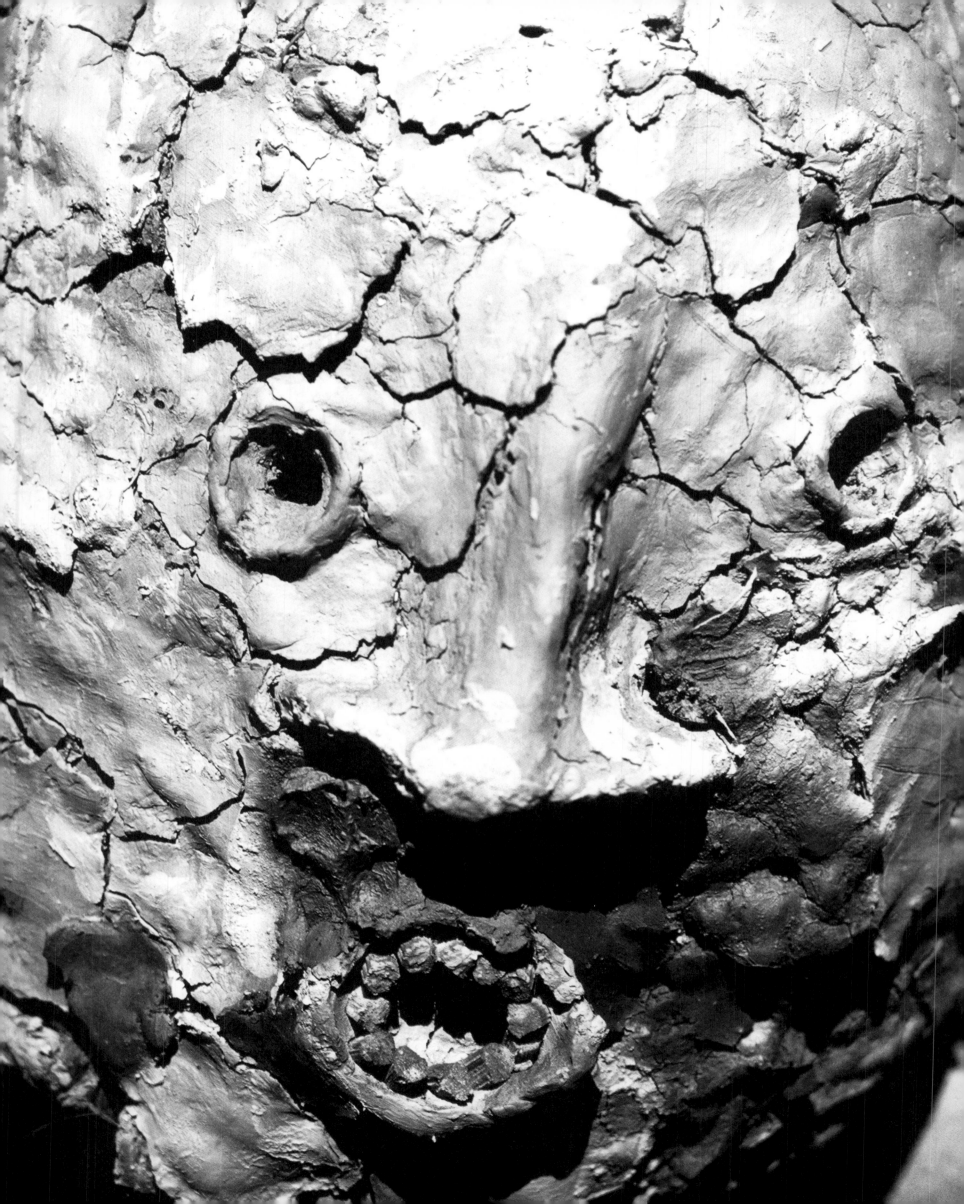

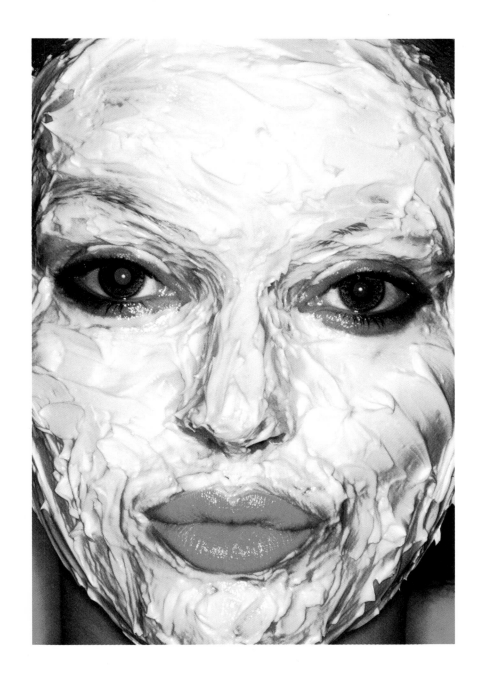

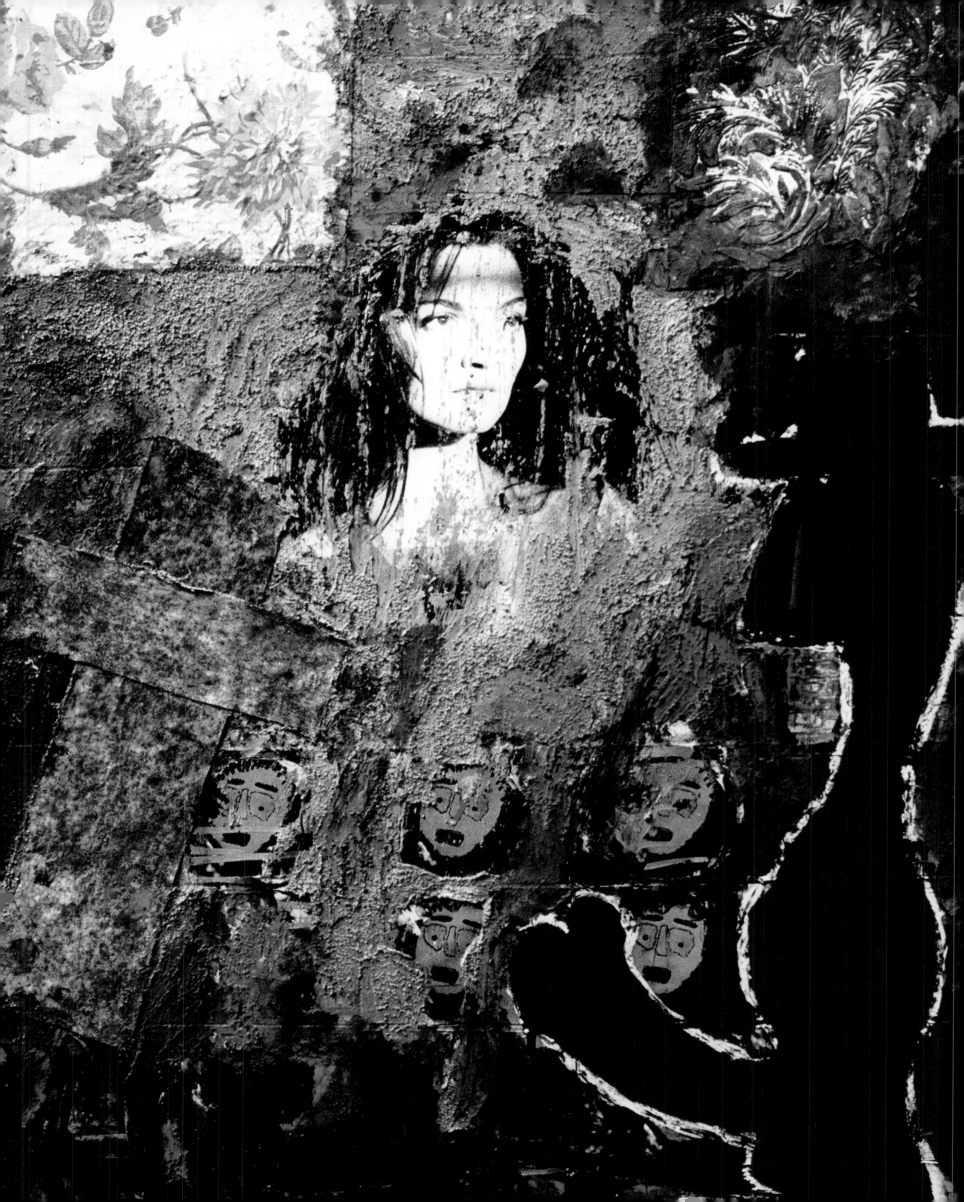

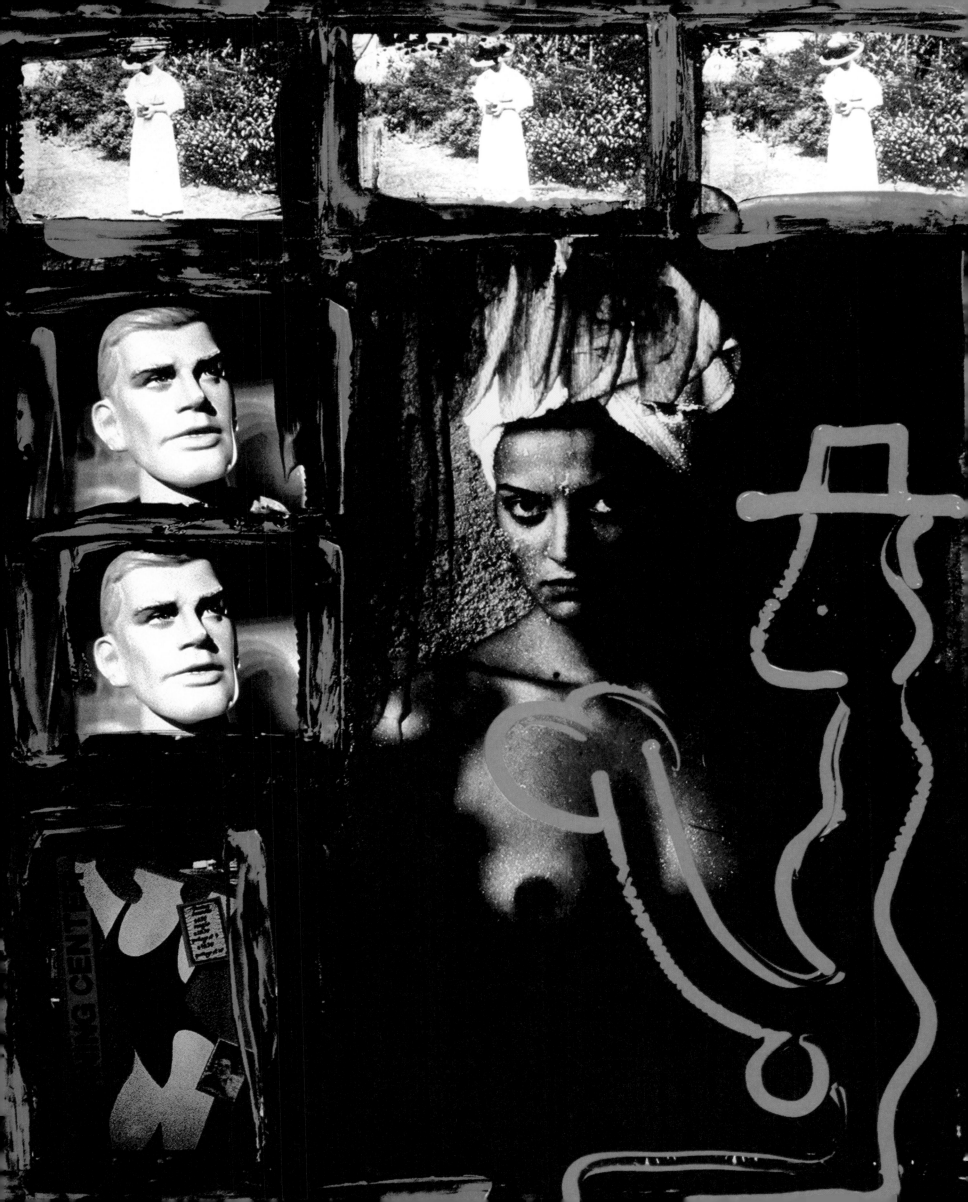

amouflage, disguise and artifice have often
enhanced Bailey's beauty photographs. But while
the fashion historian James Laver famously
wrote that 'The camera was an engine for
imposing a certain type of beauty,' the fires
have always been stoked by a variety of experts
in the field: editor-in-chief, fashion editor,
stylist's assistant, art director, beauty director,
even advertising director and publisher, all
of whom mount fierce guard over their own
pages or over the magazine's commercial
viability and potential. Such restraints might
suggest that the photographer is only an
adjunct to an agenda not particularly his own
– a mere translator into light and shadow of
a magazine's ambitions.

This is rarely the case with a Bailey sitting.
His hand is in each frame, his colleagues for
the most part willing conspirators. It is telling,
though, that so many of the images shown
here are unpublished variants. And it is even
more noteworthy that the variance is slight:
the magazine for the most part respected Bailey's
instinct. In the context of many of these
photographs, the most valued accomplice is
clearly the make-up artist. There is artifice in
virtually every photograph. But it is clear too
that the make-up artist is not necessarily an
enhancer but rather an agent of deconstruction,
a concealer, a fabricator of dreams.

Masks have long fascinated Bailey. The most
extreme manifestations of this are the scratched
and burnt-out compositions found in his book

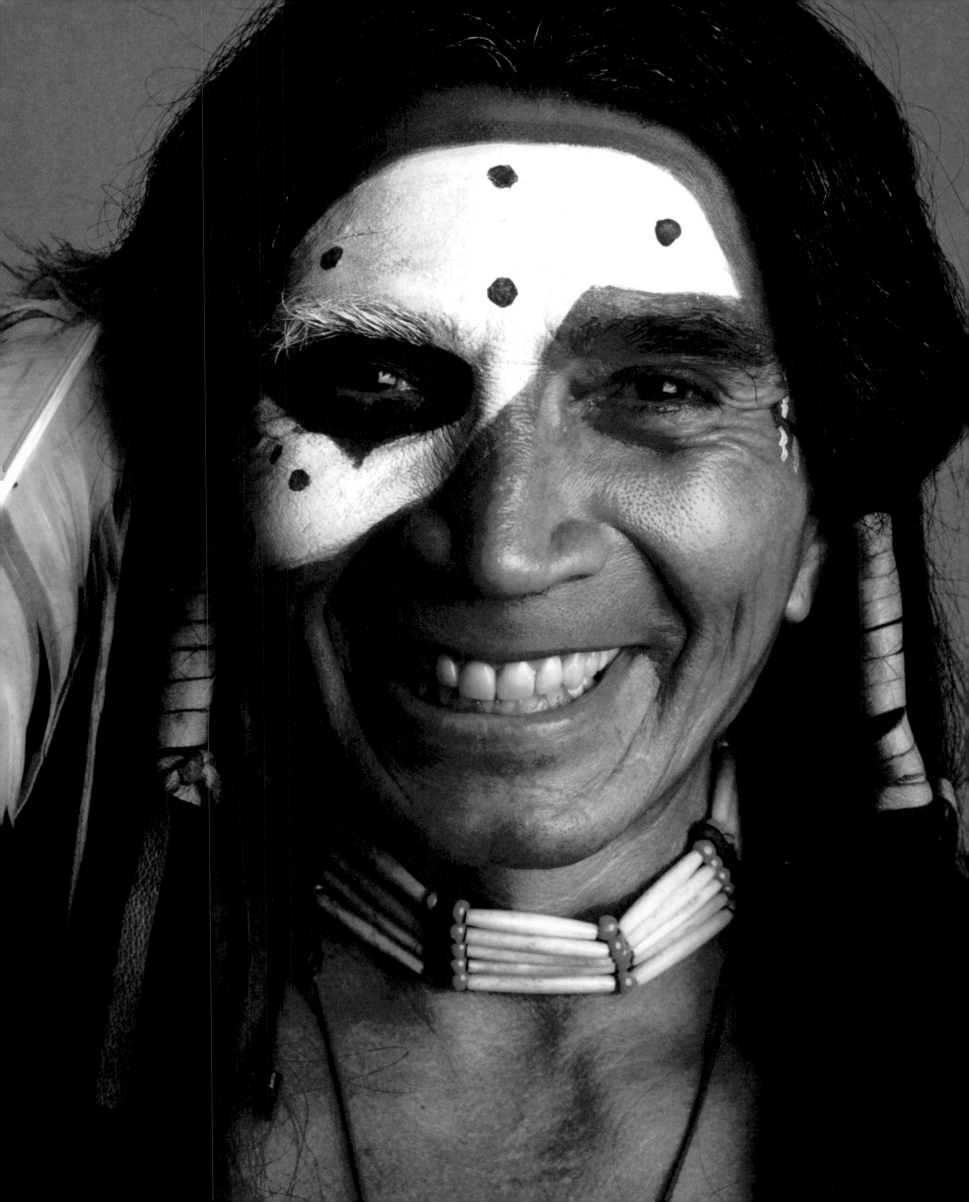

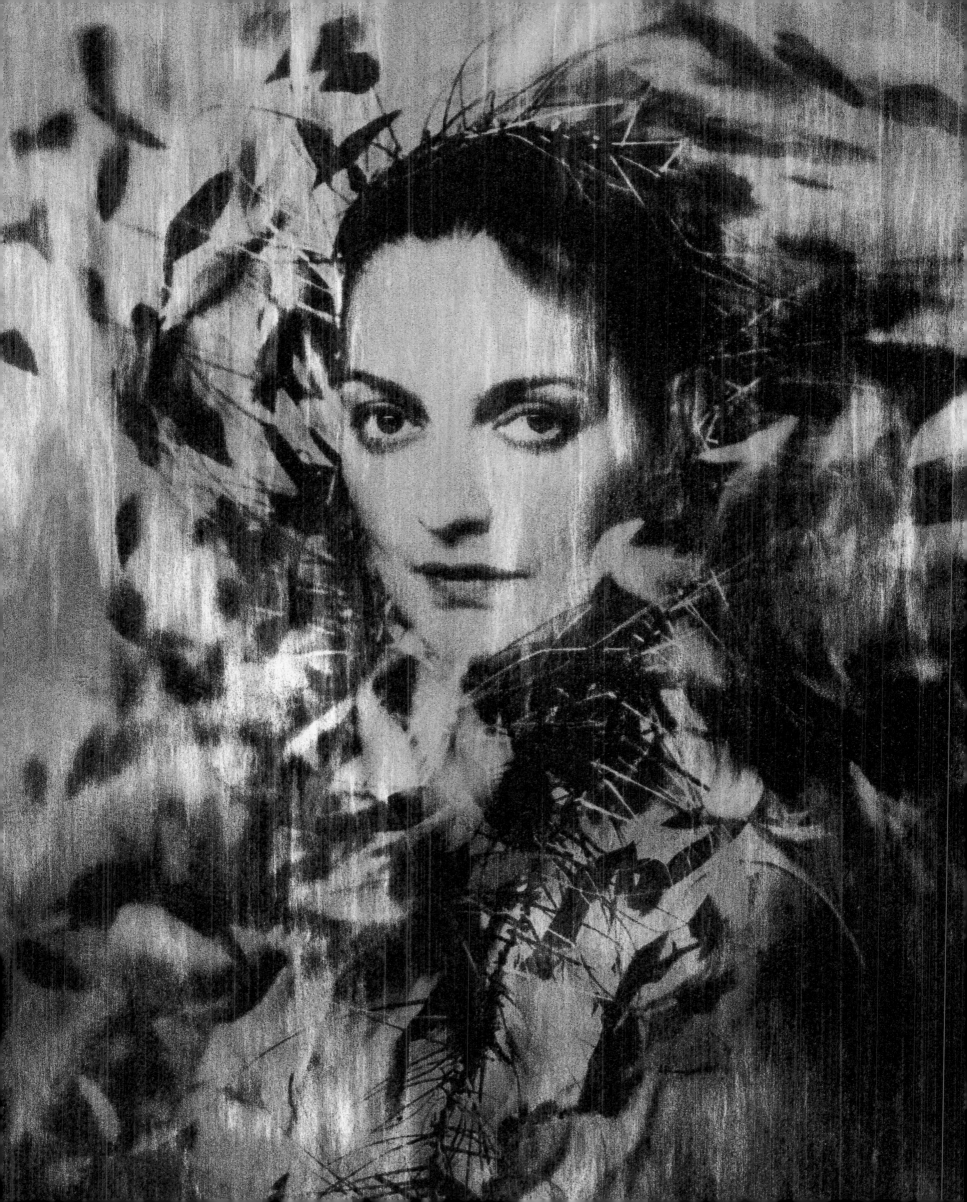

*Nudes 1980–1984*. Less brutally employed in the context of magazine work, the mask is still a device to disconcert – as in his pictorial series of ice hockey masks for *Scene* magazine – or to suggest gender subversion by playful *trompe l'oeil*, as the series of carnival masks for Italian *Vogue* show: here the make-up is applied to the mask not the bearer of it. Perhaps most all-concealing for Bailey, a collector of ethnographic artefacts, are the masks of the Asaro mud men, redolent of camouflage proper and of war paint, but with an odd fragility too, like Picasso ceramics. So a Bailey beauty photograph has also taken in anthropological portraits, from the Asaro mud men to Javanese dancers and the tribespeople of Papua New Guinea, the subject of his book *Another Image* (1975). In the Highlands of New Guinea he wrote 'that this was a schoolboy dream, that there is a place left in the world where one might meet someone who has never seen a Caucasian or been corrupted by missionaries and their stupid ideas of covering up every part of the body with European rags' (p. 3).

Interestingly, the only unenhanced photograph in this book belongs not to Bailey at all: it is a portrait of his mother, Gladys. She it was who provided him with a first epiphany when she pirouetted for him in Selfridges department store, in delighted but temporary possession of a coat she knew she could never afford to take back home from West End to East.

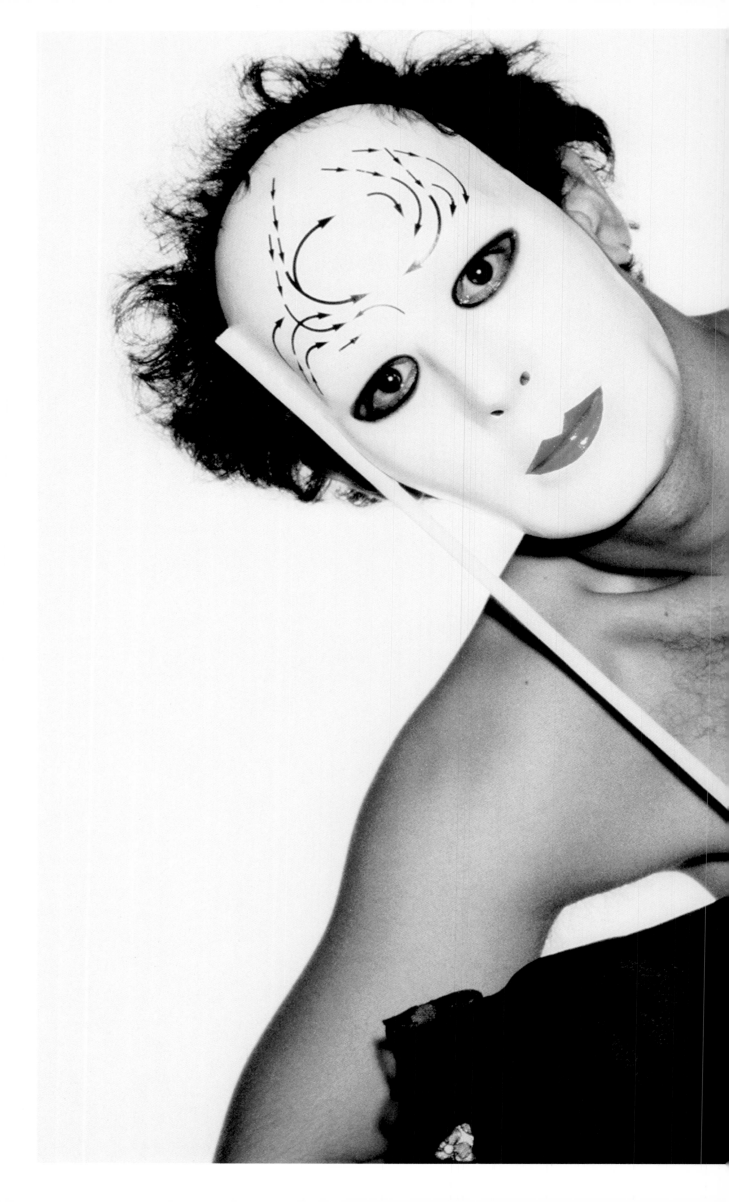

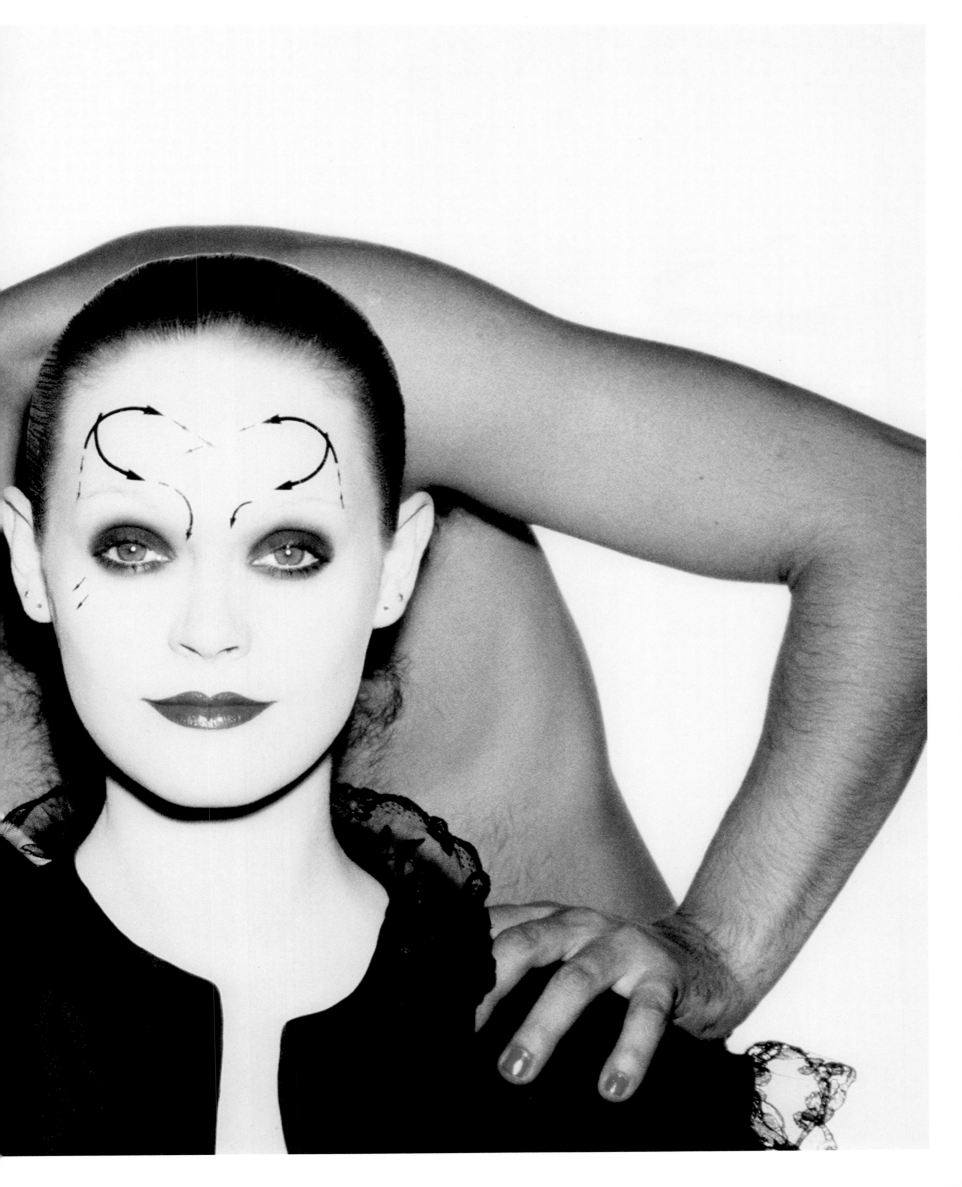

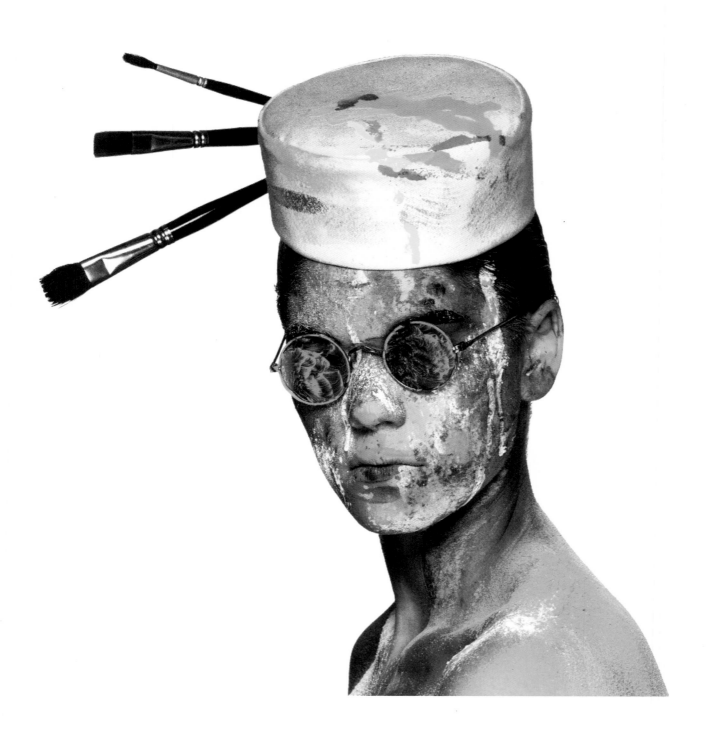

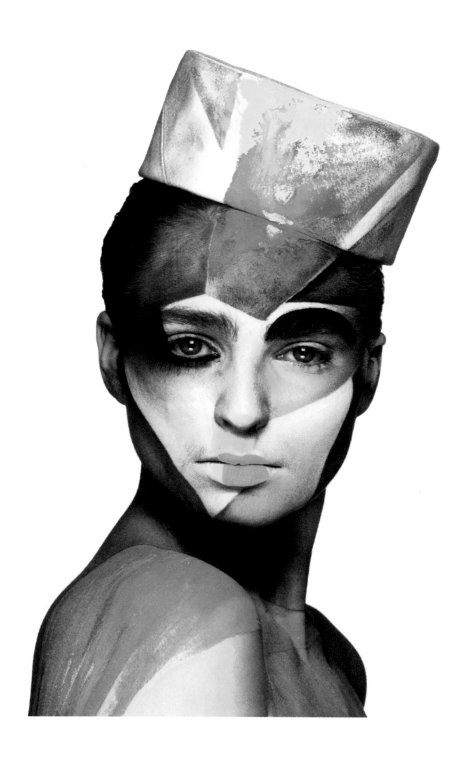

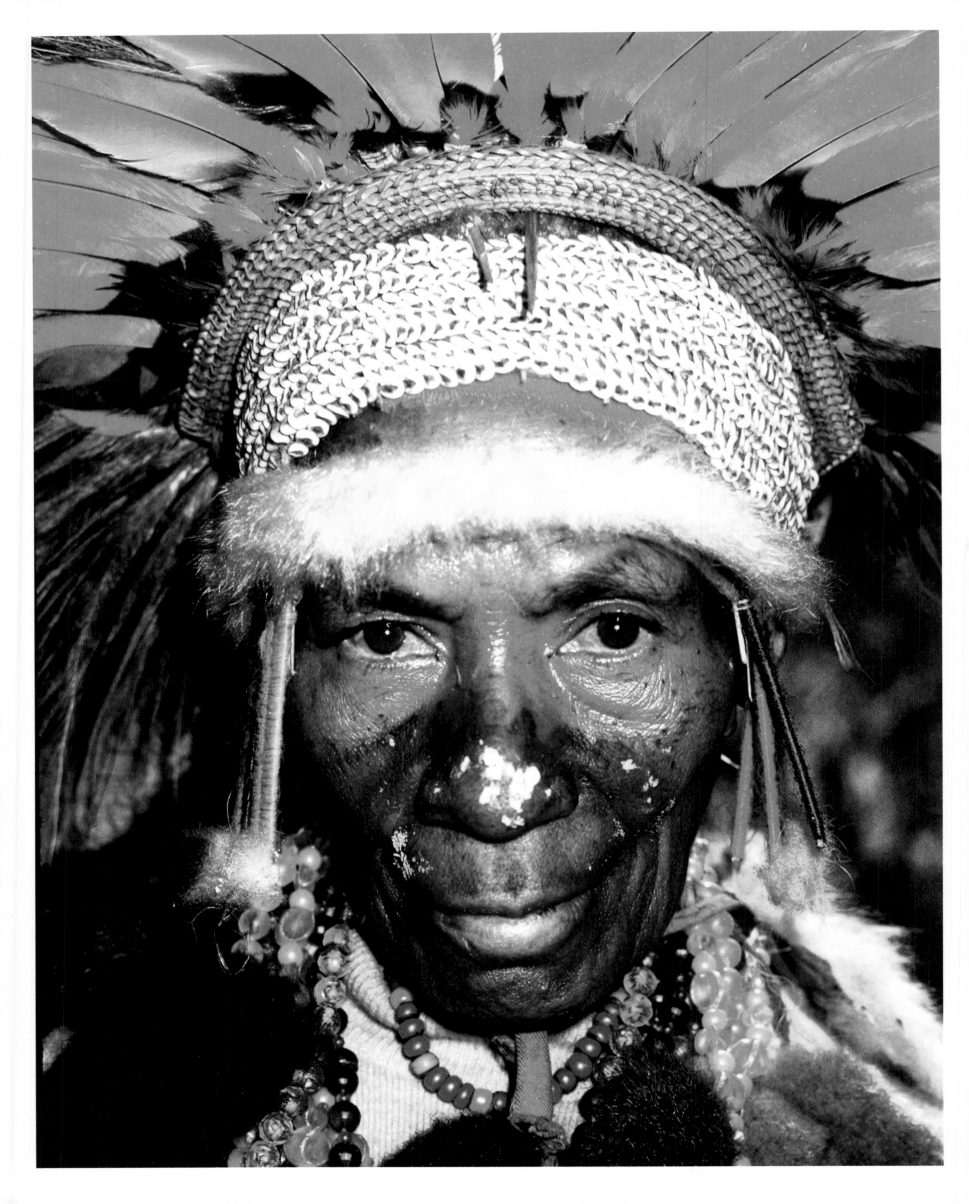

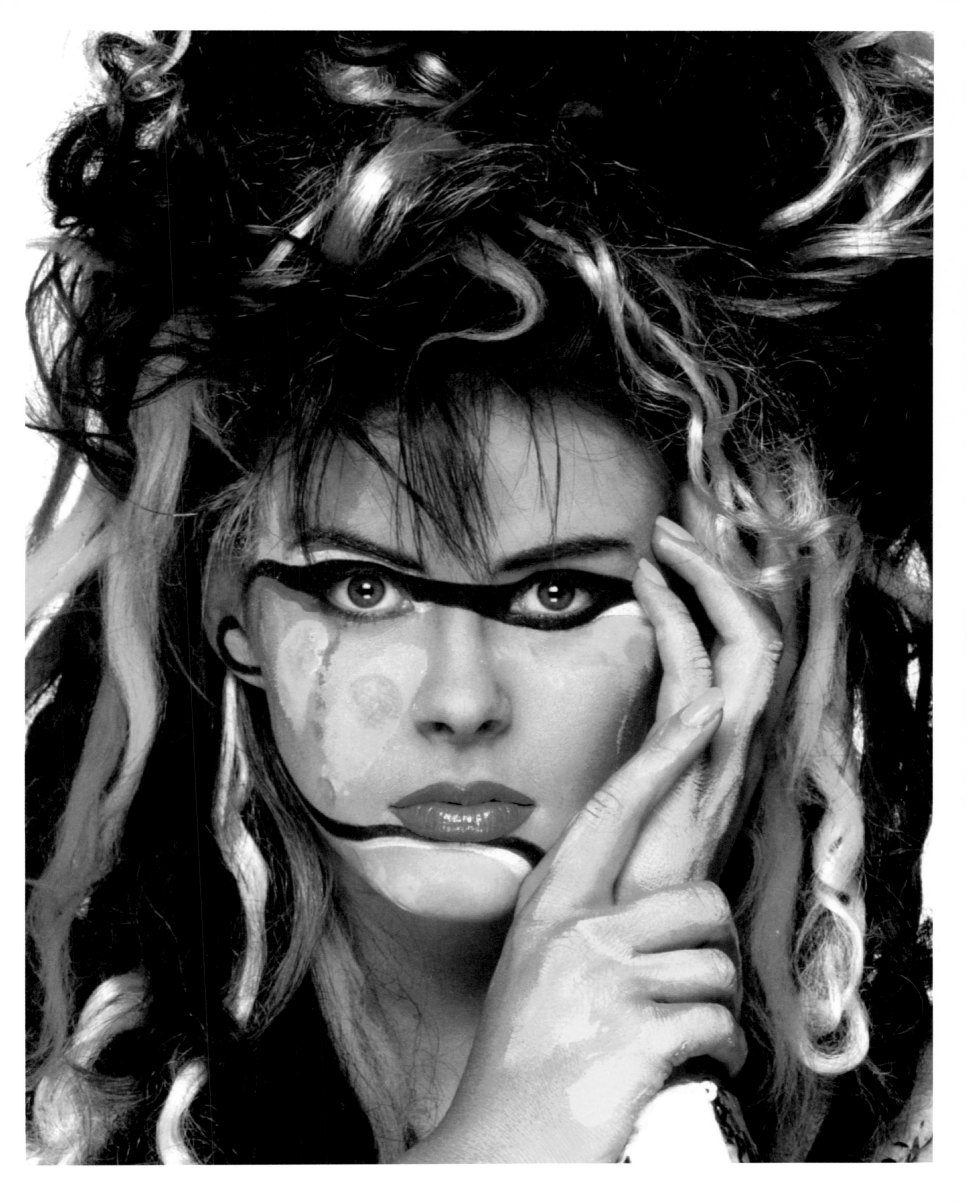

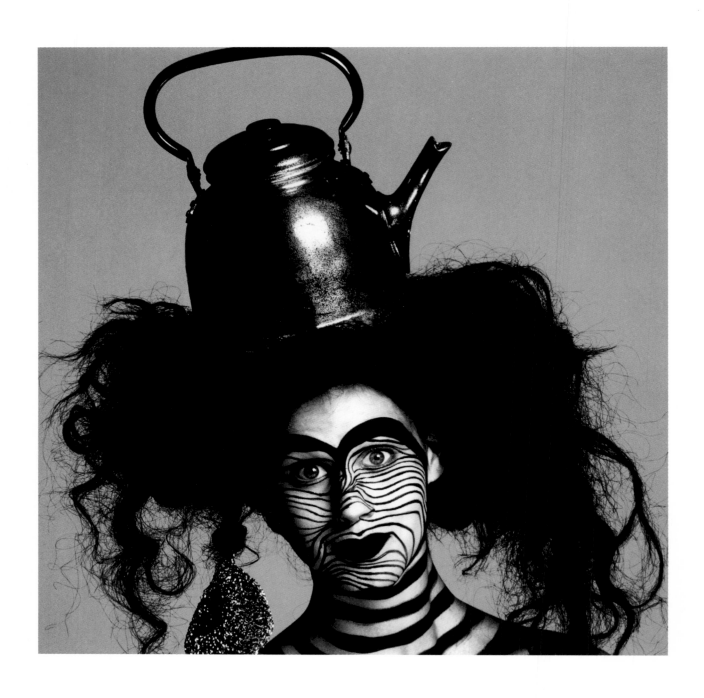

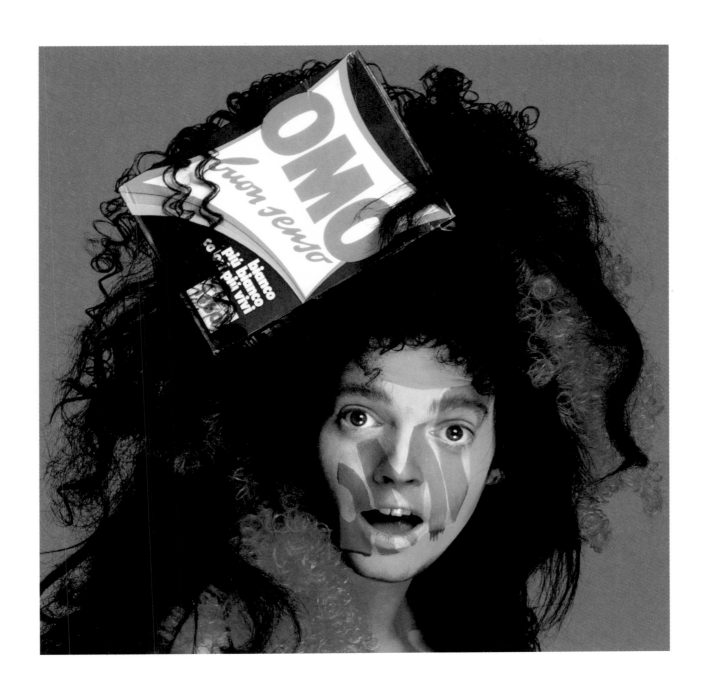

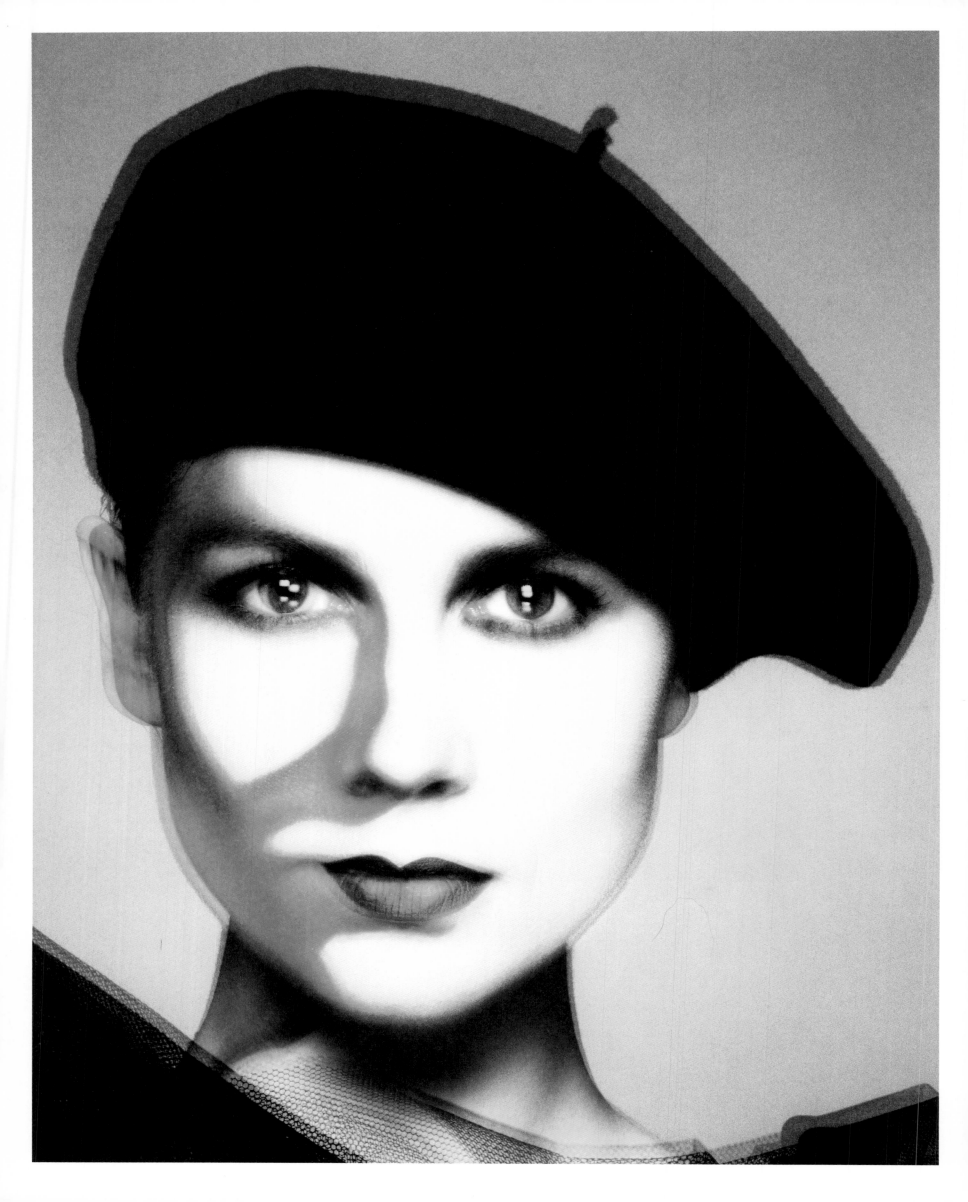

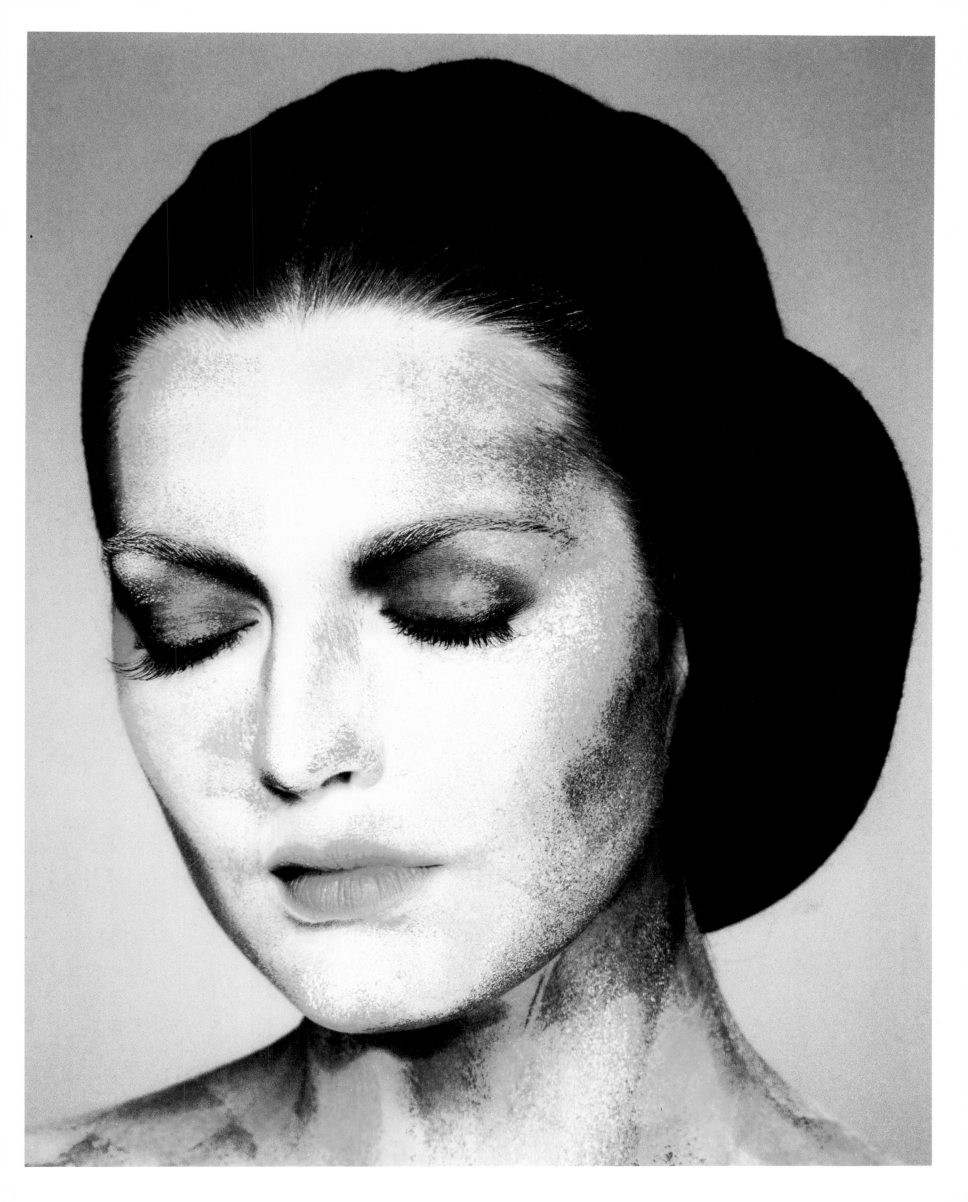

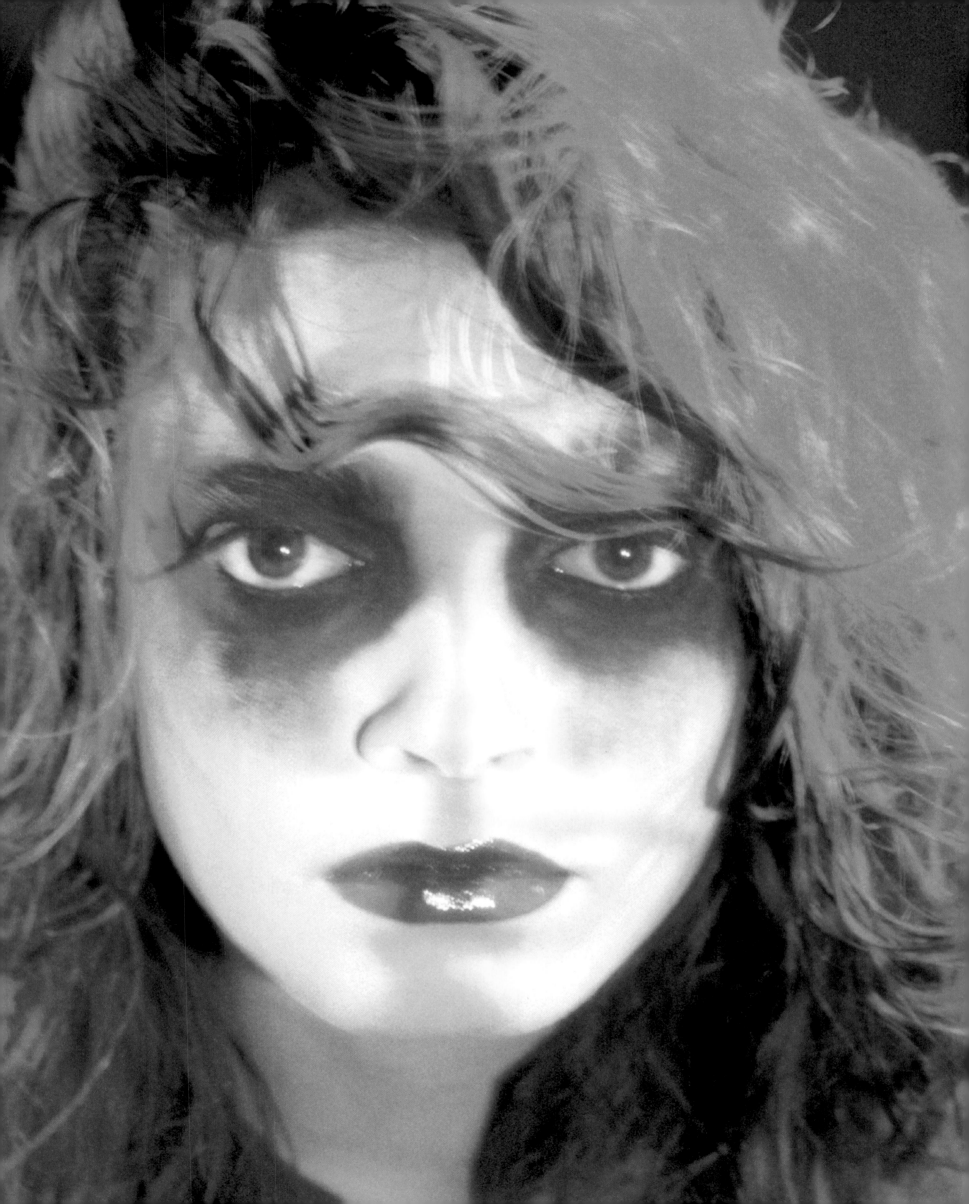

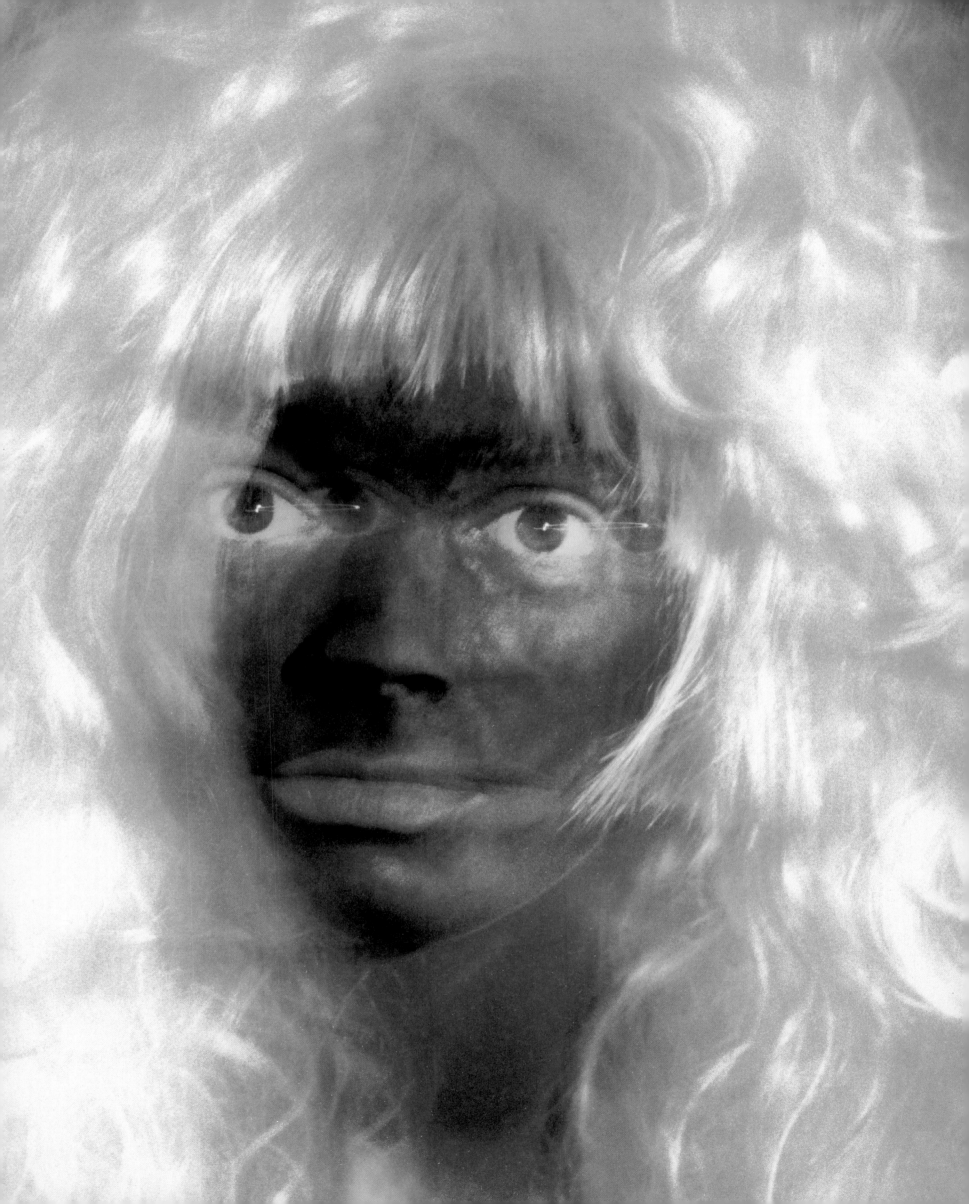

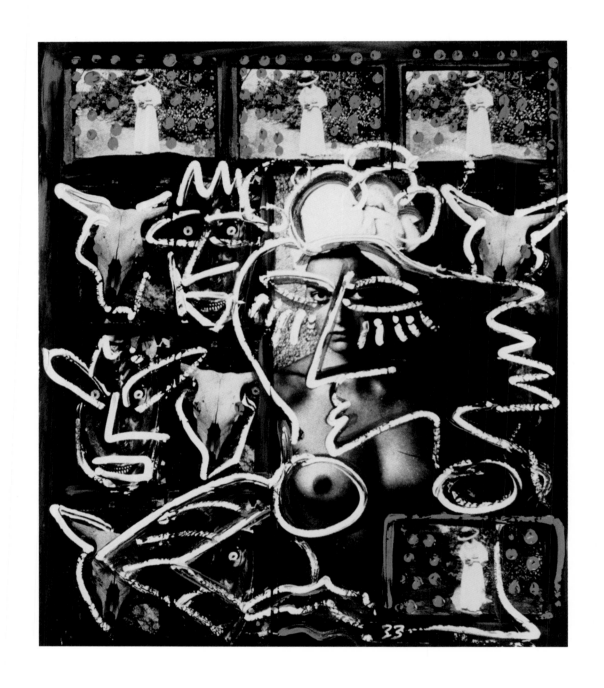

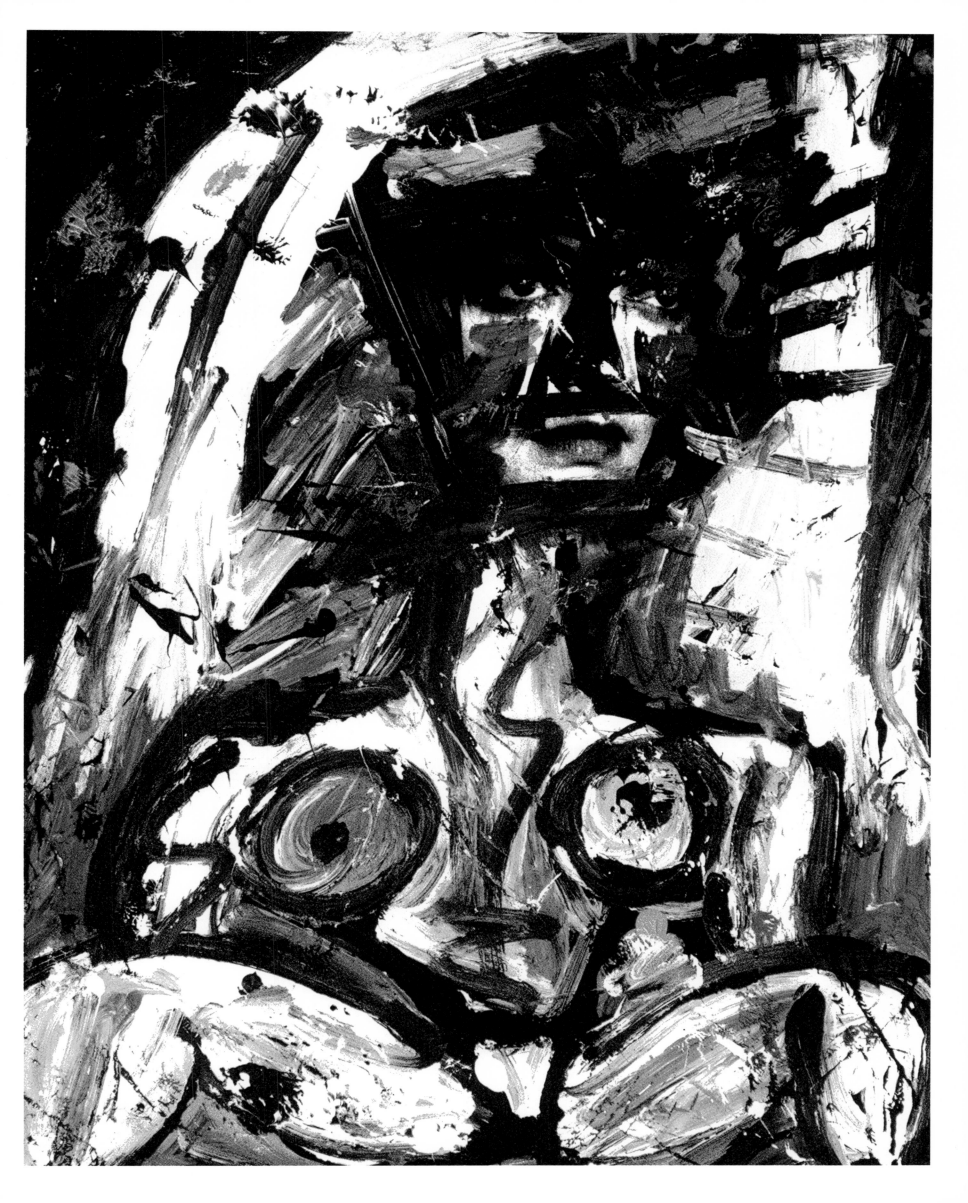

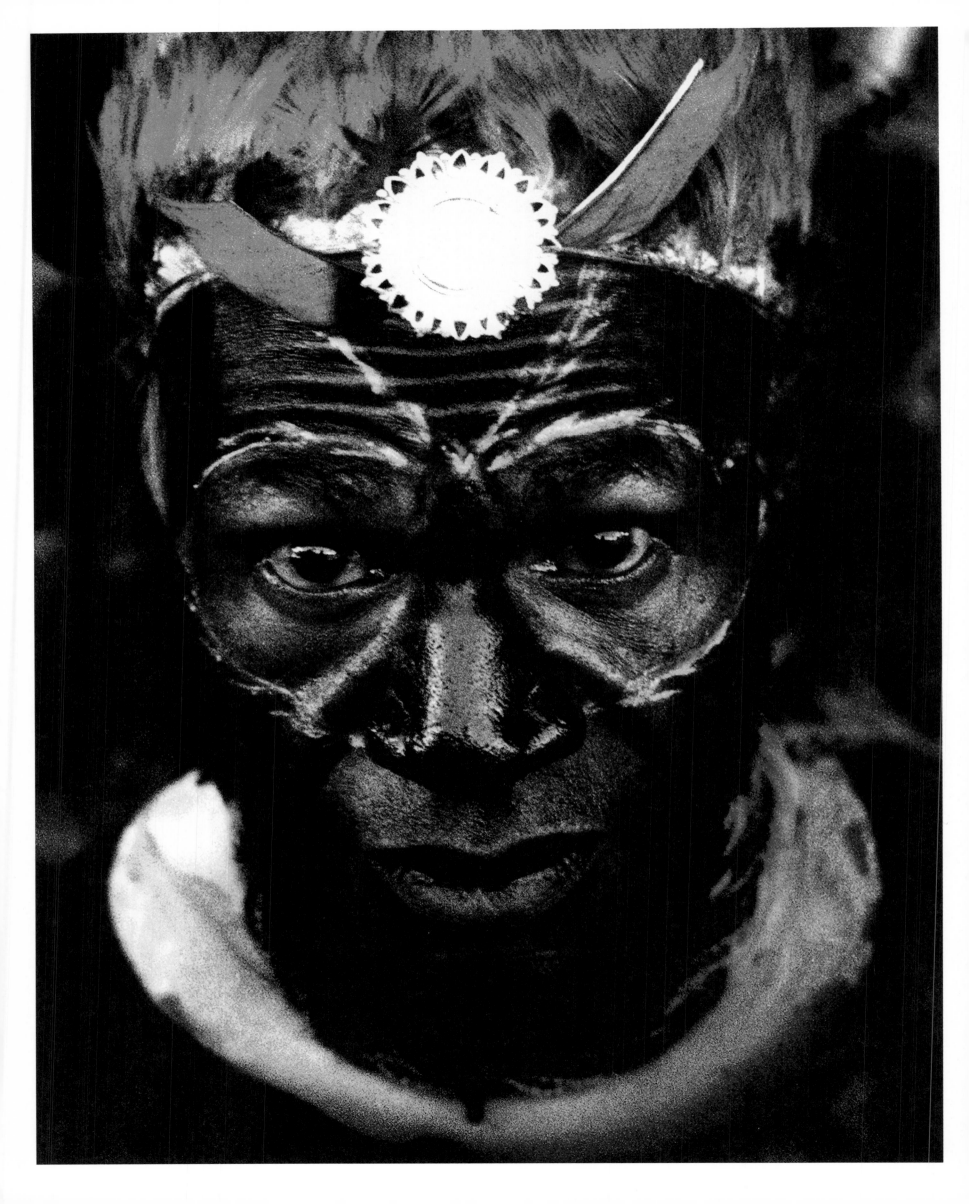

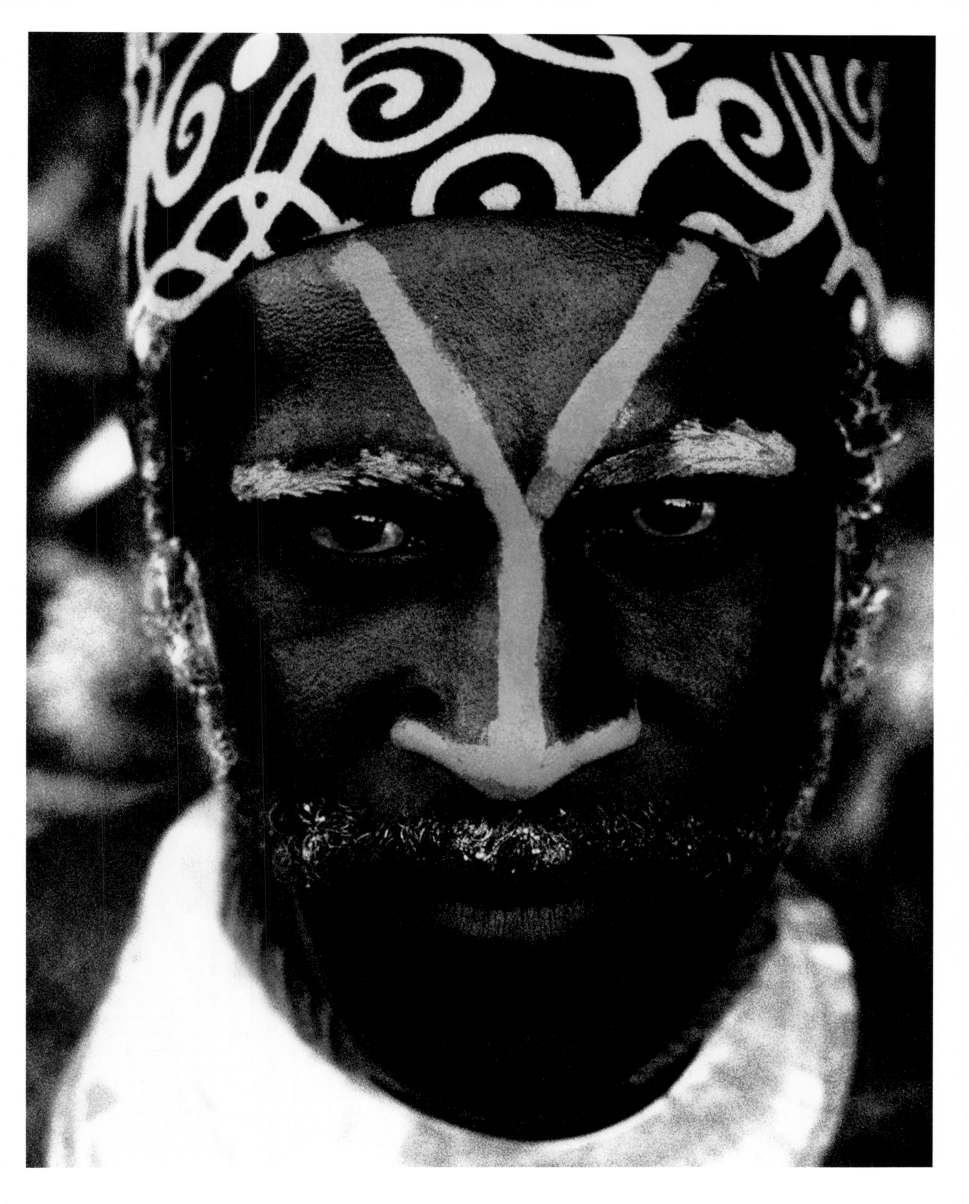

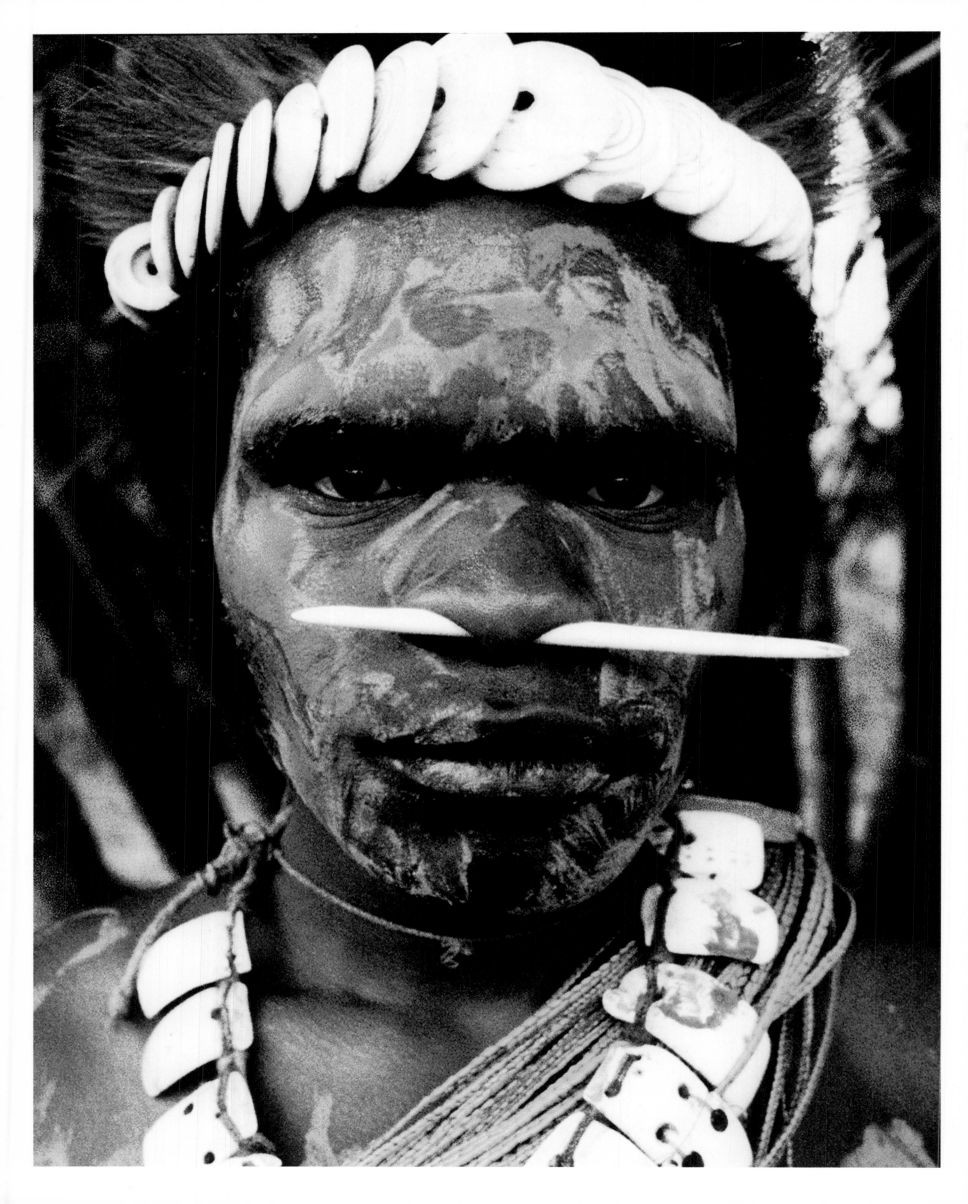

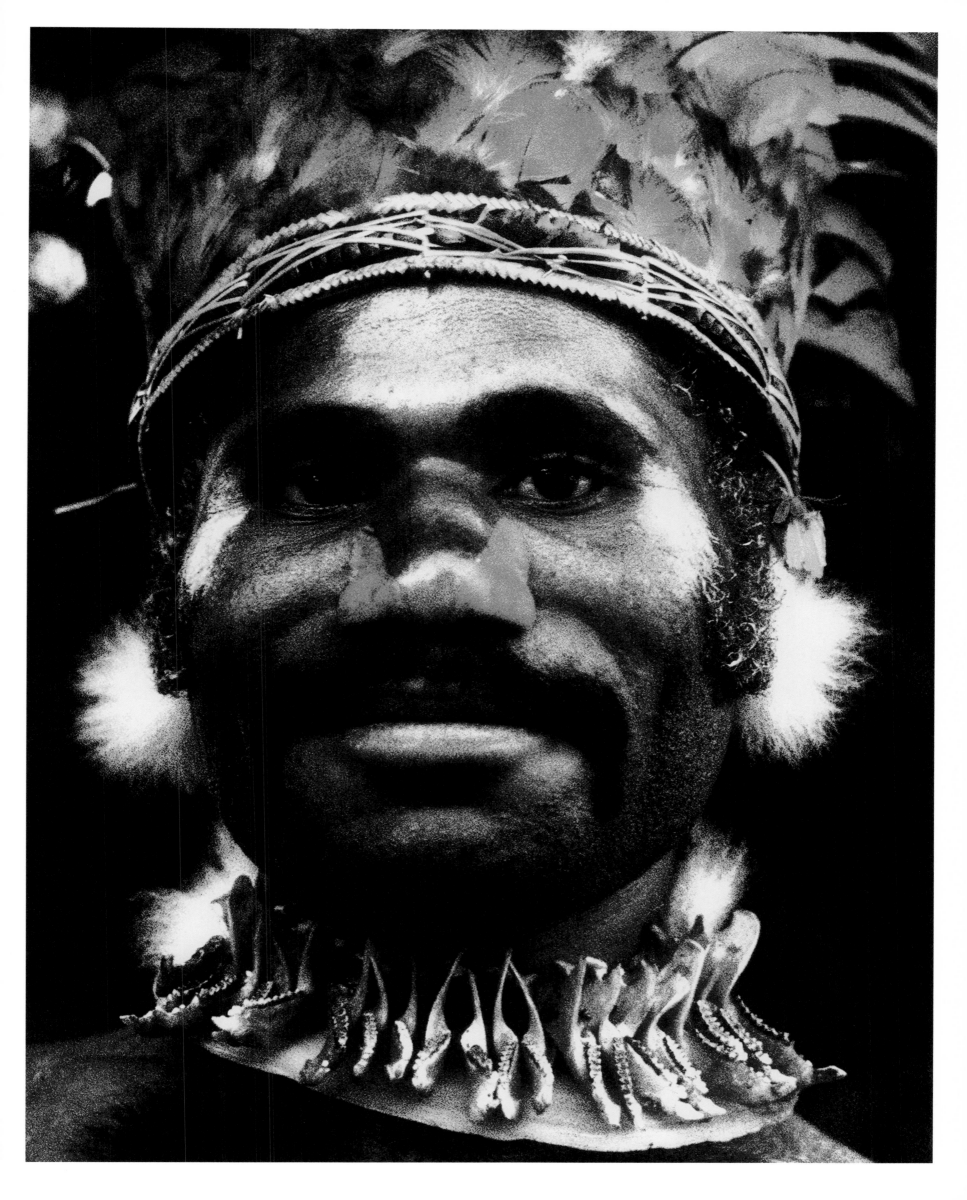

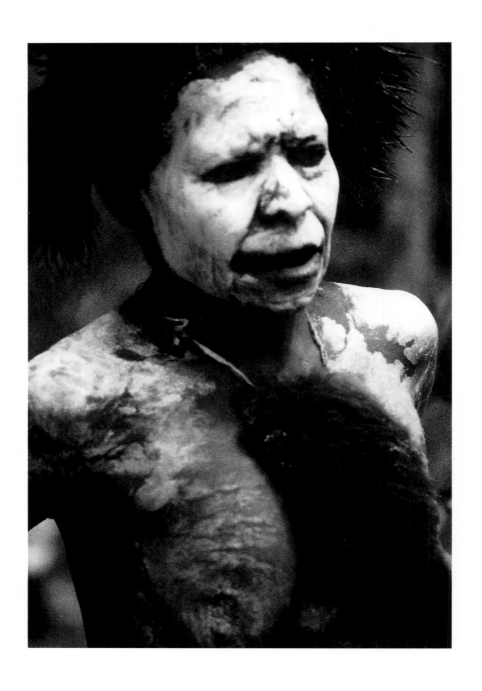

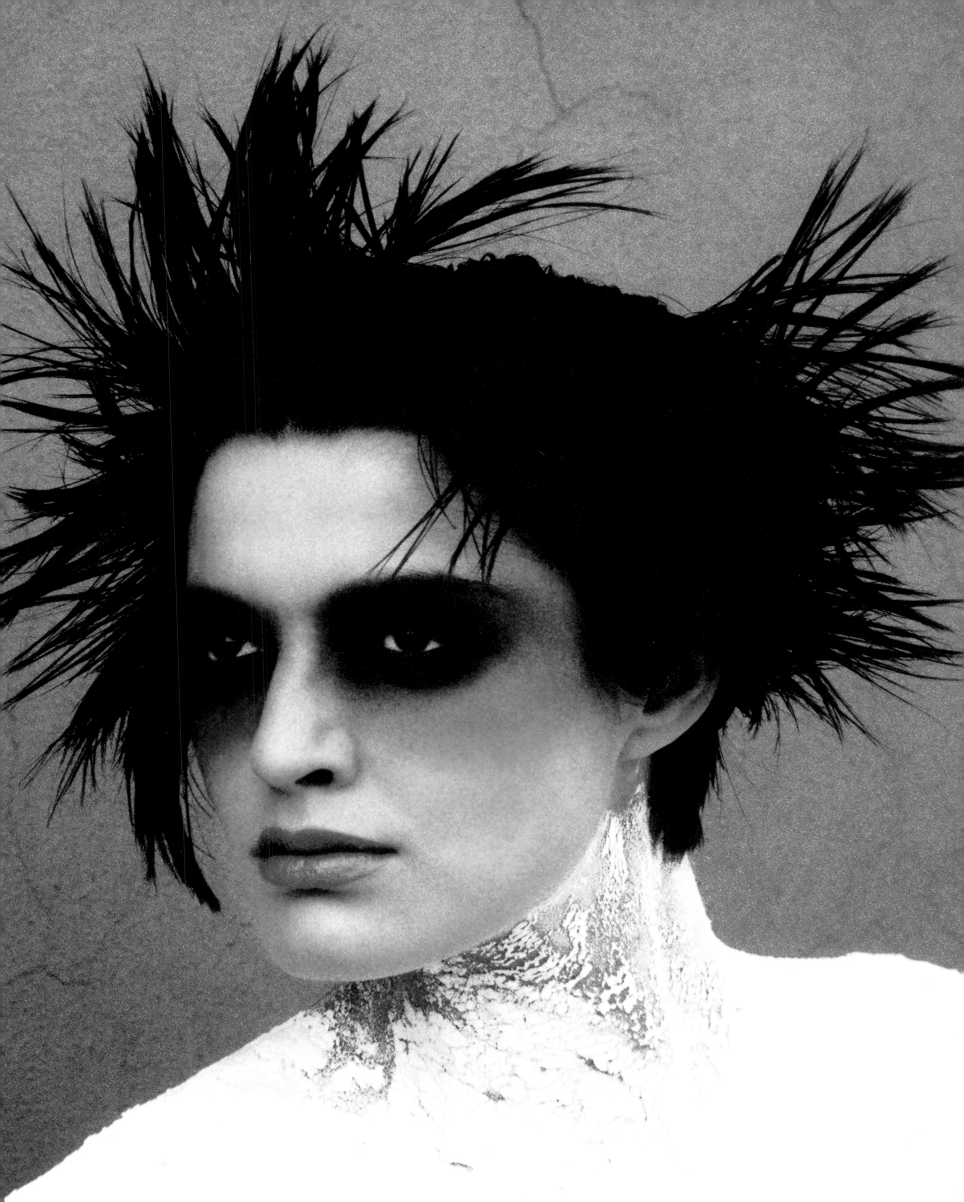

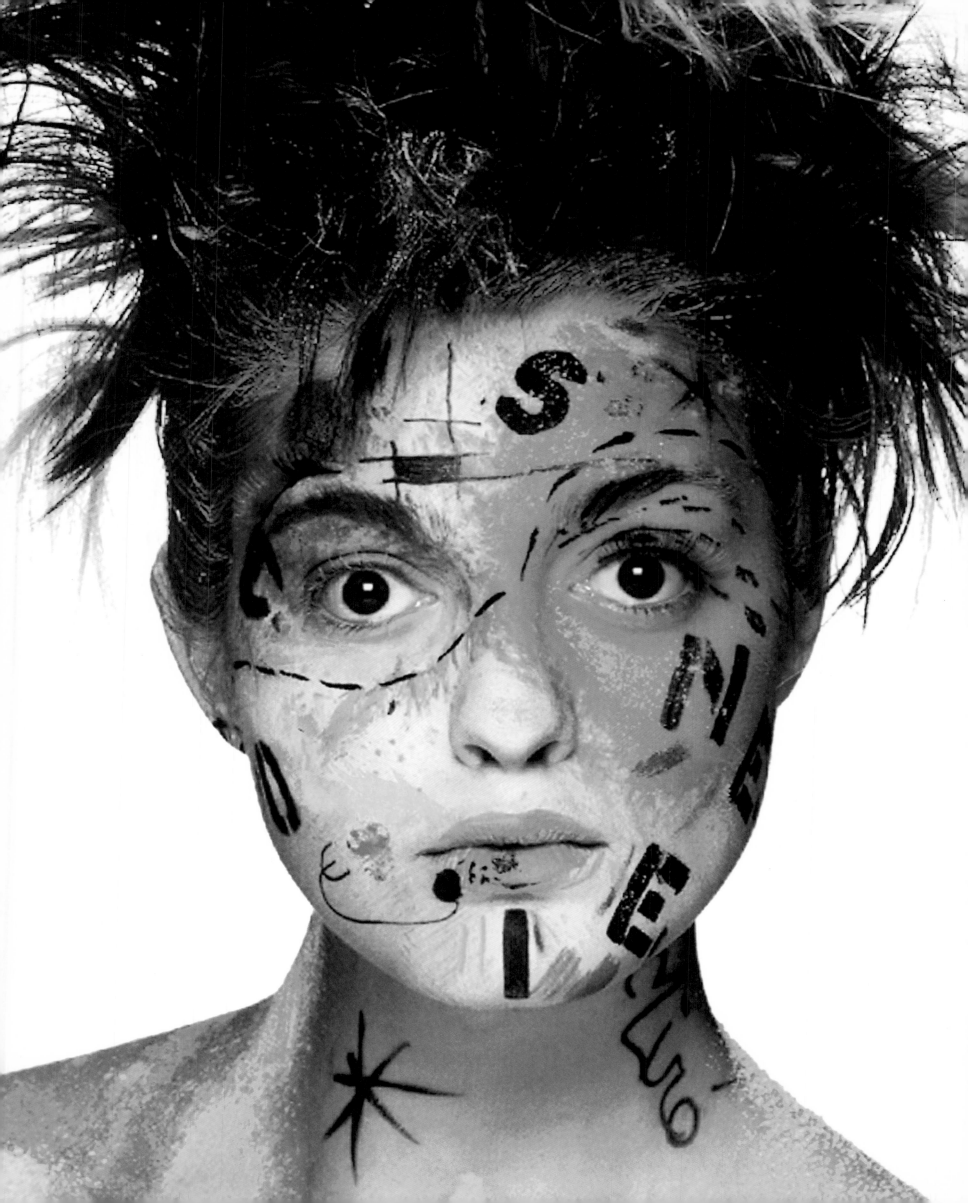

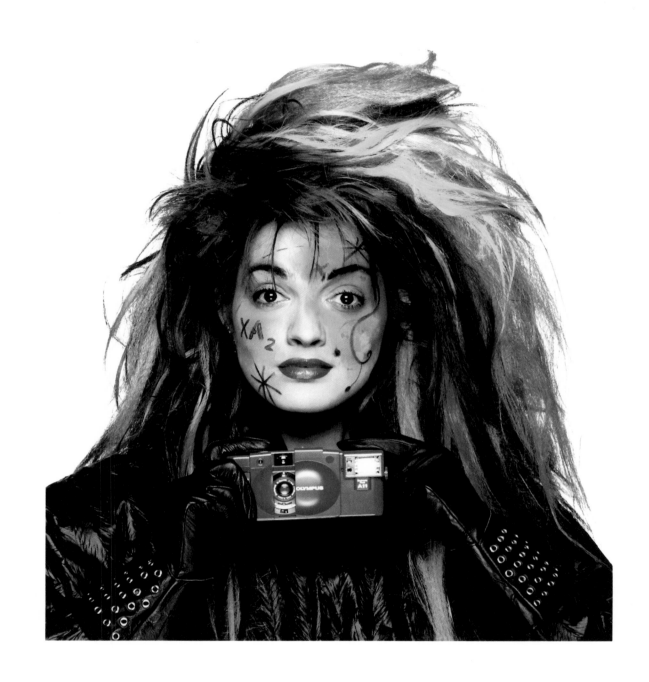

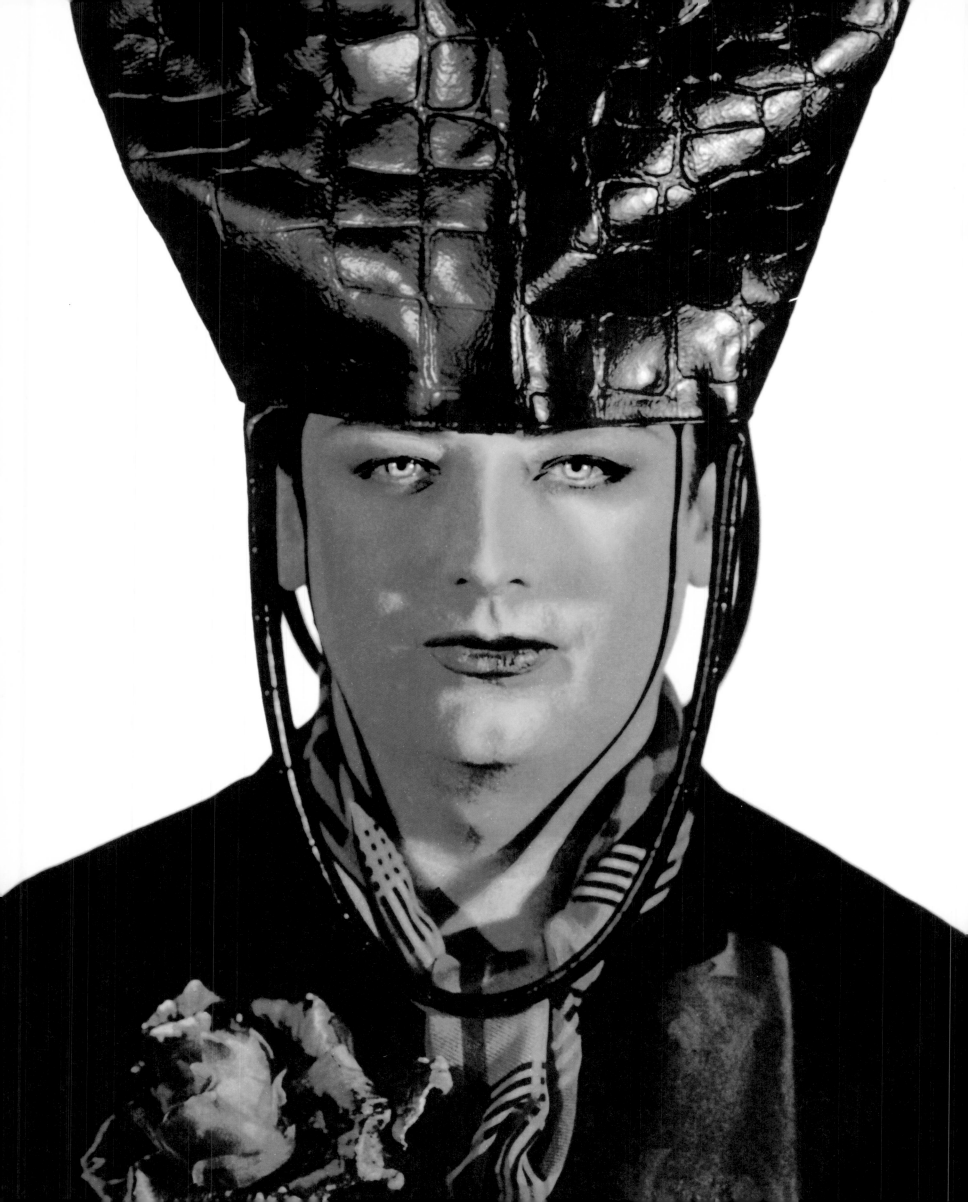

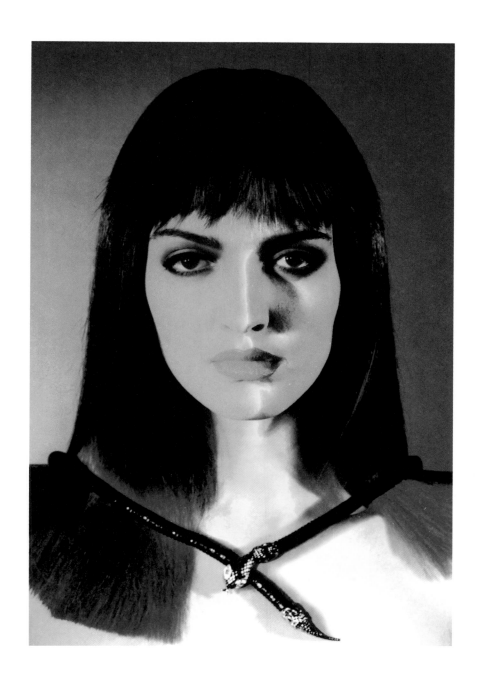

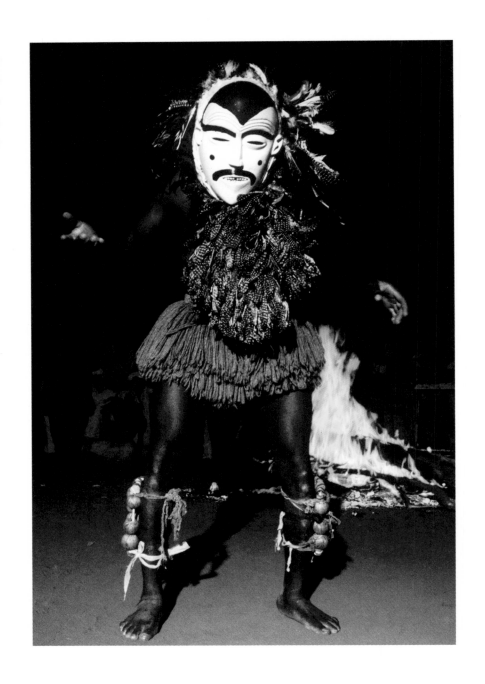

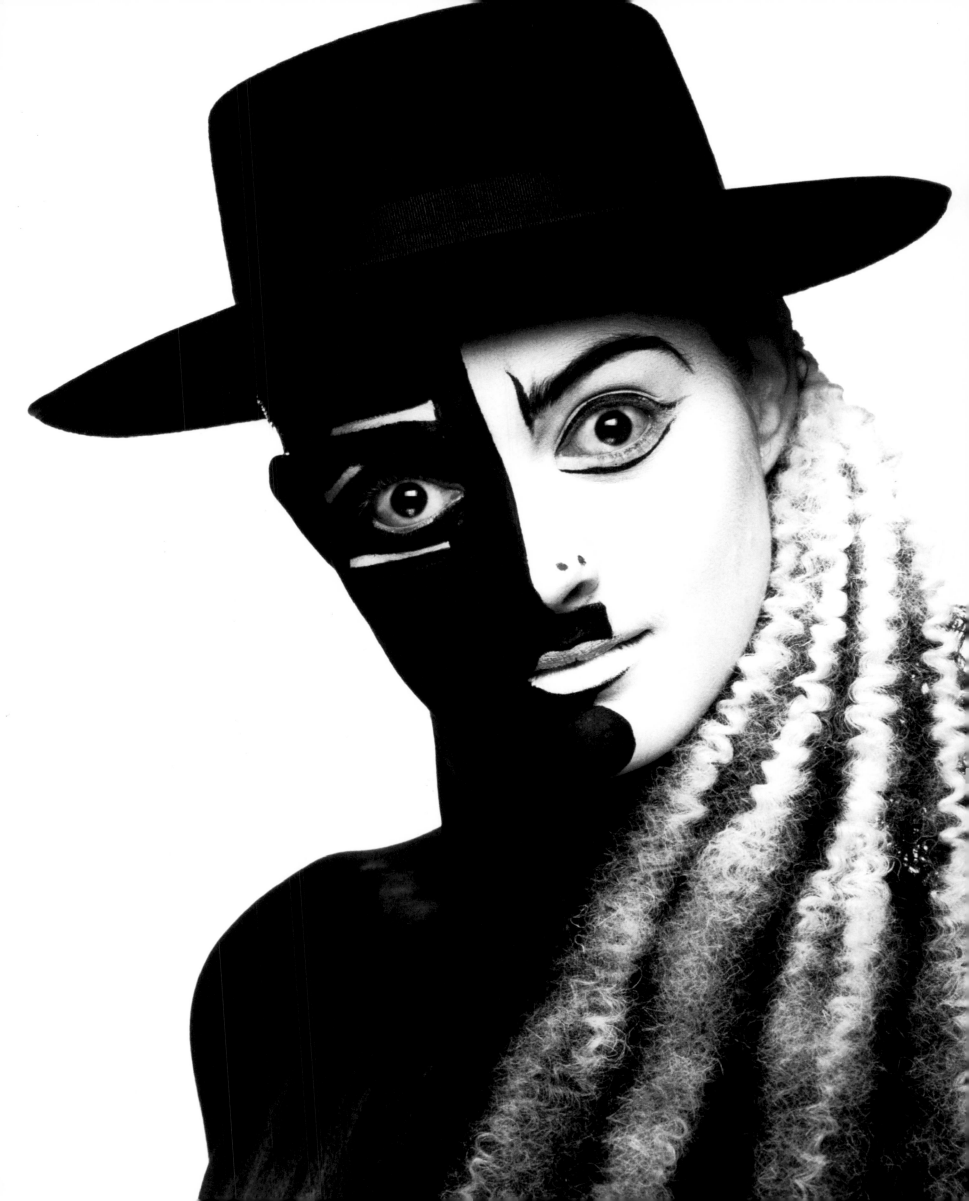

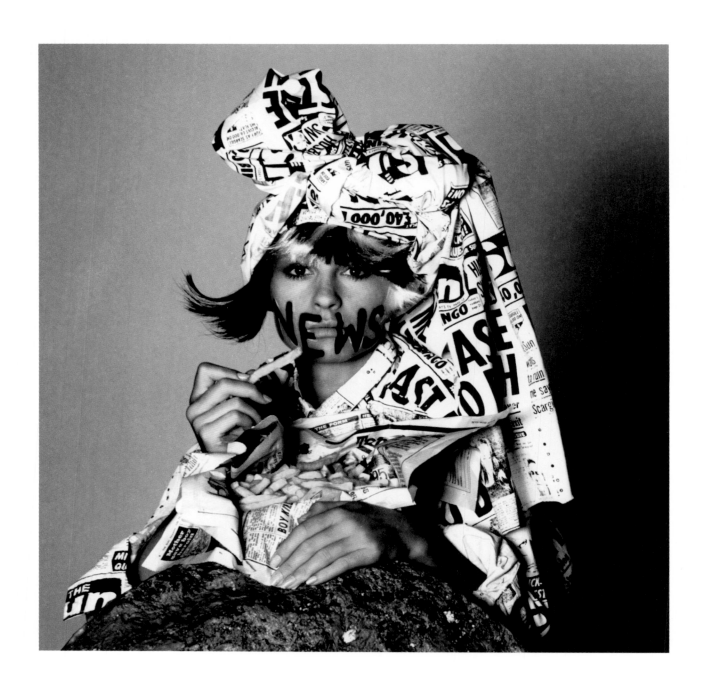

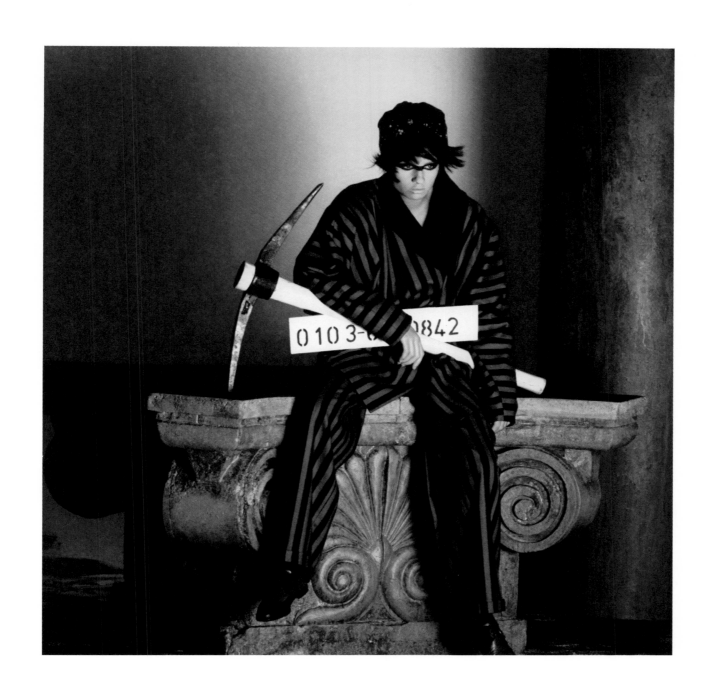

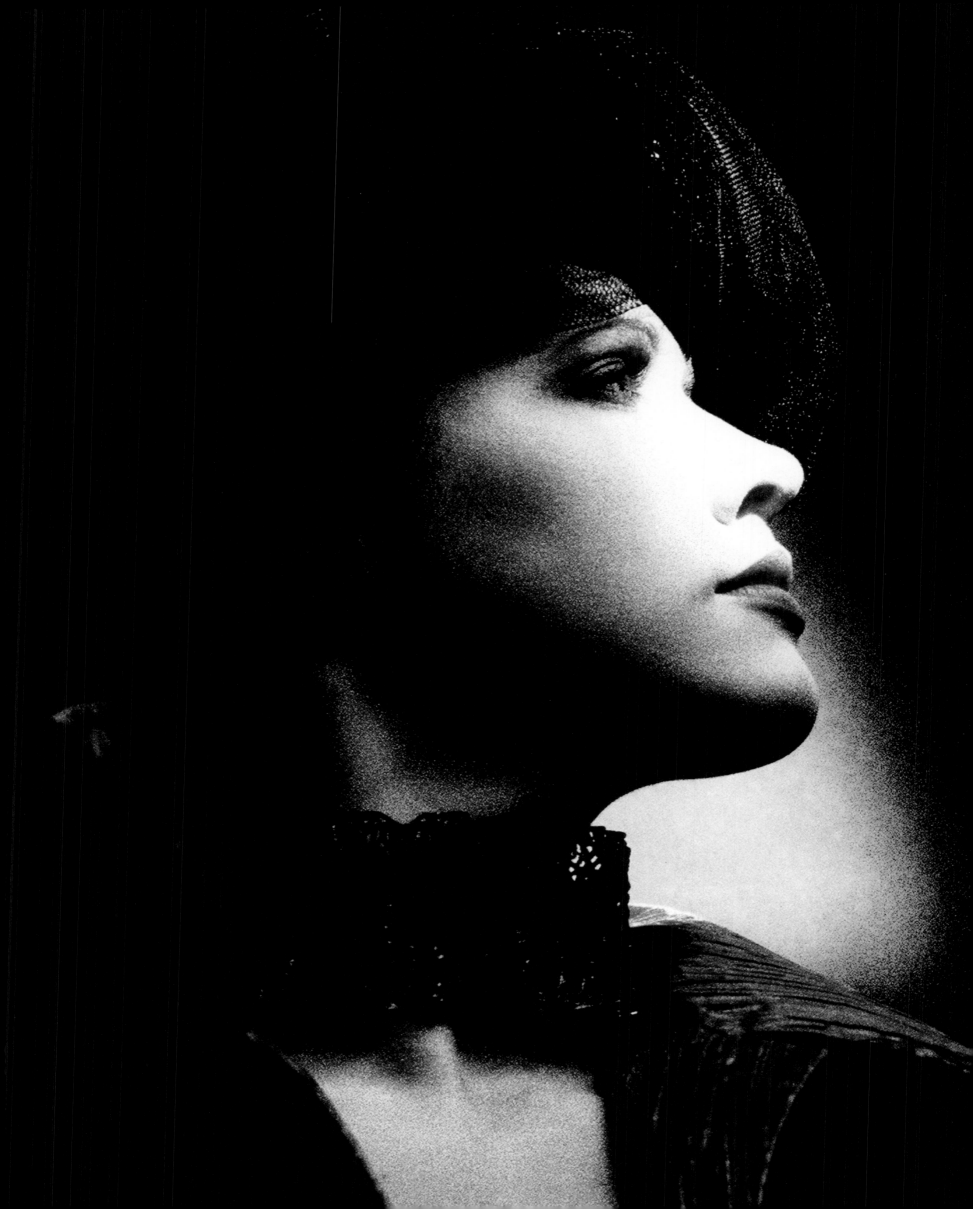

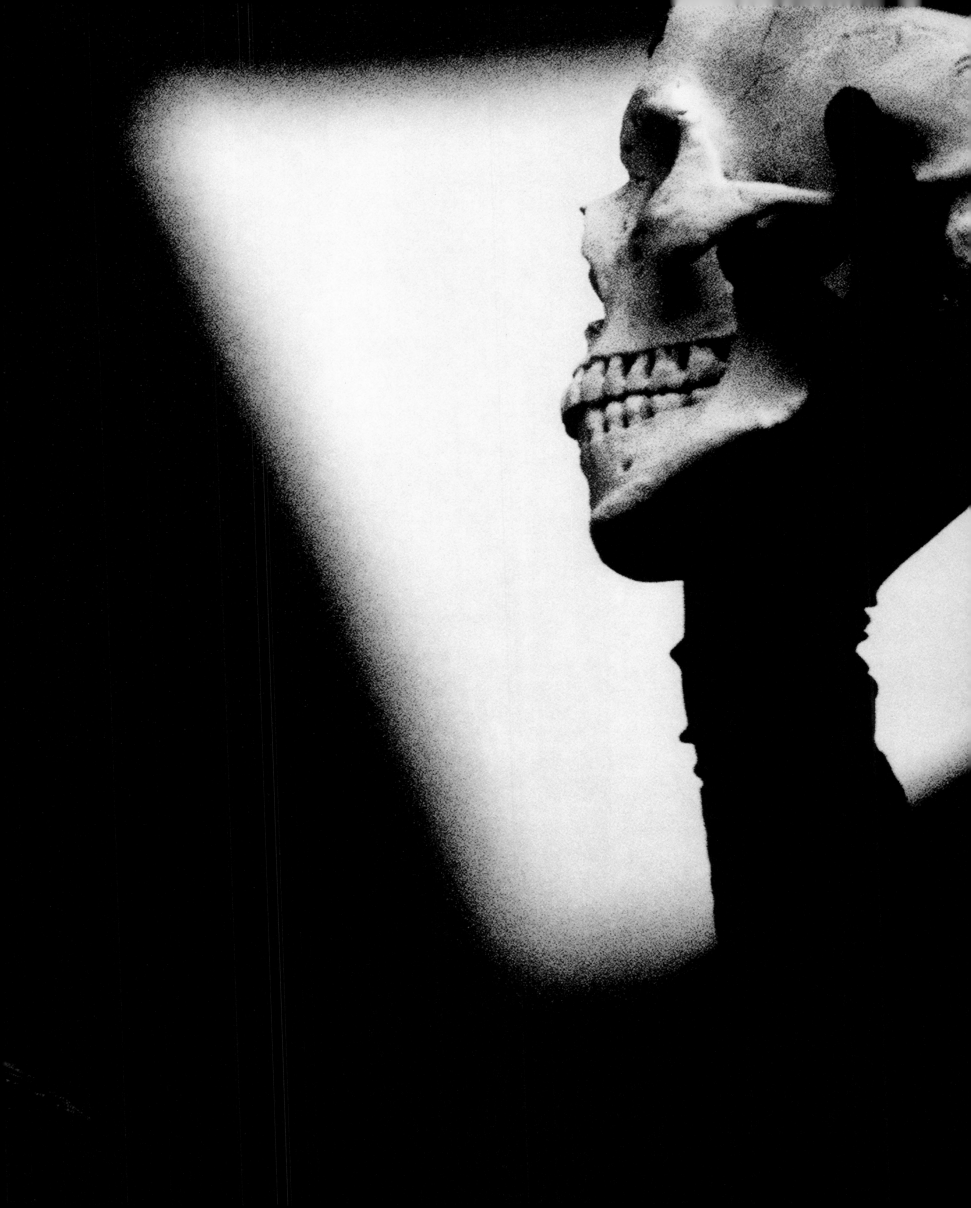

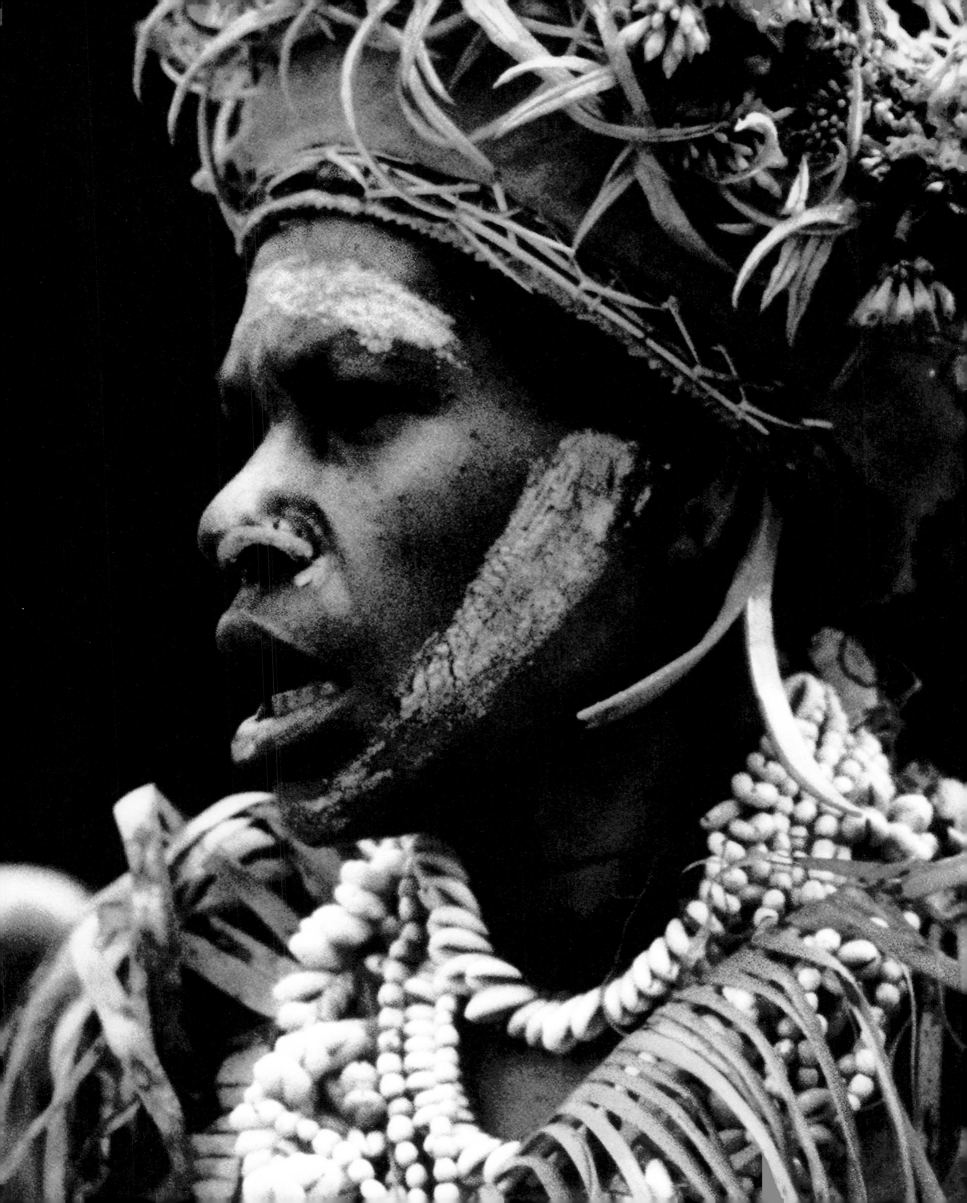

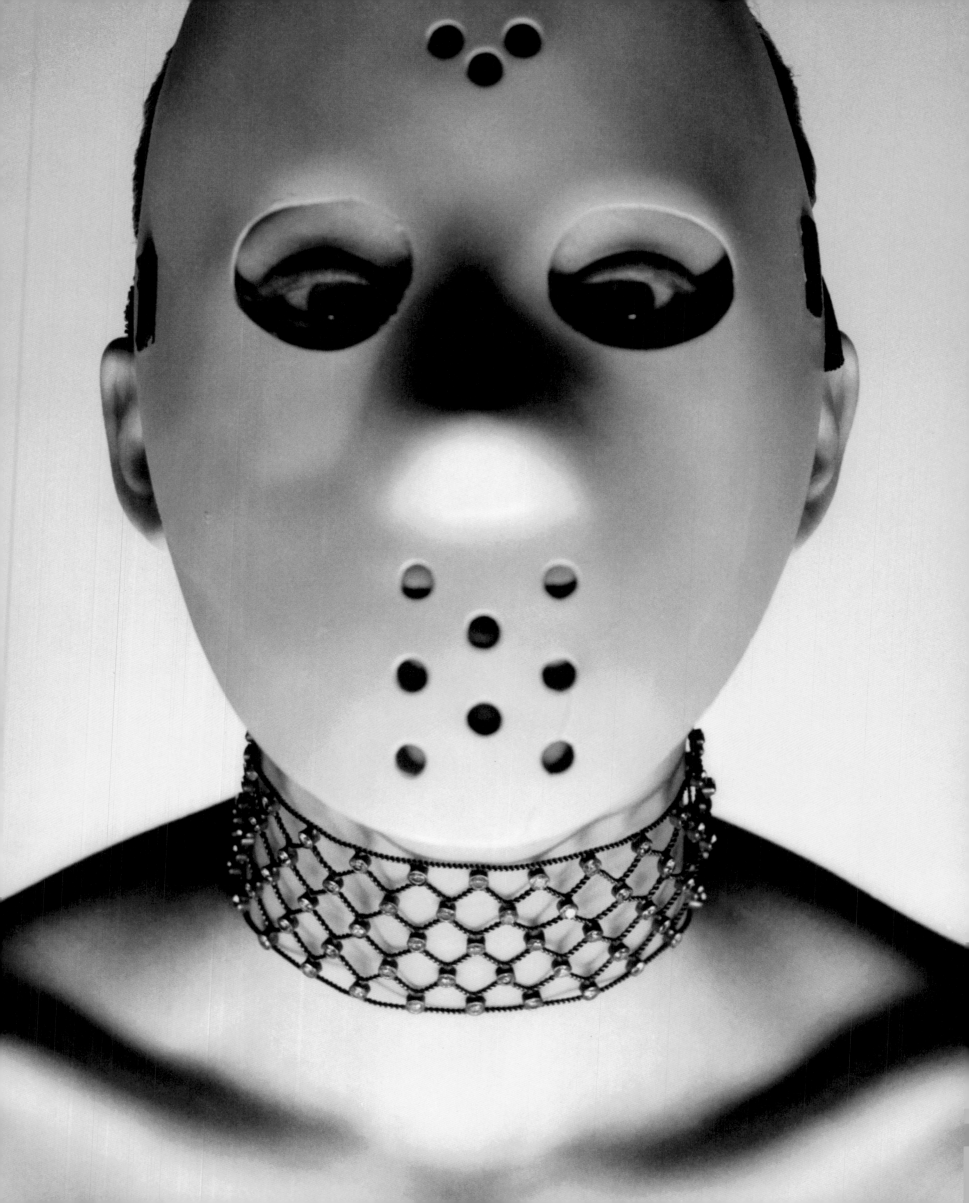

**D**eception is often Bailey's way of capturing reality. The principal leitmotif throughout his magazine work has been a striving for artistic freedom within strict boundaries – and an inherent resistance to remaining inside those boundaries. As he told the critic David A. Mellor: 'I tried to loosen things up' (*Black and White Memories*, 1983, p. 8). Bailey's language of gesture was drawn from an observation of how 'real people' (as magazines still term them) move and for *Vogue* it was entirely uncanonical. Few if any practitioners of the fashion photography of modern times actually brought real life into the studio. In the history of British magazines there are hardly any precedents for even the ersatz realism of Bailey and his contemporaries.

Bailey's friend Terence Donovan, who loosened things up concurrently, remarked: 'I don't really want to report on life...I'm quite happy to see a girl scratching her nose in a coffee bar and translate that via a model' (*British Journal of Photography*, January 1966) – a sentiment Bailey amplified. He gave the magazine a new visual language of stance and of gesture lifted from the streets, a genuine working-class 'chic'. It provided a template for the generation of magazine photographers that followed, part of a 'new urban fashion iconography', according to commentator Val Williams (*Look at Me*, 1998, p. 107). Deceptive and fake of course, when imposed onto Jean Shrimpton and Celia Hammond, but it worked.

This translation of reality into the unreal setting of the studio has produced what we now think of as the classic Bailey *oeuvre*. The informality of posture, gesture and body language evident in his fashion work with Jean Shrimpton and Sue Murray has been much imitated and is still a pervasive, long-lasting influence on fashion photography. Almost singlehandedly – at least in Britain – Bailey and Donovan, despite their own propensity towards deception, revealed the prevalent hand-on-hip, 'catch a butterfly' posturing of the previous decades to be crude and banal and – most importantly of all – utterly unlike real life.

The history of fashion and beauty photography makes much of the clarity of the early-twentieth-century image and the sanctity of an uncompromisingly direct documentation of fashion. Little has been made – until relatively recently – of fashion photography's ability to obscure and deceive. For Bailey, the unexpected clearly has more impact. His withholding of any narrative meaning in his photographs fuels a sense of unreality that has resonated in particular throughout his beauty work of the seventies and eighties. It is with a sense of consummate dissemblance that he has included here, as part of *Chasing Rainbows*, shop window mannequins, blow-up dolls and representations of the dehumanizing process of exploratory plastic surgery, that may or may not have as its subject something human at all.

Many of Bailey's paintings share the same concerns as his photography – frequently an abstract kind of beauty – and he has never treated photography and painting as bitter foes. Rather the opposite, he has drawn strengths from their interaction: a curiosity for experimentation: mixing media, for example, by over-painting photographs, scratching negatives and using a distinctive partial colour solarization process. His paintings remain contemporaneous with his photography as an exploration of the human sexual psyche with an off-kilter 'beauty' all their own. Their antecedents are most markedly the appropriation of African tribal relics by the early Surrealists, who found them indicative of our most primitive creative urges. Bailey himself has a fine collection of ethnographic artefacts and insignia. Behind it all lies the undeniable presence of Picasso, too, whom Bailey in this context reveres perhaps above all others.

Though Bailey's skill as a figurative painter has been praised and his work is widely though privately collected, his paintings are still relatively little known. Apart from exhibition catalogues, this represents the first time they have ever been published in book form. Only someone with a highly developed and democratic visual sense would include them at all in a book of photographs. And it seems only right to reiterate a magazine term: namely, that they 'work' rather well here...

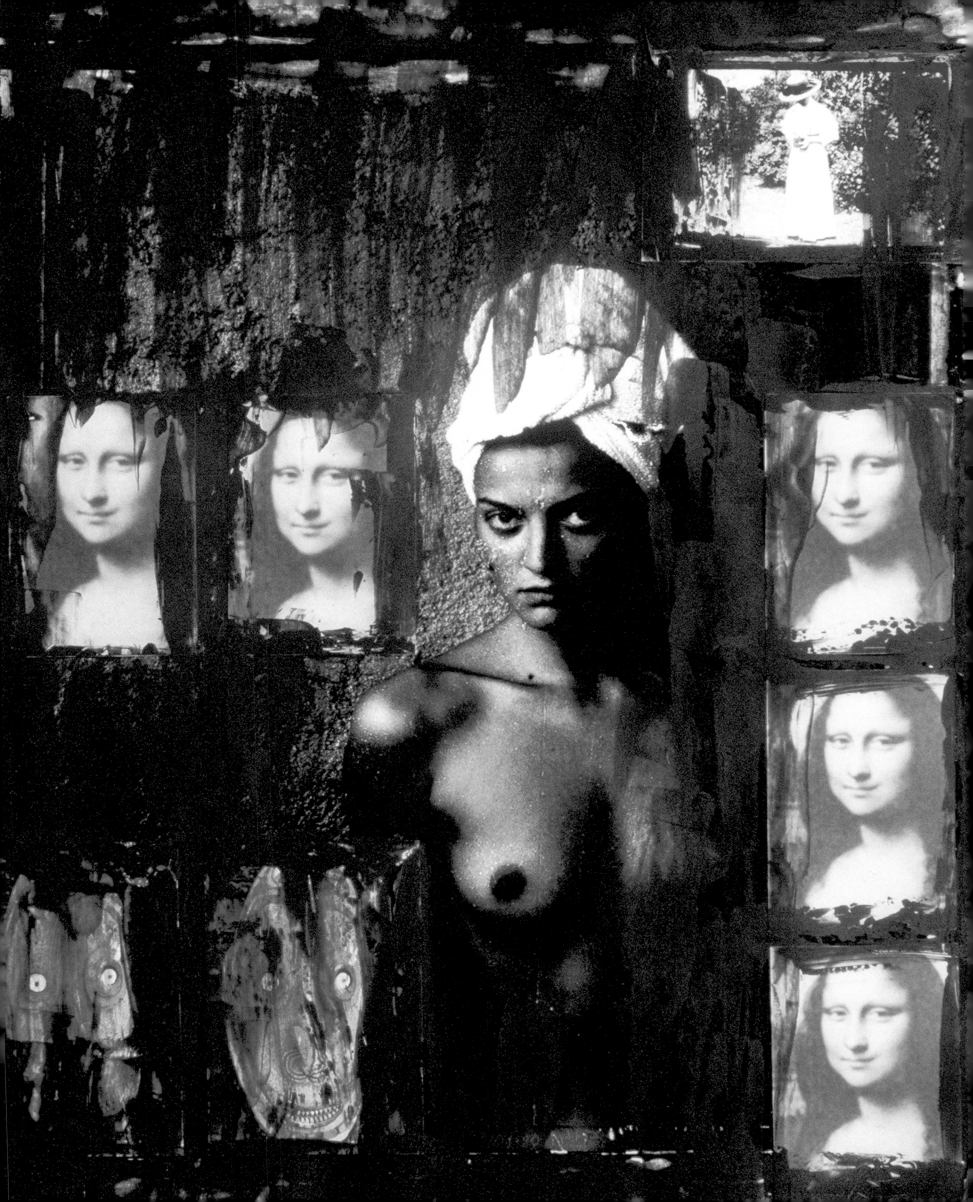

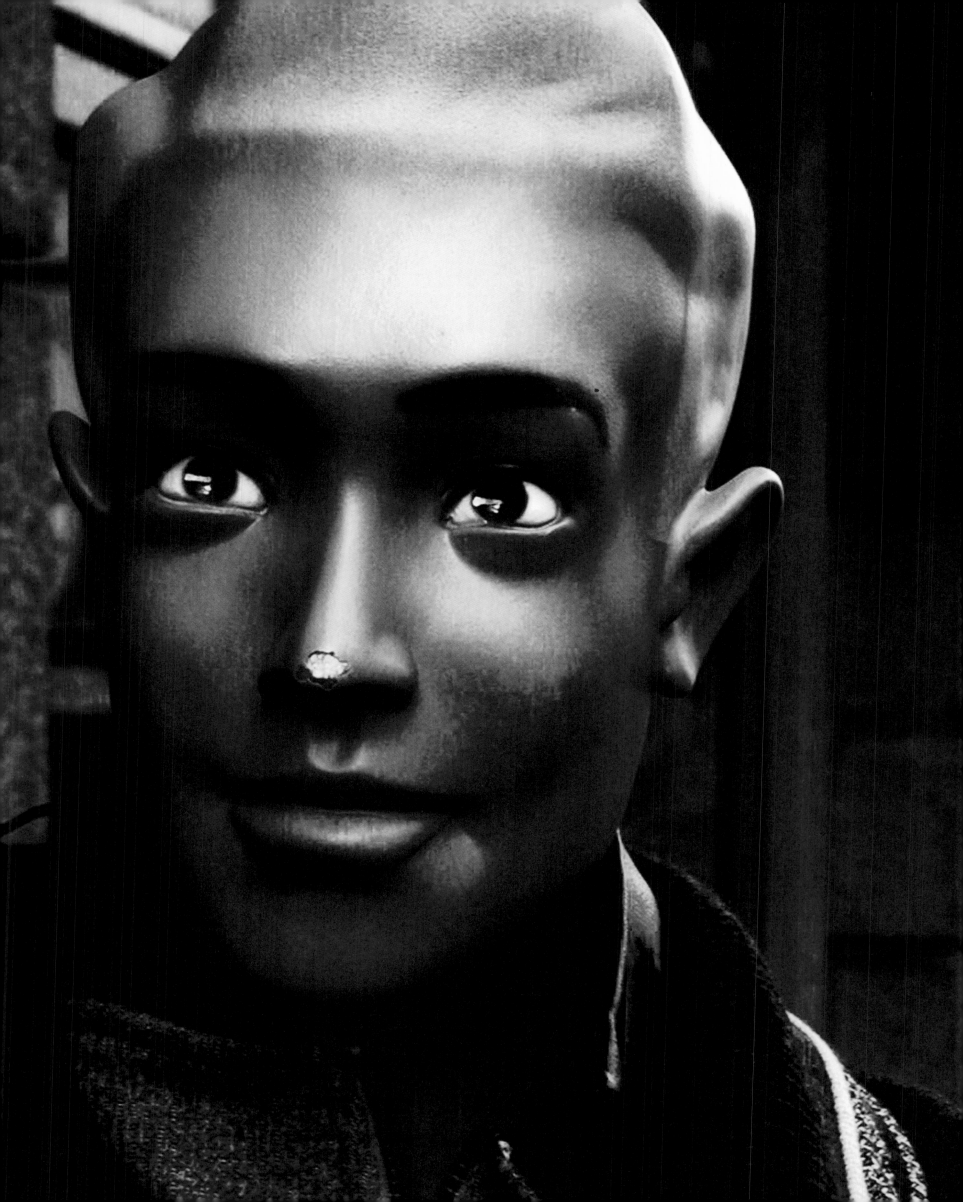

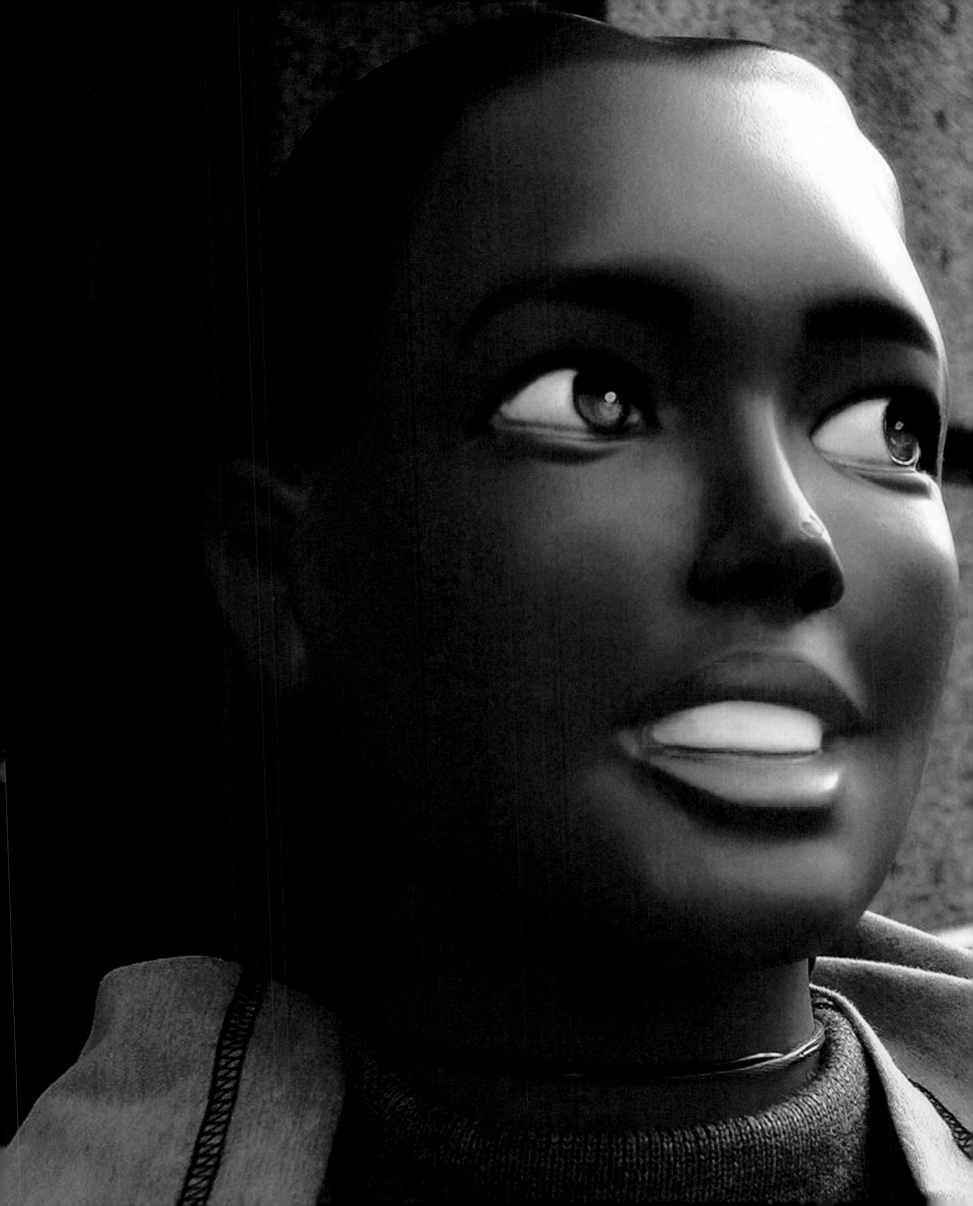

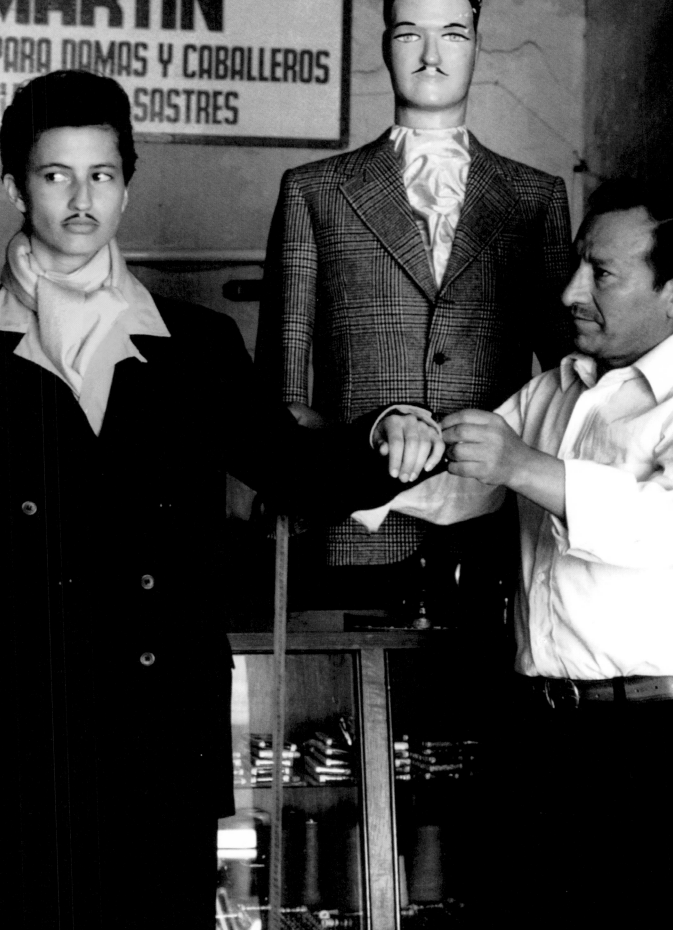

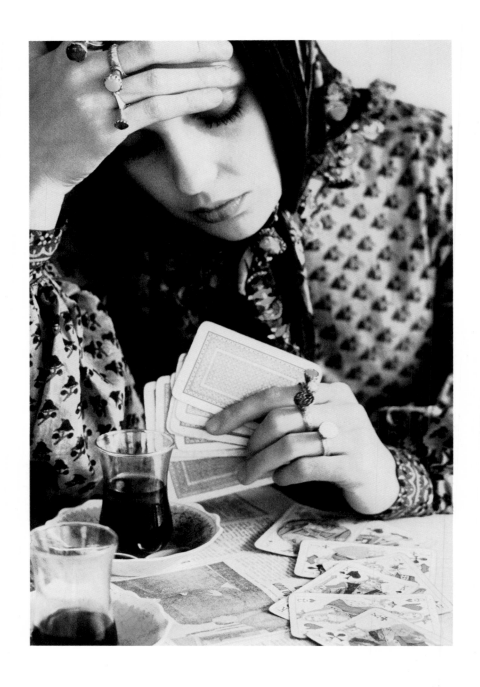

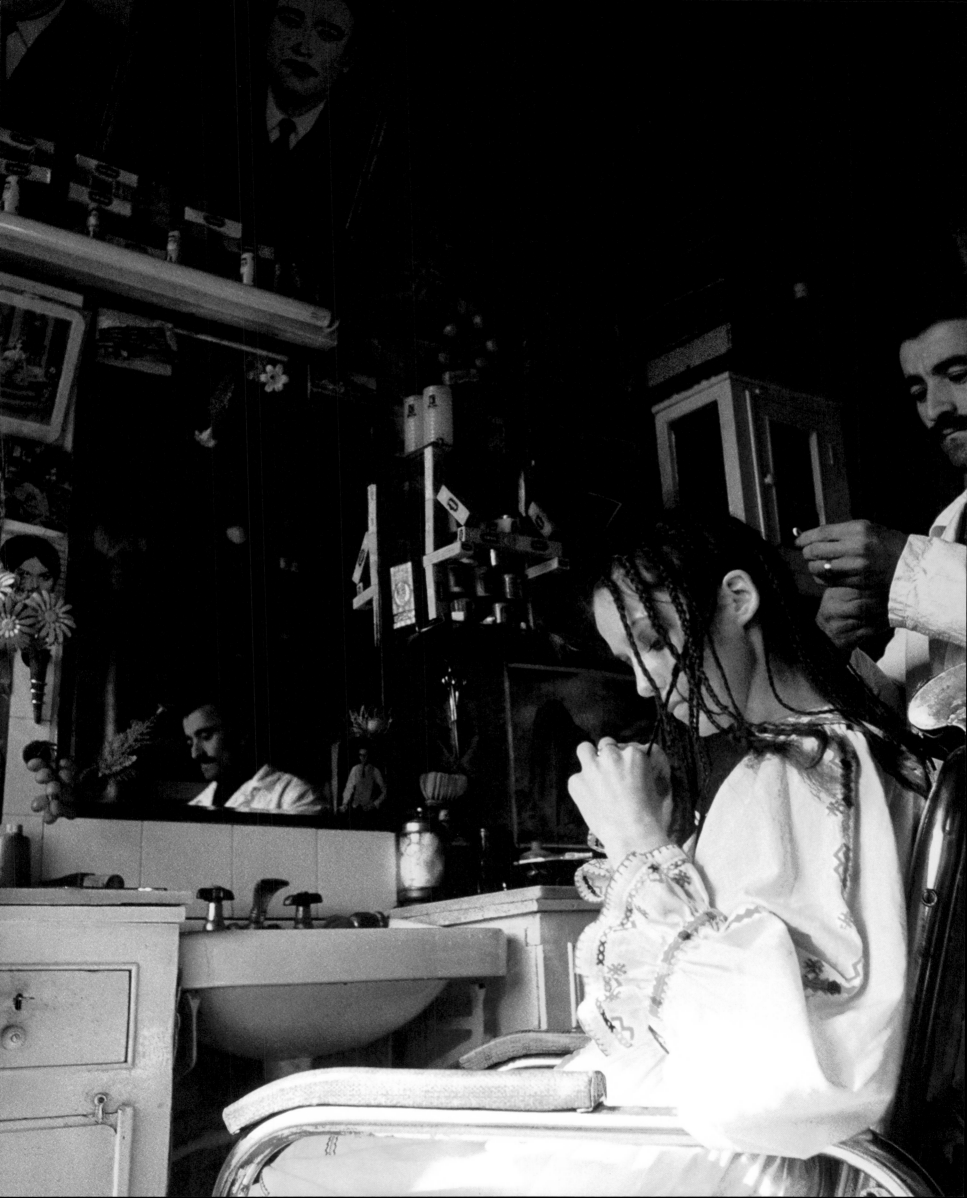

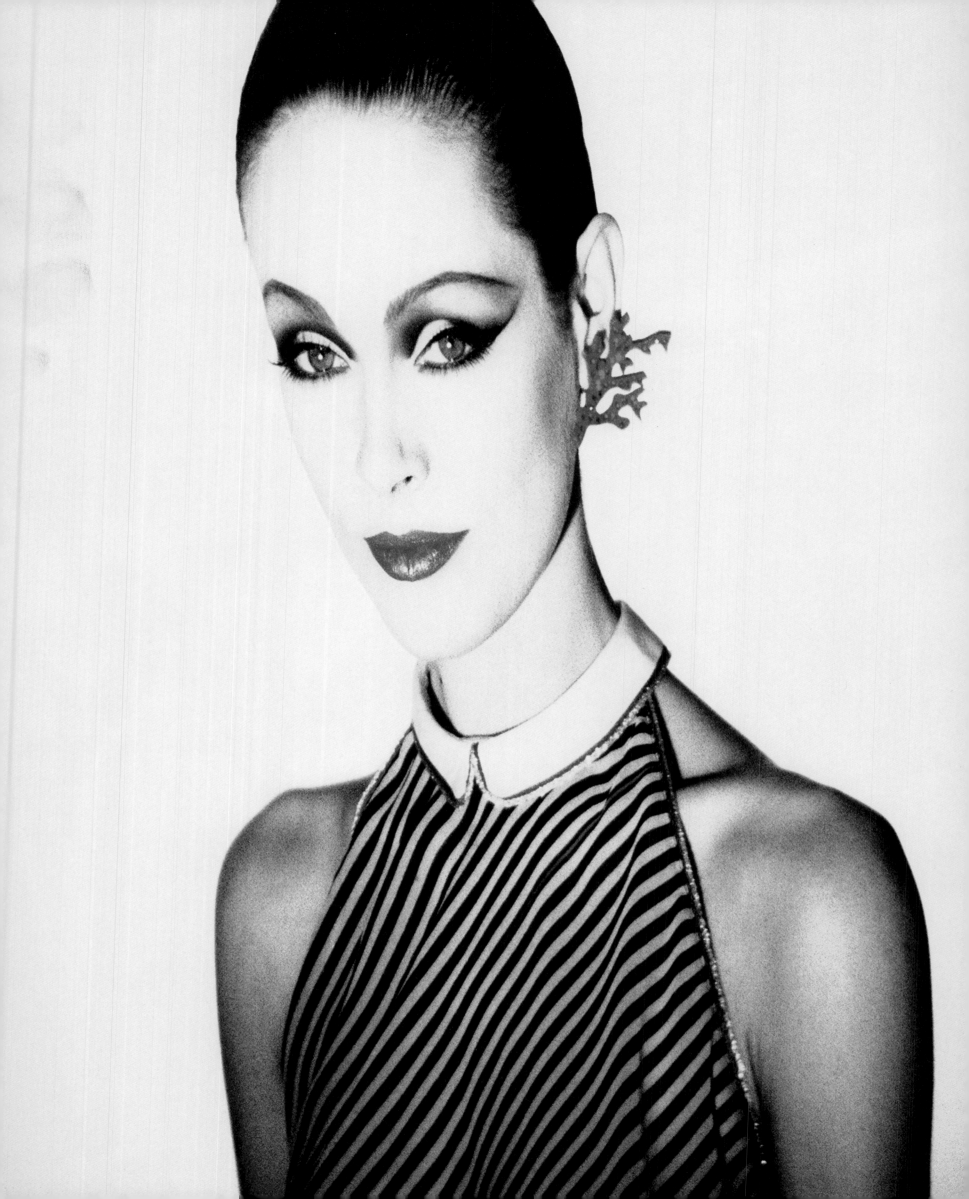

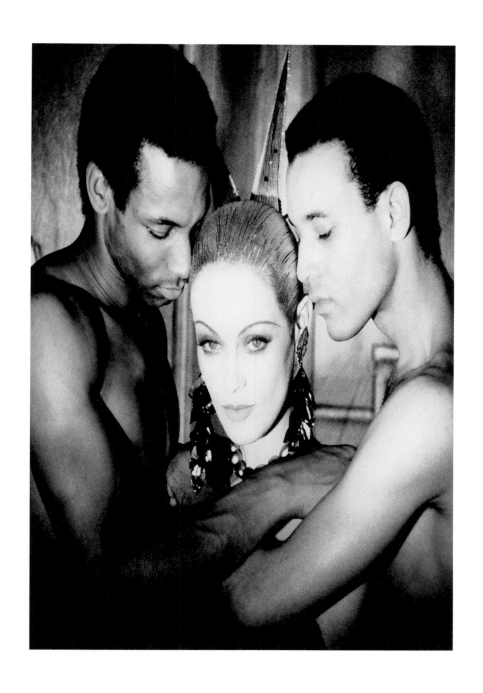

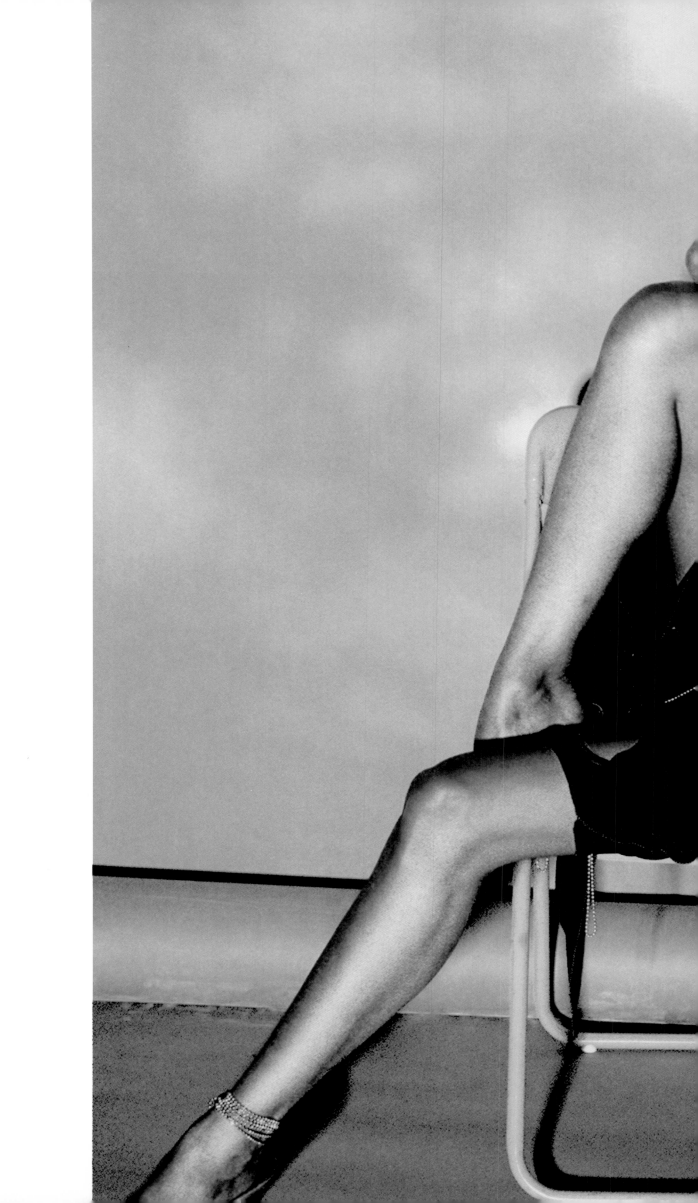

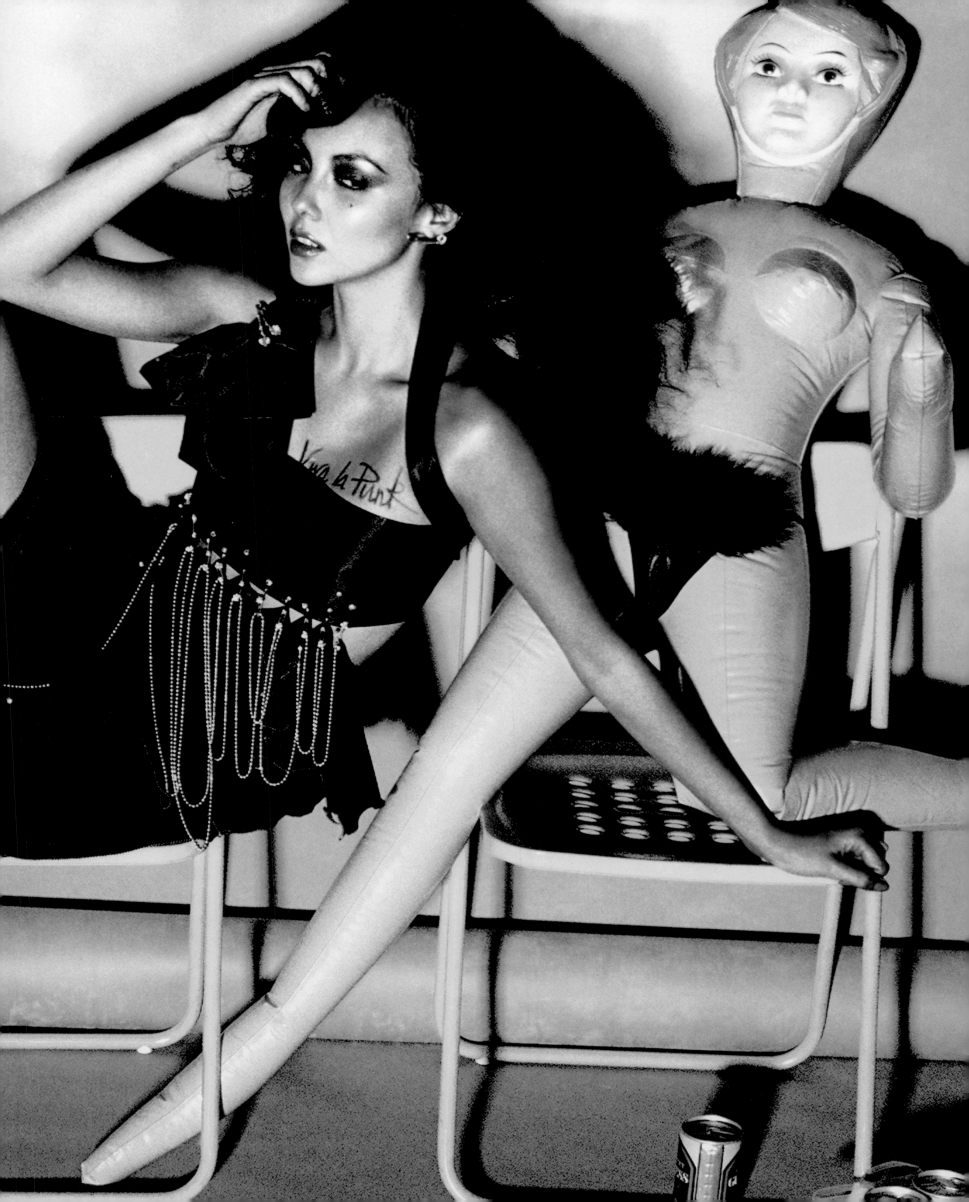

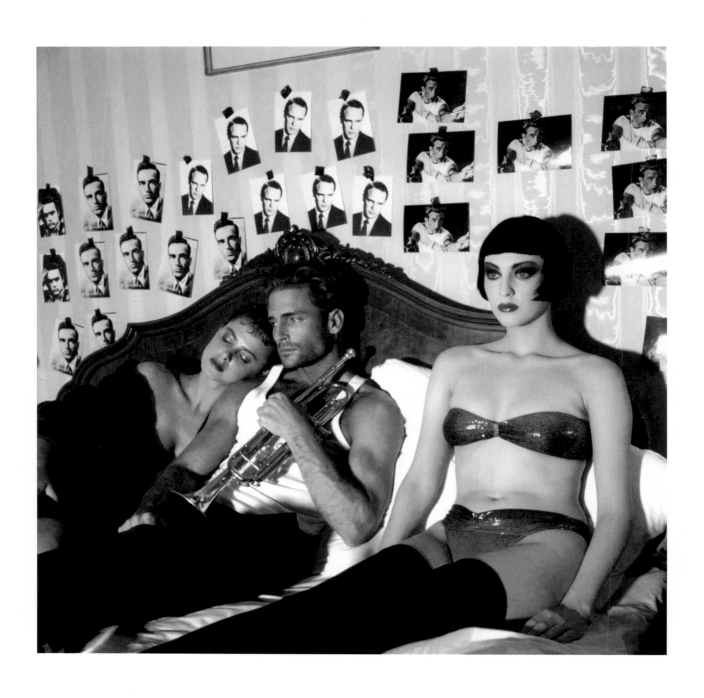

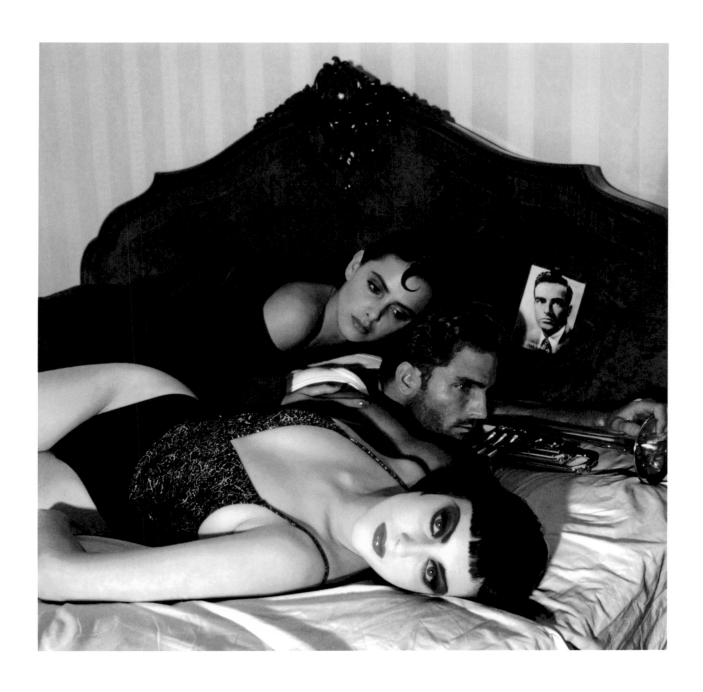

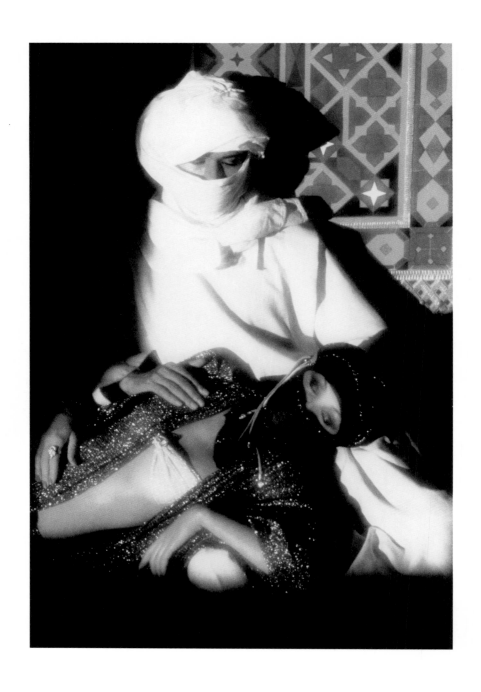

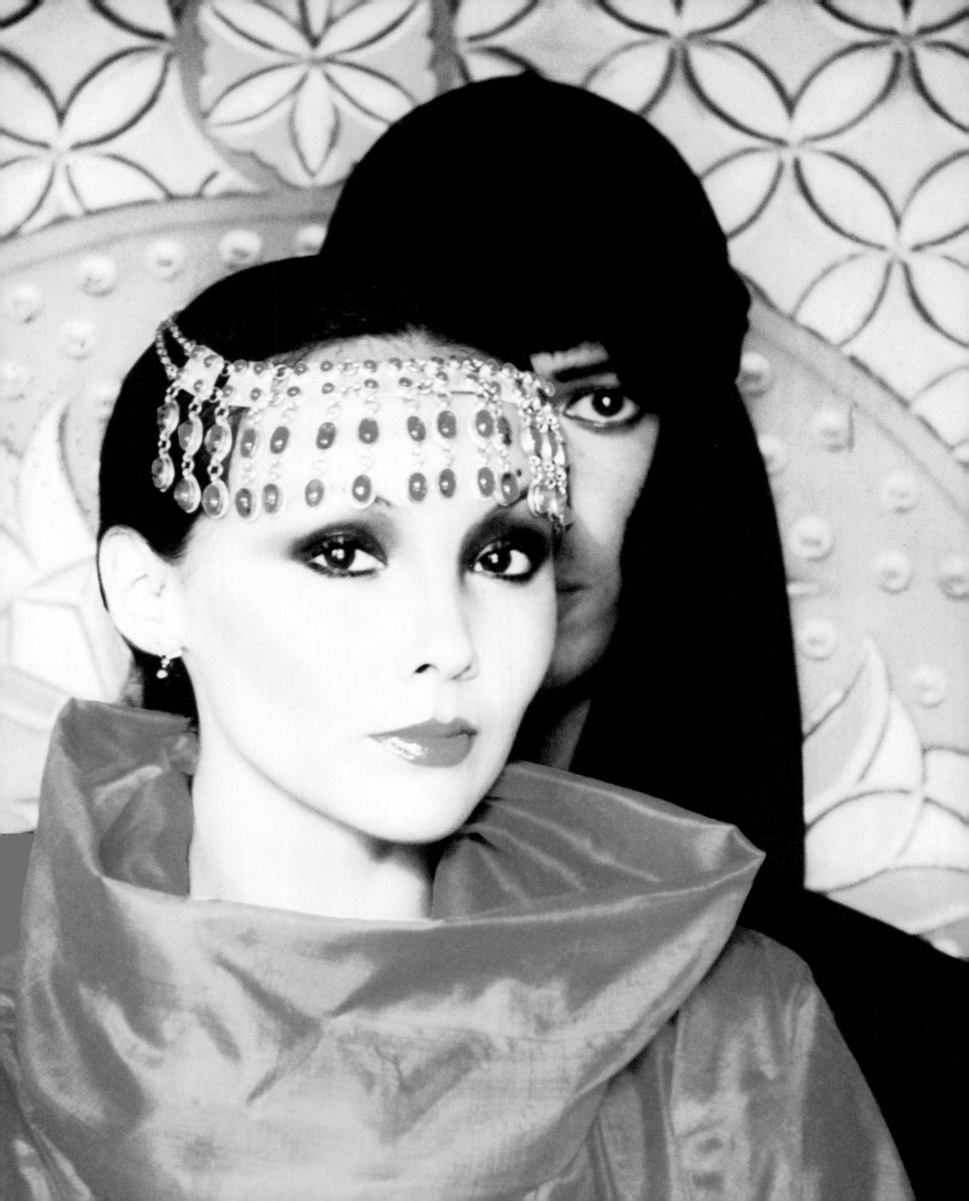

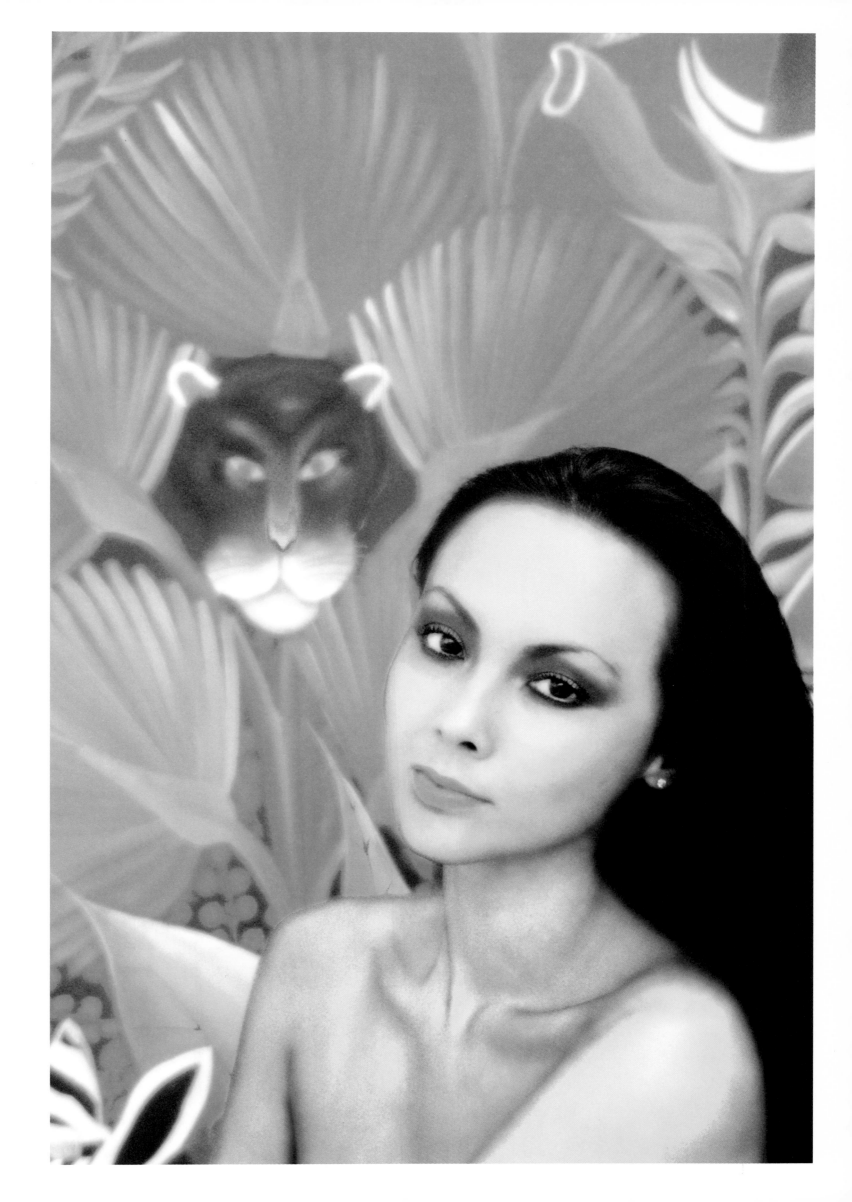

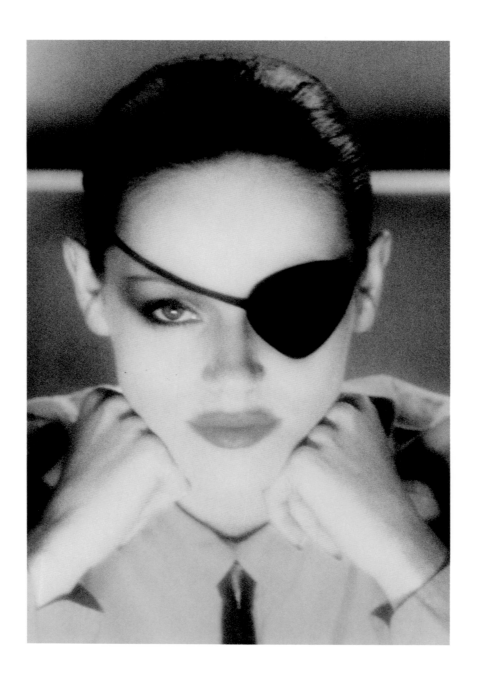

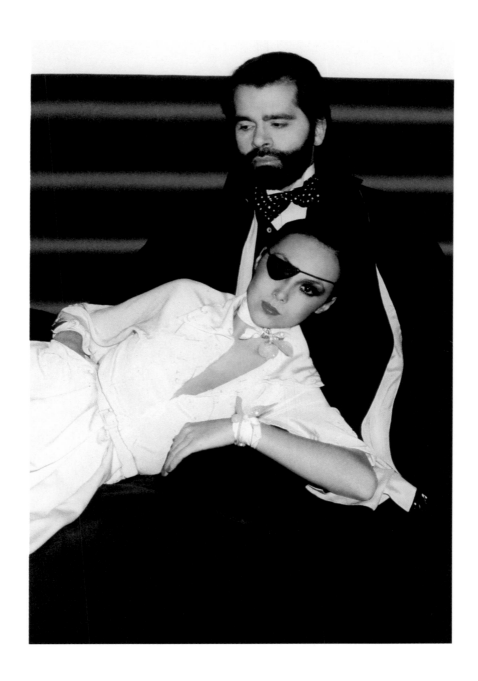

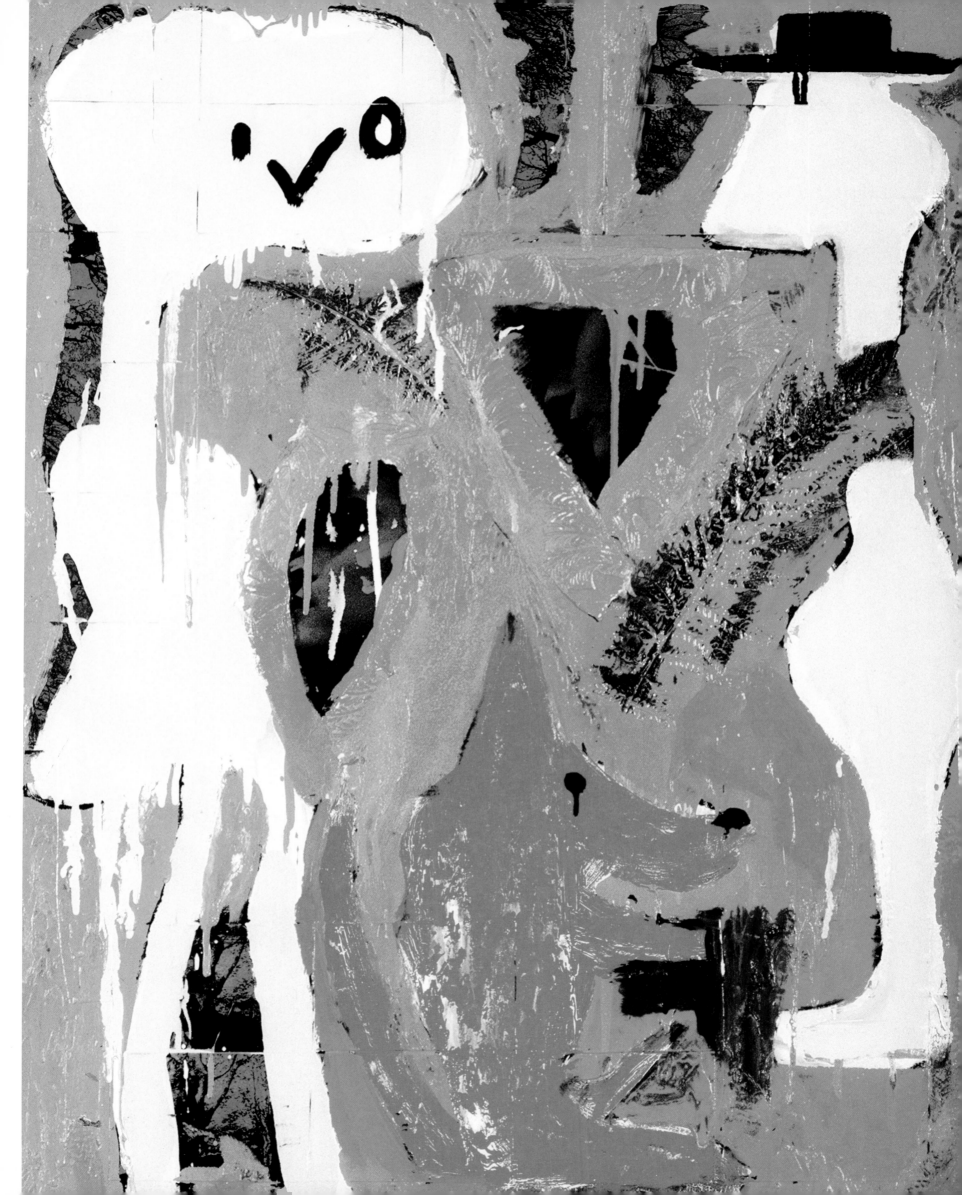

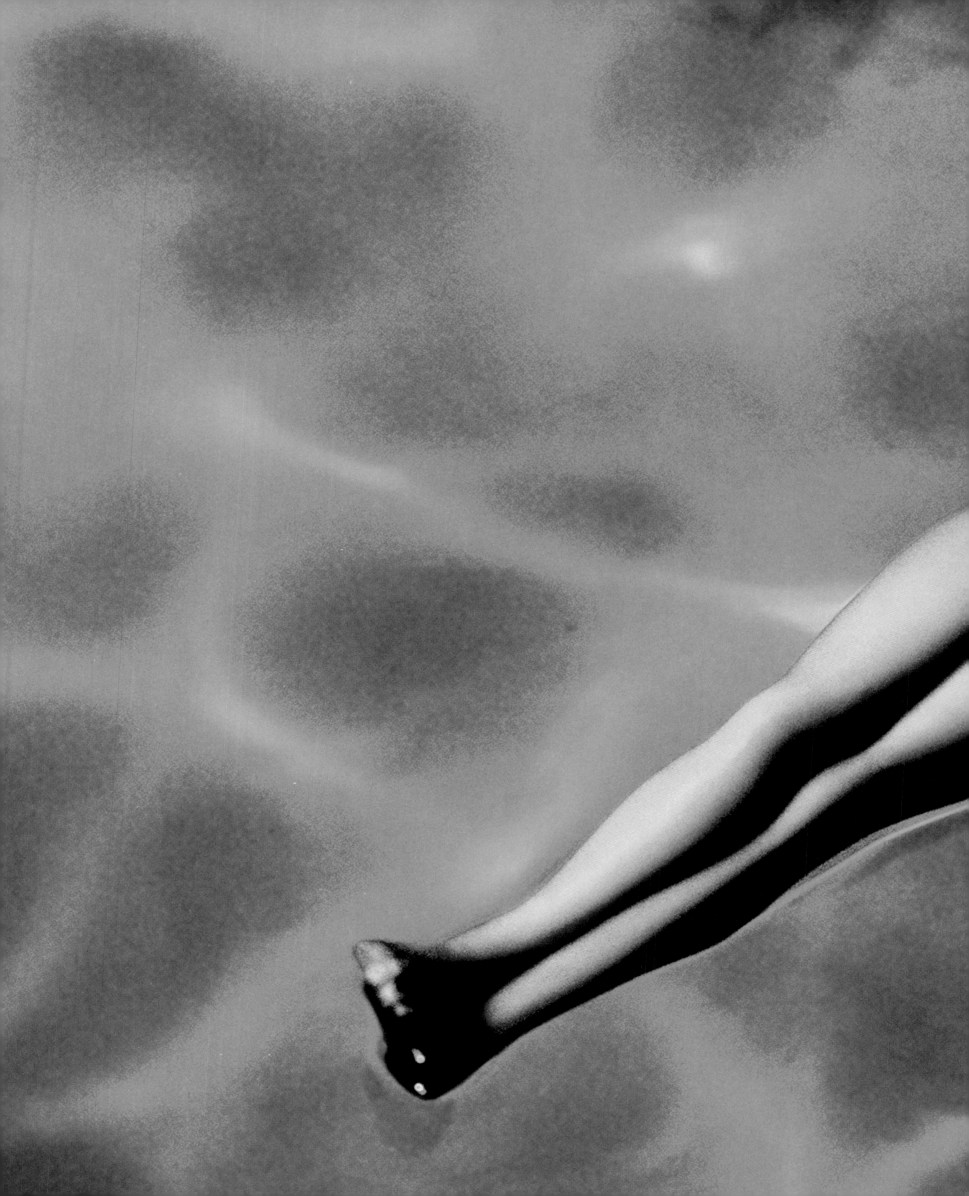

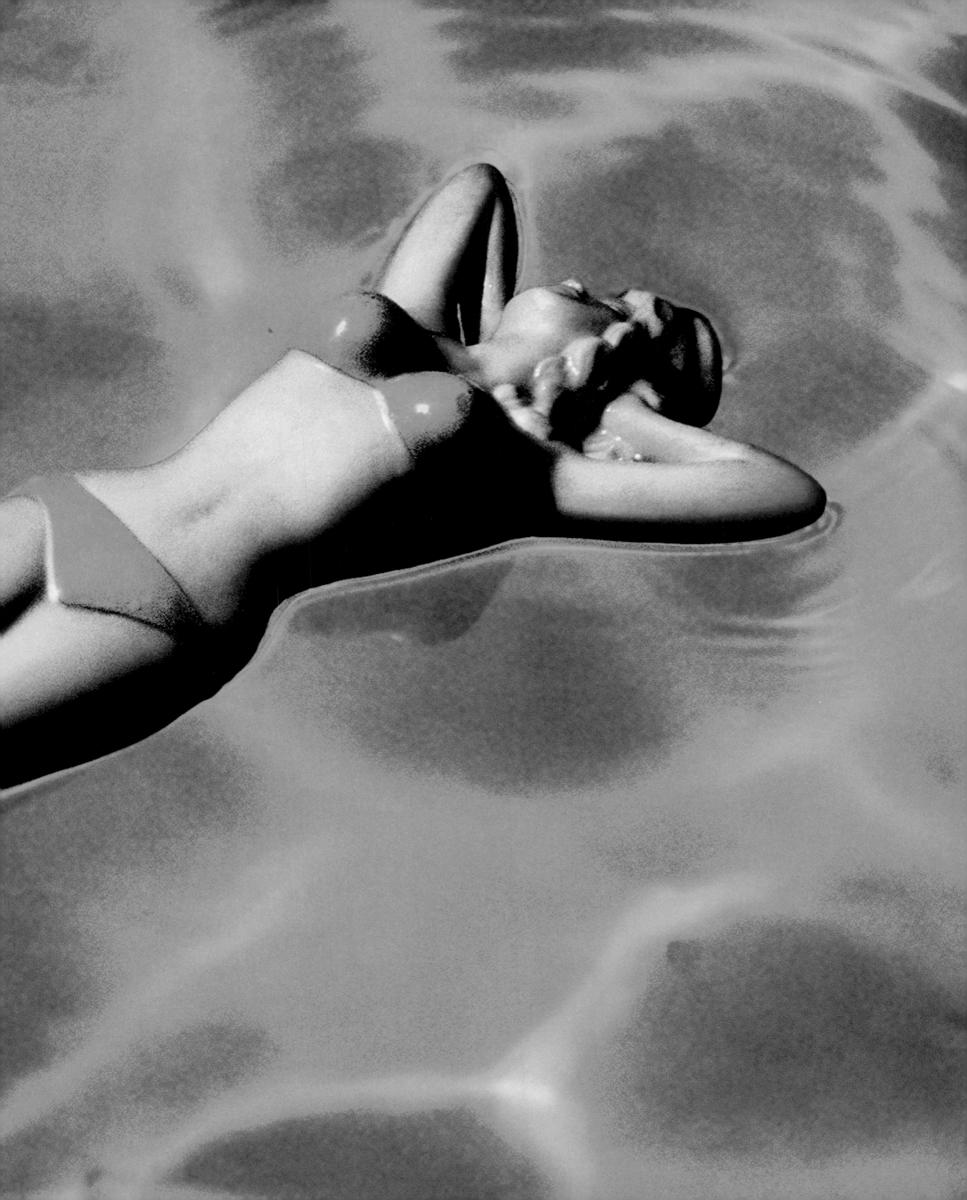

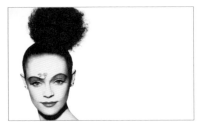

**David Bailey** by Paloma Bailey, aged 11
**Gladys Bailey** unknown East End photographer

**Kim Harris** advertising photograph, *c.* 1979

Untitled, 1990s

Untitled

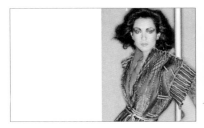
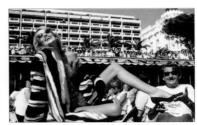
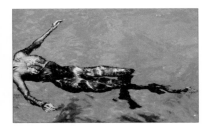

**Moyra Swan** British *Vogue*, August 1976 (variant)

**Jerry Hall and Helmut Newton** Cannes, French *Vogue*, September 1973 (unpublished)

**Marie Helvin** Haiti, French *Vogue*, June/July 1976

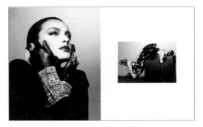
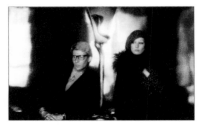

**Marie Helvin** Italian *Vogue*, June 1976

**Catherine Bailey** photographed for Italian *Vogue*, May 1983 (photograph at left: variant)

**Yves Saint-Laurent and Anjelica Huston** Paris, British *Vogue*, September 1973

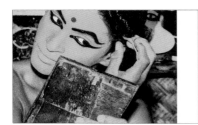
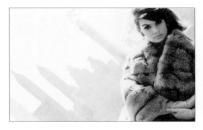
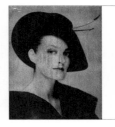

Southern India, late 1970s

**Jean Shrimpton** New York City, *Glamour*, September 1963 (variant)

**Catherine Bailey** *Spoon*, Autumn 1999

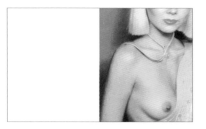
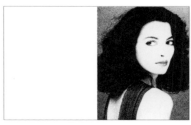

**Marie Helvin** British *Vogue*, June 1976 (cropped version)

**Catherine Bailey** Italian *Vogue*, March 1987 (variant)

Untitled

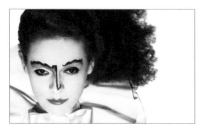
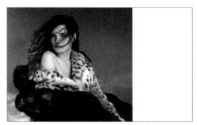
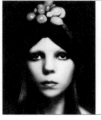

**Kim Harris** Italian *Vogue*, March 1979 (variant)

**Victoria Lockwood** *Tatler*, November 1984 (uncropped version)

**Penelope Tree** (left) **Jean Shrimpton** (right) private photographs, late 1960s (unpublished)

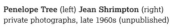

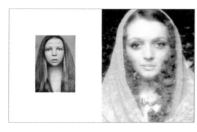

**Penelope Tree** private photograph,
late 1960s/early 1970s (unpublished)
Fashion photograph for British *Vogue*, 1970s

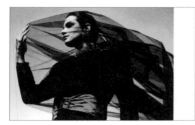

**Catherine Bailey** Italian *Vogue*, December 1987
(variant)

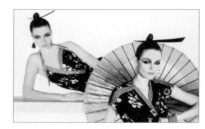

**Kelly LeBrock and Kim Harris** Italian *Vogue*,
April 1980

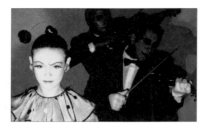

**Kim Harris** Italian *Vogue*, March 1980

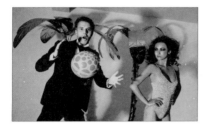

**Manolo Blahnik and Marie Helvin** photographed
for *Ritz* magazine, 1970s

**Marie Helvin** Tunisia, British *Vogue*, February 1976
(photograph at right: unpublished)

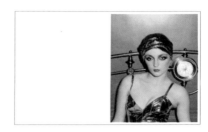

Fashion photograph for British *Vogue*, November
1973 (reversed in magazine)

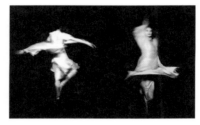

**Kathy Dunne** *Tatler*, March 1985 (variants)

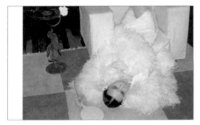

**Tina Chow** British *Vogue*, April 1976 (variant)

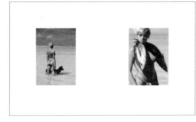

**Lorraine Coe** calendar for Lamb's Navy Rum,
1983

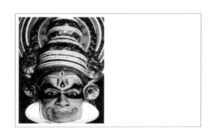

Southern India, late 1970s

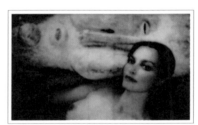

**Catherine Bailey** private photograph, 2000

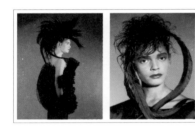

**Victoria Lockwood** *Tatler*, March 1985
(photograph at right: variant)

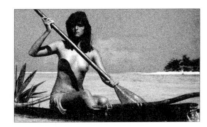

**Catherine Bailey** calendar for Lamb's Navy Rum,
1983

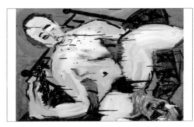

Untitled

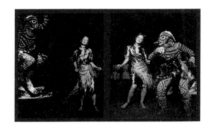

**Ingrid Boulting** Zambia, British *Vogue*, December
1970 (variants)

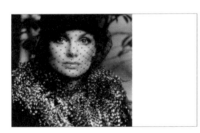

**Jean Shrimpton** Paris, British *Vogue*, September
1973 (originally published in black and white)

**Jean Shrimpton** photographed for American
*Vogue*, 1962 (unpublished)

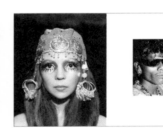

**Penelope Tree** India, photographed for American
*Vogue*, late 1960s/early 1970s
*Right:* Middle India, late 1970s

Untitled

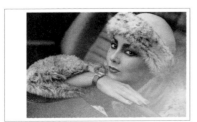

**Marie Helvin** *British Vogue Beauty Book*,
Autumn/Winter 1976 (original reversed)

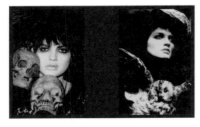

**Catherine Bailey** Italian *Vogue*, December 1975

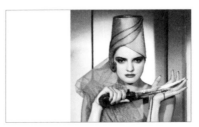

**Catherine Bailey** Italian *Vogue*, 1986

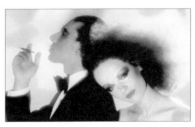

**Kim Harris** Italian *Vogue*, 1970s

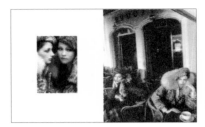

**Anne-Marie and Ann Anderson** photographed for Italian *Vogue*, 1970s

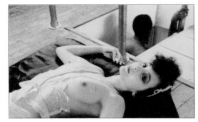

**Marie Helvin** photographed for French *Vogue*, c. 1976

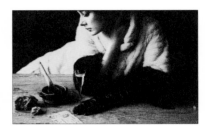

**Tania Mallet** fashion photograph for British *Vogue*, 1961 (unpublished)

**Anjelica Huston and Manolo Blahnik** Nice, British *Vogue*, January 1974

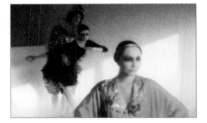

**Marie Helvin** British *Vogue*, December 1975

**Catherine Bailey** private photograph, 2000 (unpublished)

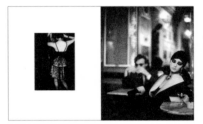

**Catherine Bailey** (unpublished) Fashion photograph for Italian *Vogue*, late 1970s

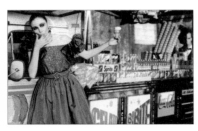

**Susan Moncur** Italian *Vogue*, 1970s

**Marie Helvin** British *Vogue*, December 1975

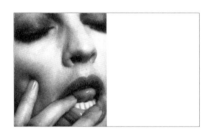

**Catherine Bailey** private photograph, 1980s (unpublished)

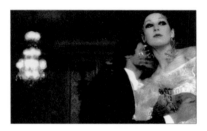

**Oliviero Toscani and Anjelica Huston** British *Vogue*, September 1973 (variant)

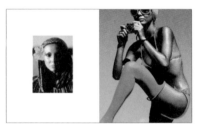

**Marie Helvin** Tahiti, Italian *Vogue*, May 1976

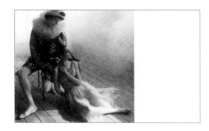

**Marie Helvin** British *Vogue*, December 1975

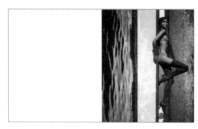

**Marie Helvin** Tahiti, Italian *Vogue*, May 1976

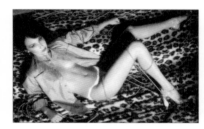

**Marie Helvin** advertising photograph, mid-1970s

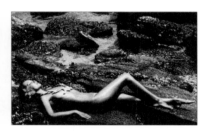

**Marie Helvin** *British Vogue Beauty Book*, Spring/Summer 1975

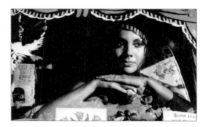

**Marie Helvin** Haiti, French *Vogue*, June/July 1976 (variant)

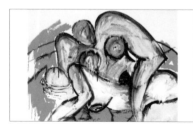

Untitled, 1995

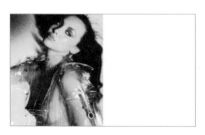

**Marie Helvin** French *Vogue*, November 1977 (variant; originally published in black and white)

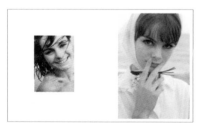

**Jean Shrimpton** *Glamour*, June 1963 (variants)

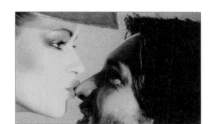

**Kim Harris** Italian *Vogue*, October 1975 (variant)

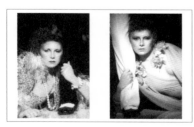

**Aurore Clement** (holding Justin de Villeneuve's leg) British *Vogue*, March 1975

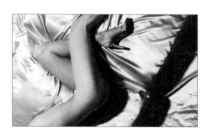

**Marie Helvin** French *Vogue*, November 1977 (unpublished)

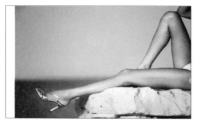

**Marie Helvin** Tunisia, British *Vogue*, February 1976

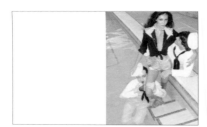
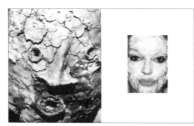
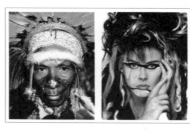
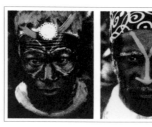

**Marie Helvin** *Cosmopolitan*, 1979

Papua New Guinea, 1974
**Kim Harris** photographed for Italian *Vogue*, 1970s

Papua New Guinea, 1974
**Annabel Schofield** *Lei*, September 1984 (variant)

Papua New Guinea, 1974

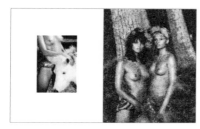

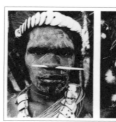

**Catherine Bailey** photographed for a Paul Smith campaign, 1990s (unpublished)
**Victoria Lockwood** Morocco, Italian *Vogue*, April 1985

Untitled

Model unknown
**Victoria Lockwood** photographed for Italian *Vogue*, 1980s

Papua New Guinea, 1974

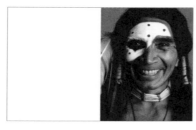

**Catherine Bailey and Lorraine Coe** calendar for Lamb's Navy Rum, 1983

Native American chief, 1970s

**Clare Park** private photograph
**Catherine Bailey** private photograph
(both unpublished)

Papua New Guinea, 1974
**Catherine Bailey** Italian *Vogue*, September 1985

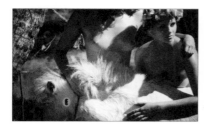

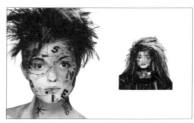

**Catherine Bailey and Lorraine Coe** calendar for Lamb's Navy Rum, 1983

**Catherine Bailey** photographed for Armani, 2000

**Victoria Lockwood** Italian *Vogue*, July 1987 (variant)

**Catherine Bailey** *Lei*, September 1984 (unpublished)
**Catherine Bailey** photographed for Olympus Cameras, 1983

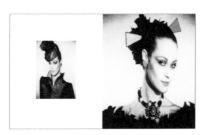
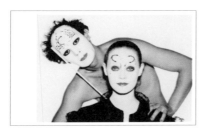
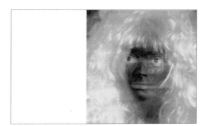
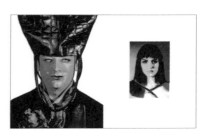

**Kim Harris** Italian *Vogue*, September 1979 (variants)

**Kim Harris** Italian *Vogue*, December 1980

**Victoria Lockwood** Italian *Vogue*, July 1987 (variant)

**Boy George** *Spoon*, Autumn 1999
**Catherine Bailey** French *Vogue*, 1986

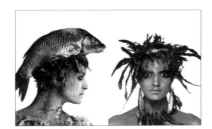
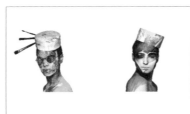
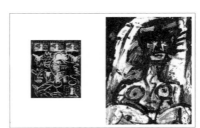
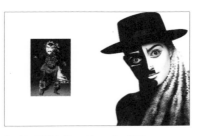

**Catherine Bailey** photographed for Italian *Vogue*, c. 1986

Private photographs, model unknown

Untitled

Zambia, British *Vogue*, December 1970
**Catherine Bailey** private photograph, c. 1984 (both photographs unpublished)

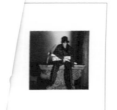

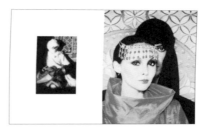

Lorraine Coe *Lei*, October 1984

Cusco, Peru, *Tatler*, September 1984 (unpublished)

**Marie Helvin and Michael Roberts** Morocco, Italian *Vogue*, December 1975

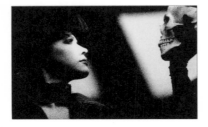

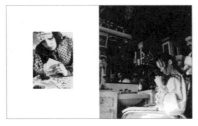

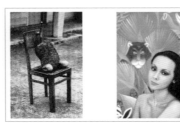

**Katrina Skepper** Italian *Vogue*, December 1985 (unpublished)

**Donna Mitchell** Central Anatolia, British *Vogue*, May 1970

Haiti, French *Vogue*, June/July 1976 (unpublished)
**Marie Helvin** Haiti, French *Vogue*, July 1976 (variant)

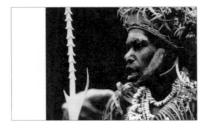

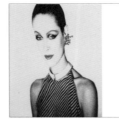

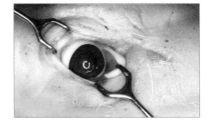

Papua New Guinea, 1974

**Kim Harris** Italian *Vogue*, September 1979 (variant)
**Kim Harris** Italian *Vogue*, March 1980

*Männer Vogue*, 1980s

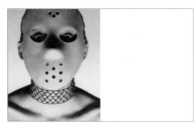

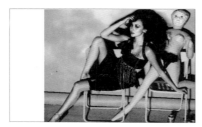

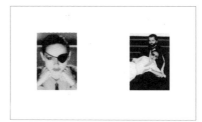

**Charlotte Flyvholm** *Scene*, November 1998

**Marie Helvin** fashion photograph for French *Vogue*, 1970s

**Kim Harris** Italian *Vogue*, 1970s
**Marie Helvin and Karl Lagerfeld** in Lagerfeld's apartment, Paris, British *Vogue*, March 1975

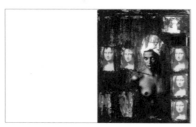

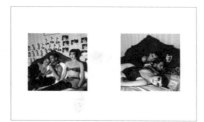

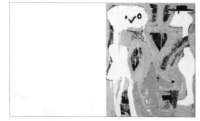

Untitled

**Susie Bick** Italian *Vogue*, June 1975
(photograph at right: unpublished)

Untitled

### Acknowledgments

This book was made possible by the support of the following people: the staff of Condé Nast fashion and art departments. The make-up artists, hairdressers, model agencies, photographic assistants, dark room technicians and models – all too numerous to mention here. Also a special mention for the freedom given to me by the late Lucia Raffaelli at Italian *Vogue*.

I am grateful to Olympus Cameras for their support, to Robin Muir for his text and painstaking research, and to my two right-hand super-professional colleagues Andrew Brooke and William Davidson.

Last, but not least, to Catherine Bailey for her enthusiasm and insight.

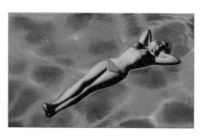

Shop mannequins, France, 1999

Untitled, 1992

Private photograph, 1979 (unpublished)